A Handbook for Academic Museums: Exhibitions and Education

A Handbook for

Academic Museums:

Exhibitions and Education

Edited by Stefanie S. Jandl

and Mark S. Gold

MUSEUMSETC | EDINBURGH & BOSTON

Contents

EXHIBITION PROGRAMS

Introduction

College and university museums originated in the desire to teach with, and learn from, original objects. While the development and focus of individual museums may vary, academic museums share a unique mandate: they are partners in education. As such, college and university museums have evolved in tandem – not always easily – with their parent organizations to support the educational goals of the parent. These museums today are multi-faceted sites for object-based learning, research, professional training, and interdisciplinary collaboration, and they play a more vital role than ever in advancing the work of their parent institutions.

Within the community of museums, academic museums have their own sets of opportunities and challenges. Like their freestanding counterparts, academic museums collect, exhibit, interpret, and educate. But they can pursue these activities and express their missions in broader, more innovative ways. They can, for example, install exhibitions that explore controversial topics or artists under the umbrella of an educational institution. They can create small, focused shows with little pressure to produce blockbuster exhibitions. They can explore the teaching possibilities of a broad range of objects and exhibit those objects in new or unorthodox ways. They have a wealth of multi-disciplinary expertise within their campus community that can be tapped for research and interpretation. And they can be campus leaders in fostering interdisciplinary collaborations and forging new directions in education.

Academic museums may have a certain freedom to

experiment, but they must operate within a layered and sometimes challenging administrative structure. By definition college and university museums have parent organizations and function within a larger educational mission defined by the parent. In this two-tier environment, operations, strategic planning, governance, administration, financial support, and fundraising all become more complex. Some museums feel they compete as neglected stepchildren with other campus departments for operational support and the attention of the administration. Perhaps the greatest source of tension centers on the mission of the museum and how it relates to that of the college or university. In recent years, some parent organizations have even questioned the need for maintaining a campus museum, and some have attempted to monetize art collections to raise capital. These events have had a chilling effect on a community of museums that have not historically been called to defend their presence on campus and their contribution to the educational mission.

As editors, our goal was to aggregate, in one place, as much good, current thinking as we could on the opportunities and issues unique to academic museums. Soon after the Call for Papers was launched, however, it became clear that confining the publication to one volume would mean the elimination of many extremely valuable and thoughtful essays. With the enthusiastic approval of MuseumsEtc, we expanded the project to two companion volumes.

A Handbook for Academic Museums: Exhibitions and Education explores the robust body of exhibition practice in academic

museums and the ways in which academic museums play an essential role in the educational mission of their parent organizations. *A Handbook for Academic Museums: Beyond Exhibitions and Education* addresses most everything else, including the "macro" issues of mission, relationship to the parent organization, phases of birth and growth of academic museums, new technologies, and the collection as a fungible asset of the parent organization.

Another mid-course correction related to the way we considered innovative thinking and practice, especially for case studies. We are both most familiar with academic museums that are blessed with generous assets and support of the parent organization that provide a platform for exploring beyond traditional boundaries and taking greater risks. That being our bias, we initially embraced most strongly the proposals that involved cutting-edge initiatives. Thankfully, and as a result of the great variety of experiences offered by our authors, we quickly appreciated that academic museums are undertaking projects and creatively advancing themselves from a spectrum of base points and with an equally diverse range of resources to support those efforts. We therefore sought to provide a collection of essays that offer best practices, innovations, and good thinking that will offer guidance and inspiration for the entire community.

In selecting our topics, we endeavored to include subject matter which would have both current and long-term applicability and sustained relevance. Other than technology, which is in a perpetual state of change, the only exception

is the immediate issue relating to the monetization of the collection – an emotionally-charged issue of recent urgency. In addressing this sensitive subject, our philosophy was not to be a forum for a debate on the merits of monetization, nor to applaud or condemn decisions or conduct in any one particular instance. Rather, we have chosen to offer information on the legal underpinnings of these issues, to provide the academic museum community with a rare look inside the processes and thinking at the presidential and trustee level as these decisions are made, and to consider how institutional history, culture, and structure can contribute to those decisions.

What is not in these volumes are essays about museums in general that may have applicability to academic museums. The essays in these two volumes are written about, by, and for the community of academic museums. They are intended to be a practical resource for that community. Authors were charged with providing useful information in their essays, such as strategies, best practices, mistakes made, lessons learned, what worked, what didn't, and why. While we sought out subjects that would be relevant to readers, it was also imperative that they be helpful. The books offer a depth of combined wisdom of the profession for the benefit of its practitioners.

Finally, we viewed our role to be editors of the volumes, and not necessarily editors of each essay. We afforded our authors great latitude so that their stories and their thoughts could be in their own voice. As a result, there may be a lack of uniformity of voice amongst the essays, but we felt that the benefits of authenticity and integrity of authorship were paramount.

The essays in these companion volumes were selected to help readers think about their own institutions, programs, challenges, and opportunities – informed and expanded upon by perspectives on what others have done in similar situations and what might be possible. They were intended to stimulate further thinking and discussion among academic museum professionals and within academic museums. We hope the essays contribute to an enhanced practice within the academic museum community and a deepened engagement with its core work: cultivating learning opportunities through original objects.

We offer our sincere thanks to the authors who have so generously contributed their time, expertise, and voice in that effort; these volumes would not have been possible without them.

Stefanie Jandl and Mark Gold
May 2012

STRENGTHENING THE TEACHING ROLE

Ackland Art Museum

Creativity and the Relevant Museum: A Proposal

JOHN R STOMBERG
Mount Holyoke College Art Museum

For centuries museums have been conceived as repositories of the past, some as forums for the present, but in the 21st century, college art museums have the opportunity to actually help shape the future. Museums are almost by definition followers, chroniclers of events and things gone by, but we can be leaders, agents for positive change in our society. Creativity, and the belief that it can be encouraged and taught through the museum, is the key.

There is already recognition on college campuses that we need to prepare our students to be adaptable leaders who are ready to adjust to ever-changing professional landscapes regardless of their chosen field. Across the disciplines we see the curricular emphasis shifting away from having students learn rote skills and toward having them focus on responsive and critical thinking. The call – and this is in every field represented by liberal arts institutions – is to have a population of productive dreamers who solve problems in innovative ways and communicate their ideas clearly. The making of things and the doing of repetitive tasks can be handled elsewhere; our students should be focused on the leadership responsibilities of imagining what should be made or done and the best ways for making and doing these things. Increasingly, creativity and innovation are emerging as critical components in the attributes that constitute leadership.

Here is the proposal. College art museums are particularly well-suited to teach the skills associated with creativity and innovation. We could underscore that these abilities are an intrinsic goal of our program and be clear about how we

foster these skills within the context of our role as a teaching museum. To do so will require clear planning of our programs and effective communication with our faculty and students – we cannot afford to lose our current constituencies on campus. As we move to a model of creativity, innovation, and leadership training through the arts, the teaching museum will gain a degree of relevancy undreamt of in the past.

To be prepared for this increased responsibility, the teachable aspects of creative practice need to be identified and in this we have had a great deal of assistance from sociologists such as Steven J. Tepper and George Kuh. In a recent *Chronicle of Higher Education* article, these scholars articulate seven finite skills associated with creativity.[1]

These include: asking *what if* questions, working collaboratively, expressing ideas effectively, taking and applying constructive criticism, thinking in a non-routine fashion, communicating on multiple platforms, and close observation. If college art museums adopt these skills as the overarching goals of their programming, they will be contributing directly to educating a new generation of innovators.

Teaching museums have already adopted a model of curriculum support and for this we have gained the respect and gratitude of our colleagues across campus. Professors from around the college come to us for ways to enhance their teaching in subjects from Ancient Literature to Contemporary Gender Studies. We need to maintain this current program as it has given college art museums a greatly enhanced position

within college life. But we are poised to take the next step in our evolution: curriculum generation. We can develop flexible, museum-centered programs that take creativity as the meta-goal while reinforcing the material covered by the faculty.

With time, this should become the expectation – the college should expect the art museum to provide opportunities for students to receive innovation training in a manner similar to the expectation that the athletic facilities provide opportunities for students to receive physical training. The museum will never stop being a center for art and art history studies, any more than the athletic facilities would forsake the members of their teams (the focus of most of their attention). Rather, we will provide an additional service to the campus, one that we are uniquely qualified to provide. Students should spend time at the gym to become physically fit; they should come away from their time at the museum creatively fit.

As a starting point, those responsible for working most closely with faculty (the Coordinator of Academic Affairs or Curator for Academic Programming – the titles are different but the job descriptions are largely the same) can begin to take on a slightly different role. In general, the professionals in this specialized field have sought to help faculty who have not traditionally taught with objects feel more competent, confident, and comfortable teaching with art. While of course the endgame has been to get students into the museum, in many ways the focus of the current coordinator position is the faculty. They do not typically teach the classes, but rather facilitate the use of campus art collections by a wide array of faculty.

As we move forward, the people holding these positions will need to have a somewhat more active role in shaping the program through which the professors' material is delivered. First, they will need to form discussion groups of professors interested in the idea of fostering creativity through the museum – at Mount Holyoke College, we have found the faculty generally very eager to begin these discussions. Working with their colleagues in a variety of departments and at the museum, the coordinator will need to develop new programs. These will need to be designed specifically for individual classes so that when students visit the museum they learn both the material of the course and some aspect of the skill set we are identifying with creativity. This represents an additional activity and not a replacement. Where we have been focused on the faculty and their needs – a role we will continue unabated – we are now also looking to address the need for students to learn creativity skills.

The museum will need to take a leadership role in bringing about these changes. It will be responsible for articulating the vision of this project and for continuously refocusing our colleagues' attention on the importance of this training. In taking on the role of agent for change, we need to think carefully about the implications of our actions and the risks if we fail. Happily, we have access to expert guidance on institutional change coming from several fields, but the world of business management offers a particularly fertile bibliography on the subject. Among those who have worked on the topic, the business consultant and Harvard Business

School professor John Kotter has received widespread praise for his incisive analysis of making productive changes that have long-lasting impact.

In his widely-influential 1996 book, *Leading Change*, Kotter set out eight clear steps for successfully achieving change.[2] These steps are directly applicable to this proposal – it assumes that the museum staff as a whole takes the role of leader. First, we need to highlight the fact that creativity has been identified as an urgent priority by individuals and departments across the campus, even if it has yet to achieve the level of a college-wide strategic initiative. Then we need to get the support of the key members of our faculty and administration who can help to drive the process. The project vision will need to be inspired, persuasive, and readily articulated in brief presentations. The vision will have to be repeated clearly and often by those involved. The team will need to be receptive to feedback containing obstacles to success and address those in a forthright manner. Kotter's sixth step is especially important for the college art museum if we are not to be taken as abstract dreamers – finding an early and demonstrable success. This will require some sophisticated mechanism for evaluating success (not insurmountable, but a challenge). His last two steps involve the long-run implementation of these changes. We need to build a track record of success, quietly amassing data that show years of true impact and the adjustments that have been made along the way to improve the original ideas. Finally, we embrace the idea as inherent to our identity. This is the part that offers so much excitement – adding creativity

training to the vision and mission of college art museums.

The Mount Holyoke College Art Museum has only recently identified the creativity skills that we wish to encourage and have only just begun to formulate the best approaches to doing so. Taking the list set out by Tepper and Kuh (above) as a starting point, we realize that there are myriad fields that are simultaneously and vigorously examining how best to further innovative thinking within their field. It is essential for the museum to become familiar with as many of these as possible to ensure the maximum utility of the programs we develop. To give a sense of the breadth of this conversation, each of the seven skills on the Tepper and Kuh list is examined below in the context of different areas of expertise, ranging from creative writing to business management.[3] What emerges is the ubiquity of concern for fostering creative thought, the predominance of these seven skills as hot topics within these discourses, and the great diversity of endeavors that set these as high priorities.

What if? Asking what if questions is essential to almost every field. What if moldy bread had medicinal value? What if we could build a rocket capable of reaching the moon? What if a kid with a yo-yo could be a prophet? This last is the premise of a novel by Karen Krossing who, in addition to writing novels, edits professionally and offers her services to new writers as a coach. On her blog, where she shares tips for creative writing, she recently dedicated a post just to the effectiveness of asking what if questions as a way to start a new story. [4] "When we ask ourselves 'what-if' questions," she writes, "we can imagine

whole new worlds, new ways of living, and unique characters who are dealing with unusual circumstances."[5] Her point is that the beginning of most creative writing is trying to imagine a scenario that doesn't yet exist. At its most fundamental level, the creative process involves conceiving either something that does not yet exist or reordering things that do.

Collaboration: In his 2002 book, *Smart Mobs,* the cultural critic Howard Rheingold elaborates how technology has created a world of collaborators linked virtually by the internet.[6] Citing political protests that erupt through text communication as a key example, he notes that the most important power of the new communications technologies (cellphones, computers, etc.) is collaboration. These technologies have made virtual communities capable of achieving significant societal change without the benefit of a governing body or a host institution. He goes further in insisting that this form of collaboration extends the evolution of the human race, which has advanced only through cooperation since the earliest days of the species. With new technologies, Rheingold foresees only growth in the area of disparate groups working to achieve specific tasks. Underlying this prediction is the observation that the nature of cooperating needs to be studied, engaged, trained, and adopted if we are to participate fully in the most productive aspects of society in the future. In other words, like it or not, collaboration will continue to grow in importance in the coming century, becoming the essential ingredient for productive societies.

Expressing ideas: More than any of the other seven, the

ability to express ideas effectively is a valued and important skill in every field. Every endeavor (with the possible exception of a statistically insignificant number of counter-examples such as the recluse or the hermit) requires the sharing of ideas. In the United States, politicians represent a particular and widespread segment of the population that has the expression of ideas built into the very fabric of its profession. Despite the wide range of media used to transport their messages – from Twitter and cable TV to small gatherings in coffee shops – one thing remains constant: just like their predecessors on a street corner standing on a soap box, on some level they are judged by how they stand up and express themselves. Sometimes the ideas they need to get across are complicated and require the ability to distill; on other occasions they take simple observations and move to draw complex inferences from them. In either case, for young people considering a career in politics, mastering the art of effective expression is essential.

Constructive critique: In the practice of law, the role of constructive critique starts long before law school and continues well into the practice of seasoned attorneys. Starting in high school, students interested in the field join mock trials (or moot court). They meet with practicing lawyers who guide, observe, and critique their performances. The United States has organized national competitions where local and regional winners advance to high-profile mock trials. This can continue through their college years and is a part of law schools' educational approach. Even more interesting for this essay, is that professional lawyers often set up mock trials for

upcoming cases, putting themselves and their arguments in front of other colleagues for evaluation. Throughout the profession, from teenagers just contemplating their future to attorneys with decades of experience, constructive critique is deeply imbedded in the practice of law.

Divergent thinking: A process can shape an outcome – in fact, it often does. If we work toward solving different problems with the same preordained set of steps, operations, or questions, then we will arrive at a solution that may have more to do with our process than with being the best outcome. For this reason, creative thinkers in many different fields are engaged in what psychologists have defined as divergent thinking, which they differentiate from convergent thinking.[7] Importantly, as New York University psychologist Scott Barry Kaufman's research has shown, the intellectual capabilities conducive to divergent thinking are not those tested for in most IQ tests. Rather, divergent thinkers – or individuals who come to this mode of thinking early in their lives – may well test poorly in IQ tests while excelling at others designed to find non-routine thinkers.

Both divergent and convergent thinking are important, but should be used at different moments in our problem-solving process. Divergent thinking involves allowing ourselves to free associate ideas that may or may not be immediately applicable.[8] It means giving the space and time to permit anything that comes to mind to make it to the table. Brainstorming, the stage in planning where no ideas are out of bounds, is one example of this approach, but there are many. Convergent

thinking imposes the necessary rules to achieve identifiable goals – the practical side of applying the discoveries made during divergent thinking exercises. Convergent thinking also provides the structure to decide which ideas make sense (having the potential to further the project) and which do not.

Communication skills: In the sciences, there have long been calls for more effective communication. In fact, the May 2012 Arthur M. Sackler Colloquia at the National Academy of Sciences was called *The Science of Science Communications.* The goals of the colloquium were many faceted and but were based on a widespread opinion in the science community that the general public needs to be more aware of what goes on in the world of science. One topic was how to best communicate complex subjects. The answer is often visual. While talks and scientific papers effectively exchange information within the field, getting the message to a wider audience requires multiple communication platforms. That is, science is frequently expressed with images – diagrams, charts, maps, photographs, etc. While these have to remain true to the science being demonstrated, they need to be somewhat easily comprehensible. If they are inscrutable to the intended audience, then their value is highly circumscribed. Scientists need to be effective visual communicators using a variety of media.

Close observation: Acute *otitis media* is an ear infection. According to the American Academy of Pediatrics and the American Academy of Family Physicians nearly 16 million cases of AOM were diagnosed in 2000.[9] This implies that many

more times – maybe even millions of times – doctors decided that the symptoms for an ear infection were not present. What is the basis of this diagnosis? In addition to ascertaining the general health of the child (is he or she showing the signs of sickness generally associated with an infection?) the doctor has to look into the ear in question and determine whether it is pinkish or reddish.[10] Tens of millions of times each year, then, doctors make a judgment on a child's health based on the close observation of a shade of color. To an art historian, this sounds like the difference between Veronese red and Titian red – it also stands to reason that close observation skills honed in an art museum have direct applicability in the medical profession.

These brief overviews demonstrate the profusion of fields where creativity skills have direct applicability. The challenge facing the college art museum is finding appropriate programmatic means to encourage these seven skills. Certainly we cannot expect every project or program to cover every skill set we hope to teach. Identifying these skills as objectives early in our planning will allow us clear criteria for selecting which projects and programs we should pursue.

At the Mount Holyoke College Art Museum, a Joseph Cornell project was recently given the green light. The artist created films, drawings, and collages along with his signature boxes. The Cornell project will involve faculty from six departments (Film, Literature, Dance, Art History, Studio Art and Music), several interns, and our museum staff working together to develop a film series and an exhibition, to organize lectures and gallery tours, and a to publish a catalogue.

It became clear in evaluating the Cornell project that both the artist and the project exemplified the values of our creativity initiative. The artist's artworks clearly emerged from asking *what if* questions. We can imagine him asking, "What happens if I do not limit my work to only marks and colors that I make or to two-dimensional surfaces?" Despite the allusive nature of his communication, he worked tirelessly to perfect a means of getting his particular ideas across with a mode of expression perfectly suited to his ideas. His works also embody divergent thinking – Cornell brought together unrelated bits of images and objects, considered them, selected those that fit his goals for the specific work under construction, and then applied his considerable experience (an example of convergent thinking) in assembling the final artwork. Further, and somewhat surprisingly, though Cornell was known for his reclusiveness he shared a friendship with the painter Walter Murch and the two met frequently to share their thoughts on each other's work – taking and giving critique. And, lastly, the finely detailed and often quite intricate marks characteristic of his art require and reward close observation. The Cornell project offers the museum opportunities to build programming around a majority of the creativity skills.

Once the creativity initiative programs are established within the undergraduate context, a similar model could be applied to K-12 programming. The direct subject would remain largely at the discretion of the teachers. That is, we would still have the 4th graders studying Ancient Civilization, or the 8th grade U.S. History class, come to the museum to have

in-depth, object-based engagements with the material their teachers were covering. But our approach would include the creativity initiative skills discussed above.

In fact, a framework set out in the past few years by K-12 educators focused on the needs of students in the next century has set forth complementary goals. The *Partnership for 21st Century Skills* has outlined in its *Skills Maps*, a series of overarching objectives for primary and secondary school education. Called *A Framework for 21st Century Learning*, the map prioritizes skills that parallel those identified with our creativity initiative, but in a different organization.[11]

What this group calls for is a general agreement on the core subjects for American students (such as History and English), providing career and life counseling as appropriate, and access to the types of technological skills useful in most careers today. Overlaying all of those topics, however, is the recommendation that four skills be enhanced, the so-called 4-Cs: Critical thinking, Communication, Collaboration, and Creativity. The National Art Education Association is already working on using the *Skills Maps* for their primary and secondary education programming recommendations.[12] Clearly, the college art museum that has adopted the goal of training their students in the seven skills on the Tepper and Kuh list are well-placed to adopt that programming for K-12 students and thereby provide much-needed assistance to the schools in our communities.

Time, space, and resources permitting, we may even permit ourselves the freedom to conceive of a future where

teaching museums provide this sort of training to individuals who are beyond their formal student years, the life-long learners. Richard Florida, a long-time advocate for the positive societal value of the "creative class" (which includes everyone from doctors to poets), continues to argue that the key to a productive, satisfying, financially-secure future for our country lies in remaking our cities into productive centers that support the needs of the creative class and the "creatifying" [his word] of low-skill jobs.[13] Florida argues that, "Our most important resource is us – or to be more precise, the creative potential that is in every human being." [14] What the country needs, he writes, is a school system that rewards and encourages creative thought and cities that welcome and cater to creative individuals. The market will follow the talent.

Consider the potential contributions which college art museums that are active in teaching creativity skills could make in fulfilling Florida's vision. What if they became places that municipalities could rely on to actually help unleash the creative potential of their citizens? It is not inconceivable that a city could make itself more attractive to companies large and small seeking to locate somewhere with a workforce capable of taking their product or project into the next century. The presence of an active, progressive college art museum could play a legitimate role in making this scenario come true. It all starts with a group of faculty and museum staff agreeing to develop programs that train our students in skills identified with the creative process.

NOTES

1 Steven J. Tepper and George D. Kuh, "Let's Get Serious About Cultivating Creativity," *Chronicle of Higher Education*, September 4, 2011, accessed March 15, 2012, 1 http://chronicle.com/article/Lets-Get-Serious-About/128843/

2 John Kotter, *Leading Change* (Cambridge, MA: Harvard Business Review Press, 1996).

3 Note that we could turn to almost any of these fields for writing on all seven skill sets.

4 Karen Krossing, "Writing by Asking "What If" Questions," January 17, 2011, accessed February 22, 2012, http://karenkrossing.com/2011/01/17/writing-by-asking-what-if-questions-2/.

5 Karen Krossing, op. cit.

6 Howard Rheingold, *Smart Mobs* (New York: Basic Books, 2002).

7 For a recent discussion of this, see Scott Barry Kaufman, "How Convergent and Divergent Thinking Foster Creativity," Psychology Today, February 9, 2012, accessed March 22, 2012, http://www.psychologytoday.com/blog/beautiful-minds/201202/both-convergent-and-divergent-thinking-are-necessary-creativity.

8 For this definition of divergent thinking I am relying particularly on: Henrique Fogli, "Divergent Thinking," Creative Gibberish.org, accessed March 22, 2012, http://creativegibberish.org/439/divergent-thinking/.

9 Unsigned, "Questions and Answers on Acute Otitis Media," *American Academy of Pediatrics and American Academy of Family Physicians*, accessed April 12, 2012 http://www.aafp.org/online/etc/medialib/aafp_org/documents/clinical/clin_recs/acute_otitis_media.Par.0001.File.tmp/aom_qanda.pdf.

10 Unsigned, "Ear Infections in Children," National Institute on Deafness and other Communication Disorders, accessed April 12, 2012, http://www.nidcd.nih.gov/health/hearing/pages/earinfections.aspx#6.

11 Unsigned, Partnership for 21 st Century Skills, "A Framework for 21st Century

Learning," accessed April 10, 2012, http://www.p21.org/index.php

12 Unsigned, "21st Century Skills Map for the Arts Released July 15 on Capitol Hill,"
 National Art Education Association, accessed April 10, 2012,
 http://www.arteducators.org/research/21st-century-skills-arts-map

13 Richard Florida, "It's Up to the Cities to Bring American Back," *Business Insider*,
 accessed April 10, 2012, http://www.businessinsider.com/richard-florida-its-up-to-
 the-cities-to-bring-america-back-2012-2

14 Ibid.

EXHIBITIONS AND EDUCATION

Using Collections to Enhance the Student Experience: Developing a New Learning Offer

DAVID GAIMSTER & RUTH FLETCHER
Hunterian Museum
University of Glasgow

With over 1.3 million objects, The Hunterian at the University of Glasgow (UoG) is one of the leading university museums and galleries in the UK, if not the world. The Hunterian was the first museum to have its entire collection recognised as being of National Significance for Scotland.

Founded in 1807, The Hunterian is Scotland's oldest public museum. The Palladian temple built by William Stark in the grounds of the Old College in the centre of Glasgow was designed to house the bequest of Dr William Hunter, (1718-1783), the pioneering physician and scientist with a passion for collecting. A former student of the university, Hunter found fame and fortune in London as physician to Queen Charlotte and as a renowned teacher of anatomy and obstetrics. He was elected a Fellow of the Royal Society and of the Society of Antiquaries, and became the first Professor of Anatomy at the Royal Academy of Arts. Hunter was well acquainted with the leading figures of the Georgian Enlightenment, who assisted him in creating an extensive collection of art, antiquities, manuscripts, numismatics, ethnography and natural history specimens, which, together with his anatomical teaching collection, he bequeathed to the university in 1783.

The world's foremost universities have great collections, and Glasgow belongs to that elite group that have invested in museums for research and learning across a wide spectrum of disciplines. Amongst The Hunterian's treasures today are the scientific apparatus used by James Watt, Joseph Lister and Lord Kelvin; monumental sculpture and antiquities

from the Antonine Wall; major earth and life sciences holdings; Scotland's most important print and numismatic collections; rare "first contact" artefacts from the Pacific Ocean; and extensive collections of European and Scottish art and design, including the personal estates of the artist James McNeill Whistler and architect and designer Charles Rennie Mackintosh.

The Hunterian has undergone many changes since 1807. The relocation of the University of Glasgow from the industrialised city centre to the west in 1870 meant the demolition of the first Hunterian and the creation of new galleries within the Gothic Revival teaching campus designed by Sir George Gilbert Scott. Both Hunterians have been blueprints for subsequent generations of museum architecture. A new art gallery designed by William Whitfield was opened in 1980 together with a building housing the interiors of the Glasgow home of Mackintosh. Recently, new galleries have been created, including The Antonine Wall: Rome's Final Frontier. Today, as before, The Hunterian supports its university in delivering excellent research, in providing an excellent student experience and in reaching out to the global learning community.

The Hunterian Learning Plan
Maintaining and enhancing the student learning experience is a key plank in *Glasgow 2020: A Global Vision*[1], the strategic plan of the University of Glasgow for 2010-15. In addition to an emphasis on research-led teaching, the university is pioneering a number of initiatives to establish innovative,

interdisciplinary programmes enabling students to broaden their university experience and develop their professional attributes. The university has prioritised the promotion of work-related learning in its post-graduate taught degree programmes (PGT) in order to enhance employability and prospects of career progression. Market analysis supports the development of a more diverse portfolio at taught postgraduate level. PGT students increasingly demand programmes that have been designed to equip students with skills required by the global job market. Personal Development Plans include work-related learning in the curricula to increase student employability. Following extensive consultation with staff, students and graduate employers, UoG has created a Graduate Attributes matrix identifying core academic abilities, personal qualities and transferable skills, which all students will have the opportunity to develop as part of their UoG experience.[2]

In its own development plan, The Hunterian is prioritising its engagement with the University of Glasgow student body and the wider learning community.[3] A short strategic review conducted in 2010 indicated that The Hunterian, despite its success in developing its visitor profile and achieving a visitor footfall of 162,000 in 2009-10[4], was less successful at attracting and retaining student interest. To rectify this deficit and in order to align itself more clearly with the university's *2020: Global Vision* agenda for providing an excellent student experience, The Hunterian has moved to create a stronger and more relevant student offer, which contributes to the stimulating learning environment and provides desired real-

time work-related learning opportunities. The Hunterian's encyclopaedic collections can create multiple opportunities for teaching, work-related learning and knowledge exchange in the arts, humanities, social, life and natural sciences. The new Hunterian Learning Plan of new programmes at all degree levels, combined with our expertise in collections and public programming, offers our students a unique experience of managing cultural assets, communicating our knowledge and engaging the public in our collections. The Learning Plan combines the following crucial features essential to attracting and maintaining student engagement: our programmes are participatory, mainly credit-bearing, provide a rich work-related learning experience in a public-facing cultural institution and contribute to developing UoG Graduate Attributes in every student.

Through its public programmes, work placements and associateship schemes, The Hunterian Learning Plan offers new opportunities for engagement at all levels of the student career cycle, from undergraduate and post-graduate teaching programmes (PGT) to the post-graduate researcher (PGR) or doctoral candidate community. Like most university museums, previously The Hunterian managed large numbers of individual student contacts on an annual basis. Most of these involved non-degree-related or non-research-driven requests for internships or work placements of varying durations, mainly in the curatorial and educational spheres, each requiring dedicated professional supervision. This activity, while institutionally unsustainable in terms of the

professional resources consumed, ultimately generated little impact for The Hunterian as a university department and service. As an individual activity, as opposed to promoted programmes, it was not recognised in the main as contributing to credit-bearing learning or to the university's performance targets in research or teaching. The Hunterian has responded to the high level of student demand for work-related learning, professional development and needs to secure opportunities to develop student skills in public engagement and knowledge exchange by creating a widely marketed and programmed schedule of activity in the three main areas of student lifecycle demand: undergraduate, PGT and PGR.

The overall strategy enables The Hunterian to develop a creative economy of professional direction and student participation for the first time. Such a formula is new to The Hunterian, which previously delivered its programmes exclusively through its professional staff. The involvement of the volunteer student body at the three main levels of study in the delivery of its public programme, in its curatorial activities and in its administrative functions creates a new dynamic both internally for staff and externally for its visitors and other stakeholders. The active participation of students in our public programmes, curatorial research or promotional work reinforces the sense that this is a university museum service that is distinguished from its national and local authority counterparts. From a student perspective, The Hunterian is aiming to make a very significant difference to the learning experience and to student satisfaction rates, by helping the

university attract new students through its invitation to participate in the delivery of the university's cultural offer and help integrate the wider international student community into the life of the university. Discussions with the university's international recruitment service reveals how highly opportunities to participate in museum and gallery activities are regarded by international students.

The appointment in 2011 of a Student Engagement Officer, a new post created through the organisational change, has been critical to the launch and delivery of this new venture. The new position, which is a new initiative in UK university museums, has been developed to ensure an excellent and consistent quality of experience for each student, supporting Hunterian professional staff in this area of activity and helping to enhance the visitor experience. The primary focus of the new role is to coordinate, manage and evaluate the learning outcomes of programmes that provide students with unique and valuable work-based learning opportunities. A key function is the management and development of relationships between academic departments and their students and Hunterian curatorial and other professional staff. Promotion of the programmes to the staff of The Hunterian is equally important so that opportunities for engagement are quickly identified and all is channelled through the Student Engagement Officer for the purposes of recording, evaluation and demonstrating public impact. In the first six months since making the new appointment the emphasis has been on firmly establishing and facilitating the delivery of the programmes

MUSE student gallery guides in training.

described below, acting as the lead Hunterian contact for all students participating in the programmes. As these programmes become established, the Engagement Officer will seek to broaden their range, attracting students from across the arts and sciences colleges in the interests of developing multidisciplinary and work-related learning opportunities for the student body.

Hunterian MUSE gallery tours

In June 2011, The Hunterian introduced timetabled public gallery tours led by student MUSEs (Museum University Student Educators) under the Club 21 work-related learning programme created by the university's careers office. The original template for this voluntary programme derives from the US university museum world, where students are regularly involved in public programmes. The Hunterian maintains a cohort of 20 or so students, recruited in a bi-annual basis,

operating public gallery tours three times a day. The MUSE tours provide an added attraction and enhance the audience experience at Friends' gallery events or evening openings. Following induction and training from Hunterian curatorial and visitor services staff, the MUSEs have conducted tours of the Hunterian Art Gallery and The Mackintosh House. The programme was expanded in September 2011 to include tours of the *Antonine Wall: Rome's Final Frontier* gallery and the special exhibition *Colour, Rhythm and Form: J D Fergusson and France*. The popular 30-minute tours offer an excellent work-related learning experience to the students in line with the Graduate Attributes framework, together with a unique insight into our collections for our visitors provided by the students. The public response has been enthusiastic and the scheme will be developed and expanded further in 2012-13.

Hunterian Exhibition Work Placement (MSc in Museum Studies)
The Hunterian has joined forces with the Humanities Advanced Technology and Information Institute (HATII) in the School of Humanities to create a professional practice strand to the university's relatively new but popular MSc degree in Museum Studies, one of only two in Scotland.[5] The collaboration between postgraduate research institute in the digital humanities and university museum service positions the Glasgow Museum Studies programme as a leading academic and practice-based PGT degree. 2011 saw the launch of The Hunterian credit-bearing exhibition development and research placement course option as an alternative to

completing a dissertation. The course consists of a ten-week programme of workshops and practical tasks led by museum professionals from The Hunterian and other major regional cultural heritage institutions. In addition to contributing to the development of Graduate Attributes, the course aims to provide students with the opportunity to gain an insight into the world of work through experiencing at first-hand how a leading UK university museum and gallery implements its policies and delivers its services. The programme was designed to respond to the student demand for developing skills in exhibition planning and development. The topics covered by the workshops include exhibition research and concept development, collections care and management, design and interpretation, education and public programmes, audience development, budgeting and fundraising, exhibition merchandising and evaluation methodology. This component counts for 20 credits, which is assessed (by the academic supervisor) via a placement diary and evidence portfolio.

In addition to the intensive workshop programme, students may opt to continue their placement in order to complete a 40 credit research project on a topic agreed with the staff of The Hunterian (combined with the 20 credits of the taught component this makes up the 60 credits of the dissertation alternative). Success in agreeing the detail of the projects depends on matching student interests and target learning outcomes with the needs of The Hunterian's gallery and exhibition programme. Assessment is completed by the academic supervisor via a project report submitted

by the student. The museum placement supervisor will comment briefly on the student's performance in support of the academic assessment process. The Museum Studies MSc extended work placement course offers the student the opportunity to be embedded in real time within The Hunterian professional teams for the duration of their placement. Given The Hunterian's heavy special exhibition schedule, which rotates on a biannual basis and which is complemented by frequently-changing "in-focus" exhibits on new acquisitions and current research, the emphasis of the programme at present is on special exhibition development and delivery. This is a contrasting approach to many UK university museum studies programmes, which offer a "student exhibition" course option, which is self-directed and designed as an adjunct to the institution's professional public output. During this first year of the programme students have been invited to assist curators in a wide range of different exhibition-related activities, including assisting with primary research tasks and documentation, involving object cataloguing and label drafting. In addition, students have been invited to assist with the development of online resource packs for teachers, research into external sponsorship, audience development research tasks and exhibition design-related learning events for the public programme, including devising new scripts for the MUSE galley tours portfolio.

New initiatives for Post-Graduate researchers
One of The Hunterian's key ambitions is to engage the

Students gaining practical collections management skills.

university's staff and student research community more actively in its collections. During 2012, supported by additional funding from the UoG Chancellor's Fund, The Hunterian has been collaborating with the College of Arts to launch a pilot Hunterian post-graduate research (PGR) Associates programme offering opportunities for students to develop their experience and skills in knowledge exchange and public engagement – both requirements of their degree. Hunterian Associates will use their doctoral research to generate new interpretations and narratives about the Hunterian collections of art, human, natural, scientific and medical history, about special exhibitions themes, or about the primary gallery exhibits. They will propose creative ways to present their ideas and findings to our visitors. At the same time, The Hunterian Associates will broaden their perspective of the research

process, by exploring how their research is connected to collection strategies past and present; they will also engage with a public audience in discussion and debate. The Hunterian Associates Programme is an opportunity for post-graduates to be creative in their approach to applying and disseminating their research beyond the confines of traditional academic discourse. We believe that our public will be stimulated and challenged by this unique research-informed encounter with our collections. A second pilot will be developed in 2013 for PGR students in the College of Science and Engineering with a view to developing The Hunterian Associates as a cross-college programme for public engagement in post-graduate research.

The nine Hunterian PGR Associates in the 2012 pilot cohort span the disciplines of Creative Writing, English Language, Scottish Literature and English Literature. Their interests and points of reference to the Hunterian collections are impressively diverse. One project involves a group of students developing creative writing workshops inspired by galleries and object displays with a view to creating live blogs and an online gallery on the Hunterian website. Inspired by individual Hunterian exhibits and collections, other students are developing public lectures, gallery talks and museum web pages on Japonism in Scotland, Paisley shawls, the fantasy and reality of sea monsters in museum galleries, the research library of William Hunter (the founder of the Hunterian collections in the late 18th century), and the prints of Ian Hamilton Finlay and the genesis of the poster poem.

Kelvin Hall: architect's sketch of proposed multi-use development, creating a joint city/university collections storage facility, including The Hunterian Collections Study Centre.

Future plans

In addition to the UoG undergraduate and post-graduate student community, The Hunterian is ideally placed to extend its collaboration and range of participation opportunities with the university's lifelong learning community, centred on its adult and continuing education service, the Centre for Open Studies. The Centre bases many of its Archaeology, Egyptology and History of Art diploma and certificate programmes at The Hunterian and is planning to develop these further and in greater depth in 2010-13. The Hunterian will encourage Open Studies Students to join its MUSEs programme and engage actively as Friends of The Hunterian. We are determined to devise new opportunities for Glasgow's lifelong learners to participate in our activities and to employ our facilities more

actively in support of their own learning needs.

The university and The Hunterian have been working very closely with Glasgow Museums (with the financial support of the Heritage Lottery Fund) to redevelop the Kelvin Hall as a shared museum collections facility – part of a multi-use regeneration of this early 20th century exhibition hall. This innovative conversion of a historic Glasgow landmark on the edge of the university campus will enable public access to an impressive range of the city's multiple museum collections. The creation of a university collections study centre at Kelvin Hall during the first phase of redevelopment will transform The Hunterian's capacity and ability to contribute fully to the UoG's *2020: Global Vision* for excellence in research and the student experience and for public engagement. The university has the option to develop new gallery and special exhibition spaces as part of a second phase of development once the collections study centre is in place. The Kelvin Hall master plan for creating greater access to collections enables The Hunterian to radically enhance its learning offer and develop new community audiences. Co-location of The Hunterian's 1.3 million-plus study collections at a single venue is intended to foster new initiatives in interdisciplinary research and learning. Kelvin Hall will deliver The University of Glasgow's strategic vision for The Hunterian as a leading global university museum and gallery service, setting benchmarks in collections research, teaching, training and in public participation. It is anticipated that the UoG Collections Study Centre at Kelvin Hall will enable The Hunterian to devise new

programmes for engaging with collections, work-related learning and professional development for all its students and lifelong learners by 2015. The investment being made now by The Hunterian in creating a new architecture of student engagement is central to informing the future Kelvin Hall Study Centre audience development, learning, and business plans.

NOTES

1 http://www.gla.ac.uk/media/media_169346_en.pdf

2 http://www.gla.ac.uk/students/study/attributes/

3 http://www.gla.ac.uk/media/media_228418_en.pdf

4 http://www.gla.ac.uk/media/media_207206_en.pdf

5 http://www.gla.ac.uk/postgraduate/taught/museumstudies/

Mining the Hidden Jewel: Engagement and Transformation

EMILY KASS &
CAROLYN ALLMENDINGER
Ackland Art Museum
University of North Carolina at Chapel Hill

The Ackland Art Museum opened in 1958 as the Ackland Memorial Art Center to great fanfare. Sharing a brand new building with the art department, the Ackland was a major addition to the University of North Carolina at Chapel Hill. For the first time university collections, previously scattered across campus, were united under one roof and cared for by a staff dedicated to that purpose. The founding director, Joseph C. Sloane, also chaired the department of art, a position that he held until 1974, remaining as director until his retirement in 1978. The following year the Ackland was renamed the Ackland Art Museum and with a new director, who reported to the provost, the administrative separation from the art department was complete. For the Ackland, this meant the ability to establish its own distinct identity, reflecting the maturing of the organization's mission. Fueled by a generous endowment for acquisitions, collections grew steadily. The art department grew as well, and in 1983 moved to an adjacent new building accommodating classrooms, studios, auditorium, and library and the Ackland took over the entire original building, which was fully renovated for museum purposes. Located on the edge of campus, and only half a block from the main downtown street of Chapel Hill, the Ackland grew into a "full service" museum, developing nationally-recognized exhibitions, an active outreach program for the community, and serving greater numbers of university students.[1]

In 1992, the Ackland received a grant from the Andrew W. Mellon Foundation and hired its first educator for university audiences. By dedicating one full-time employee to the task

of coordinating class visits to the museum, the Ackland saw immediate, dramatic results. The year before the university educator began work, 300 of the Ackland's visitors were university students engaged in coursework; the next year that number was 3,000. At the end of the three-year grant period, the university continued to fund the position on a year-to-year basis and in 2000 committed to make the university educator a permanent position. By that time, the Ackland had established relationships with faculty and courses in Art, American Studies, Asian Studies, English and Comparative Literature, History, Religious Studies, and Romance Languages, among other departments, with annual service growing to 4,500.

Carolyn Allmendinger became the university educator in 2000. With the stability of a permanent position, the Ackland could plan multiyear projects in concert with course planning timelines. Eventually, we even began to consider what courses were scheduled to be taught as we planned for exhibitions. We began more earnestly pursuing relationships with faculty and courses in departments across campus. By familiarizing ourselves with learning goals in science courses, for example, we could lay the groundwork for a future program with professional students in the Medical School. We also established an exhibition series, called *Perspectives*, in which faculty members and undergraduates collaborated with the museum to curate small exhibitions aligned with course topics such as *The Geisha in History, Fiction, and Fantasy* (related to an Asian Studies course), or *Childhood in America* (with a History course). These efforts created new opportunities to relate the

curriculum and the museum and fueled increasing faculty demand for access to prints, drawings, photographs, and other works of art that were not on display in the galleries. The Ackland's Print Study Classroom accommodated increasing numbers of classes, some taught by curators or the university educator, others taught by faculty members, many of whom felt more empowered to incorporate art into their teaching. While we were very pleased that more faculty members wanted to teach with our collection, the program growth did present certain logistical challenges. The Print Study Classroom's small size, limited to about 20 people, restricted access for some university classes, and even when faculty members taught those sessions museum staff members were needed to set up and supervise art handling. By the end of the 2006-2007 school year, curricular participation in the Ackland by students and faculty had grown to about 6,000.

Process

Emily Kass became the director of the Ackland in late 2006, drawn by the opportunities to deepen the role of the museum within the university and to expand its civic and social functions. She quickly discovered that one of the biggest drawbacks was a general lack of awareness of the resources the museum was already providing, as well as the underuse of resources by the museum staff. At that time, other than minor alterations, permanent collection galleries had not substantially changed for over ten years, despite a collection of some 15,000 works.[2] Although the museum had a record of

special exhibitions, some highly visible and very well attended, and had developed nationally significant programs,[3] the Ackland was not generally perceived as a place to return to again and again. For Kass, the all too frequent, yet strangely inspiring comment she heard from the public in her first year was: *The Ackland? Oh, I've been there once.* And even among the university administration, the most frequent (although backhanded) compliment was: *The Ackland is a hidden jewel.*

Some of this invisibility was inadvertently self-imposed by the museum's own decision makers. Educators and curators alike maintained that a core group of works must be on view the majority of the time, and that changing the installations in which these works were presented would be equivalent to removing the *Mona Lisa* from view. While a number of these works were, and continue to be, among our most important and most popular, others have become new favorites and are equally significant for teaching and public appreciation when presented with the same care and attention. A comprehensive reinstallation of the collection occurred in summer 2007 and again in summer 2011, with a number of smaller interventions occurring along the way. We now treat the permanent collection galleries far more flexibly, even retiring portions of the collection for months at a time to accommodate special exhibitions, which have also grown in scope and ambition.

That the university administration was not fully aware of the services the Ackland was already providing for students, or for the public for that matter, became an important point of conversation for Kass as she met with campus and

An Ackland Student Guide leads a discussion about a painting by Camille Pissarro with members of the community.

community leaders. Thus it was crucial that Kass and the staff at all levels learned how to talk about the museum's work in terms that reflected the goals of the university and its values.[4] In documents as basic as annual budget submissions, we realized that we must present a more compelling case even in response to questions that might seem routine. From a practical standpoint, the university was not just our parent organization, but in fact our largest single donor.[5] We began to quantify our achievements and service to demonstrate that, within a university with 29,000 students and 3,000 faculty members, we provided significant value. For example, when we requested additional resources, we made sure that our argument was made in terms of how the funds would support teaching and learning. When we asked for funding to update technology, we emphasized the benefit to students and faculty

not only in Chapel Hill, but throughout the state university system. In short, we learned how to tell the story that was important to our parent organization: how, and how many, students participated in and benefited from the Ackland as a result of the university's investment; in what ways the museum was a partner in teaching and research. This approach, with the deepened engagement that followed, has served us well in recent years, allowing us to weather consecutive years of budget cuts far better than we might have had we not demonstrated and communicated our commitment to the academic mission.

In 2008, two significant events occurred: we wrote a new strategic plan and the Andrew W. Mellon Foundation invited us to again apply for funding. The strategic planning process allowed us to address our dual role as a public and university museum and explore the needs of our various audiences on and off campus. As we began our strategic planning, we decided that it was important to take as a starting point the university mission, which asserted: "The University exists to teach students at all levels in an environment of research, free inquiry, and personal responsibility; to expand the body of knowledge; to improve the condition of human life through service and publication; and to enrich our culture."[6] As a basis for planning, we decided that by focusing on our university mission and harnessing its resources, all our audiences would be better served. Of our five strategic goals, number one was: *To promote the relevance of the Ackland Art Museum to the mission, programs, and initiatives of The*

University of North Carolina at Chapel Hill." [7]

With this in mind, we began to actively assert the need for an expanded role for university students and faculty within the museum. Not all the staff were entirely comfortable with this notion, whether due to a fear that the museum's authority would be diminished, that workloads might expand, or simply that it would mean change. However, to encourage greater use of the museum, we had to compromise and change some long-standing practices.

Although always first and foremost a university museum, we had an established public education program, with a volunteer docent program established in 1968, that served about 5,000 K-12 students a year. Expanding our work with university classes – and at the same time expanding the number of K-12 students served – required giving up the tradition of touring no more than sixty students at a time in the museum. Today, the galleries are often buzzing with students and, while greater coordination is required, there is generally a spirit of respect and cooperation among the different groups.

We also decided that we should accommodate university groups in the galleries even when the museum was closed, as long as security was present, since our open hours did not always correspond to class schedules. To supplement our professional security staff, we turned to a readily available university resource: the Federal Work-Study Program in the Office of Scholarship and Student Aid. Working together, security and academic programs staff hired and trained a corps of nine student gallery assistants to help in supervising

tour groups, increasing our flexibility to schedule without overtaxing either space or personnel. The gallery assistants, we quickly realized, could also enable us to offer more evening events that serve all of our audiences.

Over the past several years we have expanded our public program schedule. Here as well, not all staff embraced the idea of developing and participating in these programs, which were not always well attended. However, the more we were able to involve the university community as guest speakers and performers, the more successful our public programs became. With the addition of a part-time program coordinator in 2010 and allowance for the preparators to work on flexible schedules to assist with event set-up, we now have an active schedule that includes gallery talks, lectures and panel discussions, exhibition-related performances, *Music in the Galleries*, a film program, children's classes, and family days. Faculty and/or guest scholars and artists invited by the museum, along with the university's music and dramatic art departments and performing arts organization, who are frequent collaborators, help us attract a healthy mix of students, the public, and university personnel to our public programs. The programs make our campus connections visible, add depth to our interpretive model, and give audiences (including our largest funder, the university administration) new perspectives and points of access to the collections we hold and the expertise we share.

Concurrent with our planning process we made some changes to our Academic Advisory Committee. The

Committee, with three year rotating terms, had been in place since the mid-1990s. Previously, Committee meetings revolved around a series of reports by staff on Ackland projects, and committee members were largely selected because of their previous participation in and support for the Ackland. Although we did allow time for feedback from the members, the emphasis was on providing them with information they could share with their colleagues, acting as our as advocates. Today, Committee members are selected for their potential to become allies and collaborators. We present less and listen a lot more and, as a direct result, are developing a more nuanced understanding of faculty and administrative concerns regarding teaching, research, course planning, graduate students, and virtually every other issue relevant to our success. Attendance at Academic Advisory Committee meetings is now much better than it used to be, and every member participates actively in the discussion. Faculty Committee members attend our meetings even when they are on leave, and some members concluding their three-year term have asked to be reappointed.

Meanwhile, our application to the Mellon Foundation resulted in an expendable, three-year grant of $250,000, plus a $1 million challenge grant to generate a $2 million endowment for university programs. This funding immediately transformed the Ackland's profile and our ability to serve faculty and students. We created a second position in the academic programs department to coordinate the core program of service to university classes, which in turn, freed Allmendinger

to develop new and long-range projects.[8] Once fully-staffed, the academic programs department quickly increased the Ackland's level of service to university audiences. In 2007-2008, 7,000 of the Ackland's annual visitors were students and faculty in academic visits; in 2009-2010, that number rose to 10,000.[9]

Case studies

In our proposal to the Mellon Foundation, we committed to: involving faculty and students in exhibition and interpretation projects; offering course development grants; and collaborating with other campus units to provide professional development opportunities for faculty and students. In making those commitments, we acknowledged the importance of thoroughly investigating the best ways to integrate our objectives with the culture and conditions of the university. The priority, for us and for the Mellon Foundation in considering our request, was making the Ackland central to UNC-Chapel Hill's academic agenda.[10]

Placing the university's mission as the guiding force caused us to rethink the use of gallery space, even before receiving Mellon funding. In a radical departure for the Ackland, we decided to dedicate an entire 1,500 square foot gallery as a Study Gallery. In separate bays, we accommodate six course-related installations at a time, changing them three times each semester, for as many as 42 presentations each year, including summer school. Initially, the Study Gallery was perceived as a sacrifice for Ackland curators, who yielded control and real

estate to the academic programs staff. By doing so, however, the curators were better able to devote time to organizing collaborative exhibitions with faculty and students. What had originally been small-scale partnerships during the era of the *Perspectives* program, became larger, more complex, and more fully-integrated into the museum's exhibition schedule.

Now that the Study Gallery has been functioning successfully for three years, the question of territory is no longer an issue, and everyone is pleased that the Study Gallery allows us to show more than 350 works in a single year which otherwise would not be on view. Open to the public, this gallery is a destination for the Ackland's general visitors who are intrigued to see connections between works of art and university classes. Each installation includes text describing the course's learning goals, and sometimes includes a copy of a principal course text. K-12 tours frequently visit the Study Gallery because its installations, both art and ideas, support the school curriculum too.

Course-related installations range from the traditional to the idiosyncratic. For example, a first-year seminar in Psychology, Eating Disorders and Body Image, assembled works of art by Albrecht Dürer, Honoré Daumier, Philip Pearlstein, and others. With this group of images representing diverse conceptions of female beauty, students discussed changing notions of the ideal body type over the past 500 years. By considering the choices artists made in depicting these female figures, students delved into questions of objectification, as they relate to works of art, to course

readings, and to real people.

Similarly, an installation tied to the university's 2011 Summer Reading book, Jonathan Safran Foer's *Eating Animals*, fulfilled several functions. It served as a setting for one of the Summer Reading discussions held all over campus the day before classes begin; it engaged courses in multiple departments, especially those for first-year students who had read the book. And because it was listed on the Summer Reading Program's website as a related resource, it introduced new students and their families to the Ackland and its connection to the university. With varied works from the Ackland's collection, students considered the social and ethical issues the author raised – a seventeenth-century Dutch still life painting and a nineteenth-century Indian painting of a hunting picnic, a Lewis Hine scene of mealtime in a tenement apartment and an Arthur Rothstein photograph of a Chinese famine victim, Robert Doisneau's photograph of a French man face-to-face with a flayed cow's head and Sue Coe's drawing of a deadly fire in a poultry packing plant in North Carolina.

The Study Gallery's flexible space and planning timetable permitted us to act quickly and show David Wojnarowicz's *A Fire in My Belly* in January 2011, mere weeks after its removal from the National Portrait Gallery's *Hide/Seek* exhibition.[11] That installation (which included several differently edited versions of the video along with posted news releases, articles, comments book, etc.) was a thoughtful examination of the factors contributing to the controversy and drew classes in Art, Communication Studies, Political Science, Religious Studies,

and Sexuality Studies, sparking interest in a standing room only public discussion. Led by faculty members and facilitated by Ackland staff, this discussion opened the issues embedded in the controversy and was conducted in the presence of works of art. Seizing this opportunity helped to signal the Ackland's capacity to be responsive to current events and to serve as a safe place to explore difficult issues.

Planning the installation of Wojnarowicz's *A Fire in My Belly* took place during a period of about three weeks from first idea to opening the gallery. Although most installations occur on a comparatively more leisurely schedule, very few are planned more than three months in advance.[12] The average planning timetable is about six weeks. The ability to arrange Study Gallery installations this quickly is fundamental to its success with faculty, who approach course planning with widely varying degrees of lead time.[13] Once an installation is in place, faculty can teach with it in many ways – some schedule one or more class visits, while others assign papers, and even take-home exams for students to complete on their own. The Study Gallery also provides us with a way to serve large classes – its open design can safely and comfortably accommodate multiple recitation sections in large lecture classes of 100–300 students (an increasing presence in UNC-Chapel Hill's class schedules), as well as mid-sized lecture classes of 35 students, which typically do not include recitation sections. It is also significant that these installations give us new opportunities to contact donors. Each installation prompts letters to those individuals and foundations that have given works on view,

along with information about the specific course "their" work of art is supporting.

The Study Gallery helped relieve some of the growing strain on our Print Study classroom, suitable for groups of no more than 20 students. It can now function in a manner more consistent with its original design – for small groups to have intimate, up-close experiences with works of art unimpeded by Plexiglas. Studio Art and Art History courses, for example, routinely use it to study the technical and material aspects of works in the collection.

Meanwhile, as always, we continue to engage university classes in our collection and temporary exhibition galleries. In 2009, we experimented with a different way to involve university partners, inviting a team of faculty and students to advise us in planning a new collection-based exhibition, *Art and Cultural Exchange along the Silk Road*, and to participate in interpreting it to our public audiences. Although stemming from a practical problem – temporary vacancies in the curatorial department that demanded assistance from all quarters – it became a model for ways to involve faculty and students from departments across campus, thinking beyond the traditional guest curator role.

Years earlier Professor Sahar Amer (Asian Studies) and Allmendinger discussed designing and co-teaching a course on the Silk Road that would incorporate art in the Ackland's collection. The course never proceeded beyond the planning stages because of difficulties in coordinating work schedules, but the idea formed the basis for the *Silk Road* exhibition.

Allmendinger assembled an advisory group of faculty from disciplines including art history, archeology, languages, literature, history, and religion, with expertise in areas across Asia and Europe, and time periods from antiquity through the sixteenth century. We learned a great deal about the historical context of works in our collection and their connections to current scholarly issues. Faculty introduced us to colleagues at UNC-Chapel Hill and other universities in the area, helping us create a wider network of contacts and an exhibition with broad interdisciplinary involvement. In several instances, we asked faculty and their students to contribute interpretive text to the exhibition – for example, Professor Jaroslav Folda (Art) wrote about connections between Buddhist symbols on Chinese sutra covers and the iconography of Crusader art, his particular area of expertise. In others, we identified ideas for public programs – Amer spoke about the transmission of literary texts and imagery along the Silk Road (the topic of her first book), and Professor Jeanne Moskal (English and Comparative Literature) spoke about a current research project on women missionaries who traveled the Silk Road in the early twentieth century.

Early in the course of planning the exhibition, we learned that several key faculty members would be on research leave during the proposed nine-month run of the exhibition. Their contributions had been so important and their enthusiasm for the project was so deep that we decided to present the exhibition for a total of 18 months, encompassing three full academic semesters. The decision paid off in many ways. Not

only was each of the faculty advisors able to teach multiple courses related to the exhibition, but we were also able to initiate and sustain relationships with faculty in departments like Geography and Economics once the exhibition opened. In order to include the perspectives of faculty returning from leave, or of faculty who encountered the exhibition after it opened, we periodically added new information in interpretive materials. This experiment, based in pragmatic reasoning, had the effect of keeping the exhibition fresh throughout its long run.

Furthermore, by altering our approach to exhibition planning to better comply with university needs and priorities and by presenting a broadly interdisciplinary, thematic exhibition, we actually attracted more sustained interest from our community audiences than we had done with previous exhibitions of Asian art, many of which focused more narrowly on specific historical periods or geographical areas. K-12 teachers, like university faculty, had more time to plan visits to the exhibition, frequently scheduling repeat visits. The interpretive materials which faculty and students wrote inspired new ideas for our educators to incorporate in lesson plans that support the school curriculum. In addition, two Ackland docents designed and taught continuing education courses in the local community on aspects of the Silk Road, incorporating the exhibition into their classes.

Another recent example is a multiyear, multifaceted collaboration with Professor Bernard Herman (American Studies) including an exhibition and a scholarly publication on early drawings by Thornton Dial, called *Thornton Dial:*

Herman's students and colleagues discuss Thornton Dial's drawings with the artist in the Ackland.

Thoughts on Paper (2012).[14] Working closely together, Herman and the Ackland staff designed the project to coordinate with the academic calendar, Herman's teaching schedule, and the museum's exhibition schedule. Over the course of three years, Herman integrated the project into seminars and independent study courses, involving his students in conceiving and selecting objects for the exhibition, applying for a National Endowment for the Arts grant, and designing the exhibition layout. Herman engaged his international network of colleagues in writing the book and interpreting the works of art to our public audiences through lectures and performances.

The academic calendar and the tenure system are significant factors in our work. While UNC-Chapel Hill has no sabbatical

system, typically junior faculty members receive a semester of paid leave to prepare for third-year and tenure reviews. Beyond that, it can be difficult to predict when junior or senior faculty may be on campus. Planning successful long-term projects, therefore, must take into account the possibility that a faculty member may receive new research funding and go on leave at an important point in the process, and we must always structure the work to accommodate the faculty members' leave, tenure status, administrative appointments, and other concerns. Understanding and working within the constraints of these aspects of academic culture makes a decisively positive impact on relationships with university partners.

A valuable component of the Mellon grant was the ability to offer course development grants that would encourage faculty to write the Ackland's collections into the university curriculum. Ultimately we devoted three years to designing these grants in order to thoroughly examine the relevant university issues, many pertaining to tenure and promotion and the academic calendar. We researched course development grants offered by other campus units (including Jewish Studies, the Carolina Center for Public Service, and the Carolina Entrepreneurial Initiative) and the factors that made them successful. We asked faculty members what kinds of support motivate them to create new courses. We consulted with administrators about how to coordinate our grant timetable with academic planning timetables.

In spring 2011, when we issued the announcement, the university's new Academic Plan, though still in draft form, had

begun circulating on campus. Its emphasis on transformative experiences for students and on interdisciplinarity provided faculty with institution-wide support for creating innovative new courses. Our own research had taught us several important things: ask applicants to include letters of support from their department heads; allow faculty to use grant funds to support graduate student assistance; and award the grants in the spring. We received ten applications, all creative and compelling, from faculty in Art, Asian Studies, Economics, Education, English and Comparative Literature, Geography, Religious Studies, and Social Work.

We awarded three course grants in the first round: an Art History course focusing on German prints and World War I, an English and Comparative Literature course on conceptions of nature and landscape in literature and art, and an Economics course on Asian economies that uses works of art to help students consider the role culture plays in the development of national economic systems. The faculty recipients are in the process of planning their courses; two will be offered in fall 2012, and the third in 2013. We will announce a second round of course grants in spring next year.

Our strategic objectives also specified that we would provide university students with opportunities to learn about the substance and methodology of museum work. The first step in addressing this goal was to organize our existing internship opportunities into a more formal program managed by the director of academic programs. For years we had offered graduate internships, most often for art history students, and

field experiences for graduate students in UNC-Chapel Hill's School of Information and Library Science (SILS), principally for students to work with the museum's registrars. We had also offered a few undergraduate internships for academic credit. Student internships were based almost exclusively in the curatorial and academic programs departments.

The goals for our new program of internships were to increase the number and type of internship opportunities, to secure more funding, and to identify suitable internship projects in all museum departments. This year we have seven paid positions for graduate students, compared with a maximum of three prior to 2008. While the majority of student interns still work in the curatorial and academic programs departments, the external affairs department has created internships for students in communications, events and public programs, and membership. We regularly include student interns in project and committee meetings to introduce them to more of our staff and to more aspects of museum work. Our internship projects have engaged students in a wider variety of academic majors, including Anthropology, Economics, and Journalism and Mass Communication, as well as Art History, Education, and Information and Library Science.

When most students contemplate working in a museum, they imagine curating exhibitions. In our experience, involving students in planning and presenting exhibitions helps them understand how curatorial work resembles academic art historical practice as well as how it differs. Students experience the level of collaboration required in curatorial work (and in

University students examine an ancient Chinese vessel installed for their class in the Ackland's Study Gallery.

virtually every other type of museum work), to raise funds to support exhibitions, for example, to design them, publicize them, and interpret them to diverse audiences. Student interns – and their advisors – express appreciation for the rigor of museum writing, which demands conciseness and in some cases numerous rounds of revision to address varied audiences. While students may be unaccustomed to writing that way, the skills are nevertheless valuable both within and outside academic contexts.

Each year, we organize our graduate interns into a cohort so they can more easily learn from each other, discuss their internship projects, and offer each other advice. As they develop skills for teaching in the galleries or public speaking (since we ask our graduate interns to do both), they get advice

from their peers as well as from museum professionals. For each cohort, we schedule sessions with senior staff members who introduce the interns to issues of long-range and short-term planning, fundraising, and the museum's budget. They particularly like learning about the budget and fundraising – their academic training offers them virtually no exposure to these types of professional practices and the skills that support administrative success.

Until we made a concerted effort to conform to university timetables and standard pay and benefits, we frequently experienced administrative problems. Determining standard rates for graduate student stipends was the simplest of these tasks. It took substantially more investigation to understand health insurance and tuition benefits, owing in part to the fact that UNC-Chapel Hill is a large, decentralized institution where information does not necessarily flow clearly and directly from one source to the next – and even when it does, it is not always interpreted the same way. With persistence and the willingness to own up to our mistakes and confusion, we developed an up-to-date and nuanced understanding of the system and made necessary changes to the pay and benefits to make our internships competitive with other parts of campus. The remaining challenge was our annual timetable for awarding internships, adjusting to a schedule that (although out of sync with our budget process) coordinates with the university-wide recruitment calendar for incoming graduate students. As a result of these efforts, we consistently receive strong applications from students earnestly interested in the

opportunity to experience museum work.

Undergraduate students can pursue internships at the Ackland for academic credit, which they arrange through their major departments, or for volunteer experience without academic credit. Undergraduate internships typically encompass 100 hours of work over the course of a semester or the summer, averaging seven to ten hours per week. These parameters correspond to standards that were established when the university's undergraduate curriculum, revised in 2006, required students to earn experiential education credit. Our undergraduate interns work on projects that link their major fields of study with the museum's current priorities. A junior majoring in art history and journalism, for example, worked closely with our communications director, studying the *Thornton Dial* exhibition during the later stages of its development, researching suitable publications in which the Ackland could advertise it, coordinating their publishing deadlines with our planning timeline, and drafting copy for a press release. By adhering to university standards, the Ackland avoids some of the potential pitfalls rightly criticized in current national discourse on the ethics and legality of unpaid internships.[15]

The Ackland Student Guides, a program initiated in 2010, offers students another type of volunteer opportunity. Participants train with academic programs staff to research and present informal, interactive thematic tours of the museum that relate to the guides' particular interests: contemporary art, representations of women, materials and techniques, for

example. They develop research and public speaking skills, and a stronger affiliation with the collection and museum staff. We originally imagined that the student guides would be significantly more effective than the professional staff could be at attracting their peers for these tours – and indeed they are. What we did not anticipate, however, was their appeal to general museum visitors, who regularly attend their tours, advertised on the Ackland's website.

In addition to the more formal academic relationships we have with students, we also have a co-curricular student program, the Student Friends of the Ackland, whose mission is to "promote arts learning, discovery, and engagement among the student body through social and educational programs and events, while supporting the goals and mission of the Ackland Art Museum." In 2006, this group had 100 members. Today, there are over 900 members led by a student board. In addition to volunteering for the museum, the student friends hold several social events at the museum, each attended by 300-400 students. The student guides lead exhibition tours for their peers during these events. Other activities include an annual Careers in the Arts networking night which recently brought together 100 students and professionals. This year, the student friends also helped with the Ackland's fundraising gala and attracted 200 students to the ticketed After Party. This has been an important way to engage students beyond the classroom and to encourage their future participation as museum patrons. Anecdotally, we have seen an increase in the number of students who bring their families to the museum

when they are visiting.

Expanding our work with undergraduates and graduate and professional students provides the Ackland with another benefit of participating in university academics: alumni. Since the Ackland does not award degrees, we compete with academic departments for alumni support. For a growing number of students, the Ackland is becoming a significant part of their experiences at Carolina. By supporting their academic work and offering them experiences in a professional environment, we support the university's mission to "teach a diverse community of undergraduate, graduate, and professional students to become the next generation of leaders." In addition, we establish a new alumni community for the museum, which we actively reach out to for annual support and membership. While philanthropy is a limited concern for most young alumni, our efforts with student friends also support the university's initiative to engage these same young alumni as university donors within the first five years post-graduation.

From pure service to partnerships

The successes of student participation have caused us to redefine our goals for student participation from: *every student in the course of his or her college career will have an Ackland experience* to *Every Student Every Year*, which will be a central element of our new Strategic Plan, currently being written. Engaging nearly 30,000 students every year is unquestionably an ambitious goal, but we are convinced that it is attainable,

sustainable, and certain to help us achieve all of our objectives. Demonstrating that level of service – and that level of demand from the university community – will make a persuasive case to the university as we raise funds for an expanded facility in the coming years, allowing us to improve service to all our audiences.

Extending our reach throughout all sectors of the university is also a major goal, and UNC-Chapel Hill's professional schools are promising partners. With the benefit of experience gleaned from several outstanding programs at other academic museums, we are planning partnerships with the five schools in Health Affairs, customizing service to fit the university's and the Ackland's circumstances.[16] UNC-Chapel Hill's specific emphasis on engaged scholarship (i.e. scholarship connected with public concerns and consequences) impacts faculty in many professional schools, such as Professor Mimi Chapman in Social Work. Chapman, who incorporates art in her teaching,[17] is also involving us in her research with local middle school populations – another example of the close connections between our university and K-12 service.

Digital humanities resources recently established on campus present additional emerging opportunities to partner with new groups of faculty in order to maximize access to the collection and its accompanying scholarship both on campus and across the internet. While we are convinced that the direct encounter with works of art is essential to the mission of the museum, new projects that highlight digital access hold remarkable potential.

Undoubtedly, the Mellon Foundation grant offered us amazing visibility and opportunities (and a particular cachet on a campus widely supported by the Mellon), but we recognize that the real question is: how can academic museums without additional resources engage deeply with their parent organizations? Establishing relationships with colleagues at other academic museums creates a crucial foundation for this work. In our view, however, the key is in understanding the priorities and particulars of the college or university. Reading everything available about university policies and procedures – no matter how dry – is one essential step. Meeting as many people as possible in the organization is another, whether in one-on-one or committee meetings, in casual conversation after campus lectures, or at wine and cheese receptions hosted at the museum. Concurrent to all the activities outlined here, the museum began to host more receptions (at minimal or no cost to our colleagues) for campus groups such as the Honors Program, the Black Faculty and Staff Caucus, or the Kenan-Flagler Business School, in order to build awareness. These informal conversations with administrators, faculty, staff, and students have been invaluable in translating the language of official policy into the range and reality of actual practice. Mass mailings and listservs don't build relationships; researching people's interests and investing time in individualized outreach is much more effective. Although it is important to present oneself as a professional colleague, smart, interesting, and capable, it is equally important to acknowledge the primary role of faculty in the academic enterprise and adapt

one's methods to suit the varied needs and strengths of individual faculty members. The combination of research into existing policies, open conversations about constraints and creative solutions, and a willingness to strategically invest in our shared commitment to the academic mission of our parent organization have allowed all of us the chance to seize fragile opportunities and strengthen them with measurable results.

NOTES

1 The University of North Carolina at Chapel Hill is a Research I university, the
flagship campus of the seventeen institutions comprising the University of North
Carolina system. UNC-Chapel Hill enrolls 18,500 undergraduates; total
enrollment – undergraduate, graduate, and professional students – is just
over 29,000, with over 3,000 faculty members. By state law, no fewer than 82%
of undergraduate students come from North Carolina. In addition to the College
of Arts and Sciences, the university includes thirteen graduate and
professional schools: the Graduate School, Business, Education, Government,
Information and Library Science, Journalism and Mass Communication, Law,
Social Work, and five schools in health affairs – Dentistry, Medicine, Nursing,
Pharmacy, and Public Health.

2 The Ackland's collection ranges from antiquity through contemporary art, with
strengths in Old Master European, American, and Asian art, and in prints, drawings,
and photographs.

3 The Ackland's Five Faiths Project was a particularly successful program. The
Five Faiths Project used original works of art from the Ackland's collection
to introduce audiences of many types to the beliefs and practices of five of
the world's major religious traditions (Buddhism, Christianity, Hinduism,
Islam, and Judaism), each of which also has a strong presence in North
Carolina. Initially conceived as an innovative way to offer teaching resources
for North Carolina public middle- and high-school classes on world
religions, the Five Faiths Project also involved acquisitions, exhibitions,
colloquia, and publications that incorporated the perspectives of faith
practitioners, scholars of religion, and museum professionals. The Five Faiths
Project's accomplishments offered compelling examples for creating
collaborative projects aligned with university priorities.

4 We were at that time more comfortable talking about our outward work –

our public school programs, our exhibitions, without being able to define the benefits of engagement to the university. We now strive to present ourselves as fully-integrated members of the university community, not only by teaching university class sessions and involving faculty in curating exhibitions and suggesting acquisitions, but in virtually all aspects of our work. In communications, for example, we diligently incorporate the university's logo, the Old Well, we use the university's preferred web content management software, email, and calendar software, and maintain relationships with student reporters for the *Daily Tar Heel*. Professional staff members at the Ackland sit on campus-wide committees.

5 In the current year, university funding provides approximately 35% of the Ackland's $2.4 million annual operating budget. In addition, the university provides in-kind support for building maintenance, security, and other needs.

6 In 2009, the UNC Board of Governors approved a new mission statement: "The University of North Carolina at Chapel Hill, the nation's first public university, serves North Carolina, the United States, and the world through teaching, research, and public service. We embrace an unwavering commitment to excellence as one of the world's great research universities.

Our mission is to serve as a center for research, scholarship, and creativity and to teach a diverse community of undergraduate, graduate, and professional students to become the next generation of leaders. Through the efforts of our exceptional faculty and staff, and with generous support from North Carolina's citizens, we invest our knowledge and resources to enhance access to learning and to foster the success and prosperity of each rising generation. We also extend knowledge-based services and other resources of the University to the citizens of North Carolina and their institutions to enhance the quality of life for all people in the State.

With *lux, libertas* – light and liberty – as its founding principles, the

University has charted a bold course of leading change to improve society and to help solve the world's greatest problems." The Ackland's new Strategic Plan, like the 2008 Plan, will respond to the university's mission statement.

7 The remaining four strategic goals were: (2) Emphasize the importance of original research on the collection as a primary activity and as a basis for exhibitions, publications, education, and collection growth; (3) Increase public awareness of the Ackland as a significant local, regional, and national cultural resource; (4) Provide an excellent experience for all visitors and collaborators; (5) Expand resources available to the Ackland, including structured collection growth (purchases and gifts), financial support, volunteerism, corporate and foundation support, scholarly expertise.

8 Three academic programs staff members concentrate their efforts on serving university students and faculty. The director of academic programs supervises department staff, manages the Ackland's student internship program, develops new university-related initiatives, and ensures that the K-12 education programs benefit from university collaborations. The coordinator of academic programs designs and teaches class sessions for university courses and manages the Study Gallery. The assistant for academic programs provides administrative and logistical support, scheduling class sessions, assisting with study gallery installations, and creating documentation and reports.

9 In 2009-2010, we served courses in nineteen departments in the College of Arts and Sciences (African and Afro-American Studies, American Studies, Anthropology, Art, Asian Studies, Classics, Communication Studies, Dramatic Art, Economics, English and Comparative Literature, Environmental Studies, Geography, Germanic Languages and Literatures, History, Music, Psychology, Religious Studies, Romance Languages and Literatures, and Women's Studies), and in three professional schools at UNC-Chapel Hill

(Gillings School of Global Public Health, Information and Library Science, and Journalism and Mass Communication). One-third of our service involved the Study Gallery (3,414 students and faculty served). For 40% of these university classes, we offered customized guided tours; the remaining 60% was divided between self-guided class tours and written assignments which students completed in the galleries on their own.

10 See Marion M. Goethals and Suzannah Fabing, "College and University Art Museum Program," *The Andrew W. Mellon Foundation Museums and Conservation Program*, November 2007, p. 29. In the report's conclusion, the authors assert the importance of academic museums "contributing actively to the core academic agenda," identifying as a key marker of the College and University Art Museum Program's success that: "The museums came to be seen as central to the educational endeavor, as 'players' with an active role on campus, rather than as marginal luxuries."

11 *Hide/Seek: Difference and Desire in American Portraiture* was on view at the National Portrait Gallery from October 30, 2010 through February 13, 2011. Wojnarovich's work was removed in early December.

12 Working closely with curatorial department staff, we developed protocols that satisfied internal professional and practical needs such as safeguards against over-exhibiting prints, drawings, and photographs, and efficient interdepartmental collaboration and communication.

13 Faculty who plan further in advance may be actively involved in searching our collection and selecting works; those who plan closer to an opening date may delegate the selection to the coordinator of academic programs. Study Gallery installation dates adhere closely to the academic calendar, and Ackland staff members integrate them into the general exhibition schedule. Labeling in Study Gallery installations is minimal, but always includes object labels and an introductory text explaining the course's major

objectives and the connections with works of art on view.

14 Bernard L. Herman, ed., *Thornton Dial: Thoughts on Paper* (Chapel Hill, NC: UNC Press, 2012); and the exhibition, *Thornton Dial: Thoughts on Paper*, Ackland Art Museum (March 30 – July 1, 2012)

15 See, for example, "Room for Debate: Do Unpaid Internships Exploit College Students," *New York Times*, February 4, 2012.

16 Two notable examples are the pioneering partnership between the Yale Center for British Art and the Yale School of Medicine, and a newer one at the Harvard University Art Museums with the Harvard School of Medicine.

17 See Keith Schneider, "Art Museums Giving it the Old College Try," *New York Times*, March 14, 2012.

Crossing the Street Pedagogy: Using College Art Museums to Leverage Significant Learning Across the Campus

STEVEN S VOLK
& LILIANA MILKOVA
Oberlin College

College and university art museums have long served as important cultural resources for the larger campus and surrounding community. But, as teaching institutions, they have mostly identified their primary campus audience as art history and studio art students. The customary image of their pedagogy is that of the art history professor standing beside a painting, lecturing to a half-circle of undergraduates. While the museum-as-laboratory model is a venerable one, it need not limit the possibility of re-positioning the museum to be a fulcrum of learning for the entire campus community, regardless of disciplinary focus.

For the past five years Oberlin College has been piloting an innovative museum-based pedagogy, termed *Crossing the Street* (CTS), designed to put the encyclopedic resources of the Allen Memorial Art Museum (AMAM or the Allen) at the service of virtually every department and program on campus. Faculty from disciplines as diverse as Chemistry, Russian, and Mathematics "cross the street" (literally and figuratively) to introduce their students to a space of cultural and pedagogic engagement within the AMAM. While each encounter with the museum's resources is driven by specific course goals and requires a distinctive collaboration between instructor and academic curator, visits depend on a new relationship between museum, faculty, and students.

The Allen Memorial Art Museum

Oberlin College is a highly selective liberal arts college (2,200 students) and Conservatory of Music (600 students) located

near Cleveland, Ohio. It attracts intellectually-motivated undergraduates who share an interest in the arts, rigorous academic coursework, and a tradition of engagement with broader concerns. Oberlin's teaching and scholarly mission is enhanced by the Allen Memorial Art Museum, founded in 1917 as a teaching museum, and recognized today as one of the leading academic art museums in the United States. Comprising more than 14,000 works of art, its collection is housed in an impressive Italian Renaissance-style building designed by Cass Gilbert. In 1977, the architectural firm Venturi, Scott Brown and Associates completed an addition, which stands as one of the earliest and finest examples of post-modern architecture in the United States (Figure 1). Fully accredited by the American Association of Museums, the AMAM has always been open free-of-charge and its world-class collection has served as a vital educational and cultural resource for Oberlin's students, faculty, and staff. Direct experience and critical engagement with original works of art form an indispensable part of the liberal arts education that Oberlin College offers. Since its beginning, the AMAM has functioned as a laboratory for art history and studio art students and faculty.

In addition, the AMAM has long been an important resource for the larger community. The museum offers educational materials and tours to schoolchildren from the region and numerous events open to the general public. In past years, the museum favored more traditional approaches to the presentation and interpretation of its holdings. Tombstone

Figure 1: Allen Memorial Art Museum, Oberlin, OH. [Photograph: Ralph Lieberman.]

and extended labels introduced artworks in the permanent collection, while wall texts provided information on the different periods and styles according to which the gallery displays were organized. Recently, the museum's didactic and interpretive strategies have included interdisciplinary approaches, thematic, cross-cultural displays, interactive components, and a variety of audio-tours and podcasts.

Academic programs

Until the late 1990s, the majority of classes using the museum's collections involved the study of specific artistic and architectural movements and periods (or the artistic production associated with different religious practices) and relied on the expertise of faculty and curators highly-trained in those areas and deeply knowledgeable about art historical methodologies and pedagogical approaches to teaching art and architectural history. In 1997, the AMAM established the Office of Academic Programs with a grant from the Andrew W. Mellon Foundation as part of its program to better align campus museums and the academic pursuits of their parent institutions. This initiative led to the establishment of dedicated positions such as Mellon Academic Coordinators

or academic curators to function as liaisons to the faculty on behalf of their respective museums.[1]

At Oberlin, the availability of a trained art historian committed to academic outreach dramatically expanded the use of the collections, introducing the pedagogical value of teaching with (or through) art. In its early years, the AMAM's Office of Academic Programs focused on strengthening relationships with departments across the College of Arts and Sciences and Conservatory of Music and on developing fruitful collaborations with their faculty. Consequently, the way in which the museum was used in teaching and learning began to change, and class visits, collaborative partnerships, and interdisciplinary programs increased significantly. Recognizing the rich pedagogical potential of the museum's collections, in 2008 the Mellon Foundation awarded the Office of Academic Programs a $1 million challenge grant to secure in perpetuity the infrastructure of the museum essential for curricular outreach and to encourage new directions in interdisciplinary learning. In effect, while the AMAM had used its holdings in broad, interdisciplinary ways before, designating a museum staff member to provide faculty and students with greater access to the collections changed the culture and scope of the museum's outreach, pedagogical role, and visibility on campus. Facilitating access to the collection for non-art faculty spurred a wider and deeper interest in exploring art's potential as a teaching tool in disciplines that would not normally use a museum. With guidance from the AMAM academic curator, Oberlin faculty moved beyond one-

time, curator-led tours towards sustained engagement with artworks in multiple museum sessions that are conceptualized, developed, and taught collaboratively with museum staff.

At Oberlin, instructors in non-art fields increasingly began to use artworks as visual texts to enhance students' understanding of, or to provide different approaches to, their subjects. Five distinct models for teaching with art emerged from this process:

- visual literacy;
- art as cultural context;
- art as conceptual framework;
- art as primary text;
- and art as creative focal point.

A museum visit would often combine two or three of these models.

Visual literacy, learning how to look actively and critically, is applicable to many disciplines and prepares students to navigate better our complex visual environment. For example, literature and science faculty often request museum sessions that focus exclusively on teaching students how to observe, describe, analyze and interpret images to strengthen their visual acuity and ability to "read" visual data.

The collection provides a broader *cultural context* for course content by exposing students to the visual arts produced during a particular period or in a concrete locale. Conservatory classes that study the music of different countries often focus on the intersections between musical and visual artistic

expression, as well as issues of patronage, display and social and political influence.

Art can also be used to illustrate, expand, reinforce, or test the understanding of ideas and *conceptual frameworks* encountered in class. For instance, a British literature class and an introductory Environmental Studies course visit the museum to study landscapes that embody the aesthetic categories of the sublime, the beautiful and the picturesque, an experience which helps students understand better these otherwise abstract concepts.

When used as a *primary text* or cultural document, art can aid History, Politics and Religion faculty by shedding light on larger political, social, economic or cultural contexts. A class studying Orientalism will come to the museum to view 19th century prints which demonstrate vividly how the visual arts enacted the agendas of Western imperialism and colonial expansion.

Finally, the collection can be used as a *creative focal point* or inspiration for class assignments and projects such as research papers, creative writing, musical compositions, student presentations, blog posts or language exams. An advanced electro-acoustic music course, for example, studies art depicting literal and metaphorical storms in preparation for a composition assignment on the same topic.

The introduction and use of the five models briefly outlined above have allowed disciplines from neuroscience to politics to conceive of art as a valuable textual source and the museum itself as an environment where active learning in their subjects

can occur. Based on the numerous and diverse curricular uses of the AMAM over the last five years and informed by Oberlin's topography, *Crossing the Street* pedagogy reaches beyond the five models to expand widely art's application to the entire College of Arts and Science and Conservatory community.

Crossing the Street pedagogy

As Oberlin's academic curators attracted more faculty into the AMAM, the director of the Center for Teaching Innovation and Excellence (Volk) and the Allen's academic curator (Milkova) convened a workshop to discuss the pedagogical decisions which were framing the museum visits. What did faculty hope to accomplish at the museum? How were they preparing for the visits? To what extent were museum visits expected to align with overall student learning in their courses?

Our discussions disclosed that the museum visits were serving a variety of purposes, often less tied to specific course content than we imagined, and that they were generating multiple approaches to learning. We know that art can enchant, infuriate, challenge and confuse; over the course of our discussions, we came to appreciate how it also can be broadly employed to scaffold student learning. For such generative purposes to emerge, however, museum visits need to be planned with these expansive goals in mind. The *Crossing the Street* pedagogical approach that emerged from these discussions was designed to leverage the rich cultural resources of the Allen to impact learning across the campus.

Four elements inform the CTS approach. The museum visit

is able to:

· productively disrupt an ongoing course;
· support self-awareness by disclosing the students' attitude towards the unknown;
· trigger productive emotional and cognitive responses by engaging the physicality of authentic art in the galleries;
· and upend the traditional expert-novice framework which defines the classroom.

Each museum visit is shaped by course goals and involves conversations and planning between instructor and academic curator.

Planning the CTS visit

Conceptualizing, planning, and leading a CTS museum visit is a collaborative, multi-step process. The academic curator and faculty join forces to accomplish a common goal of integrating carefully selected artworks into course materials in a manner that fosters specific learning objectives. In most cases, faculty members initiate a visit and participate actively with the academic curator in designing and carrying it out. As a recent publication on collaborative learning observed, true collaboration requires each individual or agency to commit its resources and expertise, and its success depends on commitment to shared goals, a jointly developed structure, shared responsibility, and mutual authority.[2] Collaboration from the start also signals that the instructor's role will not

end when the class enters the museum.

In an initial meeting with the AMAM's academic curator, faculty introduce key issues studied in their course, discuss their learning goals and potential approaches to a museum visit, and establish criteria for the selection of artworks to be viewed. The academic curator in turn describes the different formats of a museum session (interactive discussion of each work, small group activity with reporting back to the class, intensive visual analysis, etc.) and points to works in the collection that might be especially resonant. This first visit often includes a focused tour of the galleries and discussions in front of the artworks to tease out relevant questions.

In a second meeting, or through email correspondence, the academic curator and the faculty determine a list of some 15 works, finalize the lesson plan and, if necessary, compile a set of questions to be asked during the visit. In preparation for the museum session, the academic curator and the faculty may share articles or other reading materials to better understand the other's disciplinary concerns and acquire some basic knowledge about the topic. Faculty can further prepare for the visit by consulting the AMAM's online collection database. Prior to the visit, the academic curator may recommend readings to familiarize students with artistic movements, themes, or the basics of looking at and deriving meaning from objects.

The field trip as productive disruption

Visitor studies research has produced a substantial body of

data on the impact of museum visits on students of all ages, with some suggesting that their effect on cognitive gains is modest.[3] There are a number of reasons for this, including the fact that the museum visit is frequently an unplanned one-off, that context-based learning is difficult to transfer to new settings,[4] and that museums in particular are "behavioral settings" where the visitor's experience can be strongly influenced by context-driven criteria (such as prohibitions on touching, loud speech, and boisterous activities). This does not mean that learning will not occur, but that the affective or social dimensions of the visit should also be considered: students can come away from the trip more engaged and interested.[5] Our evidence suggests both affective and cognitive gains in the CTS approach.

It is important to recognize that, from the beginning, the visit as field trip can play a role in student learning. We conceptualize the visit as a *crossing*, a movement from a familiar to an unfamiliar setting. While the great majority of Oberlin students are experienced museum visitors, a trip to the museum can be disruptive in two ways: moving out of the classroom can interrupt well-worn patterns; and a museum trip that would be commonplace in an art history course can be startling for a math class. Learning often involves defamiliarizing the familiar, and an unexpected move to a new space of learning can do this.[6] When one participant at the CTS workshop worried if a "complacent crossing" of the street might "just" turn into a field trip, he underestimated the significance the crossing itself can have on preparing students

for new ways of learning.[7]

Yet the productively disruptive value of the field trip requires that students be prepared for their visit. Not all experiences, after all, promote learning.[8] The success of the visit in terms of student learning depends on how faculty and curator can establish goals for the visit, and how the "potential created at the setting [can be] realized later in the classroom".[9]

The visit: exploiting the middle ground

During the actual museum visit, the academic curator can draw on her/his expertise to present the artworks in their individual and larger cultural, historical, and economic contexts, as well as other relevant information filtered through the demands of the course topic. In dialog with the academic curator and students, the professor links the chosen works to class readings or earlier class discussions and poses questions that help students make connections on their own. For a first-time (or only) museum visit, the academic curator starts with an exercise in visual analysis to discuss *how* an artwork establishes its meaning through its formal elements, and often deploys the Visual Thinking Strategies (VTS) teaching method to encourage students to consider the different meanings an artwork may elicit, and to evaluate it as visual evidence.

Abigail Housen's stages approach to aesthetic development informs the Visual Thinking Strategies methodology.[10] Three questions help move viewers from an "accountive" or storytelling stage to one in which they begin to construct meanings using their own perception, knowledge, and values:

What do you see? What is going on? What do you see that makes you say that? [11] This model, we realized, was useful not just in relation to aesthetic development, but as a way to help students investigate how they come to terms with what they do not know, particularly if the object of their study is disquieting.

The essence of being a learner is to confront what one does not know and accept the challenge of learning. A teacher's task is to help students transform the discomfort of not-knowing into approaches that enable them to construct knowledge, gain perspective, and welcome further engagement, gaining awareness of themselves as learners, not just acquiring knowledge of the subject matter.[12] The CTS approach helps scaffold this learning process.

Using a CTS approach, we foreground engagement with the unknown as a concrete, physically present challenge. Once in the museum, we locate students in front of the art we have selected – the unknown – to help them think about how they learn. The physical engagement of students with the art requires that they become aware not just of cognitive strategies, but of the self-regulation of their emotional state.[13] We expand Housen's Stage II approach in order to leverage greater learning beyond the aesthetic. She argues that as viewers move past the "storytelling" approach to art, they enter a stage where they use their own perceptions, values, and knowledge to build a framework for interpretation. "As emotions begin to go underground," she argues, the viewer distances him/herself from the art and develops "an interest in the artist's intentions."[14] Yet the power of art, and the way in which it can metaphorically and materially

stage a "meeting" with the unfamiliar, lies precisely in its emotional impact. For that reason, we add a new question to the VTS pedagogy: *What do you feel?*

When you walk into an art gallery and come upon a painting that makes little sense to you, what do you *feel?* Intrigued? Angry? Curious? Confused? What makes you stay to engage that art rather than turn away from it? VTS addresses this by asking: *What do you see?* This question opens a productive space we term the "middle ground." In his studies of the interactions among French, English, and Algonquians in late 17th century Upper Great Lakes North America, historian Richard White introduced the notion of the "middle ground," a space where, in the absence of any actor's ability to impose demands on the others, self-interest led each to attempt to understand what the others wanted.[15] "To succeed," White wrote, "those who operated on the middle ground had, of necessity, to attempt to understand the world and the reasoning of others and to assimilate enough of that reasoning to put it to their own purposes... [They] acted for interests derived from their own culture," but justified their interests "in terms of what they perceived to be their partner's cultural premises." [16]

Museums, for many students, are "middle ground" spaces where, in the process of encountering challenging art, they can summon up their own emotional and cognitive approaches to the unknown. As was the case in White's study, relating to an "other" can involve accessing tacit levels of self-understanding which, when disclosed, can generate significant metacognitive reflection. To cite one example: Volk and Milkova brought a

Figure 2: Guillermo Meza (Mexican, 1917-1997). Nopalera, 1946. Oil on paper.
26 3/8 x 32 ¼ x 1 ¾ in. (67 x 81.9 x 4.4 cm). AMAM, Charles F. Olney Fund, 1947.29.

group of adult visitors – all very familiar with the Allen – to
a newly-hung painting, Guillermo Meza's *Nopalera* (Figure 2),
requested that they not read the label, and asked them
to consider what the painting elicited in them. The visitors
were momentarily at a loss. Experts in their own fields, they
were not art historians and were uncomfortable speaking
as novices about an unfamiliar subject. As they began to
respond to Meza's work itself (*What do you see?*), it became
clear that their path into the painting was a "middle ground"
approach: they accessed it through their own experience
while trying to parse its meaning. One, a doctor, diagnosed
the possible basis for the woman's greenish face; another
had spent time in Mexico and commented on the Mexican

imagery in the painting. Characteristic of middle ground encounters, viewers accessed the unknown by foregrounding themselves. Knowing the "other" required self-knowledge, a valuable lesson about self-reflective learning. While the CTS approach can accommodate conversations about specific content issues (post-Revolutionary Mexican art in this case), what mattered was helping students understand their own approaches to learning and how emotional strategies (such as recognizing frustration) tie into cognitive and behavioral learning strategies. This approach proved critical when the course content was especially challenging emotionally and/ or conceptually.

Deepening understandings by engaging authentic art
In their anthology, *Violence in War and Peace*, Nancy Scheper-Hughes and Philippe I. Bourgois write, "the more frequent and ubiquitous the images of sickness, suffering, and death, the more likely they are to become invisible." [17] One way to address this, they argue, is to locate the requisite distance between observer and subject: "Those for whom the representation of hunger, misery, and violence is central to their life's work... must locate the proper distance from our subjects. Not so distant so as to objectify their suffering, and not so close that we turn the sufferer into an object of pity, contempt, or public spectacle." [18] Scheper-Hughes and Bourgois deployed the concept of distance metaphorically, but we have come to see how we can use it literally in the museum. Students can be supported in their engagement with highly-charged content

by putting them in a physical dialogue with art.

Working productively with the theme of violence was of particular concern for Volk as he planned a course on the recent history of U.S.-Mexican relations (*Brutal Borders*). The course examined the complex relationship between the two countries and could not ignore the spread of hyper-violence on the border which has claimed an estimated 50,000 lives since 2006. Volk was sensitive to the way that over-identification with the victims could become emotionally debilitating, while seeing the casualties as statistics would efface the human suffering of each victim. Both students and instructors need to calibrate an appropriate distance from the subject that would allow us to engage it without becoming over-identified with the victims or seduced by the pornography of violence.

Using the CTS approach, Milkova and Volk met to discuss course goals and the purpose of an AMAM visit. Volk felt the physicality of the artifacts, their placement *vis-à-vis* viewers, could help students fathom the violence without becoming consumed by it. We ultimately selected works from two different eras: the late 15th and early 16th centuries and the 1980s-90s. The former included Domenico Beccafumi's *Lucretia*, Erhard Altdorfer's *St. Mary Magdalene Raising a Dead Knight for Confession*, and an anonymous wood statue of *St. Sebastian*. Among the contemporary works were Nan Goldin's self-portrait, *Nan One Month after Being Battered*, and a piece by the Chilean artist, Alfredo Jaar, *Church, from the Project Real Pictures*.

Volk prepared his students by discussing the museum

visit as an entryway into their study of violence in Mexico. As much as academic disciplines insist that theirs is the work of the intellect, neuroscientists have disclosed the various ways that emotions mediate and impact cognition.[19] By opening the class's examination of Mexican hyper-violence through the screen of art, Volk suggested that the students could deepen their learning by engaging their emotions.

Once in the museum, the students divided up between two galleries, switching locations at mid-class. Working with the older art, Volk reminded the students to monitor their emotional responses to the works. After allowing time for examining the art, everyone gathered around the Italian sculpture of *St. Sebastian* (Figures 3 and 4). The figure of the Saint stands on a pedestal set away from the gallery walls, his legs crossed, seemingly oblivious to his wounds, the rivulets of blood streaked on his body. The students observed his thin body pierced by (now-absent) arrows, pock-marked with (filled-in) holes. As they circled the statue, they saw that the figure's hands had been bound behind his back, although the bindings have also disappeared over time. It was like so many Mexican drug war victims who, daily, are found murdered, hands still tied behind their backs.

Students had multiple reactions. Some questioned the relevance of early Renaissance art to a study of contemporary Mexican violence. Others were moved by St. Sebastian's martyrdom and unsettled by the sword, which drew blood from Lucretia's chest in an adjacent painting (Figure 5). After some discussion, Volk explained that one reason for the museum

Figures 3 and 4: Italian (Umbrian) St. Sebastian, *ca. 1500. Polychromed poplar and spruce wood. 75½ x 20 x 19 in. (191.8 x 50.8 x 48.3 cm.) AMAM, R.T. Miller, Jr. Fund and Mrs. F.F. Prentiss Fund, 1961.77.*

visit was the materiality and authenticity of the art on display. As the students examined the art, he observed them drawing close to the artifact, stepping back, and finally establishing a

Figure 5: Domenico Beccafumi (Italian, 1484-1551) Lucretia, 1515-18. Oil on panel. 22 x 18 5/8 x 3 in. (55.9 x 47.3 x 7.6 cm.) AMAM, Gift of the Samuel H. Kress Foundation, 1961.82.

comfortable distance for their viewing. The literal act of their positioning and repositioning *vis-à-vis* the objects provided an opening to discuss Scheper-Hughes and Bourgois' argument, that in studying violence, "we must locate the proper distance from our subjects."

A similar discussion was unfolding in the Wolfgang Stechow Print Study Room where Milkova had set out a number of contemporary works, including Nan Goldin's disturbing self-portrait (Figure 6). As in many of the 16th century martyrdom images, Goldin gazes directly at the viewer not in pain or surprise but in defiance, her face a montage of angry bruises and bright red lipstick. As viewers, we are simultaneously repelled and fascinated by the photograph. Goldin's self-portrait helped students discuss the contradictory impulse to both turn away from and be attracted to images of violence. As with *St. Sebastian*, the physicality of Goldin's work confirmed the point that as students (and, perhaps, subjects) of violence, we cannot remove ourselves from the object of our investigation. The surface of Goldin's photograph is highly reflective and when the viewer approaches it, she sees her own reflection merge with Goldin's abused face. As with the works that preceded Goldin's self-portrait by 500 years, the very physicality of the contemporary works offered a means of unlocking a discussion about the relation between violence and distance, and distance and empathy.[20] Bringing students into the museum enabled conversations that were deeply productive at many levels.

Experts and novices

One of the more unusual aspects of the CTS approach is that academic instructors – whether astronomers, biologists, or philosophers – share teaching responsibilities with the academic curator inside the museum, whereas a more typical

Figure 6: Nan Goldin (American, b. 1953) Nan One Month After Being Battered, 1984. Cibachrome print. 16 x 20 in. (406 x 508 mm.) AMAM, Horace W. Goldsmith Foundation Photography Fund, 1993.4.1. © Nan Goldin.

approach would see the curator take over. There are several reasons for structuring the visits in this manner: it signals to students that learning domains are fluid, not rigidly demarcated, that we are both teachers and learners, and that art is equally a subject of investigation and a means through which we can understand other subjects. Ultimately, though, by deliberately locating the instructors in front of the art – an unfamiliar and often uncomfortable position for them – we turn experts into novices, at least for a short time, with the objective of helping instructors become more aware of the points at which novice learners encounter challenges. This is not a reversal that faculty necessarily welcome. "I was very scared to go to the museum," one senior neuroscientist admitted. But the reversal can produce significant results for everyone.[21]

Researchers have shown the ways expert and novice learning differs.[22] Having acquired a great deal of content knowledge, experts organize it in ways that reflect their deep understanding of the subject matter. Experts notice meaningful patterns of information not observed by novices; and they approach new situations with greater levels of flexibility. Research is helping faculty "decode" their disciplines so that they can better understand where novice learners reach bottlenecks and learning can be better scaffolded.[23]

CTS cannot help faculty understand where the barriers occur in their specific disciplines.[24] But by placing instructors outside their zone of disciplinary comfort and expertise, teachers can become more aware of the challenges faced by novice learners. Our objective is not to have course instructors teach in the museum as if they were curators, but to continue the process of disruptive engagement begun with the field trip to the museum. One example can illustrate this process. A mid-career biologist had been looking for ways to prompt his students in an advanced animal physiology course to go beyond "plug and chug" approaches to science (where students simply "put numbers in and calculate"). He wanted to help them grapple with the ambiguities present in science. Encouraged by the museum's director, he took his students to the Allen where they analyzed some fifteen prints, all related to love. He had given them a set of questions to consider during their visit. Did what they saw in the prints align with what they had come to expect based on their knowledge of the biology of love? For example, one would expect that lovers

could be intimately close without any sign of a stress response. Consistent with the CTS approach, students were asked to keep track of their initial responses to the art and how/whether these shifted as they began to mediate what they observed through the filter of cognition.[25]

When a faculty member co-teaches with the curator in the museum, it allows the experience to reverberate once back in the classroom. As one faculty member said of his own museum visit, "what really made the chemistry of the class work [was] using [it] as a springboard for discussion... making sure that... when you cross a street... you always bring it back into your classroom".[26] A neuroscientist studying visual processing with his class observed that post-visit discussions in the classroom frequently referenced the paintings they had examined, particularly the Cézannes, and the way his paintings seemingly mimicked how the brain makes sense of images it has deconstructed.[27] The instructor-curator collaboration at all levels, including in the museum setting, gives the experience the momentum it needs to carry discussion back to the classroom.

Conclusion

Unlike traditional art museums, the university or college art museum serves an academic community as its principal audience. One of the challenges facing collection curators in academic museums today is cultivating the ability to see and facilitate the use of artworks as vehicles for experiential learning, rather than solely as the center of a strictly art

historical problem, style, development, or chronology. When faculty from non-art disciplines engage with artworks as pedagogic tools, the object's art historical significance becomes secondary. To the extent that AMAM curators regularly co-lead class sessions in the galleries alongside both faculty and the academic curator, they, too, must step out of their comfort zone as specialized art historians. They must approach the museum's holdings as objects that are not only the main focus of scholarship, historiographies, and various professional discourses, but also – and just as importantly – as objects that command a physical presence and whose vitality can be a potent educational tool, providing significant learning and cross-disciplinary opportunities beyond the work's intrinsic artistic and art historical value. Allowing multiple voices in the galleries may in turn further curators' own understanding of their collections and help them think of art in new ways. *Crossing the Street* approaches can put the academic art museum at the center of campus learning.

NOTES

1 Marion M. Goethals and Suzannah Fabing, *College and University Art Museum Program, Summary Report*, The Andrew W. Mellon Foundation Museums and Conservation Program (November 2007), accessed March 3, 2012, http://mac.mellon.org/CUAM.

2 Will B. Crow and Herminia Wei-Hsin Din, *All Together Now: Museums and Online Collaborative Learning* (Washington, D.C.: American Association of Museums Press), 2011.

3 Jennifer De Witt and Martin Storksdieck, "A Short Review of School Field Trips: Key Findings from the Past and Implications for the Future," *Visitor Studies* 11, no. 2 (2008): 181-197; Eilean Hooper-Greenhill, *Museum and Gallery Education* (Leicester, UK: Leicester University Press), 1991; and George E. Hein, *Learning in the Museum* (New York: Routledge), 1998.

4 D. N. Perkins and Gavriel Salomon, "Are Cognitive Skills Context-Bound?" *Educational Researcher* 18, no. 1 (1989): 16-25; John H. Falk and Lynn D. Dierking, *Learning from Museums: Visitor Experiences and the Making of Meaning* (Walnut Creek, CA: AltaMira Press, 2000), 57-60; and Stephen J. Ceci, and Antonio Roazzi, "The Effects of Context on Cognition: Postcards from Brazil," in *Mind in Context: Interactionist Perspectives on Human Intelligence*, eds. Robert J. Sternberg and Richard K. Wagner (Cambridge: Cambridge University Press, 1994), 74-101.

5 Mihaly Csikszentmihalyi and Kim Hermanson, "Intrinsic Motivation in Museums: Why Does One Want to Learn?" in *Public Institutions for Personal Learning*, eds. John H. Falk & Lynn D. Dierking (Washington, D.C.: American Association of Museums, 1995), 67-77.

6 Louis Menand, *The Marketplace of Ideas: Reform and Resistance in the American University* (New York: W.W. Norton), 2010.

7 Steven S. Volk and Liliana Milkova, *Faculty Workshop: Crossing the Street. A Faculty Conversation on Multi-Dimensional Learning at Oberlin* (transcript, Oberlin

College, Oberlin, OH, March 11, 2010).

8 John Dewey, *Experience and Education* (New York: Macmillan, 1938), 13-14.

9 De Witt and Storksdieck, *A Short Review*, 190.

10 Abigail Housen, *Eye of the Beholder. Research, Theory, and Practice*, accessed
 March 9, 2012, http://www.vtshome.org/system/resources/0000/0006/Eye_of_
 the_Beholder.pdf .

11 Ibid., 8.

12 Robert Grossman, "Structures for Facilitating Student Reflection," *College Teaching*
 57, no. 1 (2009): 15-22.

13 Paul R. Pintrich, "A Conceptual Framework for Assessing Motivation and
 Self-Regulated Learning in College Students," *Educational Psychology Review* 16
 (2004): 385-407.

14 Housen, *Eye of the Beholder*, 8.

15 Richard White, *The Middle Ground* (New York: Cambridge University Press), 1991.

16 Ibid., 52.

17 Nancy Scheper-Hughes and Philippe I. Bourgois, *Violence in War and Peace*
 (Malden, MA: Blackwell, 2004), 26.

18 Ibid.

19 Jan De Houwer and Dirk Hermans, eds., *Cognition & Emotion: Reviews of Current
 Research and Theories* (Hove, East Sussex, UK: Psychology Press), 2010.

20 O. L. Davis, Jr., Elizabeth Anne Yeager, and Stuart J. Foster, eds., *Historical Empathy
 and Perspective Taking in the Social Sciences* (Lanham, MD: Rowman & Littlefield),
 2001.

21 Volk and Milkova, Faculty Workshop.

22 John D. Bransford, Ann L. Brown, and Rodney R. Cocking, eds., *How People
 Learn: Brain, Mind, Experience, and School* (Washington, D.C.: National Academy
 Press), 1999.

23 Joan Middendorf, David Pace, Leah Shopkow, and Arlene Diaz, "Making Thinking

Explicit: Decoding History Teaching," *The National Teaching and Learning Forum* 16, no. 2 (2007): 1-4.

24 John Sweller, "Cognitive Load During Problem Solving: Effects on Learning," *Cognitive Science* 12, no. 2 (1988): 257-285.

25 Volk and Milkova, Faculty Workshop.

26 Ibid.

27 For a description of how neuroscientists are using art, see Eric Kandel, *The Age of Insight: The Quest to Understand the Unconscious in Art, Mind, and Brain, From Vienna 1900 to the Present* (New York: Random House), 2012.

Bibliography

Bransford, John D., Ann L. Brown, and Rodney R. Cocking, eds. *How People Learn: Brain, Mind, Experience, and School.* Washington, D.C.: National Academy Press, 1999.

De Witt, Jennifer and Martin Storksdieck. "A Short Review of School Field Trips: Key Findings from the Past and Implications for the Future." *Visitor Studies* 11, no. 2 (2008): 181-197.

Ceci, Stephen J. and Antonio Roazzi. "The Effects of Context on Cognition: Postcards from Brazil." In *Mind in Context: Interactionist Perspectives on Human Intelligence*, edited by Robert J. Sternberg and Richard K. Wagner, 74-101. Cambridge: Cambridge University Press, 1994.

Crow, Will B. and Herminia Wei-Hsin Din. *All Together Now: Museums and Online Collaborative Learning.* Washington, D.C.: American Association of Museums Press, 2011.

Csikszentmihalyi, Mihaly and Kim Hermanson. "Intrinsic Motivation in Museums: Why Does One Want to Learn?" In *Public Institutions for Personal Learning*, edited by John H. Falk & Lynn D. Dierking, 67-77. Washington, D.C.: American Association of Museums, 1995.

Davis, Jr., O.L., Elizabeth Anne Yeager, and Stuart J. Foster, eds. *Historical Empathy and Perspective Taking in the Social Sciences.* Lanham, MD: Rowman & Littlefield, 2001.

De Houwer, Jan and Dirk Hermans, eds. *Cognition & Emotion: Reviews of Current Research and Theories.* Hove, East Sussex, UK: Psychology Press, 2010.

Dewey, John. *Experience and Education.* New York: Macmillan, 1938.

Falk, John H. and Lynn D. Dierking. *Learning from Museums: Visitor Experiences and the Making of Meaning*. Walnut Creek, CA: AltaMira Press, 2000.

Goethals, Marion M. and Suzannah Fabing. *College and University Art Museum Program, Summary Report*. The Andrew W. Mellon Foundation Museums and Conservation Program, November 2007. Accessed March 3, 2012, http://mac.mellon.org/CUAM.

Grossman, Robert. "Structures for Facilitating Student Reflection." *College Teaching* 57, no. 1 (2009): 15-22.

Hein, George E. *Learning in the Museum*. New York: Routledge, 1998.

Hooper-Greenhill, Eilean. *Museum and Gallery Education*. Leicester, England: Leicester University Press, 1991.

Housen, Abigail. *Eye of the Beholder. Research, Theory, and Practice*. Accessed March 9, 2012. http://www.vtshome.org/system/resources/0000/0006/Eye_of_the_Beholder.pdf.

Kandel, Eric. *The Age of Insight: The Quest to Understand the Unconscious in Art, Mind, and Brain, From Vienna 1900 to the Present*. New York: Random House, 2012.

Menand, Louis. *The Market Place of Ideas. Reform and Resistance in the American University*. NY: W.W. Norton, 2010.

Middendorf, Joan, David Pace, Leah Shopkow, and Arlene Diaz. "Making Thinking Explicit: Decoding History Teaching." *The National Teaching and Learning Forum* 16, no. 2 (2007): 1-4.

Perkins, D.N. and Gavriel Salomon. "Are Cognitive Skills Context-Bound?" *Educational Researcher* 18, no. 1 (1989): 16-25.

Pintrich, Paul R. "A Conceptual Framework for Assessing

Motivation and Self-Regulated Learning in College Students." *Educational Psychology Review* 16 (2004): 385-407.

Scheper-Hughes, Nancy and Philippe I. Bourgois, eds. *Violence in War and Peace*. Malden, MA: Blackwell, 2004.

Sweller, John. "Cognitive Load During Problem Solving: Effects on Learning." *Cognitive Science* 12, no. 2 (1988): 257-285.

White, Richard. *The Middle Ground*. New York: Cambridge University Press, 1991.

Volk, Steven S. and Liliana Milkova. *Faculty Workshop: Crossing the Street. A Faculty Conversation on Multi-Dimensional Learning at Oberlin*. Transcript, Oberlin College, Oberlin, OH, March 11, 2010.

Five Strategies for Strengthening the Teaching Role of an Academic Art Museum

STEFANIE S JANDL

Most academic art museums today value the faculty and students on their campus as their core audience. These museums recognize that the museum plays a unique role in advancing the academic agenda of their parent institution and that they can, and should, work with faculty to stimulate teaching, foster scholarship, support critical discourse in the classroom, and foreground the museum as a site for interdisciplinary learning. The Andrew W. Mellon Foundation's landmark College and University Art Museum (CUAM) grant program, which ran from 1990 to 2005 and aimed to reinvigorate the teaching role of participating campus art museums, demonstrated that more than ever, academic art museums are deeply relevant to a liberal arts education. The impact of the CUAM grant program has been widely registered, and alignment with the curriculum is sought by most academic art museums today.[1]

How does a museum successfully integrate itself within the academic goals of its parent organization? How can a museum build productive working relationships with faculty across campus and develop exhibitions and programs that enhance its teaching role? How should a museum promote itself as a place to engage with original art objects and source material that enrich critical discourse throughout the curriculum? And how can a museum maximize its impact on students, the focal point of the parent institution?

This chapter will explore five cornerstones for building an effective faculty outreach program. It will not offer specific ideas for conducting faculty outreach; rather, it will outline

critical groundwork that a museum should conduct in order to optimize the impact of its individual outreach activities. Though these strategies may be familiar to some, the reader is encouraged to reconsider the impact of each element when operating at best practice levels and in tandem with one another. The power of these strategies, which the CUAM grant program demonstrated, is in executing them as a single plan and with commitment, consistency, and clarity of purpose.

The mission statement

The importance to an academic museum of a current and clearly articulated mission statement cannot be overstated. Most museum professionals, of course, are aware of the need for a well-defined mission, and indeed all accredited museums must have one. It is nonetheless worth reviewing the core value of a mission statement and what it contributes to the work of an academic art museum.

The American Association of Museums (AAM), in a brief paper about meeting mission requirements for accreditation, specifies that "a mission statement describes the purpose of a museum – its reason for existence. It defines the museum's unique identity and purpose, and provides a distinct focus for the institution." [2] A clearly delineated museum mission statement, AAM writes, "should state what the museum does, for whom, and why." [3] The Association of Art Museum Directors similarly puts forth that "the statement of mission should define the museum's purpose and its benefit to the public." [4] AAM adds that their emphasis on clear mission

statements "acknowledges an effective and replicable practice: Museums that use clearly delineated mission statements to guide their activities and decisions are more likely to function effectively." [5] In other words, museums with well-articulated mission statements are more successful in attaining their goals.

The real power of a mission statement is in its deployment. No matter how well written a statement is, it is a useful tool only when it is put to work. Too often mission statements become detached from the everyday work of the museum and appear only on grant applications and in annual reports. Academic museum leadership must actively communicate the mission to the campus community, and they must also ensure that every museum staff member knows and understands the mission and works to supports its goals. This message must emanate from the director's office, and staff members need to be supported as they implement the mission. Most importantly, every significant decision made by the museum staff should be informed by the museum's mission statement. Does this proposed project advance the museum's mission? Does it reflect the museum's values? Does it support the teaching activities of faculty, and does it intellectually engage and challenge students? A rigorous adherence to the mission keeps a museum focused and on task, and it promotes and maintains identity. This is the first building block of an effective faculty outreach program.

Not every museum administration is timely about revisiting or updating the mission, which admittedly can be a lengthy

and time-consuming process. With scrutiny, some directors may be surprised to discover "mission drift," or a statement that is slightly out-of-focus with present undertakings. It is therefore worth reexamining a mission statement when an academic art museum plans to initiate or expand campus outreach activities. The process of updating a statement can offer the academic art museum distinct opportunities.

Typically, an academic art museum that is reevaluating or rewriting its mission statement works with the senior administrative staff of the college or university. With this support the museum staff can critically examine the mission statement and recommend revised language to the college or university senior staff and trustees, who must ultimately sign off on it. This process offers a pathway for more sustained dialogue about the museum's role in the curriculum and its capacity to fulfill its promise. It can also open the door to discussing potentially more challenging topics such as staffing, budgeting, and long-range planning. In updating the mission statement, the museum not only secures the focus of administrators and trustees, but ideally their agreement and partnership as well. Mission statement revision is a process that, done well, will align the relationships between the academic art museum, administration, and trustees to advance the teaching role of the museum.

The process of updating a mission statement, of course, allows the academic museum to establish an agreement with the parent organization about the museum's purpose. Without such an understanding, an academic museum is vulnerable.

If the museum does not have an up-to-date mission with the attendant support of the parent organization when it initiates projects on campus, for example, it could receive criticism from an academic department about the museum's priorities or the character of its undertakings. It is more difficult to defend these charges without institutional backing. And, if the museum undertakes controversial exhibitions, it risks forfeiting the support and protection of the parent institution. This is especially important for academic museums, which are in a unique position to mount difficult or controversial exhibitions. When the Williams College Museum of Art, for example, organized the exhibition *Prelude to a Nightmare: Art, Politics, and Hitler's Early Years in Vienna* in 2002, the adherence of the exhibition to the mission of the museum and to that of the parent institution was valued by the college administration. Not only did Williams College support its museum in mounting the controversial but ground-breaking exhibition, they lent extra financial and planning assistance and helped work for a smooth critical reception.[6]

Once a mission statement is created, the museum should consider the language an investment in its identity. The statement should be communicated broadly and frequently so that the campus community is keenly aware of the museum's purpose. The mission should be easily visible on the museum website and in museum communications such as brochures and press releases. And language from the mission statement should be reiterated in faculty communications to emphasize the museum's commitment. The Tang Teaching Museum

and Art Gallery at Skidmore College is a model here: since its opening in 2000, the Tang has been consistently and uniformly on message with its identity as a site for "fostering dialogue between academic disciplines."[7] It is unlikely that there is a professor on campus who is unaware of the interdisciplinary opportunities offered by the museum. The academic museum's mission statement conveys the brand of the museum and should be used to advance and reinforce faculty and student awareness of the museum, its priorities, and its role in the academic community.

An effective mission statement is a current and clearly articulated statement of purpose that reflects the consensus of the senior administration and trustees of the parent organization as well as of the entire museum staff. It conveys an academic museum's place and purpose in the campus community and guides the staff in all key decisions. A well-drafted and well-employed mission statement is critical to laying the foundation for the work of the academic museum and to giving a framework and thrust for all its activities.

Staffing

With the mission statement up-to-date and the museum staff oriented toward its goals of curricular engagement, the senior staff of the museum should examine the true impact of faculty collaborations on the staff. Done well, faculty outreach is time-consuming and multi-layered work. Questions about the allocation of work and where it will take place are best addressed in advance of projects and with the staff members

who will be engaged in any aspect of the work.

Collaborative projects with faculty can take many forms, including teaching with the permanent collection, research on the permanent collection, organizing exhibitions, and developing special programming. Each of these endeavors will likely involve multiple staff members – but who? Take, for example, a routine query from a professor about objects in the permanent collection for possible curricular use. Who will answer the phone call? Who will be responsible for conducting a database search (if the museum does not have an online searchable database)? If the professor finds objects she is interested in viewing, who will pull the objects and their files, meet with the professor, and discuss the art objects? Where will the meeting take place and might it displace the work of another staff member? And who will fill in any needed research on the objects? These responsibilities could fall to a curator, educator, registrar, art handler, or intern – or all of these people. The failure to assign specific job responsibilities and identify museum priorities will result in inefficiency and tension amongst the staff. And it will most assuredly result in a half-hearted effort at collaboration with faculty, one that is not likely to build relationships with, or confidence in, the museum.

Equally important is assessing the workload of individual staff members who are engaged with aspects of faculty outreach. If a preparator, for example, is going to be responsible for moving objects in and out of storage for faculty study and teaching, can this additional responsibility be fitted into his

job? Should another responsibility or project be removed to make room for it? Will he need help in assessing priorities in instances where two projects are concurrently demanding his time? All too often museums add to staff workload without making adjustments to existing responsibilities or without articulating priorities.

The best practice for museums seeking to enhance their engagement with faculty is to have an academic coordinator on staff. The Summary Report of the Mellon Foundation's CUAM program makes clear that one of the strongest factors contributing to a successful campus outreach program "was having a dedicated staff member to coordinate the effort. Having identified faculty as a primary constituency, the more successful museums assigned one person to function as a liaison with them on behalf of the museum."[8] These coordinators not only handle faculty outreach work that would otherwise fall to other staff members, they also streamline the work. And the presence on staff of an academic coordinator importantly communicates that the museum is committed to the faculty.

Based in part on the successes of the Mellon grant program, the academic coordinator – or curator, or liaison – is becoming an increasingly common position within academic museums. These professionals are the first person a professor calls to initiate work with the museum. But academic coordinators mostly work proactively, something that staff members with other primary duties are unable to do. Academic coordinators read the course catalog, learn faculty research interests, initiate relationships with faculty, and look for creative opportunities

to enhance the curriculum with museum resources. Once projects are launched with faculty, the academic coordinator also serves as "a central clearing-house for negotiating demands on staff, spaces, and other resources."[9] In this way academic coordinators absorb much of the work and anticipate demands on museum staff for accommodating faculty collaborations, and they resolve issues before they become problems.

On many budget-challenged campuses an academic coordinator position seems like an unattainable luxury. It is, however, worth considering the essential role this professional plays in the mission and the success of the museum, and how creating such a position – full- or part-time – might be accomplished. If the museum has gone through a recent mission statement revision, a dialogue has been opened with the college or university administration that will have established agreed-upon museum goals. The museum is in a position to leverage administrative and trustee buy-in to push for creating a new staff position, or redefining an existing staff position, that serves the educational goals of the museum and the parent institution.

The Mellon Foundation was largely responsible for the emergence of the academic coordinator position, and the CUAM program is a model for the critical importance of these positions to successful outreach programs. Academic coordinators will likely become the norm for campus art museums. The art museums at Stanford University and the University of Washington, for example, now have academic

liaisons and, like their Mellon-funded counterparts, these museums are effecting measurable growth in faculty engagement. The creation of an academic coordinator position should be considered best practice, and should be a high priority where potential funding and support may be available.

Facilities

A well-designed campus outreach program requires space in the museum for engaging faculty and students with art objects. An academic museum should identify and quantify its available space and, because most museum work areas have multiple uses, articulate what priority the outreach program has on that space.

The gold standard for academic museums is a dedicated classroom space where faculty can hold class sessions with works of art, where museum staff and faculty can meet and look at art objects together, and where students and scholars can study works of art individually or in small groups. It should be a secure space that allows for art to be safely stored or installed prior to class sessions, it should have flexible furniture and exhibition space, and it should be a "smart" room that offers advanced technology support at the same or higher level as available elsewhere on campus. (It is important, though, that the museum classroom be under the control of the museum and not some other office of the college or university that could treat the museum classroom as a space to which they assign classes.) The classroom should be designed to accommodate a typical smaller class size for the campus. Today most, if not all,

of the academic art museums that participated in the Mellon CUAM program have such a classroom space, and a number of them have, or are planning to create, additional classrooms because the original space is in such high demand. A classroom is essential for creating a stage for faculty-student encounters with art objects, and its presence sends an important message: the museum is committed to the faculty and is willing to dedicate valuable museum space – and equip that space – to meet the needs of faculty.

Museums that do not have the funds to create a classroom, or which are still in the planning stage for a permanent classroom, have some options. Some museums have print study rooms or open areas adjacent to storage that can be altered to accommodate small classes. Before such a space is adapted into full- or part-time classroom use, however, it is essential to ascertain the safety of art objects in the space (and this includes appropriate climate control and air handling as well as the physical security of art objects). From there, the number of students that can be accommodated in the space needs to be determined as well as the type and quantity of art objects that can be studied. Knowing the exact capacity of the classroom space enables the museum to reach out to classes that the space can actually support.

Most museums have high demand on behind-the-scenes workspace. A print room may be used, for example, for individual scholars viewing art objects, for collection photography, for a registrar condition checking art objects, or for a preparator who needs extra space for a day. If an existing

workspace is going to be appropriated for teaching support, it needs to be done with the mission of the museum in mind as well as the other ongoing work of the museum. When behind-the-scenes workspace is repurposed for class study, it is highly recommended that alternative space be identified and developed for staff to conduct other work with art objects.

Some museums have no space available behind-the-scenes and have instead adapted a portion, or all, of an exhibition gallery for use as a classroom. In these cases, a classroom is created with the installation of temporary walls, a lockable door, and extra security. Although this may not be the most elegant solution, it is a strategy that works for museums which are fully committed to enhancing their teaching role on campus. And, ideally, such a space will attract the support of the parent institution – support that could lead to the creation of a permanent classroom space.

Within the galleries, there are several additional ways of enabling faculty to teach with art objects from storage. A dedicated teaching gallery allows a museum to be responsive to faculty needs while minimizing the impact on staff. A particular gallery may be designated for course-support exhibitions, or for the installation of a selection of works relevant to a particular course of study. This arrangement gives classes the opportunity for repeated contact with selected objects: the class can meet in the gallery, and students can return multiple times to study an object for a paper or presentation. In addition to, or in lieu of, a teaching gallery, an academic museum can designate a particular area – a wall

or a corner – of the museum for course support and equip it with wall cases, floor cases, or pedestals where art objects can be efficiently and quickly installed on short notice for study. Museums that have designated teaching galleries or spaces often find that their campus communities and general public are intrigued to get a glimpse of the teaching activities of the museum.

A museum that is dedicated to integrating its collections with the teaching activities of its parent institution will commit and equip space, or multiple spaces, in the museum for small classes or individual students to meet, study, and discuss works of art. With these spaces defined and their capacity established, the museum can effectively and visibly support faculty and enable its collections to play a vital role in the curriculum.

The permanent collection

In its College and University Art Museum grant program, the Andrew W. Mellon Foundation wisely urged grant recipients to build upon and cultivate their permanent collections.[10] While these museums continued to host and organize loan exhibitions, the Mellon grants enabled them to successfully expand scholarly work on the permanent collection and to stimulate new dialogues around original works of art for both students and faculty. In doing so, the museums were investing in their assets and strengthening their capacity to capitalize on those assets. This is a model for all academic museums to consider.

At the inception of the CUAM grants, the Mellon Foundation recognized that "attention to the collection at many of the museums had taken second place to the development of loan exhibitions." [11] The Foundation supported the museums as they reexamined the full depth of their collections and cultivated new faculty relationships around them through research and teaching activities. At this time scholarly inquiry was beginning to examine art outside of the canon more intensively, and objects that were previously seen as having a lower status found new life, which included "material culture" or "primary source material." One Mellon-funded museum, for example, developed a material culture session to support a professor who taught Chinese history. The objects, which included shoes for bound feet, sandals, and clothing, had not been used for teaching purposes in recent memory but were transformed by new academic thought into playing a key supporting role in the classroom.

A focus on the permanent collection offers several advantages for faculty outreach efforts. First, it allows professors the opportunity of discovery. They can encounter objects previously unknown to them and initiate learning about them either through existing museum research or through their own original research. Their views about a subject or period might be challenged or refined based on this encounter. Professors can use the objects to advance their research or teaching objectives and in doing so they begin building a relationship over time with the objects. They can teach with the work, they can make class assignments, and

they can make revisions to how they work with the objects. In doing so they are becoming familiar with objects which will always be available to support their teaching needs.

Of course, any research conducted by faculty on the objects in the permanent collection benefits the museum as well. And this enables the museum to use the objects for further outreach, to build bridges to other faculty – and possibly between faculty members. It also helps the museum interpret an object in multiple ways, viewpoints that can be invoked should the object go on view. It is invigorating for the museum staff to see its collection through new eyes, a process that promotes further creativity and collaboration.

Faculty encounters with art objects in the museum benefit the most critical constituency: students. The Mellon Foundation's study of its CUAM program found that "campus museums are uniquely positioned to contribute to the core goals of a liberal arts education by demonstrating that original works of art demand and foster the most rigorous critical thinking." [12] The bedrock of these encounters is a museum's permanent collection, and helping a professor accomplish this in the classroom for the benefit of students is one of the most profound things an academic museum can do with its resources.

Building relationships
The heart of a faculty outreach program is simple: relationships. Building good working relationships with faculty is an investment that allows a museum's campus

outreach efforts to take root. Without these partnerships, it is very hard to reach students and integrate the museum's resources in a meaningful way into the curriculum.

Developing relationships with faculty takes time, focus, energy, and thoughtfulness. It starts with the director, who should send clear and consistent messages into the campus community about the commitment of the museum to the needs of faculty. The staff members who regularly work with professors – including, ideally, an academic coordinator – share the work with the director to cultivate these relationships. This means taking the time to learn about a professor's scholarly interests, courses, and teaching style. It also means reaching out to faculty in tailored ways rather than with blanket communications (although there are occasions when this is appropriate). For example, if ten professors are being invited to preview an exhibition, it is important to communicate to them individually and to indicate why they are being invited – what their particular interests or curricular goals are that tie in with the exhibition. It is worth the effort to get each communication exactly right and not reach out to a professor excessively or for insufficient reasons; one well-placed email that piques interest goes much further than two that waste a professor's time.

The Mellon-supported museums found that mutually beneficial projects, developed together from the ground up, were especially productive for building strong working relationships with professors. For example, a number of museums developed faculty planning committees for

exhibitions in order to plan programming that complemented the show (which may be co-curated with a faculty member). Comprised of faculty whose expertise overlapped with the exhibition, these committees recommended speakers that were relevant to both the exhibition and their teaching. In some cases the faculty had helpful recommendations that were beyond the ken of the museum; in other cases, the museum and the faculty were able to combine funds to bring high-profile speakers to campus. In this way the museum ensured it would bring speakers of direct value to the curriculum and that events would be well-attended. And in the process, faculty became more likely to incorporate the exhibition into their teaching. Faculty planning committees, though simple in concept, when done effectively, have a strong impact on building trust and respect with faculty.

A number of the Mellon-supported museums observed that there is easier *entrée* with junior faculty – especially new hires – than with more established faculty. These new professors are typically developing their courses and locating course support, and can be more open to working with museum resources. In time they bring colleagues to the museum, become tenured faculty, and mentor younger faculty. This is not to suggest that more established faculty should be overlooked; rather, it can be productive to start with junior faculty to build a track record before reaching out to more senior members of a department. Carefully cultivating relationships brings long-term dividends of ongoing engagement with the museum and its resources.

Finally, the Mellon CUAM program demonstrated the

value of nurturing faculty relationships with objects in the permanent collection. When a professor engages with an art object in some way, she is likely to return to "her" object and build on the experience by seeking additional objects for teaching. This pattern has been observed at the Williams College Museum of Art through its *Labeltalk* exhibitions. Building on the premise that a work of art has multiple meanings, the museum periodically exhibits a group of art objects, each with labels written by three or four professors from different disciplines. While the most evident result of this still ongoing experiment is a fascinating, multi-disciplinary look at an art object, the museum also noticed that the exhibition series had enormous relationship-building potential. Professors who came to the museum to meet and learn about their assigned art object were being individually engaged in meaningful ways, and more than half of those who participated in a *Labeltalk* exhibition returned to teach with their assigned art object, or to seek other objects for course support.

Another way in which some museums create opportunities for faculty relationships with museum resources is to offer summer seminars to faculty for intensive contact with a collection that relates to their teaching and research interests. Other museums reach out to a small number of professors for a sneak-peak at a new acquisition that closely ties in with their teaching. The Mellon-funded museums repeatedly saw successes with professors who were given meaningful and individually-designed opportunities to engage with art objects

that complement their work.

When reaching out to faculty, it is important to remember that it is useful to work slowly and by targeting small numbers of people. Begin with departments and faculty who are likely to be receptive to museum resources and build outward into the faculty. This is individualized work and it takes time. It is far more productive to develop good relationships with twelve professors in one academic year than to have passing contact with fifty of them.[13]

Concluding thoughts

The five cornerstones to a successful faculty outreach program that have been discussed in this chapter are simple. The weight of these recommendations is in committing to them and executing each one of them in a thoughtful, deliberate manner. Integrating a museum's collections, exhibitions, and programs with the curricular aims of the parent organization is work that takes time but, done well, yields long-lasting relationships that benefit the museum, the faculty, and most of all, the students.

NOTES

1 The Andrew W. Mellon Foundation's College and University Art Museum

grant program was launched in 1990 to address a divide that had developed

between academic art museums and their companion art history departments. It

also aimed to enhance the teaching role of the art museum throughout the

curriculum. For further reading on the mission and outcomes of the grant see

Marion M. Goethals and Suzannah Fabing, *College and University Art Museum

Program Summary Report* (New York: Mellon Foundation, 2007), accessed at

http://mac.mellon.org/CUAM.

2 *The Accreditation Commission's Expectations Regarding Institutional

Mission Statements*, Washington DC: American Association of Museums, 2005,

accessed on March 29, 2012, http://www.aam-us.org/museumresources/accred/

upload/Mission%20ACE%20(2005).pdf

3 Ibid.

4 *Professional Practices in Art Museums*, accessed on March 29, 2012,

http://aamd.org/about/documents/2011ProfessionalPracitiesinArtMuseums.pdf.

5 *The Accreditation Commission's Expectations Regarding Institutional Mission

Statements*, Washington DC: American Association of Museums, 2005, accessed on

March 29, 2012, http://www.aam-us.org/museumresources/accred/upload/

Mission%20ACE%20(2005).pdf.

6 For more on this exhibition see Deborah Rothschild's essay *Art, Politics, and

Hitler's Early Years in Vienna: Managing a Controversy* in this volume.

7 *About: Tang Museum Overview*, accessed on March 29, 2012,

http://tang.skidmore.edu/index.php/pages/view/185/section:185.

8 Goethals and Fabing, 15.

9 Ibid, 16.

10 Ibid, 2.

11 Ibid, 11.

12 *The Andrew W. Mellon Foundation Report 2008* (New York: Andrew

W. Mellon Foundation, 2008), 26, accessed at http://www.mellon.org/

news_publications/annual-reports-essays/annual-reports/content2008.pdf.

13 For more specific outreach ideas see Goethals and Fabing, 30; and Katja

Zelljadt, *Best Practices for Academic Initiatives*, Harvard University Art Museums,

2004. While this document is unpublished, parts of it are available in a discussion

thread on the AAMG website, accessed on April 2, 2012, http://www.aamg-us.org/

aamg_l_outreach.php.

OBJECT-BASED LEARNING

Logan Museum of Anthropology, Beloit College

Visual Literacy and the Art of Scientific Inquiry: A Case Study for Institutional and Cross-Disciplinary Collaboration

ELLEN M ALVORD
Mount Holyoke College Art Museum

LINDA K FRIEDLAENDER
Yale Center for British Art

As academic art museums experiment more freely with their role as a resource for teaching in fields as disparate as mathematics, chemistry, English, sociology, and economics, visual literacy has come to be seen as an essential and transferable 21st century skill that promotes cross-disciplinary exchange in exciting new ways. College and university museums can act as crucibles for the development of visual literacy and observational skills, promoting the ability to interpret, negotiate, and make meaning from information presented in the form of images. Looking closely at original works of art and deriving meaning from them is an ability that can be actively improved with training and practice.

The Mount Holyoke College Art Museum (MHCAM), thanks to a transformative grant from the Andrew W. Mellon Foundation in 2009, realized an opportunity to promote visual learning in disciplines beyond the arts and humanities. Mount Holyoke is known for its strength in the natural sciences – biology in particular – and museum staff had long wanted to explore the provocative similarities of visual richness inherent in both the arts and sciences. MHCAM staff looked to other institutions already doing innovative work in this arena for inspiration and were particularly intrigued by the distinguished *Enhancing Observational Skills* (EOS) program developed by the Yale Center for British Art (YCBA). The program was designed to train students at the Yale School of Medicine in observation techniques to help these future doctors be more adept and accurate in formulating diagnoses. While EOS has been adopted in one form or another by some

twenty other medical schools in the United States, it had not yet been replicated at the undergraduate level. MHCAM curator and grant author Wendy Watson envisioned the promise of partnering with the YCBA to equip undergraduate students even earlier in their academic careers with these critical tools.

This three-part exploration began with the well-established model at the YCBA, followed by the transfer of this method to the post-baccalaureate program for pre-medical students at Mount Holyoke, and finally the application of the lessons learned to a broader, more experimental collaboration with the undergraduate curriculum in biological sciences at MHC.

Art and medicine: the Yale Center for British Art model

Enhancing Observational Skills is a museum tutorial now in its fourteenth year at the Yale School of Medicine and a requirement for all first-year students. The program was co-founded by Linda Friedlaender, curator of education at the YCBA and Dr. Irwin Braverman, Emeritus Professor of Dermatology at Yale. Its efficacy was outlined in a study published in the *Journal of the American Medical Association* (September 2001), and today its use has been extended to the Yale School of Nursing and the School of Physician Assistants. EOS is designed to level the playing field for students and faculty by using works of art generally unfamiliar to the participants, thereby giving them the opportunity to focus more clearly on the process of looking closely in a more methodical and objective way. Once this is accomplished, an analytical approach is introduced, using visual cues to draw conclusions, whether about a painting's

content or a patient's diagnosis.

In this way, the YCBA project gives practical expression to integrating art and science in education, using fine art as a medium and as a formal training tool for teaching clinical medicine. Emulation of attending physicians and house staff alone is often insufficient to develop visual acuity in a clinical setting. The teaching methodology of the YCBA project uses a student-centered approach to sharpen observation and thus accelerate the acquisition and application of visual diagnostic skills. One of its core assumptions is that the visual tools required to analyze a narrative painting can also be useful in understanding the evolution of patient disease. The use of representational paintings in the YCBA project capitalizes on the artworks as unfamiliar objects to students; since they have not formed any predetermined biases as to their levels of importance, they attend equally to each of the paintings' details. Additionally, because the students are in a familiar small group with their classmates, they are comfortable discussing a subject in which they have no prior training. The discussion format also serves as an exercise in communication skills. By verbalizing observations, students become more prepared to share diagnostic information about the patients with other health care professionals.

The *Enhancing Observational Skills* program in action
Each spring, first-year medical students visit the Yale Center for British Art in groups of twenty and then are divided into five groups of four students each with a facilitator from

the museum or the medical school. Students are told as a group that they are there as part of a study to evaluate how a museum intervention might improve looking skills. Each student is randomly assigned a different painting and has fifteen minutes to study it. They may sketch the object and/or take notes on what they see, but this is not required. Students are reminded that this is an exercise about looking and observing and therefore requires no background in art or art history. In addition, labels are temporarily covered so that students rely only on the visual information available in the paintings themselves.

After fifteen minutes, the facilitators gather together their four students and ask them one by one to report back to the group. Standing in front of the painting, each participant describes his or her object in as much detail as possible without any interpretations, conclusions, or opinions. If students begin their presentations with either *I think* or *it appears*, they are asked to use *I see* instead. If they begin to interpret, or use value judgments, they are stopped and asked to use descriptive words to list the painting's visual details. When the student feels he/she has thoroughly inventoried the painting, the others are asked if anything was missed. Then, a student will be allowed to explain what they think is going on in the picture based only on what they see, not what they may know. Any conclusions or interpretations must be grounded in the visual evidence in the painting. Each of the four students has an opportunity to go through this same process with his or her assigned painting.

Afterwards, all groups reassemble in a museum classroom for a parallel session with Dr. Braverman focusing on dermatological case studies. Students are given enlarged color photographs of a variety of skin lesions to describe and evaluate as a group. Following on the heels of the gallery exercise, their language was clearly more colorful and their descriptions more elaborate.

The EOS program aims to slow down the looking process and train students in visual literacy skills. It is compared to the clinical experience of examining a patient and looking for signs and symptoms in order to make a unifying hypothesis or diagnosis. If one cannot see the details, then there is nothing to analyze. After examining paintings, first-year medical students – still naïve in clinical medicine – were able to improve significantly their written descriptions of pictures of diseased patients compared to a control group which had not experienced this visual training. While the medical school curriculum stresses rote memorization of patterns, the museum workshop stresses the recognition of details in the unfamiliar. Students come out of the workshop with a heightened ability to organize visual information and to convey it to others in a meaningful way.

Enhancing Observational Skills at Mount Holyoke
The impressive and documented success of Yale's tutorial can be attributed, at least in part, to the precision with which its format and teaching objectives have been aligned with its medical school clientele. Aiming for a similarly well-

customized program to serve its undergraduate student population, MHCAM staff began thinking about the logistical modifications necessary to translate the initiative from one institution to the other, and from one audience to the other. Some of the challenges that needed to be addressed were:

1. identifying faculty or administrators with whom to partner;
2. deciding who would lead the EOS student workshops (museum staff, outside consultant, faculty members, or a combination) and then providing appropriate training;
3. identifying relevant undergraduate science curricular objectives and how to best achieve them;
4. and selecting optimal works of art from the permanent collection (i.e. detailed narrative paintings) for the tutorial.

For Mount Holyoke, initiating such an ambitious and complex program was made more manageable by the launch of two small pilot programs. These enabled staff to determine both what was possible and what produced desired outcomes, before attempting a larger departmental collaboration. What follows is a summary of three iterations of the program over a two-year period, each involving collaboration with faculty members from the biological sciences department and developed with guidance from the YCBA curator of education.

1. *Piloting EOS with the MHC Postbaccalaureate Program:* While MHC does not offer any graduate-level medical courses, it

does offer a small but widely-admired Postbaccalaureate Pre-Medical Program designed for students who already have a B.A. but need to fulfill additional prerequisites in order to apply to medical school. In early 2010, members of MHCAM staff were introduced to David Gardner, the newly appointed Dean of Pre-Medical Programs and coordinator of this expanding postbaccalaureate program at the College. Professor Gardner was not only willing to meet with museum staff and learn about the Yale program, but also expressed enthusiasm for developing a partnership and even suggested his postbaccalaureate students be the first participants in EOS training sessions at Mount Holyoke. To bypass the potential complexity in scheduling these workshops, he generously offered two three-hour lab sections from his fall introductory course (Biology 146), the only class that all postbacs are enrolled in simultaneously. These two labs would meet at the museum and form the basis of the pilot project for the *Enhancing Observational Skills* tutorial at MHC.

In May 2010, Professor Gardner, his assistant, one student, and members of the MHCAM staff traveled to Yale to meet with YCBA curator of education and co-founder of EOS, Linda Friedlaender, in order to learn more about the structure and methodology of the program. They followed an EOS session in the galleries with first-year medical students and returned to Mount Holyoke convinced that an adaptation of the Yale program would be an enriching addition to the postbaccalaureate program.

Enhancing Observational Skills was piloted on the Mount

Holyoke campus in the fall of 2010 in conjunction with Professor Gardner's introductory biology course. Prepping his students for the museum workshops, Gardner described the program as "...a simple, elegant and creative lesson in how to combine observational skills in the world of art with those same skills applied to medicine."

That October, Ms. Friedlaender led the first workshop, spending three hours with the postbac students in the galleries of the Mount Holyoke College Art Museum. She ran the session just as she normally would with Yale medical students, instructing them to visually describe their assigned paintings, to record notes of their detailed observations if they wished, but to take care not to make assumptions, inferences, or draw conclusions during this initial exercise. The students then reassembled and, one by one, each was given an opportunity to stand in front of their assigned object and begin describing it in as much physical detail as possible. Only after the painting had been thoroughly inventoried to the entire group's satisfaction, was the student able to move on to the second part of the exercise: interpretation. The rest of the exercise followed the same procedure as that of the Yale medical students.

To lead the second workshop in December, Professor Gardner invited Dr. Jill Griffin, a local emergency physician and founder of a medical scribe program in which several of his students participated. In Dr. Griffin's workshop, students were able to use observation skills honed in Ms. Friedlaender's session to decipher images of actual medical case studies – primarily dermatology and radiology examples – taken from

her recent experience serving in emergency relief efforts in Haiti. This workshop was intended to parallel Dr. Braverman's presentation of dermatology case studies at the end of EOS sessions with Yale medical students.

Student feedback on both workshops was extremely positive, and subsequently the program was repeated in the fall of 2011 following the same format. As David Gardner explained to museum staff, "the benefit of adopting the training with our postbaccalaureate students has included not just the development of their observation skills, but also has served to introduce the excitement of working with medical evidence into their very first biology course."

2. Adapting the YCBA Model for Biology 325 Labs: Simultaneously in the fall of 2010, another biology faculty member, visiting assistant professor Lamis Jarvinen, approached MHCAM staff about designing a lab in the museum for her 300-level stem cell biology course. She planned to reinforce the scientific method by having her students apply it to the study of something outside the sciences. In addition, she wanted to foster their use of clear, descriptive language for a grant-writing component of her course.

Together with museum staff, Professor Jarvinen designed a lab deeply grounded in the spirit of *Enhancing Observational Skills*, where the central activity involved having the students look closely at a painting for an extended period of time, noting every visual detail in as objective a way as possible, while holding back on the natural tendency to interpret what appears

to be taking place in the painting (or in scientific terms, making a hypothesis about what one thinks is happening.) However, to facilitate the logistics of this particular museum lab session as well as customize the experience to match the pedagogical goals of the course, some new elements were added, inspired by methods used by other museum educators.

The first element was a technique borrowed from the *Gallery Conversations* series created by Rika Burnham, head of education at The Frick Collection, which involves the study of a work of art quite literally from multiple points of view. Burnham's method of doing this is artful and subtle. As she engages visitors in a collective, hour-long experience, closely studying and exploring a single work of art, the audience members exchange ideas about possible meanings and interpretations. Typically, visitors start at a more distant vantage point, taking in the whole painting and then, as the looking process organically unfolds, Burnham asks her visitors to exchange seats from one side of the room to the other, and then eventually she has them move in as close to the painting as is safely possible to take in the minute details that cannot be seen from a distance. This practice makes the viewer conscious of the variations in data available from different vantage points. Museum staff incorporated this simple, yet highly effective technique, by asking students to begin their observations from a distance (around nine feet from most paintings, but variable depending on the size of the work of art) and then, after a specified amount of time, having them move closer (to three feet, again variable) – both distances

marked in advance of the activity by tape on the floor.

The second and third variants involved having a staff member model close-looking for the whole class at the beginning of the lab, followed by having the students work in small, collaborative groups. This later idea was particularly appealing to Professor Jarvinen, who pointed out that learning how to work well collaboratively in a laboratory setting is a key skill for any aspiring scientist. MHCAM had begun to experiment with small group exercises for a number of visiting classes, but this particular biology class demonstrated just how effective and engaging this strategy can be. The twelve students of Biology 325 were divided into four groups, each of which was assigned one painting. The three students in each group began their lab work independently, but after a specified time period they were asked to share observations and analysis with one another. This sharing of ideas proved not only productive but also added a lively dynamic to the process.

The fourth and final adaptation involved a technique articulated through the *Learning to Look* program developed by the education department at Dartmouth College's Hood Museum of Art, in particular by educator Vivian Ladd. *Learning to Look* is a five-step sequenced approach: the first step includes careful observation, the second initiates analysis, the third calls for researching the object or gaining more supplementary information, the fourth begins the process of interpretation, and the fifth optional step involves critical assessment and response. The biology students were asked to follow a condensed version of this method. First, they spent

an extended period of time looking closely and recording an inventory of visual details uncolored by presuppositions. They were then asked to begin a preliminary analysis, at which point they were given a one-page "object summary" with background information about the work of art. The assignment that followed asked students to weave together the visual data they collected with the supplementary information to formulate a hypothesis about the painting.

Each of these variations provided useful pedagogical strategies for customizing the lab experience to meet undergraduate needs and to open up possibilities for a range of curricular connections. As one of the participating students, Karina Reid, noted after the experience, "As we undertook this experiment, I thought to myself that this is what a liberal arts education is truly about. It is about incorporating different disciplines through innovative means and using them to get a desired product. It allowed me to see and appreciate, in a practical sense, that the skills we acquire in one subject can be applied to several areas. For me, this was a very novel and refreshing lab experience."

3. Establishing a larger collaboration with the Biological Sciences Department: The success of the museum laboratory sessions for the Biology 325 course piqued the interest of other biology faculty. In the spring of 2011, the coordinator of academic affairs attended a department meeting in order to assess the possibility of creating a larger and more formal collaboration between the department and the museum's fledgling EOS

program. The timing proved fortuitous, since Biological Sciences had just completed an external review giving faculty an opportunity to discuss common curricular goals in a careful and in-depth manner. Rather than a single large course, introductory biology at Mount Holyoke is offered through a number of small courses which thematically reflect each faculty member's specialty. These smaller courses feed into a much larger 200-level course, thereby motivating the department to identify skills sets that students should acquire at the 100-level. Detailed observation and clear, descriptive writing were cited as important skills needed to prepare students for Biology 200, How Organisms Develop, a course noted for its "visually rich" content.

To further advance a potential partnership between Biological Sciences and the museum, the coordinator of academic affairs scheduled individual follow-up meetings with faculty members who expressed interest in learning more about EOS. These conversations also yielded important information about the course content and teaching objectives of each instructor. A number of common themes emerged: the importance of noting minute details of size, shape, color, structure, and other visual elements in lab exercises, especially those involving microscopy; the ability "to see nuance in complicated form" and to attune oneself to that which might be initially "hidden"; the practice of effective communication and clear, concise description; and finally the exercise of making hypotheses based on detailed observation.

Another key outcome of these meetings was the realization

that the best starting point for collaboration would be to focus exclusively on the introductory courses (Biology 145 and 160), integrating the EOS tutorial directly into one of the lab sections. During the 2011-2012 academic year, eight such courses were scheduled – six in the fall semester, and two in the spring – taught by eight different faculty and three additional lab instructors.

Training Biological Sciences faculty in EOS methodology

The level of involvement from the faculty was instrumental to the success of this program, since each introductory course is unique to the particular faculty member who teaches it. In addition, the logistics of running EOS workshops for 19 separate lab sections without faculty coordination would have been beyond the scope of the small MCHAM staff. For these reasons, as well as the museum's philosophical goal of empowering faculty with resources for teaching, the decision was made to provide training and support for the instructors to facilitate the sessions directly.

Working on a tight timetable to prepare for fall classes, Linda Friedlaender led an *Enhancing Observational Skills* workshop at MHCAM in June 2011. Seven of the eight biology faculty, including the chair of the department, attended the three-hour seminar. The faculty were put through the same program as all Yale medical students who experience the tutorial, with a few modifications borrowed from the Biology 325 museum lab. They worked in small groups but began with silent observations, first from a more distant vantage point,

followed by time looking at the paintings up close, and only then were they permitted to exchange ideas with others in their group.

The session was productive and time was reserved at the end to discuss possible applications to course content. Faculty commented on the usefulness of experiencing the same exercise that their students would be following, and generated a range of ideas about how it could be integrated into their sequence of laboratory assignments. Feedback from the written evaluations was insightful and enthusiastic. Following is a sample of the comments received:

- *It was good to force myself to slow down and observe something very carefully and in great detail. All science students (and all scientists) need to learn these skills.*

- *Describing very objectively without making any assumptions... is more difficult to do than you might think!*

- *I would like to use a similar exercise to... help students recognize the difference between observation and interpretation.*

- *Making clear distinctions between presenting observations/ data and formulating conclusions based on those observations is something students struggle with and I think the museum exercise could help with that.*

- *Viewing the work from near and far was very illuminating, and I think I will be able to draw parallels between that and the microscopy we will do during the semester – we use dissecting, compound and the scanning electron microscope.*

The program in practice

Following the June faculty workshop, preparations began for the fall semester EOS labs at the museum. This included fine-tuning a template lab schedule (see Appendix) that made the most efficient use of the visit, leaving time at the end for each faculty member to conduct a customized follow-up discussion or writing assignment. Careful consideration was also given to the selection of art best suited for the exercise. Richly detailed narrative works of art with some level of ambiguity are the most reliably effective, as noted in the YCBA model. However, a few faculty requested art that also could serve other purposes, such as images incorporating course-related content (i.e. representations of different plant life or ecosystems), or art featuring a variety of world cultures to better mirror the mix of international students in these courses. Given the collaborative and experimental nature of the project, museum staff worked with the faculty to meet these requests.

The initial EOS introductory biology labs took place over the first five weeks of the fall semester in three-hour afternoon blocks. Each course had two or three lab sections with around twelve students per group, which turned out to be an ideal number. At the start of each lab, the coordinator of academic affairs worked with the whole group to model close-looking with a single work of art, introducing the ideas of separating observation from interpretation, studying the work of art from different physical vantage points, and using precise description to locate specific visual elements in the painting, while resisting the temptation to physically point.

Mount Holyoke professor Denise Pope's Biology 145 students discuss their observations of a 15th century Italian panel painting.

Equipped with museum lab manuals and instructions created by their professor, students were next divided into four groups of three and each group was assigned a painting. Initially asked to work individually, students spent fifteen minutes silently observing their artwork and taking notes, first from a distance and then up close, at which point they were given an additional ten minutes to compare observations within their group. The students were reassembled for small group presentations and class discussion facilitated by the faculty member. Although not provided to students, object summaries were given to instructors in advance of the visit to increase their comfort level in leading the museum tutorial.

Following the fall museum lab sessions, a January meeting

was scheduled with all participating faculty, MCHAM staff, and the YCBA consultant to evaluate the results of the first semester. Feedback from this gathering proved critical for faculty teaching introductory biology courses in the spring. The range of insightful comments from colleagues who had taught EOS labs as part of their fall courses, for example, inspired visiting Assistant Professor Denise Pope "to think carefully about what I wanted my students to get out of the exercise and how it fits in with my overall goals for the laboratory portion of my spring course."

Faculty also shared discussion questions and writing assignments with one another as well as lab instructions and objectives for the museum exercise, enabling instructors to benefit from each others' creative ideas in immediately helpful ways. As Professor Pope summarized, "we essentially were able to condense multiple iterations – which would normally only happen over several semesters – into one academic year."

The fine tuning made possible by this collaborative process, and the explicit parallels drawn between course content and the objectives of the museum activity, can be seen in the written student reviews of Professor Pope's EOS lab sections. Student reflections – like the three that follow – provide useful insights into the potential of this approach, underscoring its promise for the future:

I think this exercise really helped me not to jump to analyzing things and searching them for hidden meaning but instead to slow down and observe them for small details that I might

have otherwise overlooked. I liked that we looked first from a distance and then from closer because it showed me how things, in this case paintings, can look so different depending on your perspective. I think this skill of close observation and subsequently, the ability to convey those observations to other people, is extremely important in Biology and in science in general. (Biology 145 student, lab visit 2-7-12.)

In science, revolutions can occur simply from looking at things in a new or alternate way, the same way that my interpretations of some of the paintings were completely changed after someone suggested a new idea. This was great practice in looking at things objectively – observing and describing first and interpreting second, rather than making an immediate assumption. This strategy is crucial in science, since many things end up being completely different than what was previously thought. (Biology 145 student, lab visit 2-9-12.)

Before this lab, I was unaware of the similarities between lab observation and art criticism, but now I see that such similarities are absolutely striking. Analyzing individual elements of a piece of art requires the same diligence as analyzing the contents of a petri dish or animals in their natural habitats. This lab has opened my eyes to a new way of seeing – one that I will carry with me through my time in this course as well as real world application. (Biology 145 student, lab visit 2-9-12.)

Conclusion

During 2011-2012, eight faculty members and three lab instructors brought a total of 238 students in 19 separate lab sections to participate in *Enhancing Observational Skills* sessions at the museum. The scope and objectives of this project were ambitious, but were made possible by a group of faculty willing to work with one another, the MHCAM staff, and the YCBA consultant in experimental and unconventional ways. Together they launched a new collaborative effort providing visual literacy training to undergraduate liberal arts students. While this collaboration is still a work in progress, the groundwork for a new form of interdisciplinary exchange has been laid through collegial partnership, shared resources, and a commitment to innovative teaching.

APPENDIX

Mount Holyoke College Art Museum
Enhancing Observational Skills
Biology 145 Lab Sessions (2011-2012)
(12 students per lab)

TEMPLATE FOR MUSEUM LAB SESSIONS

1:15 - **Welcome and Introduction** to the Mount Holyoke College Art Museum

1:20 - **Large group activity–museum staff member to model close looking, focusing on a single work of art** (30 minutes)

1:50 - **Small group assignments to look at 4 paintings** (25 minutes)

 Painting 1 – (3 students)
 Painting 2 – (3 students)
 Painting 3 – (3 students)
 Painting 4 – (3 students)

 Instructions for 25-minute Observation Assignment:
 silent observation, note-taking, and sketching:
 5 minutes – sit or stand at approximately 9 feet (marked by tape on floor)
 10 minutes – sit or stand between 3 feet - 6 inches (tape on floor)

 final 10 minutes – discussion within small group to share observations

Reassemble into larger group: (faculty member to facilitate)

2:15 - Group 1 to share observations with larger group (15 minutes)

2:30 - Group 2 to share observations with larger group (15 minutes)

2:45 - Group 3 to share observations with larger group (15 minutes)

3:00 - Group 4 to share observations with larger group (15 minutes)

3:15 - Class discussion or writing reflection exercise in museum classroom (45 minutes)

Three-Dimensional Learning: Exploring Responses to Learning and Interacting with Artefacts

DEBORAH SCHULTZ

Richmond American International University London

This chapter relates to practical interaction with the parent organization and the ways in which a university collection can be used creatively in teaching. The institutional framework provides students with a campus teaching resource and facilitates hands-on engagement with artefacts, a combination which would not be possible elsewhere.

Items in the Arnold Daghani Collection at the University of Sussex – drawings, paintings, diaries, writings and documentation created and collated by a Holocaust survivor – were used in a teaching project to examine responses to learning and to promote reflection.[1] The project encouraged students to reflect creatively both on Daghani's, and on their own, responses to the Holocaust. They studied the traumatic life of the artist through his artworks and writings, while their emotional responses to his life story enabled them to engage with the wider issues of the Holocaust. In contrast to conventional two-dimensional teaching methods, based around lectures, seminars and printed matter, the project offered students the opportunity for direct contact with artefacts, exploring the hypothesis that interaction with artefacts deepens student learning. It proposed that any subject can be enhanced through haptic engagement. Through touch, and by extending into three-dimensional space, the learner becomes more conscious of him/herself and increasingly reflective. By shifting from two- to three-dimensional learning, students entered a new level of engagement with the material and greater critical understanding.

Theoretical background

In recent years the *biographical turn* has developed in the social sciences,[2] and the use of narrative has been foregrounded in history.[3] Life history and oral history are now established disciplines[4] and the lives of ordinary individuals, as opposed to major figures, are perceived as of significant value in understanding history.

Art history was reborn in the 1980s as the New Art History, drawing on Marxist and feminist approaches. In recent years, psychoanalytic methods have also been applied to art historical subjects. However, biography remains tainted by its over-use in the past, in which coffee table books frequently began by setting out how the artist was born in x, his father was y and he studied under z. While this information may be relevant it is often simply stated rather than explored. Romanticism and Hollywood dramatised the lives of individual artists, suffering in their garrets. Social art history responded by shifting the focus firmly from the artist to the work, and to the context in which it was produced and consumed.

For analysis of the work in question these methods used alone are lacking. Arnold Daghani not only worked in a wide range of media (from drawings to paintings and objects), he also wrote short stories and poetry. Furthermore, he wrote diaries and incorporated legal testimony into his works. He frequently combined a whole range of approaches such as in his book projects which place visual forms alongside diary entries and extracts from testimonies.[5] Life history methods offer a way of reintroducing the biographical to an

art historical subject that combines the verbal with the visual, art with document.

The Sussex teaching project approached the enormous subject of the Holocaust within this interdisciplinary framework. It acknowledged the breadth of Daghani's practice and the ways in which items could not easily be classified exclusively as works of art or solely as documentary material. Thus students were presented a wide range of items, demonstrating the ways in which, on the one hand, the artist's life was inextricably connected with his work, while, on the other hand, his writings and visual works were all carefully created artefacts, connected with the works of other writers and artists. Thus, the biographical and creative narratives were firmly intertwined.

The Arnold Daghani Collection

In June 1942 Arnold Daghani (1909–85) and his wife Anisoara were deported from Cernauti, the capital of the Bukovina (formerly Czernowitz in the Austro-Hungarian Empire, after the First World War in Romania, now Chernivtsi in Ukraine) through Transnistria, and across the river Bug, to a slave labour camp at Mikhailowka in south-west Ukraine. The camp was run by the SS, and the inmates worked on repairing the main road in the region, a strategic supply route linking occupied Poland with southern Ukraine. Mikhailowka was one of a number of camps set up in the region between the river Bug and the road. The work was extremely demanding. Rather than transport machinery to the region, the engineering firms

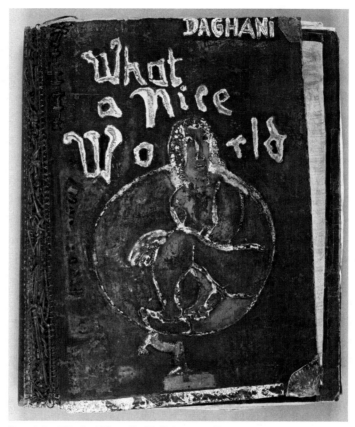

Figure 1: Arnold Daghani, What a Nice World (1943–77) (G1).
Arnold Daghani Collection, University of Sussex. © Arnold Daghani Trust.

used the cheaper human labour, and, as Daghani portrays in words and images, the camp inmates worked with pickaxes and shovels on the road.

Daghani's artistic skills played an important part in his experiences at Mikhailowka and ultimately led to his and

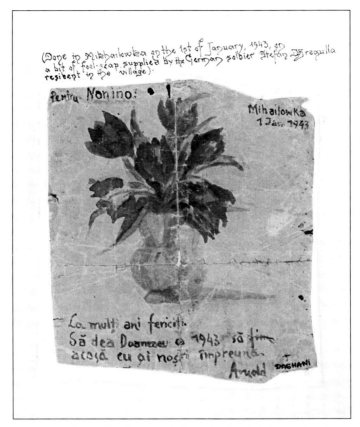

Figure 2: Arnold Daghani, New Year flowers for Nanino (1943) in 1942 1943 And Thereafter (Sporadic records till 1977) (1942–77) Ink and watercolour on paper. (G2.060r). Arnold Daghani Collection, University of Sussex. © Arnold Daghani Trust.

his wife's escape. Initially, he had been reluctant to take his watercolour box to the camp. In *What a Nice World* (Figure 1), an extensive collection of his writings and drawings bound together in book format, he emphasised that it was not his choice to take the art materials. However, in Mikhailowka

he began to both paint and write, aware that he would be punished if it became known that he was making a record of the ordeals of the labour camp. Within a year, as he recalled in the introduction to his published diary, many of the inmates would be exterminated and buried in unmarked graves. The most poignant of those early works, combining word and image, is the creased and tattered painting of a vase of red tulips (Figure 2). On the painted surface are inscribed the place and date, *Mikhailowka 1 Jan. 1943* and the dedication to his wife (in Romanian): *Happy New Year! May God help us that in 1943 we should be home together with our family. Arnold.* This was one of the works smuggled out of the camp when the couple escaped. The signature DAGHANI was written later, and when the watercolour was attached to a mount, he added a further inscription in ink, recalling that it was painted on a piece of foolscap paper provided by a German soldier. The image appears unremarkable but its inscription renders it a powerful narrative of the love of a man for his wife transcending the danger and captivity of the camp. An apparently unremarkable vase of flowers represents the strength of individual emotions within the suffering of the Holocaust. These items, together with a number of other works from the slave labour camp and the Bershad ghetto to which Daghani and his wife escaped, are held at the University of Sussex. The collection also contains many later works in a wide range of media through to the 1980s, in which the artist reflected on his traumatic wartime experiences.

How could items such as these be incorporated into

teaching on the Holocaust? Their materiality is highly significant. The book, *What a Nice World*, is large and bulky, weighing around twelve kilos. The rough work on the spine seems to encapsulate its most striking qualities: passion, frustration, anxiety and creativity. Both its subject and its making convey intense emotion.[6] Daghani worked on this volume for over 30 years, continually adding to its intensely layered pages. Despite its size, he carried it with him to the Public Prosecutor in Lübeck in the 1960s when he gave his testimony on the executions at Mikhailowka, indicative of its importance for him. He later added notes from the investigations, thereby combining his individual artistic reflections with legal enquiry. It is a powerful and intense object, filled with drawings and written reflections as well as quotations from the testimonies. It is both artwork and document.

Daghani's life story was long and complex, and raises many issues about shifting borders and identities; the Second World War and the Holocaust; Fascism and Communism; deportation and slave labour. The artist draws attention to the hierarchy of camps in which greater focus has been paid to those labelled *concentration* or *extermination* rather than *slave labour*, despite the fact that most inmates died in the latter. His works address the ways in which people behave in strange circumstances; the parallel lives of the engineers and the slave labourers; reconciliation; the recognition of others as individuals; survival guilt; fate; the trauma and suffering of the Holocaust. They raise issues concerning memory; diary writing; the relation

between verbal and visual forms of representation; the role and position of the artist; Holocaust representation; migration and statelessness. As Daghani survived the war and the camp he was able to reflect on his experiences from a later perspective, a position many other slave labourers did not reach.

Daghani articulated his life story in an accessible manner in both verbal and visual forms. He used the format of the diary, described as the "document of life *par excellence*", while letters also comprise an important part of the Collection, often pasted into books or rewritten with additional comments.[7] Both formats suggest intimacy, while they are also constructed and rewritten with an audience in mind. Thus, they provide insight into the nature of the artist's trauma and anxieties. His works are often clumsy, overworked and unresolved. Their emotional intensity, and perhaps their awkwardness, engage the viewer who is drawn into the artist's story. This adds to their accessibility for students who sometimes struggle with their own emotional responses to the Holocaust.

Application of the Daghani Collection to teaching

Coming from a background in fine art and art history, I was a Research Fellow on the Arnold Daghani Collection at the University of Sussex from 1999-2010. The Collection was donated to the university by the artist's family after he died in Brighton in 1985. Alongside cataloguing the Collection I organised a number of exhibitions of items from it, presented conference papers and published about it. Once the Collection went online, I wished to make it more physically accessible and

to incorporate it into teaching programmes. While teaching art courses at institutions in London, now at Richmond American International University, I often take students to the National Art Library at the Victoria & Albert Museum where they have the opportunity to pick up and examine artists' books. These are not books about art but books produced as art objects. In my experience, students have always responded extremely well to this visit and I wanted to enable students to engage with the Daghani Collection in a comparable way. The enormous scale of the disaster and the figures of those who died can be difficult for students to comprehend and often act as barriers. I was keen to test my hypothesis that holding and looking at items would render the Holocaust more vivid, resulting in a deeper level of engagement and learning.

A successful funding application to the Creativity Development Fund enabled me to work with my colleague, Chana Moshenska, who taught courses on the Holocaust. The aim of the project was to build on what the students learnt in the seminar room and lecture theatre, and so we organised seminars in which students would have hands-on access to a range of items from the Daghani Collection. Focusing on the life and production of the artist, we argued, would individualise the Holocaust and make it more accessible.

The Daghani Collection is housed in Special Collections in the University of Sussex Library. It is a large collection of over 6,000 items, both artworks and archival objects. The items are stored in the building's basement, and so for the seminar I put together a list of twenty items to view. Many of these are

in book or folio format, comprising both words and images, and so what may seem to be a rather brief list was more than sufficient for a two hour seminar. With regard to the practical aspects of safely handling the art and archival objects, Special Collections does not require viewers to wear gloves, following the policy that it is better to have clean hands than wear gloves which can make the viewer/reader clumsy. As most of the items in the Collection are paper-based, many with fragile and brittle edges, it can be difficult to handle these delicate items carefully when wearing gloves. As a result, a physical barrier between the students and the items was removed.

At the start of each seminar I gave a presentation to provide an overview of Daghani's life and career. I explained key events and how they impacted on his experiences as an artist, both in his life and in what was happening in the wider context of the time. Students were invited to ask questions from the start and to engage in discussions about the items. They were then given the opportunity to look at and handle the works. Each seminar lasted around two hours so there was plenty of time to do so. Students were also informed about how to return individually if they wished to look at the items further. The atmosphere was informal in that students were allowed to choose what they looked at and to move around the room freely. Our discussions continued while they were looking at the items, sometimes on a one-to-one basis, at other times in small groups. The students were given worksheets to fill in while they were looking at the items, with prompt questions which were designed to get them thinking and talking about

the works, to help and encourage them to engage fully with the items. They were asked:

1. What are your first impressions of the Arnold Daghani Collection?
2. Note words to describe/that relate to the items you have seen.
3. Discuss a particular work and explain why you chose this one.
4. Discuss Daghani's works as Holocaust representation.
5. Note if Daghani's works remind you in any way of the representations of other artists/writers.
6. Has seeing Daghani's work altered in any way your understanding of the Holocaust?

The first two questions were designed to get them looking and thinking. The students came from a range of disciplines in the humanities, from history to modern languages and so I could not assume that they had any particular analytical skills in looking at artworks. I was interested in how their thoughts about the items might change during the course of the seminar, from their first impressions to their later reflections after more sustained analysis. The third question prompted them to do just this; in case they were feeling overwhelmed by the complexity of the materials, they were asked to focus in depth on one particular item which would, in turn, help them to understand other items better. The fourth and fifth questions made connections with previous seminars they had already had on Holocaust representation in art and literature,

thereby building on and relating the items to what they had studied in other classes.

I concluded the seminar with a group discussion bringing all the students back together, picking up the key threads of their responses and comments.

The students' responses exceeded our hopes and expectations. They wrote copious responses on the worksheets and entered into lively discussions in the seminar room. It was useful for us as seminar leaders to have their written as well as their oral responses. They tended to go into greater detail on paper, especially those who were quieter in the classroom, while the written method also prompted the oral discussions and provided a useful basis on which they could think through and explore the works. They described the Collection as "fascinating", "poignant" and "very complex", and felt it gave "an insight into Daghani's life not just his work". They found his words were easier to grasp than academic writing and the images, especially photographs, reminded them that the Holocaust did not take place very long ago, a response I had not anticipated. They were struck by the range of material, the intensity of it and the ways in which his camp experiences affected his whole life's work. They noted what seemed to be a contradiction in the works: their intimate quality combined with an evidently public intention. They questioned why he wrote in English and the audience he had in mind. They commented on the time-consuming and mannered quality of Daghani's handwriting, noting the lengthy process of compiling many of his works. They were impressed by the

Figure 3: Arnold Daghani, Woman wearing headscarf of names (1975) in The Building in which We had a Narrow Escape *(1974–8). Ink on paper (C45.46v). Arnold Daghani Collection, University of Sussex. © Arnold Daghani Trust.*

volume and quantity of his output and by the range of his interests, media and forms of expression.

Students also responded to the individual voice Daghani

offers, and his connection to the range of individuals he encountered. They were impressed by the way in which he emphasised "the dignity and humanity" of the inmates, and they found that his practice of writing names "makes their deaths more real" and "humanises each victim". By arranging the names as a face, for example (Figure 3), they found themselves studying and reading the names which they would be less likely to do with a list. However, one student also noted that, "Although he gives voice (and faces) to those who have been forgotten, he simultaneously highlights the futility of their deaths and how they have become nameless".

The students were struck by the authenticity of the works, such as the painting of flowers, and the sharp contrast between the simple, subtle image and the history that the small scrap of paper has had. A 1943 watercolour (Figure 4) led to a comparable response. It depicts the interior of the accommodation at Mikhailowka where Daghani and Anisoara were housed. It is painted in soft colours and is relatively small (measuring 20 x 29 cm). The figures are carefully depicted and the scene appears remarkably cosy. On viewing this item, students were impressed and moved by its long journey, rendering it rich with emotional references: smuggled out of the camp and ghetto, hidden inside a metal tube, sewn into the lining of Anisoara's coat and later smuggled out of communist Romania via a diplomatic bag, it was transported across geographical and political borders before reaching its current home. Some years after its making, Daghani pasted it onto a sheet of much larger paper on which it sits surrounded

Figure 4: Arnold Daghani, Untitled (Mikhailowka accommodation) (1943) in 1942 1943 And Thereafter (Sporadic records till 1977) (1942–77) (G2.063r). Arnold Daghani Collection, University of Sussex. © Arnold Daghani Trust.

by white space. In a concise inscription the artist draws the viewer's attention to the water damage on the top edge of the painting that occurred when he and Anisoara were wading across the River Bug in July 1943. Thus, the significant point of crossing in their escape between the danger of Nazi-occupied Ukraine and the relative safety of Romanian Transnistria left its visible and irremovable, indexical mark on the image – a unique "watermark", confirming its authenticity. This small sheet with coloured marks on it becomes a significant historical item. It is seemingly insignificant, but testifies to the emotional agency of objects. For the students, it offered direct physical access to another time and place. At the same time, it reminded them how recently the Holocaust occurred.

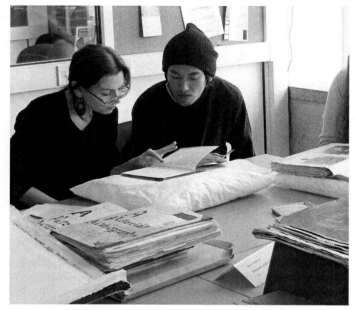

Figure 5: Seminar on the Arnold Daghani Collection at the University of Sussex.
[Photograph: Deborah Schultz]

It indicated how the impact of an historical event can be experienced through the immediacy of artworks, especially when directly handled.

Regarding Daghani's work as Holocaust representation, students wondered whether art-making was a form of therapy for him "or a torment he cannot escape?" and how it related to his survivor guilt. They noted that "it brings into question the usefulness of diaries as a source". It was "an emotional response to the Holocaust" reflecting "the feelings and thoughts" of a survivor "haunted by his experiences". One commented that, "his work conveys the trauma felt by survivors, guilt from

surviving and loneliness from the lack of understanding as to what had happened".

Students related Daghani's work to that of other artists and writers. They found it "very unique" that while sharing "the same rage" and "the haunting of other survivors" it had "a personal tone"; that his mixed media approach was similar to other Holocaust representation; and that his "methodical work ethic" was "reminiscent of *Maus*". One student commented that his writings were comparable to that of Wiesel as "both *Night* and Daghani's works contain irony and a sense of bitterness and sadness. But Daghani's writings are much more haphazard and abstract". His work reflected "as with most survivors, the need to ask questions" while revealing "confusion".

In response to the question on whether seeing Daghani's work altered in any way their understanding of the Holocaust, they responded that, "It wasn't anything like I thought it might be. The interaction with the material has made it far more accessible". "It brings into focus the enormity of what happened". "It has confirmed that it is unrepresentable". And "it reaffirms a belief that the experience never leaves the survivors/victims". It gave one student "a closer understanding of an emotional response to the Holocaust". Another noted that "seeing the paintings and drawings has brought a new dimension to the Holocaust as they seem to reflect the survivors' inner state of mind in a way writing does not. The huge amount of work Daghani has produced shows that he is possessed by his memories and also his need to express himself". They found the viewpoint of an individual a valuable

way of understanding Holocaust survival, trauma, guilt, relationships and memory. The range of media, words and images made them understand how there are "many different ways to express the events" and they considered whether words or images are more appropriate forms of representation. They felt that his work conveyed the dehumanising effects of the Nazis and that it was very important in terms of the experience of a survivor and the lack of a healing process. It personalised the Holocaust, so that "you can actually start to imagine the people involved rather than thinking of them in terms of statistics".

Following the seminars with students on the Holocaust course, the project was extended to students on other courses who were not studying the Holocaust: photography students undertaking photography projects on archives and memory; anthropology students studying sites of memory; language students studying German language and German history; and law students engaged with human rights issues. I was interested in their engagement with the artefacts and how they articulated their responses in relation to their own backgrounds, with, for example, photography students producing photographic works and language students producing written work that take the Collection as their starting point to engage with other forms of Holocaust representation. In this way the hands-on experience of the seminar stimulates students to develop their own practice beyond the immediate themes of the Collection.

Conclusion

Based on the seminars, my hypothesis proved correct that interaction with artefacts deepens students' learning. Being able to view and touch three-dimensional items from the Arnold Daghani Collection offered a more meaningful experience for students than seeing two-dimensional images displayed on PowerPoint, or works of art at first hand but in a gallery context, behind glass. The Collection provided a way for them to address wider issues of the Holocaust and Holocaust representation, and their comments were thoughtful and intelligent. The interdisciplinary nature of the items resulted in the students making connections between different parts of their studies: between, for example, issues of representation, history and trauma, or between artworks and human rights issues. Having the Collection on campus also helped to join up the seminar with other aspects of their university learning. The haptic experience of direct access to Daghani's works brought to life what they had read and discussed in class. It was the combination of the material and its hands-on accessibility within the context of the university that enabled students to reach a greater understanding of the Holocaust.

Thus, from this point of view, the project was very successful. If there was one hoped for outcome that was not achieved, it was to make the Daghani Collection a fundamental part of teaching the Holocaust at Sussex University. Neither Chana nor I work at the university any longer, and other faculty members have not been willing to use the Collection without our presence. The Collection remains in its semi-dormant state

in the storeroom, waiting for the next possibility of direct student contact.

However, this situation may change in the near future. In 2013 the Daghani Collection, as part of Special Collections at Sussex, will be relocated to a new, purpose-built home known as The Keep, a fifteen minute walk off campus. The building will offer the most up-to-date conditions for the environmental management of archives and will provide a space shared with the archives of East Sussex County Council and Brighton & Hove City Council. The aim is that each collection will benefit both from the expertise of colleagues and from longer opening hours, offering increased accessibility. It will be interesting to observe the presentation of, and future engagement with, the Daghani Collection within this historical resource centre. While the move may distance some potential student groups, it may also open up the Collection to new audiences.

NOTES

1 This chapter has developed out of a project on *Three-Dimensional Learning: Interacting with artefacts and exploring new assessment methods* that I worked on with Chana Moshenska, 2006-8 at the University of Sussex. I am very grateful to the Creativity Development Fund for its support of the project. For online information on the Arnold Daghani Collection go to http://www.sussex.ac.uk/library/specialcollections/az.

2 See Prue Chamberlayne, Joanna Bornat & Tom Wengraf, eds., *The Turn to Biographical Methods in Social Sciences: Comparative Issues and Examples* (London: Routledge, 2000).

3 Hayden White has been instrumental in focusing on the narrative of history. See, for example, Hayden White, *The Content of the Form: Narrative Discourse and Historical Representation* (Baltimore. MD: Johns Hopkins University Press, 1987).

4 Key works in this area have been Paul Thompson, *The Voice of the Past: Oral History* (Oxford: Oxford University Press, 1978) and Robert Perks and Alistair Thomson, *The Oral History Reader* (London: Routledge, 1998).

5 Daghani wrote his diary in a number of different formats. It was first published in Romanian in 1947, in German in 1960 and in English as *The Grave is in the Cherry Orchard* (London: Adam, 1961). The most recent version is Deborah Schultz and Edward Timms, eds., *Arnold Daghani's Memories of Mikhailowka: The Illustrated Diary of a Slave Labour Camp Survivor* (London: Vallentine Mitchell, 2009). For analysis of Daghani's word-image relations see Deborah Schultz and Edward Timms, *Pictorial Narrative in the Nazi Period: Felix Nussbaum, Charlotte Salomon and Arnold Daghani* (London: Routledge, 2009).

6 For analysis of Daghani's books see Deborah Schultz, 'Crossing Borders: Migration, Memory and the Artist's Book', in *Moving Subjects, Moving Objects: Migrant Art, Artefacts and Emotional Agency*, edited by Maruška Svašek (Oxford: Berghahn, 2012), 201-221.

7 Ken Plummer, *Documents of Life: An Introduction to the Problems and Literature of a Humanistic Method* (London: George Allen & Unwin, 1983), 17–24.

Bibliography

Daghani, Arnold. *1942 1943 And Thereafter (Sporadic records till 1977)*. 1942–77. Unpublished folio, Arnold Daghani Collection.

Daghani, Arnold. *What a Nice World*. 1943–77. Unpublished book, Arnold Daghani Collection, University of Sussex.

Daghani, Arnold. *The Grave is in the Cherry Orchard*. London: Adam, 1961

Schultz, Deborah. 'Crossing Borders: Migration, Memory and the Artist's Book'. In *Moving Subjects, Moving Objects: Migrant Art, Artefacts and Emotional Agency*, edited by Maruška Svašek, 201-221. Oxford: Berghahn, 2012

Schultz, Deborah and Timms, Edward. *Pictorial Narrative in the Nazi Period: Felix Nussbaum, Charlotte Salomon and Arnold Daghani*. London: Routledge, 2009.

Schultz, Deborah and Timms, Edward eds. *Arnold Daghani's Memories of Mikhailowka: The Illustrated Diary of a Slave Labour Camp Survivor*. London: Vallentine Mitchell, 2009

Coaxing Them Out of the Box: Removing Disciplinary Barriers to Collection Use

DAN BARTLETT
Logan Museum of Anthropology
Beloit College

The days when a small to medium-sized college or university could afford to operate a discipline-specific museum may be numbered. As resources become tighter, many schools are deciding that their museums' staff, collections, and facilities are expendable at best and assets for liquidity at worst.[1] Making academic museums relevant beyond the disciplinary borders that defined and nurtured their creation and development is critical to ensure their future viability. But why would a chemistry professor want to bring her students to the anthropology museum, or a math instructor bring his class to the art museum? The answer lies in the unique teaching opportunities that objects provide.

Using objects in college teaching is second nature to many disciplines. Concepts in geology are better illustrated with actual specimens than with images. The same holds true for the structures of a cell or the properties of a chemical reaction. Teachers of literature or economics are much less accustomed to structuring lessons around objects. None of these disciplines typically use anthropological materials – material culture – in their classrooms. This chapter explores the advantages of building course units around material culture, lays out two models for using material culture, and gives examples and tips for disseminating these ideas across campus.

Premises

At Beloit College's Logan Museum of Anthropology, our argument for including objects in teaching across disciplines is based on three premises with venerable histories on our

campus.[2] First, that encountering objects in the classroom is a potentially powerful, motivating experience. Second, that the social nature of objects encourages and facilitates interaction in the classroom. And, third, that objects can be easily integrated into several teaching strategies that have proven to be effective in increasing student interest and achievement. Let us briefly review each premise.

Object transactions

Philosopher John Dewey wrote about the interactions people have with objects. For Dewey, objects have intrinsic and extrinsic meanings. Extrinsic meaning is related to function: a knife cuts things. Intrinsic meanings are divorced from function or materiality: the knife is finely made, or was purchased as a souvenir related to a pleasurable vacation, or once belonged to a famous person. Contemplating these meanings can absorb a person's attention and feelings in unique and profound ways. Dewey was particularly interested in interactions with objects of art and the transcendent "experience" that might result.[3] The encounters Dewey describes (he calls them "transactions") are dependent on something tangible – on objects. Kiersten Latham, in discussing what she calls "numinous experiences" with objects, builds upon Dewey and identifies the "object link" which is the physical trigger igniting the thoughts and feelings surrounding the intrinsic meanings of an object and transporting the viewer to another state, or to what Dewey calls an experience.[4]

The point here is that objects have a unique ability to act upon the thoughts – and especially the emotions – of people who encounter them. This potential emotional impact should not be undervalued as a tool for successful teaching and learning in the classroom. Latham found that objects can bring other times, places, or ideas to life, or reveal the minds of their makers, and that this ability has profound impacts on people's understanding. As one informant told her, "You read about it in books, and people talk about it and things. It's just different when you see it".[5]

Object conversations

Objects are social. Nina Simon, in her book *The Participatory Museum*, refers to a "social object" as "one that connects the people who create, own, use, critique, or consume it." Objects play a role in enabling conversations by allowing people to talk "through" an object. Simon uses the example of her dog as a social object. When walking her dog, strangers approach and talk to her through her dog. "The dog allows for transference of attention from person-to-person to person-to-object-to-person. It's much less threatening to engage someone by approaching and interacting with her dog, which will inevitably lead to interaction with its owner".[6] Objects may provide the same facilitated communication in the classroom, leading to more productive discussions and greater class cohesion.

Object advantages

Finally, objects make excellent foci for inquiry-based,

problem-based, task-based instruction – as well as active learning methods. The use of these teaching techniques has been shown to foster increased skill in higher-level critical thinking, greater acceptance of conceptual change, increased student investment (through ownership of the process or more active mode of instruction), knowledge retention and transfer (because application is required in different contexts), language comprehension and application, and better understanding of complex material.[7]

Visual and material culture pedagogy

"Visual literacy" is the ability to critically analyze images, information graphics, and mass media like film and video to discern the overt and covert messages encoded within them. This definition can be extended to include material culture, because objects can also be encoded with overt and covert messages. In addition, objects frequently carry attached cultural values that can change across time and place. The ability to recognize, analyze, and understand the messages and values in media and objects, and the ability to combine media and material culture with documentary evidence in research and argument, are goals of an instructional technique we call *Visual and Material Culture Pedagogy* (VMCP). Note that this chapter refers to material culture. The choice to concentrate on objects in this discussion was made because, while most people are accustomed to looking at photos for information, few people have the same skill with other forms of cultural material.

Visual and Material Culture Pedagogy incorporates two ways of thinking about objects. The first is to think of objects as lenses or prisms. The second is to think of objects as anchors.

Objects of instruction: cultural prisms

"White" light is the sum of all of the hues of the visible light spectrum. If white light shines through a prism, the component spectral colors are split out and become individually visible. If we consider "culture" to be the sum of many individual aspects – such as political and religious beliefs, class and gender roles, aesthetics and the arts, economic structures, voluntary associations, language, and institutions – in the same way that white light is composed of multiple individual colors, then the we should be able to employ a "cultural prism" to emphasize these individual aspects. Objects are cultural prisms.

Looking through the cultural prism is accomplished through an inquiry-based process of object analysis. People who study material culture have proposed several models designed to uncover aspects of culture encoded in objects. All of these begin with a careful physical examination of the object before unwrapping layers of context to uncover its central cultural "meanings". Understanding what objects are saying and how to use them in teaching and learning requires the ability to examine them systematically – to really see them – at a number of different levels. After a basic, detailed description, these models move gradually outward into deeper explorations of manufacture, use, cultural context, and interdisciplinary linkages. As this rich understanding is created, the interrelated

aspects of culture can be seen with greater clarity. Just as orange can be seen to be a component of white light, aspects of gender, class or status, economics and so on can be identified. Dorothea Lasky gives the most succinct description of what's happening when she writes, "Objects house the human drama and help reflect the human condition back to learners".[8] The instructor chooses the focus of the exercise by consciously selecting the objects for study – by choosing specific objects embedded with highly gendered cultural relationships, for example. The VMCP model uses a seven step process. Knowing the "correct" answers is unimportant. Recognizing whether an object is made of wool or cotton is not the point. The questioning, critical thinking, discussion and critical looking is what matters.[9]

The first step is a basic but detailed visual inspection of the object to answer the question, *What can I see?* Describe its size, shape, materials, texture, color, weight, and smell. How was it made? Does it show evidence of its manufacture: tool marks, fasteners, adhesives, welds, or maker's marks? Does the object show evidence of use such as wear, patina, repairs, or modifications? What is the general condition of the object?[10]

Consider in the next step the object's function and worth in answering the question, *What is its value?* What is the object for – what does it do? How does its form affect its function and vice versa? Are the raw materials used to make it inherently valuable? Did it require skill to make or use? It may not be possible to answer some of these questions at this stage if the object is ceremonial or is otherwise inscrutable

from our modern cultural perspective. In this case, students should speculate on what they think the answers might be and why. They should not just guess. Greater insight gained in later steps of the analysis will help validate or invalidate their interpretations.

In the third step, students begin to incorporate evidence from sources outside the object – from other pieces in the museum or in other museums' collections online, and from text or image-based sources. Compare the object to others like it to answer the question, *Is it unique?* Use similar objects from the same culture, different cultures contemporary to the object's culture of origin, and cultures distant in both time and space. Is this object common or uncommon? How did different makers approach the design and manufacture of the objects? How practical or efficient is the object in comparison to others like it?

What does it represent? is answered in the next step. At this point, individual cultural aspects begin to emerge with greater clarity. The research continues moving further afield into other sources – ethnographies, diaries, and scholarly articles, for example. The key questions at this stage involve the meanings ascribed to the object by its maker, its user, and its collector. Is high status accorded to the maker or owner? What does the object symbolize within the culture of origin? Can anyone make or possess one? What inherent and attached values does the object have for different people at different times and places? Students should also return to unanswered *What is its value?* questions in the light of what they have uncovered so far.

The object remains the center of inquiry, but questions in the next step are intended to uncover broader contextual layers that surround the object. *What was its context?* questions examine the lives of the people who have come in contact with the object. What was the physical environment like where the maker and user lived? What were these people's daily lives like? What was the relationship between the maker and the user, and the user and collector? What relationships and institutions within their society ordered their lives? How did these people interact with their cultural neighbors or other outsiders? How did these people understand the world around them? The goal of this step is to build as complete a picture as possible of the object's world at the time it was made, used, and collected.

The full range of the cultural spectrum is revealed when the analysis moves on to step six, asking *How does this object relate to different disciplines?* All the thought from earlier steps – about the function of the object, relationships of the object to its maker and owners, their relationships with each other, the inherent and attached values of the object, and the world the object existed in – creates a contextual framework upon which specific disciplinary lenses can be attached. For example, a late 19th century ceramic vessel created by a Native American woman specifically for purchase by a non-Native trader to sell to collectors back East can dramatically illustrate classroom discussions about colonial power dynamics, the status and agency of women in that time and place, micro-economic decisions surrounding resources, markets, and exchanges, or the aesthetics of the Gilded Age in the United States. Theories,

concepts, and facts conveyed through readings and lectures are reinforced in all their nuanced wonder in an actual specimen. Theory becomes reality.

The final step is metacognitive. *What does it mean to me?* questions reflect on how original assumptions were validated or not, the extent of knowledge learned about the object and its world, what could yet be learned and what might never be learned, and how the student feels about the object at this end stage as compared to first impressions. Reflection of this kind reinforces for students that they have agency in their own learning and helps them to make meaning of what they have learned in the process.

It's not necessary to follow these steps like a road map. A course module could ask students to begin at steps four or five, with more contextual information and skipping the basic descriptive and comparative steps. However, beginning with the basic descriptive and comparative phases requires students to slow down and really look at the object. The use of material and visual culture in teaching typically pairs a visual, and an explanatory text revealing the significance of the visual, with some theme related to the course topic. Think of a textbook photo with caption, or a museum object next to an interpretive object label. The object or image itself is little more than a prop used to illustrate a story. Most people have been trained by habit to glance briefly at the photo or object before moving on to a detailed study of the text. Many people are unable to slow down, concentrate, and really see what they are looking at. Starting with careful observation and basic description

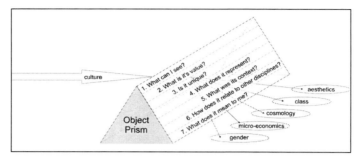

Figure 1: Objects can be used as prisms to isolate specific cultural aspects for study in the classroom. Locating specific objects within disciplinary theory helps students process complex abstract concepts.[12] Model based on techniques proposed in Rethinking the Gallery Learning Experience through Inquiry by Pat Villeneuve and Ann Rowson Love in From Periphery to Center: Art Museum Education in the 20th Century. (National Art Education Association, 2007).

might seem unnecessary, but it encourages students to really look at and understand the object they are studying.[11]

Case study: the living table
Jennifer Esperanza, Assistant Professor of Anthropology at Beloit College, conceptualized an object-based research activity for her Food and Culture class which was designed to connect the course's main themes to an object from the collections of the Logan Museum of Anthropology. Museum staff selected a unique object related to food production or consumption for each student. Students completed research on their objects, looking for connections between the object and the course's themes which included "eating and institutions" (food and sociality), "the immigrant experience" (food and cultural symbolism), and "food and identity politics" (sex, gender, sexuality, class, race, etc.). The research was guided by, and

findings were presented as, an interview with the object.

The project culminated in a class session that was held in the museum's main exhibit gallery. Tables were arranged as in a banquet hall and covered with tablecloths. The objects were seated next to their student interviewers who "introduced" their objects to their classmates, summarizing their research findings.

The final portion of the assignment was to write a 300-350 word label, as if the object was speaking about how it related to one or more of the course themes. Museum staff used these labels in a small exhibit featuring the objects.

Our first attempt with this assignment was a bit disappointing. The students' written object labels did not focus as much on the course themes as had been hoped. Most students simply described the object and how it was used, rather than what it represented and how it related to food production or consumption in its culture of origin. This may have been because of their inexperience in working with artifacts and in seeing aspects of culture within a tangible object. It may also have been for a reason mentioned earlier: that most museum objects are used as props and exhibited to illustrate stories narrated by the exhibit text. They may have assumed we expected that kind of object label.

As an example of the kinds of deep connections we were after, consider one of the objects we chose: an unremarkable looking late 18th century bone squash knife from a Mandan Indian archaeological site. A typical exhibit label describing its form and function might focus on the fact that it was made

from the scapula of a bison, that it was an expedient tool, how it was made, and what it was used for. But food production among the Mandan was highly gendered. Men hunted while women farmed. The squash knife was a woman's tool. A man would not have used it, yet a man's work as a hunter was crucial in order to acquire the raw material needed to make it. Women's agricultural work was essential to feeding the tribe over the winter, including the hunters. The knife then stands as a physical representation of symbiotic gender roles surrounding food production among the Mandan. These were the kinds of associations we were looking for in the students' work.[13] In the future, we will be more explicit in the assignment's description, provide more guidance during research, and possibly provide an example of what we are looking for. What follows is one example of the best student work produced for this assignment:

> I am a mortar basket and I was used during the mid-to-late 19th century by Gabrielino (aka Tongva) tribe of present day Los Angeles, CA.
>
> The Gabrielino people had a diet rich in shellfish and salmon. They did not plant crops, but instead collected acorns and used me for processing them. Californian acorns are bitter with tannin and must be de-hulled and ground into flour before consumption. My stone base mortar is a perfect tool for grinding. My textile basket is affixed with asphalt and is watertight. After grinding, the next step in processing is

Figure 2: Mortar basket. Gabrielino. California (Los Angeles County). LMA 18079.

pouring water into the mix to leach out the tannin. Stones would be heated in a fire and added to the basket to boil the mixture until ready to eat. The gruel this created was an important part of diets in many Californian Indian cultures.

It could also be made into cakes and breads.

Mortars like me are good indicators of growing acorn economies and increased commodity trading that coincided with cultures moving away from hunting and gathering lifestyles. We also represent the important roles women played in production. Prior to the widespread use of mortars and pestles, both men and women collected shellfish for subsistence. With population growth, those cultures turned toward economic trade and more gender-specified roles in food production. This gender division became even more prominent in post Spanish contact.

Men, women, and children all gathered acorns, but women took it from there. They created gathering and processing equipment, and built and maintained their own mortars. A woman's status was linked to her ability to prepare acorns and her identity was held in her mortar. In some cases a woman's mortar was broken and buried with her in death.

We mortars are a global common household item today used for grinding smaller herbs. In industrialized cultures we are separated from gender roles, but in some indigenous cultures predominantly women continue to use us in preparing traditional meals.
– Rachel McCarty, Beloit College Class of 2014.

Objects of instruction: object anchors
Using objects as anchors multiplies exponentially the possible classroom uses of any object. When used as an anchor, an object is divorced from its cultural context in the service of some other learning goal. For example, a collection of archaeological metal is studied for the physical properties of the metal itself rather than for the object's cultural significance. Course units built around object anchors work well with courses in the sciences, literature, and language. The object becomes a specimen, inspiration, or talking point as needed.

Task-based language instruction couples well with object anchors. In task-based instruction, students engage in written and/or spoken activities meant to simulate real-life communication. In the museum, task-based language

instruction might involve students haggling in Chinese over the "sale" of a Chinese bronze, or writing descriptions of objects for an auction catalog. At the Logan Museum of Anthropology, intermediate Arabic students produced a mock news report. One student, the reporter, prepared a list of basic questions about an object, a knife from Sudan. A second student, portraying the curator, answered the questions. The exercise was not scripted in that the curator had no idea what questions the reporter planned to ask. The exchanges were very basic: Question: "What was used to make the knife?" Answer: "The blade is iron and the handle is wood wrapped with leather." Afterwards, students spoke enthusiastically about the activity, saying that it was an engaging break from more traditional classroom language instruction.

Even if task-based language instruction is not used, museum objects lend themselves to language learning. Objects provide endless examples for practicing basic vocabulary, either alone or in a small group: colors, shapes, sizes, numbers, and textures. Objects need not be from the culture of the language spoken in the classroom. Chinese is as good a language to use in describing Pre-Columbian ceramics from Peru as is Spanish or Quecha.

Anchor objects used in science classes become specimens for study, perhaps even for destructive testing if the museum's policies allow. Examined microscopically, evaluated for deterioration from chemical processes, or used to illustrate the properties of glass, ceramic, metal, plastic, or other materials, object anchors provide specimens that are "real" pieces with unique histories and affiliations. They are not just generic lab

samples. A 4000 year old lump of copper worked by North American Archaic people into a spear point that shows evidence of the metal's malleability, use, and corrosion is more interesting than a copper ingot or other contemporary copper lab specimen.

If a picture paints a thousand words, as the cliché says, then it can be argued that objects do, too. Used as anchors for creative writing exercises using both poetry and prose, students can write rich descriptions of, or fictionalized histories for, museum objects, or they can write in the object's voice. In the Logan Museum's visible storage gallery, students pair up and write a haiku, limerick, or cinquain that describes an object, then switch papers and see if they can locate each other's object using the poem.

Case study: objects as anchors in Chemistry 117

Beloit College Professor of Chemistry George Lisensky developed this module in 2010 after the college's museum staff held a workshop for faculty interested in teaching with objects. The workshop acquainted (or reacquainted) faculty with the art and anthropology museums and their staffs, collections, documentation, and access policies, and then discussed VMCP and its possible applications. The resulting Chemistry 117 lab module has been used successfully by different faculty members in multiple sections of this introductory course. Students are briefed on appropriate behavior in the museum prior to the visit and are given a worksheet for the activity. They visit the museum as a group with their professor. For this exercise, students are allowed to handle the objects so,

Figure 3: A student examines North American Archaic copper tools during a Chemistry 117 class visit to the museum lab. The properties of the raw copper ores found by native peoples allowed them to fashion tools and ornaments from the material without the need for smelting technology.

on entering the museum's collections lab, a museum staff member provides gloves and basic handling instructions and reiterates the behavior expectations.

The goals of the lab are for students to discover that metal objects can be identified based on corrosion residues and that the properties of metallic elements affect how or why the material was used. In the collection lab, students are presented with a variety of metal objects including Archaic North American copper artifacts and lumps of raw copper, copper beads and ear spools from Mexico, a steel blade from Indonesia, an Iron Age sword blade from Switzerland, a Native American stone pipe with metal inlay, a tumbaga (alloy of gold

and copper) burial mask from Peru, and a large coiled piece of iron currency from West Africa.

After examining the objects and completing the worksheet, the professor, assisted by a museum staff member, leads a discussion about the objects, asking students to identify different materials, pointing out characteristics of the objects related to the physical properties of the metals used, and discussing possible non-destructive means of identifying the metals in the lab. Even the use of gloves when handling the objects becomes a teachable moment when discussing reactions between metals and other substances, such as the oils and salts found on human skin. Students frequently request cultural or collection information, so the museum staff member provides data about each object. This information often leads to discussions about the availability of certain metals at different times and places, or the available technology for smelting and fabricating metal objects. Using a variety of metal objects from around the world makes the chemical properties discussed and explored in the lab more immediate and real.

Object caveats

Museum practitioners understand that the research and interpretive possibilities of collections go far beyond exhibits. This is not true for most people outside the museum. Breaking through the "use equals exhibit" mindset is the first step. When we began advocating a wider use of our collections at Beloit College it was assumed by many that we wanted classes either to come to exhibits in the museum, or to create exhibits

in class for the museum. We do encourage both of these things when appropriate, but in most cases it's far more effective to teach with select objects pulled for use in the museum lab. In almost all cases it's far less work for the museum staff than mounting an exhibit.

Part of refocusing attention away from exhibits involves training faculty in using the museum. They need to be aware of the collection's organization and cataloging system, the access and use policies, associated documentation and how it can be accessed and used, which staff people to ask for what, and how objects should be stored and handled for preservation. Just like learning to use a library or archive, most people don't know the ropes until someone makes the effort to show them. Once faculty members have climbed the learning curve they can begin to do much of their course module development and class preparation themselves.

Whatever the subject, any single object or group of objects can rarely carry the objectives of an entire course, so it's best to create individual object-based course units or modules. These modules, like any other course assignment such as a paper or a lab, need clear learning goals and a carefully thought out lesson plan. This is why we encourage faculty to approach us for assistance in developing a module before the semester is underway. To be most successful, object modules need to be carefully integrated while the syllabus is under construction. A module that seems grafted onto a course and stands apart from the rest of the semester's activities and assignments may well disappoint both the students and the instructor. Disappointed

students and instructors are unlikely to return to the museum.

Finally, don't expect that simply preaching the advantages of VMCP will bring converts flocking to use your collection. Invite faculty to the museum. Introduce VMCP. Get testimonials from faculty who have successfully used objects in their teaching. Provide examples of course modules and compile and make available modules that faculty have completed in your museum. Just as students often need a guide to take them from theory to practice, so too might faculty who understand the advantage and have the desire to use object-based instruction but have never organized or led an object-based unit.[14]

Academic museums are uniquely situated to enhance learning opportunities across campus and across disciplines. Using objects in teaching is a novel idea for many faculty, but given support and guidance from museum staff they can successfully add objects to their courses, return the academic museum to relevance, and enhance student achievement.

Case study: The Hidden Harmony

Beloit College Assistant Professor of Music and Director of Choirs Susan Rice is developing a unique course that pairs museum objects and choral selections and combines the cultural prism and object anchors techniques. Her proposal describes the class as:

A collaboration between the Music Department's choral program and the Logan Museum of Anthropology and Wright Museum of Art. Chamber Singers, a 24-28 voice chamber

choir, utilizing four objects selected from the collections of each museum, will rehearse and explore a program of choral music wherein each musical selection is paired with one of the eight museum objects. Music and museum objects that engender the broadest intersection with academic areas beyond music, anthropology and art history will be chosen. With the aid of mini-lectures provided by select members of the Beloit College faculty, the students will explore not only the form and artistry of the music and the museum pieces as individual entities, but also the manner in which each pair might reflect, expand or illustrate one another. At the end of the semester, Chamber Singers will present three performances in the Wright Museum, with each piece of music sung in the presence of its paired museum object; an exhibit/ program booklet with color photos of the museum objects, faculty essays, and program notes to elaborate on the musical selections will be provided to the audience members. A variety of gallery talks drawn from the semester's mini-lectures will be offered before the performances begin and a question-and-answer/reflection session with the student performers, lecturers, project collaborators, and audience members will take place at the conclusion of the concerts. One proposed object/music pairing is:

Object pairing:
Ghost Dance Dress (Figure 4). *Arapaho. Oklahoma. 1890s.* LMA 30449.

Figure 4: Ghost Dance Dress. Arapaho. Oklahoma. 1890s. LMA 30449.

Choral Pairing:
Thomas Benjamin (b. 1940): The Sacred Hoop *for SATB chorus.*

Text Pairing:
Excerpt from Black Elk Speaks: Being the Life Story

of a Holy Man of the Oglala Sioux (as told to John G. Neihardt), *New York, William Morrow & Company, 1932. (Black Elk [1863-1950] was injured in the Wounded Knee Massacre.)*

"Then I was standing on the highest mountain of them all, and round about beneath me was the whole hoop of the world. And while I stood there I saw more than I can tell and I understood more than I saw; for I was seeing in a sacred manner the shapes of all things in the spirit, and the shape of all shapes as they must live together like one being. And I saw that the sacred hoop of my people was one of many hoops that made one circle, wide as daylight and as starlight, and in the center grew one mighty flowering tree to shelter all the children of one mother and one father. And I saw that it was holy."

Possible academic intersections include religious studies, history, philosophy, and dance (the history/implications of circle dances.)

The course is scheduled for the Fall of 2013.

NOTES

1 Here are only a few of the recent stories:

"U. of Northern Iowa Will Close Museum and Lab School," *The Chronicle of*

Higher Education, February 25, 2012. Accessed April 20th, 2012,

http://chronicle.com/blogs/ticker/u-of-northern-iowa-will-close-museum-and-lab-

school/40862.

"Lawmaker Eyes U. of Iowa's Pollock Painting for Cash." *The Chronicle of*

Higher Education, February 10, 2011. Accessed April 20, 2012,

http://chronicle.com/blogs/ticker/lawmaker-eyes-u-of-iowas-pollock-painting-for-

cash/30396

"In the Closing of Brandeis Museum, a Stark Statement of Priorities." *The New*

York Times, February 1, 2009. Accessed April 20, 2012,

http://www.nytimes.com/2009/02/02/arts/design/02rose.html

2 Lawrence S Breitborde, "Reading and Writing the Anthropology Museum,"

Treasures of Beloit College: 100 Works from the Logan Museum of

Anthropology and Wright Museum of Art, (Beloit, WI: Beloit College Press, 1995):

49-55; Andrew H Whiteford, "The Museum in the School" *American Anthropologist*

58 (1956): 352-356. Reprinted with additions in *Treasures of Beloit College:*

100 Works from the Logan Museum of Anthropology and Wright Museum of Art,

(Beloit, WI: Beloit College Press, 1995): 31-45.

3 Philip W Jackson, *John Dewey and the Lessons of Art* (New Haven: Yale University

Press, 1998).

4 Kiersten Latham, *Numinous Experiences with Museum Objects* (Ph.D. Diss.,

Emporia State University, 2009): 80.

5 Latham, *Numinous Experiences with Museum Objects*, 83. For more about

how people and objects interact and how "object knowledge" creates different

layers of meaning for people, see Elizabeth Wood and Kiersten F. Latham,

"Object Knowledge: Researching Objects in the Museum Experience"

Reconstruction: Studies in Contemporary Culture 9, no. 1 (2009).

6 Nina Simon, *The Participatory Museum* (Santa Cruz, CA: Museum 2.0, 2010): 127-129.

7 Amy Edmonds Alvarado and Patricia R. Herr, *Inquiry-Based Learning Using Everyday Objects* (Thousand Oaks, CA: Corwin Press, 2003); John Barell, *Problem-Based Learning: An Inquiry Approach* (Thousand Oaks, CA: Corwin Press, 2007); Rosalind Duhs, "Learning from University Museums and Collections in Higher Education: University College of London," *UMAC Museums and Collections Journal* 3 (2010): 183-186; Betty Lou Leaver and Jane R. Willis eds, *Task-Based Instruction in Foreign Language Education: Practices and Programs* (Washington, DC: Georgetown University Press, 2004).

8 Dorothea Laskey, "Learning from Objects: A Future for 21st Century Urban Arts Education," *Perspectives on Urban Education* 6, no. 2 (2009): 72-76.

9 Many models of object study have been advanced over the years. One recent addition was articulated by Pat Villeneuve and Ann Rowson Love in *From Periphery to Center: Art Museum Education in the 21st Century* (Reston, VA: National Art Education Association, 2007). Their model has familiar antecedents to students of material culture and while it was developed to guide inquiry-based art gallery education, at the Logan Museum we have adapted their model for the use of anthropological materials and other items of material culture as cultural prisms. Those familiar with their model will see similarities. To those unfamiliar with their work, I highly recommend it.

10 The ability to handle an object increases the potential for a deeper emotional experience and greater understanding of the object during this basic analysis. See Elizabeth Pye, ed. T*he Power of Touch: Handling Objects in Museum and Heritage Context*, (Walnut Creek, CA: Left Coast Press, 2007). Object handling by faculty and students is a museum policy question that needs to be addressed in the planning stage. It's my personal belief that while not every object should be

handled by students, with basic training in object handling and appropriate supervision, most objects in academic museums should be made available for students to handle. Feeling the weight and balance of an ancient tool or the texture of a contemporary textile in one's hand gives insight into the world of the maker or user that the most careful visual but non-tactile examination cannot.

11 I do an active-looking exercise with our undergraduates in the Logan Museum in which I ask them to closely examine our collection of Moche ceramics for two minutes without speaking. In the many times I have done this exercise not once has a student ever spotted the erotic vessel. The piece is not obviously sexual but it is easy to see that the "family scene" shown is very explicit. What is required is a reading of the scene that goes deeper than the immediate impression of dad, mom, and baby in bed. *Looking* is easy. *Seeing* takes practice.

12 Duhs, "Learning from University Museums and Collections," 183.

13 In addition, Mandan society is matriarchal. Asking the question, *What was its context?* in the course of object research connects the knife to a number of specific gender and family relationships and customs relating to property ownership. These themes were not a part of the Food and Culture assignment but are mentioned here to illustrate the wide range of cultural aspects that can be perceived through a single object prism.

14 For a longer discussion on implementing object-based course modules see Joe Cain, "Practical Concerns when Implementing Object-Based Teaching in Higher Education," *UMAC Museums and Collections Journal* 3 (2010): 197-200.

Bibliography

Alvarado, Amy Edmonds, and Patricia R. Herr. *Inquiry-Based Learning Using Everyday Objects*. Thousand Oaks, CA: Corwin Press, 2003.

Barell, John. *Problem-Based Learning: An Inquiry Approach*. Thousand Oaks, CA: Corwin Press, 2007.

Breitborde, Lawrence S. "Reading and Writing the Anthropology Museum." In *Treasures of Beloit College: 100 Works from the Logan Museum of Anthropology and Wright Museum of Art*, Beloit, WI: Beloit College Press, 1995.

Cain, Joe. "Practical Concerns when Implementing Object-Based Teaching in Higher Education." *UMAC Museums and Collections Journal* 3 (2010): 197-200.

Duhs, Rosalind. "Learning from University Museums and Collections in Higher Education." *UMAC Museums and Collections Journal* 3 (2010): 183-186.

Jackson, Philip W. *John Dewey and the Lessons of Art*. New Haven: Yale University Press, 1998.

Laskey, Dorothea. "Learning from Objects: A Future for 21st Century Urban Arts Education." *Perspectives on Urban Education* 6, no. 2 (2009): 72-76.

Latham, Kiersten. *Numinous Experiences with Museum Objects*. Ph.D. Thesis, School of Information and Library Management, Emporia State University, Emporia, KS, 2009.

Leaver, Betty Lou, and Jane R. Willis eds. *Task-Based Instruction in Foreign Language Education: Practices and Programs*. Washington, DC: Georgetown University Press, 2004.

Pye, Elizabeth, ed. *The Power of Touch: Handling Objects in*

Museum and Heritage Contexts. Walnut Creek, CA: Left Coast Press, 2007.

Simon, Nina. *The Participatory Museum.* Santa Cruz, CA: Museum 2.0, 2010.

Villeneuve, Pat, and Ann Rowson Love. "Rethinking the Gallery Learning Experience through Inquiry". In *From Periphery to Center: Art Museum Education in the 21st Century,* ed. Pat Villeneuve. Reston, VA: National Art Education Association, 2007.

Whiteford, Andrew H. "The Museum in the School". *American Anthropologist* 58 (1956): 352-356. Reprinted with additions in *Treasures of Beloit College: 100 Works from the Logan Museum of Anthropology and Wright Museum of Art,* Beloit College Press, Beloit, WI, 1995, pp. 31-45.

Wood, Elizabeth, and Kiersten F. Latham. "Object Knowledge: Researching Objects in the Museum Experience." *Reconstruction: Studies in Contemporary Culture* 9, no. 1 (2009).

EXHIBITION PROGRAMS

Living Worlds at The Manchester Museum

HENRY MCGHIE
Manchester Museum

This chapter explores the background, development and rationale of *Living Worlds*, a new type of natural history gallery which opened in April 2011 at The Manchester Museum. This is presented with special regard to the ways in which academic activities were built into the development and intended uses of the gallery. The museum is one of the largest non-national museums in the UK and is its largest university museum. It is particularly unusual among UK university museums as it includes both natural history/sciences and humanities subject areas. It has close links with academics throughout the University of Manchester and with academia more generally and is extensively used in the teaching of students in the University of Manchester, in the presentation and dissemination of faculty-based academic research through exhibitions and events, and as a social venue for university staff, students and their visitors. It is widely regarded as Manchester's civic museum in the traditional model and attracts around 350,000 visitors each year, mostly from the local area, including some 30,000 organised visits from schools and colleges. The museum serves a diverse local and regional audience and has a history of working in partnership with community members and special interest groups on a wide range of projects. Taken together, these features make it a particularly dynamic place where people are engaged with different disciplines and perspectives.

History, reinvention and positioning

The Manchester Museum developed as a place where students

of the Victoria University of Manchester could be taught using collections and displays. It has also been open to the public since 1890, has always had free entry and has a long history of educational provision for schools. The museum expanded through the 20th century and was extensively redeveloped during 1997-2003 to improve physical access through the disjointed Victorian and Edwardian buildings and to create new public spaces. These included a lecture theatre, conference suite and a publicly accessible Discovery Centre for close encounters with objects and for public and formal educational events. Collection storage was also extensively rationalized and collections were rehoused in significantly improved conditions. More recently, a Resource Centre was developed for visitors to undertake their own research based on collections and associated papers, while curatorial staff continue to facilitate visits to stored collections.

These physical rearrangements and developments formed part of a programme of redirection and rethinking of the museum's role, to become much more outwardly facing and to provide a high standard of services for its various users. This programme of change continues through continually evolving working practices and in response to a shifting external environment. The museum's context has changed enormously since redevelopment: it is part of the University of Manchester, an institution that was formed by the dissolution of the Victoria University of Manchester (formerly Owens College) and the University of Manchester Institute of Science and Technology in 2004. The University of Manchester is

now one of the largest universities in Europe and the largest single-site university in the UK, with over 10,000 staff and approximately 40,000 students from 180 countries. The museum is one of the cultural assets of the university along with the Whitworth Art Gallery, Jodrell Bank Discovery Centre, John Rylands Library and Martin Harris Centre for Music and Drama. These sit outside of the four faculties, making them especially interesting places where cross-disciplinary activities can be developed and presented for both academic and non-academic audiences.

The fundamental mission of the museum is to help its parent institution achieve its strategic vision, which is to be one of the top 25 research universities in the world by 2020. The university aims to be a place where all students enjoy a rewarding educational and wider experience, known worldwide as a place where the highest academic values and educational innovation are cherished, where research prospers and makes a real difference and where the fruits of scholarship resonate throughout society. The university has three core goals to achieve this vision, around learning, research and social responsibility. This last is a particularly strong element of the work of the University of Manchester and is championed from the highest level.

The museum and other cultural assets have a particularly strong role to play in helping achieve the university's ambitions in social responsibility and in providing unique learning experiences for students. The museum's activity falls within two main strands of work: "promoting understanding

between cultures" and "promoting the development of a sustainable world". Everything we do fits within one or both of these themes.

Approaches to topics

As a university museum, we see ourselves as playing a particularly important role in engaging our various audiences with – and in – contemporary debates and big issues facing society and the natural environment, using our world-class collections as a basis for programmes. These include the third largest natural sciences collection in the UK and some of its finest archaeological, Egyptological, numismatics and anthropological collections. The collection includes around 4.5 million objects and is formally designated as an outstanding collection. We have a wealth of academic expertise on our doorstep and specialist staff within the museum, both in terms of specialist curators and specialists in public engagement and formal learning. We always aim to handle topics in ways that are respectful and intellectually honest and do not shy away from difficult topics; and we aim to provide leadership in these areas within the sector. To give some recent examples, we have extensive experience of working with communities on the retention and display of human remains; in the representation of different viewpoints within temporary exhibitions and galleries; in the presentation and interpretation of biological evolution, and in new approaches to collecting.[1]

Working with our audience is, of course, of paramount importance. Approximately 40% of our audience come in

mixed age family groups, while the remaining 60% consists of adults. Only a minority of visitors possess specialist knowledge or interest. We acknowledge that visitors (and other museum users) have different motivations, previous experiences, interests and abilities and learning styles.[2] Rather than an old-style museum which tried to tell you what you should think, to us it is more important that visitors are encouraged to think for themselves. Our exhibition practice is based around trying things out, including the familiar with the unfamiliar; we aim to introduce innovation in the way topics are selected, explored and presented. This requires intellectual and professional confidence that we are doing things for the right reason: promoting deeper understanding and reflection, and contributing positively towards visitors' quality of life. We take it for granted that dearly-held museum traditions are not the only way of doing things. Sometimes we may need to do things radically differently in order to engage our audiences with topics and discourses in different or new ways, and to break out of ruts.

Living Worlds: environmental sustainability and museums
The Manchester Museum has extensive natural history galleries in the traditional mode and enormous stored collections in zoology, entomology, botany and earth sciences – some 3.5 million objects. The natural history galleries are situated in the original museum building, designed by architect Alfred Waterhouse and with Grade II* listed status. These are certainly some of the finest examples of their type, with beautiful Gothic

Revival architecture, display cabinets and metalwork. Until recently the displays were rather standard classifications of the natural world. In the Mammal Gallery (now *Living Worlds*), for example, all the Cats were together, as were all the Primates; other, less well-known groups (the Even-toed Ungulates) were similarly co-located. The original Waterhouse fabric had been added to piecemeal with the insertion of additional cases; dioramas were added when the gallery was last redisplayed in the 1980s. This approach had become problematic for us as it offered limited scope for visitors – or us – to explore contemporary topics relating to the natural environment, such as biodiversity and its conservation, climate change and human relations and interactions with the environment.

A funding opportunity arose in 2008 through the *Raising the Game* funding programme from the Northwest Development Agency, aimed at raising the profile and standard of Manchester's cultural offer. We were successful in attracting funding to redisplay the much-loved, but out-of-date Mammal Gallery, as well as for other projects. Additional funding to redevelop the Mammal Gallery came from the DCMS/Wolfson Museums and Galleries Improvement Fund.

There is a well-established disarticulation between the popularity of nature (as demonstrated through the number of television programmes on nature) and the low level of awareness or confidence in engaging with environmental sustainability debates and activities. In terms of natural history museums, displays are often disengaged from topics that are widely reported in the media or in the schools' curricula.[3] The

key objective of our project was to transform the traditional Mammal Gallery to become a fit-for-purpose exhibition that made a positive contribution to people's lives and to the natural environment.

Developing the project

The strap-line and core guiding principle for the gallery was that it was "about the natural world and people's relationships with it", referring to people both as individuals and collectively. From the earliest stages, we wanted to show that the world is full of amazing things; that living things are interconnected and interdependent; that we each relate to nature in different ways; that human actions can have a negative impact on the environment; that the choices we make have an effect on the natural world, and that our individual actions count.

We imagined an installation that revealed the beauty of the original architecture and interior (which had got somewhat lost in 20th century additions). We wanted to work with the charismatic atmosphere of the gallery and to make a radical, modern insertion that enhanced the existing interior, and included objects individually, grouped and in mass displays. Ultimately, we wanted to produce a stunning, unique experience that provided a positive experience for visitors.

Three pieces of work were fundamentally important in developing the project. The first was based around work by leading environmentalist Stephen Kellert of Yale University. He established a typology of nine basic human attitudes to nature based on surveys and questionnaires (Figure 1).[4] This

work has been used extensively to explore attitudes between different [human] age groups,[5] genders[6] and cultures.[7] This work can be a powerful tool for developing activities relating to the environment where people are in mixed groups or come from different backgrounds and interest groups typical of a museum setting. The work has not been used in a museum setting previously to my knowledge.

Secondly, we were heavily influenced by concerns relating to mobilising people in the face of potential "bad news" stories. It has been articulated by Swaisgood and Sheppard that "there is a continuing culture of hopelessness among conservation biologists... that will influence our ability to mobilize conservation action among the general public."[8]

Thirdly, as we were interested in supporting people to participate with nature, we were influenced by work that promoted behaviour change, notably a piece of work by Futerra, a London-based sustainability communications agency, which developed messages relating to biodiversity as part of the 2010 International Year of Biodiversity initiative.[9] We were in full agreement with Futerra's argument that "people will protect nature because they want to, not because they have to." We adopted the *five ways to well-being* as a device for developing messages and ideas, based on a piece of work by the New Economics Foundation.[10]

If our project was to be successful, we recognised that we would need to engage with visitors on an emotional level. Our funding came with relatively few strings attached, except that we should attract greater numbers of visitors from outside

Attitude	Primary interest
Naturalistic	Primary interest and affection for wildlife and the outdoors.
Ecologistic	Primary concern for the environment as a system, for interrelationships between wildlife species and natural habitats.
Humanistic	Primary interest and strong affection for individual animals, principally pets. Regarding wildlife, focus on large attractive animals with strong anthropomorphic associations.
Moralistic	Primary concern for the right and wrong treatment of animals, with strong opposition to exploitation of, and cruelty towards, animals.
Scientistic	Primary interest in the physical attributes and biological functioning of animals.
Aesthetic	Primary interest in the artistic and symbolic characteristics of animals.
Utilitarian	Primary concern for the practical and material value of animals.
Dominionistic	Primary satisfactions derived from mastery and control over animals, typically in sporting situations.
Negativistic	Primary orientation an avoidance of animals due to indifference, dislike or fear.

Figure 1: Kellert's attitudes to nature.

the region and introduce innovation. These two factors were of key importance in the selection of designers. From a large number of British and European design firms, we selected villa eugénie, a Brussels-based design and events company. They have an excellent track record of staging spectacular events as part of art and fashion shows, and work primarily with major fashion houses. They had never undertaken a museum gallery

design before but were chosen specifically for their expertise and potential in creating dramatic, visually-spectacular spaces. Importantly, of all applicants they demonstrated the greatest level of innovation and had a clear understanding of the museum's position, in terms of the traditions of the listed building status and our intended aims about transforming ourselves into a new type of museum. They also had a very clear corporate commitment to environmental sustainability which was important in the selection.

From the beginning, we knew that the gallery would include objects from our enormous collection, including many of the old favourites from the previous gallery such as a mounted Polar Bear and Tiger, and a Sperm Whale skeleton. These would be interpreted by museum staff, who led on the development of content, themes and groupings. They were to be presented in the transformed environment, sensitive to the listed status of the building, to produce a fantastic new exhibition space; this work was driven by villa eugénie. Of course, the interface between these two aspects was developed through close negotiation and discussion between museum staff and the designers. The project was led by myself in terms of aims, topics and content; the head of exhibitions navigated the interface between museum-led work and work with the designers; the head of learning and interpretation helped shape aims and themes; the director acted as client, and project management was provided by the university. Specialist natural sciences curators were responsible for researching content stories and objects. Each story needed to

relate to one of the six main messages outlined above, to relate to a particular Kellert attitude to nature, and to be capable of being illustrated by objects in the collection. Museum staff engaged in schools learning, public events and day-to-day visitor services provided input in terms of what would work for visitors. I also worked closely with a large number of University of Manchester academics, and with local and national partners in the development and shaping of content.

From an early stage we moved away from concentrating on repeating negative, sometimes shocking, facts about the state of the environment which people are generally all too familiar with from the mass media. Instead, we focused more on individual behaviour and attitudes to nature, as a way in to engaging and, hopefully, inspiring visitors during their visit – and encouraging them to get involved with nature on their own terms after their visit. We wanted to take people beyond thinking of the environment as a series of issues (as often presented in the media) and, instead, to connect their lives with nature for their own health and well-being as much as for the good of the environment.

The project developed to concentrate on what was likely to achieve the maximum benefit after visitors left the museum, which was a step change for us. What visitors did during their visit became a means to an end, rather than an end in itself. We wanted to connect with people's lives, before, during and after their visit, supporting and encouraging them to engage with nature. We envisaged a gallery that grabbed visitors on first entering the space, when they were *spectators*. Within a short

time, we envisaged them becoming *selectors* of content, which would be developed to appeal to a broad range of interests and attitudes to nature. Then, we saw visitors becoming *participants*, exploring things that appealed to them and engaging with museum staff and other visitors. And, finally, we hoped that visitors would become *activists*, hungry for information and keen to get more involved with nature, having been stimulated by their experience in the museum, and by thinking and talking with other people after their visit about their experience.

Design direction

Through discussion with museum staff, villa eugénie developed a design direction to meet our aims, and one which would address the potential tension between the museum's listed and historic status with our desire that it should build its contemporary relevance. They developed a direction based on six principles:

Tradition

- To use the original and traditional elements of the museum while showing them to visitors in a new way.
- The displays would be poetic as well as informative, developed as works of art and presented to the highest standard, with light playing a major role in the design.

Technology

- Technology would not be an end in itself but a means of delivery.
- The hardware would remain unobtrusive, almost

invisible to the visitor.
- Smartphone technology would be used to deliver content.

Interactivity
- Each visitor should be able to construct their own unique visit.
- Interactivity would be optional and responsive rather than mechanical.
- The gallery should create a leisure-park effect, inspiring visitors to make return visits.

Futurism
- Cutting-edge technology would be used in ways that would ensure it was not out-of-date too soon after opening.

Sustainability
- To emphasize the central message of the exhibition: that the choices we make impact on the natural world.
- To make the display with as low a carbon foot-print as possible.

Sensory experience
To give visitors a multi-sensory experience.

Staying relevant and building relevance
Both the designers and we were very keen that the gallery

Figure 2: The smartphone app that accompanies Living Worlds, *showing information about a particular object (a mounted Tiger) and links to images of living Tigers from ARKive.*

was not filled with text and focused instead on presenting a clean, clear message, with supplementary information and suggestions for activities to get involved in. With a gallery that is to be in place for ten to fifteen years, one of our greatest challenges was to find a way that the display could stay contemporary and relevant. We had some top-line messages that we wanted all visitors to encounter so these were presented as text panels that accompanied – but did not interfere with – installations. The designers wanted to tap into developing technologies that would put the latest information at visitors' fingertips, connecting with the enormous amounts of information available outside the museum, notably on the internet. The detailed information about individual objects, which could potentially dilute the most important

messages, was taken out of the cases and was delivered via a specially developed smartphone app (Figure 2) and in ring-binder folders for those not wishing to use technology. The app was developed for iPad, iPhone, Android tablet and Android smartphone (*Living Worlds*, free for download for these devices). Tablets were to be available in the gallery, with the added bonus that if visitors had their own smartphone or tablet, they could download the app for free and continue to explore the gallery after their visit, or even without ever visiting the museum. The app was developed in partnership between villa eugénie, ourselves and Mubaloo, a leading app developer based in Bristol.

As we wanted to be able to continue to modify the information on the app over time, we developed a new interface with the museum's collections management system, KE EMu. The app interfaces with KE EMu via the internet (there is free superfast Wi-Fi in the gallery) in order to retrieve object-specific information, links to activities to take part in, sources of further information and to films on YouTube. We were very fortunate to develop a working partnership with ARKive, described as "the ultimate multimedia guide to the world's endangered species"." Intellectually, this connection to the outside world was very important as we never intended to show the specimens as if they were real animals, but to connect visitors to nature using our collection. Working with ARKive via the app gave us a different way to connect visitors with living animals. Information on each object was entered onto KE EMu and was presented as a story about why that particular

object fitted into the narrative of the display case. This was accompanied by information about the history and origins of the object itself, which often meant saying that it was shot. We felt it was important to be honest about the history of the objects in the collection and where they came from, rather than attempt to play this down. The app serves a very important role in signposting visitors (and other app users) with a *What's Next* section, to either *Find out more* or to *Get involved*.

We were keen that people should feature in the gallery, but were conscious that they did not appear in the displays themselves and we were reluctant to complicate the display with screens. Instead, we decided that text panels would be authored by relevant people, many of whom were University of Manchester academics. Each panel contained a top-line message of up to 200 words, which was the authored element. This was accompanied by subheadings which gave a couple of sentences on what each display was about and, lastly, provided some detail about what the objects were. To us, the most important thing was that visitors encountered as many of the top-line messages as possible, rather than getting embroiled in the detail of object information; there are no object labels in the display cases. We are also currently developing a series of films about people who reflect particularly strong attitudes or values towards nature, with funding from the HLF *Nature and Me* project.

Realisation

The designers developed a gallery space that is visually

Figure 3: Living Worlds - *neon case headings help orientate visitors.*

stunning and which has completely transformed the museum's natural history displays (Figure 3). During the first phase of redevelopment, the original gallery was revealed by removing display cases that had accumulated through the 20th century. After an extensive analysis of the historic paint, the original display cases were stripped back and ebonized to restore them to their original appearance. Additional work to the original terrazzo floor (much of which had been covered by display cases added during the last century) and to the metalwork of the railings and staircase, revealed much more of Waterhouse's original architecture. Windows, which had previously been covered by unattractive curtains, were boarded up to provide additional display space. These works created an atmospheric stage for villa eugénie's spectacular design. They developed a space that is very dark and which uses dramatic lighting effects to pick out specimens, with the aim of generating a sense of wonder, in order to connect with people emotionally and engender a sense of the value and preciousness of the objects on display, and of the importance of the topics being

Figure 4: Domination *display, exploring how animals have been killed by people out of fear and admiration. Note the absence of labels from the case.* © Ant Clausen.

explored. The construction of this new setting had minimal environmental impact, being based around the existing structure; boarding of windows also saves a great deal of energy as the windows are single-glazed; LED lights are used in cases, again reducing energy costs and emissions.

Thematically, each display case has been developed to connect with a contemporary topic and Kellert attitude. Together, the cases reflect a range of environmental topics and human approaches to the natural world, illustrating the main messages of the gallery outlined earlier. Some cases are more people-focused, some more nature-focused, but each one explores the inter-relationship between the two. The gallery's multi-faceted approach includes some displays based on massed objects; others take a small number of carefully selected objects to produce highly poetic and evocative displays;

Figure 5: Peace *display, juxtaposing a piece of rubble from Hiroshima with a mounted crane and hundreds of origami cranes, international symbol of peace.*

others incorporate unexpected, playful treatments (Figure 4). Each case is treated differently, whether with images, props or the use of additional technologies. Each case can be used on its own to explore an individual subject. While large themes, such as climate change, can be explored across many of the displays: how people use resources, disasters, the weather and the variety of life (each element forming a separate installation). To take one example (Figure 5), a mounted crane and a piece of rubble from Hiroshima collected in 1947 are juxtaposed, accompanied by the story of Sadako Sasaki (1943-55), who was affected by the Hiroshima atomic bomb as a young girl. She and her friends tried to fold a thousand paper cranes to grant her wish to be well again. This story is told to show how nature can help people try to come to terms with personal difficulty, and to demonstrate the terrible effect that people can have on

one another and on the environment. The installation is called *Peace*, and includes 1,000 origami cranes, the international symbol of peace.

Topics that were of greatest importance in delivering the central messages of the gallery were placed in the "warmest" parts of the gallery: those with most energy in terms of how people select and approach them. More contemplative topics, which we wanted people to treat respectfully, were placed in the quieter, "cooler" parts of the gallery (away from the entrance and opposite the warmer areas). We were particularly keen that a human skeleton and a display containing a cast of a woman killed at Pompeii were in these quieter areas. The central case, at one end of the gallery, presents the single most important message, *Connect*, encouraging people to connect with nature and with their surroundings, and to connect their choices with the consequences of those choices. Topics that dealt with deep time were placed at the far end of the gallery; contemporary topics occupied the central section; and topics about now and the future were placed at the front end of the gallery. Visitors to *Living Worlds* could readily find out what each case was about, as the designers used large neon signs on the top of each case, so that visitors could easily select which installations to view. Visitor services staff are available to assist visually impaired visitors. (See Figure 6 for a summary of *Living Worlds'* displays.)

Programming and satellite projects
Living Worlds opened to the public on 14 April 2011. Since then it has been the springboard and focal point for a comprehensive

programme of family and adult public events, many of which are developed in partnership with, or with the involvement of, University of Manchester academics, and has also been used extensively by lecturers and students. Around 80% of the museum's visitors experienced the gallery in its first year, contributing to a significant overall increase in visitors to 350,000. A temporary allotment was developed in front of the museum, where people can learn how to grow vegetables and appreciate where their food comes from.

The *We are extInked* exhibition presented the work of people who had been tattooed with illustrations of endangered species and had become ambassadors for the conservation of those species, a project that resonated with the central messages of *Living Worlds*.

The gallery has provided the opportunity for some significant public and policy-related discourses: the Academy of Medical Sciences and the Institute for Science, Ethics and Innovation (iSEI, part of the University of Manchester) held *Human bodies: animal bodies* in *Living Worlds* in November 2011 – a discussion about the opportunities and implications of biomedical research involving the combination of human and animal cells and DNA. Another discussion, on a completely different topic, was the *Climate Change Question Time*, held in *Living Worlds* in February 2012 and including a panel of leading experts, including University of Manchester academics, involved in climate change policy work. A number of new educational sessions for schools make direct use of the gallery, which is much easier than previously as topics are more aligned

with the National Curriculum – *The Museum of Mystery*, a web-based interactive, encourages users to explore evidence and some of the topics of the gallery.[12] Final year BA photography students developed their portfolio projects around the themes of *Living Worlds* in 2011, which were exhibited as their final year show. A Foundation Year photography student produced a photographic archive of the project. A practice-led PhD project included an examination of the changing display of particular taxidermy specimens, developed as a film of the movement and installation of the specimens. *Living Worlds* is increasingly used in undergraduate and postgraduate teaching and some course modules are intended to make use of, and contribute to, the development of the content on the accompanying app. *Living Worlds* also helps articulate the university's institutional commitment to sustainability.

A success?

From the outset, we wanted to do something that was radically different, to develop a new type of natural history display. Working with the creative industries ensured that our project would be an innovative one and this has certainly been achieved, combining innovative approaches to the interpretation of the natural environment driven by the museum with innovative approaches to presentation of natural history displays driven by villa eugénie. This required a risk-taking approach. One journalist wrote:

Change is a word that most of us are a little bit scared of,

especially when it comes to messing around with things that remind us of childhood. There probably isn't a kid in Greater Manchester who, on a day off from school or even on a class trip out, hasn't set foot in Manchester Museum's famous Victorian Animal Life gallery... It surprised some, then, to hear that one of the most beloved areas of Manchester Museum was to undergo a £400,000, two-years-in-the-planning, radical overhaul...[13]

Intellectually, the project was always centred on the experience of the individual visitor, not necessarily of the "traditional" museum visitor, and on achieving our aims of improving the lives of visitors and promoting a safe and healthy natural environment. I maintain that these aims are the right ones to have, and if something isn't working in the museum to meet these, then it needs to change. Through the process, considerable effort went into communicating and articulating the project and its aims to museum staff, so that they understood what we were trying to achieve and why it was the right thing to do.

Formal evaluation of *Living Worlds* has been undertaken in a variety of ways, including visitor surveys and other feedback, by structured observation and by monitoring the use of the app, notably through a bespoke evaluation of 308 visitors by a placement student from Reinwardt Academy, Amsterdam. Results demonstrate that 89% of visitors viewed the redevelopment of the gallery as a success, which is extremely positive given that it is undoubtedly a radical change. Most

visitors (83%) considered it to be inspiring and a similar number (84%) considered it to be accessible. A significant proportion of visitors (37%) said they were more likely to get involved with activities relating to environmental protection as a result of their visit.

Selected visitors' comments:

- The new gallery is amazing, I recommended it to all my friends. I found it a very emotional experience and after being in the space for just a few moments knew it would become one of my most favourite places and I will return again and again.
- I am dyslexic and respond to visual learning and found this was interesting and strait [sic] away I could understand it. (Written about the *Humans* display)
- Moved me to tears.

The new gallery has also enjoyed highly positive peer review. One reviewer in *Museums Journal* commended the redisplay as "an ingenious and arty revamp... new displays work beautifully within a very elegant and practical Victorian ambience, rather than fighting against it".[14] An editorial noted how, "It must be tempting to go for a 'safe pair of hands' when choosing a design company for a big project, but this can sometimes lead to mediocre galleries that could be anywhere. There are exceptions, of course. Manchester Museum's *Living Worlds* gallery is a playful and inspired redisplay of its natural history collection".[15] *Living Worlds* was shortlisted for the Museums +

Heritage Permanent Exhibition Award 2012 and in the Design Week Awards 2012, having been submitted in the Exhibition Design category.

The take-home message from the project is that taking the plunge can be worth it. We have managed to break out of the mould and connected our aspirations to our visitors in terms which matter both to them and to us as a university museum, with the aim of meeting some of the big issues that face society.

Figure 6: Living Worlds' displays

Installation	Topic/story
Connect	See the connections in the world, between ourselves, our choices and the natural world.
Domination	Control of nature through fear and admiration.
Symbols	Importance of nature in our lives as symbolising things.
Peace	Importance of nature in helping people deal with personal difficulty.
Disasters	Nature can be threatening, and people can cause disasters.
Experience	Some animals are thought to be beautiful, childish or scary.
Experience (2)	People have observed the natural world.
British Wildlife	British wildlife has changed over time, for good and bad.
Humans	We are connected to nature by shared ancestry.
Bodies	Animals' bodies are shaped by adaptation.
Life	Life is amazing.
Weather	The climate has changed and is changing because of people.
Resources	Everything we use comes from nature
Variety of Life	There is a wonderful variety of life

Contents	Text panel author
Three dioramas, of mounted British predators, jungle animals and a Polar Bear (presented against images of habitats)	Museum
Mounted trophy heads and Tiger, Elephant tusks (presented with trophy photographs)	Museum
Mounted Eagle, Lion, Snake, Swan, Story and Bees, accompanied by images and objects showing them as symbols	University of Manchester (U of M) social anthropologist, Sharon Macdonald
Mounted Crane and piece of rubble from Hiroshima (presented with a thousand origami cranes)	Sadako Sasaki, victim of the Hiroshima atomic bomb
Plaster casts of woman and dog killed by volcano at Pompeii (presented against backdrop of image of lava)	U of M geographer, Richard Huggett
Mounted Peacock, Sun Bear, 'baby' Elephant, Wolf, Spider, Rat and Skunk (presented with images of cultural associations)	Museum
Collections of insects, minerals, display of mounted garden birds, glass lantern slides	Museum
Mounted animals and plants reflecting conservation successes, effects of farming, introductions, and the importance of UK wildlife (presented against images representing each topic)	Manchester City Council biodiversity manager, Dave Barlow
Skeletons of a Human, Gorilla, Chimpanzee, skulls of Primates and fossil Humans	Museum
Skeletons of birds and mammals	U of M animal physiologist, Holly Shiels
Specimens representing life (giant egg), growth (slice of wood), eating (shark jaw), movement (Hummingbirds), death (Dodo head)	U of M evolutionary biologist, Prof. Matthew Cobb
Coal, fossils of tropical and cold climate animals from Britain, species undergoing changes at present (presented against giant map and with LED displays with facts about climate change)	U of M atmospheric scientist, Lorenzo Labrador
Species we used and affect by our uses, eg. mounted sheep wearing a woolly jumper (showcase fitted out as inside of an apartment)	U of M sustainability researcher, Joanne Tippett
Species that have become extinct; species that are being conserved, and species whose future is uncertain	Museum

NOTES

1 Henry A. McGhie et al. (2010), Bryan J. Sitch (2010), N. Merriman (2012).

2 Henry A. McGhie et al. (2010).

3 eg. Jim A. Secord (1996).

4 Stephen R. Kellert (1985).

5 Stephen R. Kellert (1985).

6 Stephen R. Kellert and Joyce K. Berry (1987).

7 Stephen R. Kellert (1993) see also Stephen R. Kellert (1996).

8 Ronald R. Swaisgood and James K. Sheppard, "The culture of conservation
 biologists: show me the hope!" *BioScience* 60(8) (2010): 626.

9 http://www.futerra.co.uk/downloads/Branding_Biodiversity.pdf
 [accessed 25th April 2012].

10 http://www.neweconomics.org/projects/five-ways-well-being
 [accessed 25th April 2012].

11 http://www.arkive.org [accessed 25th April 2012].

12 http://www.museumofmystery.org.uk [accessed 25th April 2012].

13 http://www.citylife.co.uk/news_and_reviews/news/10019305_manchester_
 museum_unveils_new_living_worlds_gallery [accessed 25th April 2012].

14 *Museums Journal*, June 2011: 40-43.

15 *Museums Journal*, Sept. 2011: 4.

ACKNOWLEDGEMENTS

I am most grateful to the director, Nick Merriman, for having faith and confidence that we were doing the right thing and for giving me the opportunity to work on such a wonderful project. I am particularly grateful to Jeff Horsley, Pete Brown and Stephen Booth for helping to bring *Living Worlds* to life. I am similarly grateful to villa eugénie, especially to Etienne Russo, Melody Goethals, Lauren Drablier, Inge Gelaude and Anne-Sophie Prevot for challenging us to think differently and for bringing our project to life. I am also grateful to KE EMu (Manchester), to Mubaloo, notably Louise Sturgess, and to ARKive for helping develop our app and its content. I am very grateful to David Gelsthorpe, Dmitri Logunov and Leander Wolstenholme for help in researching content for the gallery and the app, and to conservators, technicians, and curatorial assistants Judith White and Susan Martin for help in preparing specimens, mounting and installation. I am grateful to Dorota Kawęcka of Reinwardt Academy (Amsterdam School of the Arts) for undertaking the evaluation as part of her Masters in Museum Studies. I continue to be grateful to museum colleagues who develop activities and events linked to the gallery and to its aims.

References

Kellert, Stephen R. "Attitudes toward animals: Age-related development among children." *Journal of Environmental Education* 16 (1985): 29-39.

Kellert, Stephen R. "Attitudes toward wildlife among the industrial superpowers: The United States, Japan, and Germany." *Journal of Social Issues* 49 (1993): 53-69.

Kellert, Stephen R. *The Value of Life*. New York: Island Press, 1996.

Kellert, Stephen R. and Joyce K. Berry. "Attitudes, knowledge, and behaviors toward wildlife as affected by gender." *Wildlife Society Bulletin* 13 (1987): 363-371.

McGhie, Henry A., Pete Brown and Jeff Horsley. "Dealing with Darwin." In *Science Exhibitions: communication and evaluation*, edited by Anastasia Filippoupoliti, 412-445. Edinburgh: MuseumsEtc., 2010.

Merriman, Nick. "Transforming the University Museum: The Manchester Experience" in *A Handbook for Academic Museums: Beyond Exhibitions and Education*. Edinburgh, MuseumsEtc., 2012.

Secord, Jim A. "The Crisis of Nature." In *Cultures of Natural History*, edited by Neil Jardine, Jim A. Secord and Emma C. Spary, 447-459. Cambridge: Cambridge University Press, Cambridge, 1996.

Sitch, Bryan J. "Consultation or Confrontation: Lindow Man, A Bog Body Mystery." In *The New Museum Community: Audiences, Challenges, Benefits*, 366-386. Edinburgh: MuseumsEtc., 2010.

Swaisgood, Ronald R. and James K. Sheppard. "The culture of conservation biologists: show me the hope!" *BioScience* 60(8) (2010): 626-630.

Setting the Table:
Creating Communities of Awareness
Around Eating Disorders

LAURA EVANS
University of North Texas

- One out of four college-aged women are clinically diagnosed with an eating disorder each year.[1]
- 91% of college-aged women are dieting at any given time.[2]

When *THIN*, an exhibition of photography addressing the social problem of eating disorders, toured the United States from 2008-2010, it traveled only to university art museums. Lauren Greenfield, the curator and photographer, and the museum staff decided that university museums would be the best forum for exhibiting *THIN*; statistics like those above offer a compelling reason why. However, the questions of how these museums handled such a socially important topic and how their audiences responded, are both more intriguing and important questions for the museum community to ask. This exhibition had the potential to be socially educative, to influence viewers, to create communities of change, and to encourage these groups and individuals to take action against eating disorders. But the impact of the show ultimately depended on how these university museums chose to engage with their visitors and with *THIN*.

In this chapter, I examine how visitors experienced *THIN* at the University of Notre Dame and at Smith College. At each site, the public was encouraged to write comments about *THIN* in a logbook. I analyzed each logbook, looking specifically at visitors' remarks about how community learning was a part of the exhibition and how this was done within a university context. In addition, I have provided an in-depth account of how *THIN* was exhibited in these two museums and how this

changed the university community.

The exhibition
The exhibition *THIN*, curated by Trudy Wilner Stack and the
world-renowned photographer Lauren Greenfield, exposes
the ugly underbelly of eating disorders to the public by way of
large-scale portraits, documentary photographs, art, journals,
interviews, video, and narratives from the show's subjects: in-
patient eating disorder victims at the Renfrew Center, a Florida
hospital dedicated solely to eating disorders. Greenfield and
Trudy Wilner Stack began touring *THIN* in February of 2007
at the Women's Museum in Dallas, Texas, an affiliate of the
Smithsonian Institution which closed its doors in the fall of
2011. The exhibition traveled to university art museums until
2010, visiting the Smith College Museum of Art, the Snite
Museum of Art at the University of Notre Dame, the University
of Missouri, and the University of Utah. *THIN* follows in the
wake and popularity of *Girl Culture*, Greenfield's first touring
exhibition of photographs which helped to raise awareness of
body image issues in America.

Objectives
In this chapter, I look at how visitors to *THIN* experienced
the exhibit, and how they commented on their encounter
with the art, the museum, and with others at the university.
The hundreds of visitors who chose to leave a comment left
their imprints in logbooks located at the exit of the various
exhibition spaces. I have chosen two sites to analyze (the Smith

College Museum of Art and the Snite Museum of Art at the University of Notre Dame) and, thanks to accommodating staff at both locales, have copies of each logbook.

My research questions are born out of museum and educational theory about the importance of university museums in supporting the growth of communities (learning and social groups of individuals and groups). Specifically, I ask: Was there community learning and sharing at work at the Snite Museum of Art and the Smith College Museum of Art? Did the exhibit and its place in the university museum encourage visitors to make connections between themselves and others and to their own self?

Museums and eating disorders: what does THIN have to gain in a university setting?

One of the more unique aspects of *THIN's* tour across the country is that it was only exhibited at university art museums. Considering that one out of four college-aged women will be clinically diagnosed with an eating disorder, and that one out of three of this same population has "disordered eating," [3] the choice for *THIN* to be shown to the population who seem to need it most could hardly be considered an accident. When 91% of women surveyed on a college campus are dieting,[4] it seems that any attempt at reaching out to a small segment of these women would be beneficial and socially educative.

University art museums are unique spaces because they are balanced between the public and the private concern. With commitments to art, education, the university, and

the community where it is situated, and likewise with the concomitant variety of obligations and types of patrons, the university art museum has a challenging role. Yet little research has been done in the field of museum studies about university art museums, which makes them a rich area for more investigation.[5] Each university museum has its own tale of creation, its own storied collection, and its own delicate balancing act between its many purposes: a study center, a community gathering place, a research institution, a social space, and more. The university art museum, at its best, can be a "nexus for collegial interactions and interdepartmental inquiry" as well as a vortex for the public community, those not associated with academia.[6]

At the Smith College Museum of Art and the Snite Museum of Art, I looked specifically at whether the museum and exhibit have encouraged communities of learning and caring at the university. Hopefully, it will benefit future university art museum educators who plan to have socially impactful exhibitions that reach out to their student populations, and to those beyond.

Community learning and art museums

Community learning is a relatively new area of study for museums, with a comparatively short history in the field of museum education. Outside luminaries like Cooley,[7] Mead,[8] Dewey,[9] and Vygotsky[10] have influenced how museum educators view group learning and integrate social dynamics into the museum experience.[11] Dewey, besides advocating for

education with a social purpose, also wrote eloquently about how collective issues required an engaged community of minds and bodies. Within the field of museum education, John Falk and Laura Dierking have created a three-part Contextual Model of Learning where socio-cultural context plays a leading role in how visitors make meaning at museums.[12] According to Dierking, socio-cultural learning occurs on individual and group levels so that many different, yet connected, communities are joined in a community learning experience.

Joan Jacobs Brumberg,[13] one of the most prominent scholars of the day on girl culture and eating disorders (she also wrote the introduction to the *THIN* catalog), has noted the decline in the number of women's community support networks and the increase in eating disorders. During their period of great popularity between 1880 and 1920, single-sex organizations acted as "protective umbrellas" where young women could learn from other, older women in a safe, inter-generational environment that emphasized keeping girls "wholesome and chaste." [14] Thousands of young ladies between the ages of 10 and 18 spent time each week learning from and interacting with other girls and female leaders in such groups as the Girl Scouts of America, the Young Woman's Christian Association, and the Camp Fire Girls. These organizations are still woven into the fabric of American society, but to a much lesser degree than they once were. Equally and fascinatingly, eating disorders were practically non-existent at this time. Is there a correlation between strong female role models and protective, safe, community organizations for girls to learn about what it

means to become capable and complete women? As Brumberg writes, "most of all, this 'protective umbrella' meant that girls had many projects – other than their own bodies – to keep them busy and engaged." [15] Brumberg asserts that these protective organizations were successful because they all involved intergenerational mentoring (a form of facilitated mediation[16]) and community learning (intercultural exchange, sociocultural learning, or within group learning[17]):

> *Adult women were the most important part of the protective umbrella that spread over school as well as extracurricular activities. Whether Christian or Jew, black or white, volunteer or professional, most women in this era shared the ethic that older women had a special responsibility to the young of their sex. This kind of mentoring was based on the need to protect all girls, not just one's own daughters...* [18]

Can university museum educators and exhibits like *THIN*, act as protective umbrellas, or communities of support, for today's young women who do not have the support networks that their great-grandmothers relied upon to keep them buoyed against negative body image? In this way, could and did these university museums and *THIN* encourage inter-group dialogue about eating disorders, build strong communities of support, and help to move visitors towards positive change? By looking at visitors' comments from Smith and Notre Dame, we can have a better idea if they positively impacted people in this way.

Explanation of analysis

The visitor logbooks are invaluable documents. They chronicle the voices of visitors to *THIN*, and through them we have a glimpse into their experiences. In the following segment, I reflect upon the musings of these visitors, whom I know only through their stark black words on clean white paper. I will connect the visitors' comments to the larger issues I discussed in the introductory section to this chapter, those of the importance of the university museum in encouraging and promoting communities of learning and support.

Over 200 visitors (203, to be precise) felt moved to write a comment in the Smith logbook, and almost 190 (188 by my count) did so at Notre Dame. No doubt, many hundreds more visited but chose not to leave a remark. From those that did, we have a wealth of rich, thick, and heartfelt words that share a piece of each visitor's experience. Of those who left comments, 45% at Smith and 30% at Notre Dame felt compelled to write a form of thank you: to the museum, to Greenfield, to their university, to the women in the exhibit, or to any number of things. I think the amount of gratitude in the logbook speaks volumes about the nature of these museums and *THIN* to educate, move, and expand its visitors. Maybe there are an abundance of polite people at Smith and Notre Dame, but I would also assume there are a number of discerning people at these institutions who are not cavalier about giving thanks. A visitor from Notre Dame summed up the extensive list of thank you notes by simply stating, "Thank you for using art to talk about this prevalent problem in society." [19] Personally,

I am thankful that so many people saw fit to give thanks for a museum and an exhibit that moved them to acknowledge their gratitude.

Visitor comments on community

John Dewey believed that community learning occurred when an engaged group of minds and bodies came together over a collective issue.[20] His work, along with those of other educational theorists, greatly influenced museum educators and their views on social dynamics and group learning.[21] With the advent of museum studies, other museum and educational theorists have looked specifically at how group learning occurs in these spaces,[22] but there is still relatively little research about how such a rhizomatic process occurs.

As mentioned, Joan Jacobs Brumberg,[23] cites that eating disorders have become so prevalent, so quickly, because young women have not had the support of protective organizations. Without them, young women have desperately lacked opportunities for intergenerational mentoring (a form of facilitated mediation[24]) and community learning (intercultural exchange, socio-cultural learning, or within group learning[25]). According to Falk and Dierking, museums (I would argue that this applies especially to university museums) can provide such things through carefully planned exhibits, outreach, and education. In this section, I will ask: Did the Snite Museum of Art and the Smith College Museum of Art encourage inter-group dialogue about the subject of eating disorders, promote communities of support, and help move visitors move towards

positive change through sociocultural learning?

After mining the visitor comments for hints of how people learned about the exhibit, I can see why community learning is still a relatively new field in museology. It is difficult to find traces of how learning occurred in an anonymous person's writing. Unless responding to a questionnaire, I do not think the average person would write a comment about their process of making-meaning at an exhibition. So, instead of searching for direct and obvious hints, I looked instead for evidence of interactions with others within the space of the university museum.

At both Notre Dame and Smith, 15% of visitors connected to communities with their words and observations. The comments reflected a relationship and a connection to learning and people in some way. For example, some of the remarks were very obvious and one can easily see how visiting the university's art museum to view *THIN* was a community learning experience:

My women's studies class came to this exhibit after seeing THIN... My class really liked [it].[26]

Thank you for making this exhibit. I struggle with an E.D. and this was a group field trip for a college class. This was a way for me to reflect back on what I've been doing and realize I don't want this for the rest of my life. I don't want to be in and out of treatment. I have better things to do so thank you very very much![27]

*Thanks for this exhibit! I have a friend at Notre Dame who
I came with today who is struggling through this and I am try-
ing to be healthy everyday for her sake.*[28]

Each of these visitors was clearly part of a group. In the first
two comments, the community is a classroom of students on
a field trip. The third comment sheds light on a relationship
between two friends at Notre Dame. In the second and third
comments, we see that THIN has had a positive effect on its
writers who are trying to be healthier, whether for themselves
or for others.

With other comments, it was harder to determine who the
community was but it was clear to me that there was a learning
relationship formed. For example, one person at Smith wrote,
"Thank you. I'm 78 years old and I meet myself in the eyes of
every one of these women. May they/we all heal and come to
love ourselves," and a visitor at Notre Dame penned, "Eye-
opening and heart-breaking, yet, in a way, I feel a connection
to every woman in these photos." These viewers are writing
about connection and about community. They have not come
as part of a class or a group from either of the universities,
but they have noted a strong bond between themselves and
the works of art. I believe that this is expanded community
learning at work – people from the community inspired to
come to the university museum because of an exhibit that
meant something to them. Further evidence of this link
between visitor and exhibit are elucidated by others such as
this visitor at Notre Dame:

*I related so much to the girls in this exhibit. I struggled with
my weight my entire life. It's hard to like yourself when you're
sized 11 and according to our society, that's fucking plus-sized.
This exhibit showed me that this disorder affects everyone
from all walks of life. Beautiful, yet sad.*

This visitor has written about her own struggles, related it to
the women in the exhibit, and examined cultural expectations
of beauty. This is critical thinking and reflection (hallmarks
of community learning),[29] though it did not necessarily occur
with another person. The same can be said of a visitor at Smith
who wrote:

*It was very powerful to read the stories of these women and
see the pictures but it was equally powerful to see a room
full of people, mostly women, of every shape, size, and are
respectfully silent, going from story to story, deep in thought
and probably relating on some level or another to those shar-
ing and discussing "the elephant in the middle of the room."
My thoughts and prayers are with all of us fighting whatever
demon we have to fight.*

Here, the writer notes the community around them. They feel
connected though they are not necessarily there with any of the
women they notice in their writing. Another visitor to Smith
reflects on her own community and how she will share her
knowledge of *THIN* with them:

The exhibit was completely terrifying – especially because I can see some of these obsessive tendencies in myself. It makes me want to reach out to all the women in my life, all the little girls I know, my younger sister and make sure they feel beautiful, smart, and strong – because I know they are. It makes me want to have daughters and raise them to know that they are beautiful and are loved.

This exercise in coding comments relating to community learning in university museums made me rethink the definition I held for community learning. I imagined that community learning had to be done within the walls of the museum, but these comments made me realize that community learning extends outside of the space of the exhibition. Community learning is even more powerful when the visitor transports their knowledge, experience, and meaning-making beyond the university, beyond the museum, and into their own communities. As Frankel suggests:

Museums must make the most of their special power to engage people in creative problem-solving, help people connect, create context for complex issues, open dialogue, and encourage critical thinking. Museums have a unique capacity to place today's issues in context to create a sense of place and a learning community. [30]

The above comments and categories show that visitors reflected on their connection with others and themselves, were

engaged in dialogue, and thought critically about the work and our world,[31] proving that community learning was at work in these university museums and in *THIN*.

Further impact: changing the university community

When the exhibit featuring eating disorders debuted at Smith in 2009, it seemed that the young women of Smith who struggled with the same afflictions came out of the woodwork. Smith was vastly unprepared for the deluge and had no psychologists on staff who were trained to help women with eating disorders. Before *THIN*, Smith women who struggled with eating disorders were referred to other counselors at schools in the area, such as Amherst and Williams, forcing the girls to travel many miles in order to seek help. Thankfully, the power of the exhibit at the Smith College Museum of Art changed all of that. The uprising of women who cried out for help when *THIN* opened its doors in the university's museum made administrators realize the urgent need for a psychologist trained in eating disorders. When I visited Smith in March of 2009, the search was in progress, and they hoped to have a new therapist on staff before the next school year. Would any of this have happened if it had not have been for the Smith College Museum of Art's impetus in exhibiting *THIN*? Was *THIN* the social justice catalyst that launched the search for an eating disorder counselor? I was warmed by the thought that the relationship between *THIN* and Smith had been one of great importance, and had educated the administration to take action against this social issue.

I am thrilled that *THIN* caused such a commotion for the Smith counseling community. Given that over 90% of eating disorder victims are female,[32] I was shocked that an all-woman's college could remain so aloof about women's issues with body image. I am proud that the staff at the Smith College Museum of Art had the courage to ignite such a fire by bringing *THIN* to the attention of its visitors and the Smith administration. It is a heartening story that proves the social and political power of museums. Without the Smith College Museum of Art sponsoring *THIN*, would there still be an incomplete counseling staff? Would students continue to be shipped off to other schools to see a therapist who specializes in eating disorders? I would like to think that the museum, *THIN*, and the visitors who were touched by the marriage of the exhibit and the gallery were given the courage and the opportunity to speak out because of this partnership. This example showcases how university museums can and should be sites of social awareness and how they can (and should continue to) promote issues that affect our communities, for better or for worse.

Snite Museum of Art: University of Notre Dame
"When deciding what we will bring to the Snite, we ask the question: Is it relevant and will it speak to the audience here?", the university's chief curator, Stephen Moriarty explained in a personal interview. "This exhibit enables dialogue and gets people talking about [eating disorders]." His awareness of the important role museums can play in creating social awareness was one of his main reasons for wanting *THIN* to be exhibited

at the Snite and to such an audience.

"There was enormous response to [THIN]," said Moriarty, citing the number of campus groups that had visited in the fall of 2009: dorm floors, university classes ranging from women's studies to exercise science, and therapy groups from Notre Dame and beyond.[33] Moriarty reminisced about when Greenfield came to campus where she gave a large lecture about her work and the critical issues it addressed. The artist also gave a smaller lecture to a group of only women. "When she visited here, we had an evening at Saint Mary's (an all-women's university near Notre Dame) where she came to talk to the girls," said Moriarty. "When we got there, there were over 200 women, a huge group. She went on stage, pulled up a chair, sat down and said: Girls, let's talk." [34] The high numbers in attendance reflect the powerful alchemy of Greenfield's work and a university community. "We were hoping [THIN] would elicit discussion, conversation and argument, which it has," Moriarty continued.[35] To Moriarty and to Greenfield, this is the essence of an exhibit of this sort in a university art museum: to get people talking about social issues and to increase understanding of the density of the problems such a show addresses. In the case of THIN, this means getting people to talk openly about a hidden topic: eating disorders.

With such a thorny topic, Moriarty enlisted the help of professionals such as Valerie Staples, an eating disorder specialist who came to Notre Dame in 2001. "I think it's really powerful, as people walk through [the exhibit] and they're quiet and that's a positive thing right there," Staples said.

"It helps people on our campus ask what are some things we can do to help...To me the value is [*THIN*] brings eating disorders to people's awareness on a different level with more of an emotional connection that draws you in. It helps people become aware of eating disorders as more than just a superficial thing."[36] Before Staples, eating disorders were delegated to departments like Athletics or Health, but there are now dedicated professionals in eating disorder counseling at Notre Dame.[37] Staples cites that 10.3% of all students who sought counseling services in 2009 listed that they were there for eating disorders. This is consistent with statistics from other years, where the numbers were as low as 9% and as high as 12%. Staples echoed Moriarty's feelings about the importance of a show like *THIN* at a place like Notre Dame. "Notre Dame students have a lot of passion and energy they can generate for change when standing behind a social movement," she pointed out. "We want to ignite that passion behind this issue... Notre Dame is an environment of high achievers. It may be difficult for them [students with eating disorders] to reach out and ask for help and acknowledge that it's a problem"[38]

Stephen Moriarty was proud to report that *THIN* had been very well-attended at the university's museum in 2009. Even he was surprised at the outpouring of visitors and was thrilled by the amount of critical conversations that were inspired by the show. He showed me a train of letters to the editor that had been written to the *Notre Dame Observer*, the school newspaper. Student after student chimed in to voice their opinion about whether Greenfield's work should be considered art, if the

exhibit was too "triggering" for students, and if Notre Dame was hypocritical for its support of eating disorders through the exhibition of *THIN* but not through students' attitudes about body image. The editorial debates were impressive to read, and students wrote passionately and critically. It seemed that the Snite Museum of Art, Greenfield, Moriarty, and Staples had achieved much of what they set out to do, which was to create a dialogue throughout the university and to bring people to the museum to add to the critical conversation.

Conclusion and suggestions

Since almost one-third of visitors who wrote in the logbooks at Notre Dame and half of those at Smith felt compelled to write "thank you," I believe *THIN* had a strong impact on its viewers. This display of gratitude encompasses the visitors' thankfulness for the education and the experience of viewing *THIN*. The exhibit had a powerful impact on me, and I was eager to know if I was the only one. The logbooks' comments speak for themselves and have left us with a legacy of affirmation for the work of these university museums, Greenfield, and *THIN*. Visitors were transformed by Greenfield's powerful images and the feeling of community that emanated from the exhibit, whether between a photograph and a viewer or between groups of visitors within the university museum.

From the visitors' comments on community, I saw openings for university educators to take advantage of such a socially impactful exhibition. Panel presentations, community forums, or an interactive conversational evening would be a

wonderful way to include visitors, answer questions, receive feedback, and build a community in the university setting. As another Smith visitor wrote, "These photos help start a good dialogue but it's only the tip of the iceberg."

I agree, and the museums that hosted *THIN* could have also offered the opportunity to explore more of that iceberg. At Smith College, *THIN* coincided with the month of February, which is Eating Disorder Awareness Month. Whether this was coincidental or not, Smith made good use of the occasion to advertise Eating Disorder Awareness Month on its website and to host an informal, open forum at the museum called *The College Body: What's Perfect? What's Normal?* This conversation was led by Smith professor of psychology Dr. Patricia Dibartolo, and included other speakers who shared their "insights into the cultural notions of perfection and normalcy" and their effects on self-esteem.[39] The goal was that faculty, staff, and students would be able to ask questions and to voice concerns about the subject of the "college body."

To further the lessons of *THIN*, university museums could offer workshops on media literacy and how to analyze and be critical of the messages that society sends us. As one Smith visitor wrote, "I see bright-eyed young ladies in the classroom but I fear that when they go home and are alone with what they see on TV, on billboards, in newspapers..." Those ellipses capture the visitor's fear that the media is influencing how these young women think of themselves. There is good reason to worry. When the average US resident sees approximately 5,000 advertising messages a day[40] and when the typical

American adolescent watches three to four hours of television a day, it seems that it would be valuable for citizens to be more aware of the influences of the media. In addition, visitors to workshops held at university museums could be taught how to "talk back" to the media by calling representatives, joining or launching campaigns, writing letters, or engaging in other ways to make their voices heard. According to the National Eating Disorders Association:

> *Encouraging the media to present more diverse and real images of people with more positive messages about health and self-esteem may not eliminate eating disorders entirely, but it would help reduce the pressures many people feel to make their bodies conform to one ideal, and in the process, reduce feelings of body dissatisfaction and ultimately decrease the potential for eating disorders.* [41]

If teaching media literacy is one step towards "decreasing the potential for eating disorders," then it is an opportunity that university museum educators should not miss.

As alluded to in the last example, the next natural step for university museums is to move from social education to social justice education. In workshops similar to those that would teach media literacy, university museums could provide outlets for activism and suggestions for how to influence eating disorder legislation. In such workshops, visitors could be taught how to rally for the eating disorder cause and understand how best to approach their legislators and how to

educate others. For example, people could be taught that eating disorders affect over ten million people while Alzheimer's affects around four million.[42] In 2005, the National Institute of Health gave almost $650,000,000 to Alzheimer's research but only $12,000,000 to the study of eating disorders.[43] This is some 75% less funding than for Alzheimer's, yet eating disorders affect more than twice as many people. These statistics are significant, and when put into the hands of people who were strongly affected by *THIN* and by motivated communities at university level, they could go a long way towards improving the treatment of eating disorders.

As can be seen from the examples above, and from the analysis of *THIN* at Smith College and at the University of Notre Dame, university museums have an important role to play in creating awareness of important social issues, even those that are not the nicest things to talk about. Similarly, our role as university museum educators is to encourage communities in our spaces so that people can bond, share, learn, and explore themselves, others, and the world through art. *THIN* was an exhibition with a resounding impact in the communities of the university museums it visited. Through these examples, our own university museum community can move forward to create even more reverberations within our visitors, to keep them hungry for more such powerful exhibits, and to keep them coming to the table that we set together.

NOTES

1. "Eating Disorders 101 Guide: A Summary of Issues, Statistics and Resources." Renfrew Center Study. http://www.renfrewcenter.com/uploads/ resources/1067338472_1.doc. (accessed May 12, 2008)

2. Hoek, Hans Wijbrand & Daphne van Hoeken. "Review of the Prevalence and Incidence of Eating Disorders." *International Journal of Eating Disorders* (2003): 383-396.

3. "Eating Disorders 101 Guide: A Summary of Issues, Statistics and Resources." Renfrew Center Study. http://www.renfrewcenter.com/uploads/ resources/1067338472_1.doc. (accessed May 12, 2008)

4. Hoek, Hans Wijbrand & Daphne van Hoeken. "Review of the Prevalence and Incidence of Eating Disorders." *International Journal of Eating Disorders* (2003): 383-396.

5. Pat Villeneuve. *From Periphery to Center: Art Museum Education in the 21st Century*. Reston, VA: National Art Education Association, 2007.

6. Tishman, Shari, Alythea McKinney, and Celka Straughn. *Study Center Learning: An Investigation of the Educational Power and Potential of the Harvard University Art Museums Study Centers*. Cambridge, MA: Harvard University Press, 2007.

7. C. H. Cooley. *Human Nature and the Social Order*. New York: Charles Scribner's Sons, 1902.

8. George Herbert Mead. *Mind, Self, and Society*. Chicago: University of Chicago Press,1934/1970.

9. John Dewey. *Experience and Education* (12th ed.). New York: Macmillan,1938/1970.

10. Lev Vygotsky. *Thought and Language*. Cambridge, MA: MIT Press, 1962.

11. Susan Longhenry. "Reconsidering Learning: The Art Museum Experience." In *From Periphery to Center: Art Museum Education in the 21st Century*, edited by Pat Villeneuve, 153-157. Reston, VA: National Art Education Association, 2007.

12. Falk, John and Lynn Dierking. *Learning From Museums: Visitor Experience and the Making of Meaning*. Walnut Creek, CA: AltaMira Press, 2000.

13. Joan Jacobs Brumberg. *The Body Project: An Intimate History of American Girls*. New York: Vintage Books, 1997.

14. Ibid

15. Ibid

16. Lynn Dierking. "The Role of Context in Children's Learning from Objects and Experiences." In *Perspectives on Object-Centered Learning in Museums*, edited by Scott G. Paris, 3-19. Mahwah, NJ: Lawrence Erlbaum Associates, Publishers, 2002.

17. Ibid

18. Joan Jacobs Brumberg. *The Body Project: An Intimate History of American Girls*. New York: Vintage Books, 1997.

19. Notre Dame. *THIN* Logbook of Visitors Comments, 2009.

20. John Dewey. *Experience and Education* (12th ed.). New York: Macmillan,1938/1970.

21. Susan Longhenry. "Reconsidering Learning: The Art Museum Experience." In *From Periphery to Center: Art Museum Education in the 21st Century*, edited by Pat Villeneuve, 153-157. Reston, VA: National Art Education Association, 2007.

22. Falk, John and Lynn Dierking. *Learning From Museums: Visitor Experience and the Making of Meaning*. Walnut Creek, CA: AltaMira Press, 2000.

23. Joan Jacobs Brumberg. *The Body Project: An Intimate History of American Girls*. New York: Vintage Books, 1997.

24. Lynn Dierking. "The Role of Context in Children's Learning from Objects and Experiences." In *Perspectives on Object-Centered Learning in Museums*, edited by Scott G. Paris, 3-19. Mahwah, NJ: Lawrence Erlbaum Associates, Publishers, 2002.

25. Ibid

26. Smith. *THIN* Logbook of Visitors Comments, 2009

27. Ibid

28. Notre Dame. *THIN* Logbook of Visitors Comments, 2009.

29. Diane Frankel. "Museums and a Learning Community." In *Presence of Mind: Museums and the Spirit of Learning*, edited by Bonnie Pitman, 161-66. Washington, DC: American Association of Museums, 1999.

30. Ibid

31. Ibid

32. "Something Fishy Statistics." Something Fishy. http://www.something-fishy.org (accessed June 1, 2009).

33. Anne-Marie Woods. "THIN Exhibit Generates Discussion." *The Observer*, September 18, 2009.

34. Ibid

35. Ibid

36. Ibid

37. Jenn Metz. "New Film Profiles Self-Image." *The Observer*, March 2, 2009.

38. Ibid

39. "Smith Calendar of Events." Smith College. http://www.smith.edu/news/calendar_text2.php?weekof=2009-02-23 (accessed September 28, 2010)

40. Aufreiter, Nora, David Elzinga and John Gordon. "Better Branding." *The McKinsey Quarterly*, 4 (2003).

41. National Eating Disorder Association. *The Media, Body Image, and Eating Disorders*. The National Eating Disorder Association, Seattle, WA, 2005.

42. Ian McDowell. "Alzheimer's Disease: Insights from Epidemiology." *Aging*, no.13 (2001): 143-162.

43. Ibid

Go With the Flow:
Fluxus at Play in a Teaching Museum

JULIETTE BIANCO

Hood Museum of Art, Dartmouth College

After I taught [the course titled Flux Dartmouth: Adventures in (Muse)ology] *I felt freed up in my teaching, having done something so out there and so experimental without any of the conventional systems for evaluating students. I put myself out there as well, and participated in the event scores for example. I saw how successful it was as a way of getting students to think through the phenomenon of Fluxus rather than just studying it. I feel like I can employ some of this in everything I do. I don't have to be so rigid in my teaching. I feel like I have become a much better teacher since then.*
– Mary Coffey, Associate Professor of Art History, Dartmouth College.[1]

Mary Coffey taught a radically different Art History course at Dartmouth College in the summer of 2008. Inspired by consultation with the Hood Museum of Art for the then-forthcoming exhibition *Fluxus and the Essential Questions of Life*, she taught a class about the artistic and historical phenomenon of Fluxus that would dispense with papers, daily reading assignments, and exams in favor of other forms of engagement with the material.[2] Students were encouraged to respond to a rich discussion they had in the museum about Al Hanson's *Homage to the Girl of Our Dreams* (Figure 1) by writing a "recipe" for making a work like it. One recipe read:

1. Take a common item.
2. Decide what it means to society (general messages or ideas it conveys/invokes).
3. Apply this meaning to something seemingly unrelated,

yet it connects on at least one point.

4. Enjoy![3]

Students then exchanged recipes and each presented to the class an object they had made from the recipe they had been given. When all but one shared a candy-wrapper collage, they were disappointed to see that they had not followed their recipes but instead simply mimicked the work by Al Hansen that they had studied. This began their process of understanding Fluxus, and questions followed: What parameters existed in the art world at the time? What assumptions were in place about what an art work should look like, what an artist and [his or her] attitude towards the art market should be like, and how did Fluxus artists attempt to think through these things to generate new possibilities? The term-long exploration of Fluxus through experience and action brought students in the class from, as Coffey said, "point A to point Z once they learned to just kind of go with it."[4]

Allowing students to "mess around" with museum collections is something that Janet Marstine explored in her article *What a Mess! Claiming a Space for Undergraduate Student Experimentation in the University Museum*. She argues that this phenomenon is "part of the post-modern, pedagogical shift in undergraduate education towards the participatory and collaborative."[5] Marstine's signaling of contemporary pedagogy's arrival at Fluxus's long-ago embrace of participation and collaboration in art as a process gives us a framework within which to test the impact of this fifty-year-old

art phenomenon. Coffey commented further, "Students are very adept at writing papers, and fairly adept at taking timed exams, but working collaboratively is difficult because they want individual credit. Working collaboratively is important, and was part of the Fluxus dynamic. It taught them also to be civil and cooperative instead of competitive, prepared them for a world that is collaborative, and helped them understand that museums function through collaboration." [6] In this chapter I hope to show that Fluxus has something in particular to teach undergraduates, as we found at Dartmouth through the distinctive ways that students and faculty interacted with *Fluxus and the Essential Questions of Life*. Indeed, when brought into the classroom, the experimental, experiential, and collaborative characteristics of Fluxus forced students to ponder the complications that arise when art and life intersect.

Fluxus at Dartmouth

Creating the Fluxus collection at Dartmouth College was an "act of faith." [7] Founded in 1962 by the Lithuanian-born George Maciunas, this radical and influential art phenomenon grew as part of a global cultural impulse to blur the boundaries between art and life. When Maciunas died just sixteen years later, on May 9, 1978, he left as his legacy a group of loosely connected artists around the globe who shared that radical vision. The objects they created – from the event scores to the bottle of prescription stress relief (gelatin capsules filled with jokes) to the "flux kits" filled with all manner of objects from keys to pine cones to unicorn poo – were, unsurprisingly, not

the first things that art museums were scrambling to add to their collections. In fact, how – or even if, when, or why – to conserve Fluxus collections continues to challenge museum professionals to this day.

The first Fluxus exhibition at Dartmouth College opened in November 1978, just months after Maciunas's death, and was described by then-museum director Jan van der Marck as a flop – "T.H.U.D." were his exact words: "the reaction fell like a proverbial brick." [8] Perhaps Fluxus, born at about the same time as a then-college freshman, was too new, or too subversive, for the Ivy League's hallowed halls. But reportedly neither he, nor the artists who participated were bothered, including Alison Knowles, Dick Higgins, Nam June Paik, and Yoko Ono. Van der Marck, nationally known as both visionary and controversial, had bigger plans in store for Fluxus at Dartmouth when he founded its George Maciunas Memorial Collection. The collection now numbers nearly six hundred objects, with the latest addition made just recently in Fall 2011, Hollis Melton's *Black and White Piece*. This rare work, an accordion-style album of ten black and white photographs, commemorates a performance in celebration of George and Billie Maciunas's FluxWedding on February 25, 1978, less than three months before his death. It is a fitting addition to a collection founded in his memory.

When attempting to make the Hood's Fluxus collection known to a wider audience of Dartmouth alumni, the *Dartmouth Alumni Magazine* in 1992 quoted Maciunas as having once said, "High art is something you find in museums. Fluxus

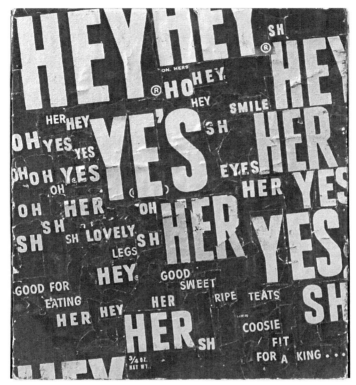

Figure 1: Al Hansen, Homage to the Girl of Our Dreams, 1966; Hershey Bar wrappers collaged onto wood (19 x 16.5 x 1.9 cm); Hood Museum of Art, Dartmouth College.

you don't find in museums… because we never intended to be high art. We came out to be like a bunch of jokers."[9] Yet at the same time, Jan Van der Marck felt that Fluxus had something big to teach the students of Dartmouth College and so that same year he founded, "with the express purpose of educating students and other museum patrons about the ephemeral aesthetic not documented or easily accessible

anywhere else," [10] the George Maciunas Memorial Collection and solicited contributions from artists. La Monte Young, Yoko Ono, Dick Higgins, Alison Knowles, Claes Oldenburg, John Cage, and Nam June Paik responded. Whatever the stated non-relationship between Fluxus and art museums, Fluxus objects entered and continue to enter museum collections. They bring with them, by their very nature, a requirement that museum professionals question even the most rote practices of classifying, characterizing, and conserving the works in its care. Indeed, we must imagine when, for example, trying to decide whether to conserve or replace the dead fly in Ben Vautier's *Living Fluxsculpture*, that this is yet another function of Fluxus.

Yet van der Marck's intention to "publish a catalogue" and desire for the collection to "travel extensively and do all the sort of things we have claimed for it" [11] remained unrealized. Beyond his initial exhibition, the collection saw little attention aside from a few small installations and registrarial efforts to catalogue and stabilize various components. In 2007, former Hood director and independent curator, Jacquelynn Baas, suggested an exhibition that would fulfill Van der Marck's desire to see the collection studied and published by presenting Fluxus in way that was "fresh, useful, and appealing to students" – not what is Fluxus (which has been done many times over), or who is Fluxus (ditto), but how is Fluxus useful in everyday life, and, furthermore, "how can college students relate to Fluxus, fifty years later?" [12]

Baas conceptually organized *Fluxus and the Essential*

Figure 2: Studio Art students discuss Fluxus and the Essential Questions of Life *in the exhibition galleries.*

Questions of Life[13] (Figure 2) and its accompanying catalogue to connect with those questions that might be most on the minds of college students: for example – in no particular order – Sex? Health? Happiness? Freedom? Death? Time? God? and What am I? As Baas writes in the exhibition catalogue, Fluxus teaches that "no answer (much less any question) is wrong... Put aside your predilections and fears and use your six senses to apprehend this ever-changing world. Fluxus can help by providing art-experience as life-experience that is guaranteed to change your mind." [14]

Breaking the rules

The Hood has a long-established pattern of cross-disciplinary engagement with faculty and students at Dartmouth, yet it took Fluxus to free the museum staff to experiment with

the institutional norm.[15] Marstine writes that the teaching museum, as neither a public museum that casts a very wide net nor an alternative space that forefronts risk, can become a "third space" when "student-produced, open-ended exhibitions... complicate, and, sometimes, even contradict institutional narratives." [16] In turn, artist, game designer, and educator Mary Flanagan writes about Fluxus in her book *Critical Play: Radical Game Design* in relation to Johan Huizinga's modernist theory of the importance of play in human society. Huizinga defined his "magic circle" as a place where play happens and contradictory ideas can coexist; one enters voluntarily – for example when playing a game – and the rules are different than those in everyday life.[17] Flanagan writes that, with Fluxus, "The magical transformation of ordinary materials... speaks to conceptualizations of time and to the transformative act that a playful repositioning of the everyday can occur." At the Hood in mid-2011, the third space of the teaching museum was circumscribed by a magic circle created not, in the end, by any of the objects on view, but by the most conceptual contribution of Fluxus to the art world – the event score. Event scores in vinyl lettering floated in the upper registers of the exhibition gallery's walls, playfully hinting at their cerebral existence (see Figures 2 and 6).

Fluxus and the Essential Questions of Life introduced students to the event score at the very entrance to the exhibition through Yoko Ono's *Painting to Be Stepped On*, which instructs: "Leave a piece of canvas or finished painting on the floor or in the street." The Hood chose to follow Ono's instructions

by dropping a finished canvas, donated by a local artist for this purpose, in the exhibition's entryway, where it was awfully hard to miss. The moment of transgression that Ono encourages pushed students to contemplate "breaking the museum rules" – something they are not accustomed to doing. Similarly, when Coffey's students argued that they could not apply what they learned from Fluxus to their other coursework, citing the expectations of their professors, she argued back, "well, how do you know? The professor gives you some parameters, but... we are looking to be surprised and inspired by what you do. Is this a case of the professor telling you what you have to do, or is it you having decided in your head what the professor wants the paper to look like?"[18]

The viewer's share

Flanagan explains that the event score – one of the great contributions of Fluxus to the art world – contains rules that seem perfectly explicit on the surface. But as she notes, the art in the score derives from "Implicit rules" that "arise at those points where the player of a Fluxus game must negotiate the jump from an everyday action into play, into the magic circle where, hopefully, the player will go along with the joke and truly have a new, unusual, or delightful 'sense-heightening' experience."[19] Performing founding Fluxus member Alison Knowles's iconic *Proposition* of 1962, *Make a Salad*, which was included in the exhibition's *Staying Alive?* section, confronted students with just that (Figure 3). The Hood invited Knowles for a week-long residency and public performance of *Make a Salad*

Figure 3: Alison Knowles, at the far end of the table, and Theater 65 students' public performance of Alison Knowles, Proposition *(1962),* Make a Salad, *Novak Café, Baker-Berry Library, Dartmouth College, July 21, 2011.*

in conjunction with theater Professor Peter Hackett's Drama in Performance class.[20]

Hackett's students thought that Fluxus, and Knowles's attempts to teach it, was a joke until they negotiated with her about what the seemingly explicit rules of making a salad really meant. The students came to realize that this everyday activity became something else when prepared as a performance. Theater major Talene Monahon reflected that performing on stage is essentially doing everyday life events – like making a salad – but in character. The naturalness with which she performed with Alison Knowles is something that she may draw upon in the future when doing everyday events as part of a staged theater production.[21] Talene's response makes apparent that Fluxus cannot be confined to the magic

circle and it is in fact at play outside as well.

Knowles further challenged the students to write and perform their own event scores. Professor Hackett later observed, "Creating the Fluxus pieces forced the students to improvise, to trust their intuition and instincts and act on them without analyzing what they were doing. It got them out of their heads." [22] The students' scores had them tearing up books (*Take a book... and destroy it*), throwing balls down stairs (*Bounce*), and shouting a dozen names for God (*Sacred Tourette's*) in front of their friends, professors, and the public. Student Emma Fidel had known that no matter a playwright's or actor's intentions, each audience member experiences something different, but Fluxus helped her think more critically about the relationship between the performer and the audience. By removing many of the layers of artifice from customary theater behavior and turning her idea of theater on its head, Fluxus made this relationship more apparent. [23] For example, the students and the audience had come to a silent agreement on the "rule" of clapping after each event score, yet the "end" of many was not always apparent. Students awkwardly began to clap for themselves as a signal for the audience to do likewise. The rules of the game no longer applied – a destabilizing and unexpected outcome for many students. When performing Knowles's *Proposition Make a Salad*, Fidel felt exposed inside that magic circle where her class went along with the joke and turned an everyday event into performance. After the public performance, one student in the audience declared, "This is possibly the best-looking salad I have ever seen in my life,"

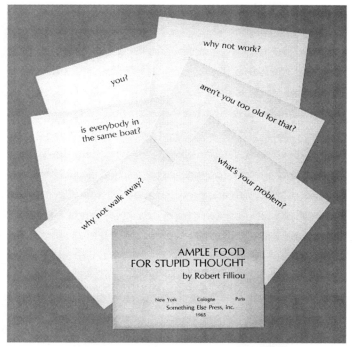

Figure 4: Robert Filliou, Ample Food for Stupid Thought, 1965; Ninety-three postcards with questions printed on them (12.6 x 17.7 each); Hood Museum of Art, Dartmouth College.

reminding us that for all the experiential qualities, aesthetics are also part of Fluxus.[24]

Students in Mary Coffey's class learned a similar lesson when they emailed questions – à la Robert Fillou's *Ample Food for Stupid Thought* postcards (Figure 4) – to the Dartmouth student body. They were confounded and annoyed by what they perceived as the off-topic responses they got back, which Coffey chalked up to "what Duchamp calls the viewer's share. The artist has intention and works hard to craft an object that

will solicit a certain response. But the artist does not control that response. That response is ultimately determined by discrete viewers." [25] Students in both classes learned through experience that Fluxus, although seemingly straightforward on the surface, is in fact multi-variable and unpredictable, particularly in the way it presumes viewer participation and interpretation.

Building bridges

After visiting *Fluxus and the Essential Questions of Life*, with her Sculpture I class, professor Stina Köhnke assigned students to "respond" in the medium of their choice. "At first many students were baffled and suspected me of playing a trick on them. The more time they spent... the more enchanted they became with the mischievous mood of the show. Some students made collaborative performances and interactive games. Channeling the neurotic nature of the work, students reflected on their own compulsive imagination in a profound but playful manner. Several students commented that the exercise... validated their own perspective and gave them confidence to take greater risks in the future." [26]

Rebecca, a student in Köhnke's class, is a computer science major at Dartmouth who was there because she had never taken art seriously, had never understood it, and had never had an emotional experience in front of a work of art. Her first assignment – to fool around with some materials and make a sculpture – was a disaster, "a mass of wires that meant nothing to me." Then she saw *Fluxus and the Essential Questions*

of Life. Fulfilling the assignment to make a creative response, she ushered the entire class into the girls' bathroom and asked her peers to remove towels from the automatic dispenser. She said, "You can take a sheet really fast, or wait for it to stop unrolling. There's variation to how you pull towels out and that tells you something about what kind of a person you are." [27] There was also the unintentional effect, she said, that was created by fifteen people crammed in an unusual space – it was uncomfortable, another implicit response to Fluxus that is only understood thorough experience.

For Rebecca, Fluxus broke down the barrier she had always thought that art had with the rest of the world, one she had always experienced when visiting museums. "Fluxus is the first time I felt something when looking at art." She connected her experience with Fluxus to the work she feels most comfortable with as a computer scientist. "Sometimes when you are programming, you have to make decisions that are not logical – you have to follow your feeling." Fluxus's subversion of the materials, subjects, and aesthetics often associated with fine art helped her describe the art in computer programming to the students she tutors. "College is about learning," she said, "but some subjects are hard unless you have a bridge point. Fluxus strikes me as a bridge point." [28]

Wounding furniture

A final Fluxus-related project marked the first time the Hood put student work on view in its galleries, allowing them to interact in the "third space" not as curators, as they

are somewhat accustomed to doing through the museum's internship program, but as artist-collaborators. When the exhibition opened to the public, the wall under Alison Knowles's 1965 event score *Wounded Furniture* was left intentionally blank. A sign announced what would appear there in three weeks' time. Studio Art professor Sunny Park's Sculpture I class and Film and Media Studies professor Jodie Mack's Handmade Strategies class would team up to perform the score, which reads: "This piece uses an old piece of furniture in bad shape. Destroy it further, if you like. Bandage it up with gauze and adhesive. Spray red paint on the wounded joints. Effective lighting helps." Museum staff promised to integrate the relic into the exhibition.

Students struggled to respond to this collaboration (Figure 5). Student Sean Hammett said that he had a hard time indulging something so unstructured. But the performance changed his ideas about art; in addition, as an engineering major, he enjoyed the structural puzzle of destroying something and then putting it back together so that it would stand up again. Sean insightfully described the variety of approaches employed by students to transform the perfectly usable dresser into something else with saws, sledgehammers, paint, and duct tape. Some were delicate and others more destructive, but all worked together through body language and subtle movements. Yet, in the end Sean deemed whole event "silly."[29] Erika, a student who filmed the event, wished she'd also been performing because, "deep down, everyone wants to smash a dresser... and then bandage it up and say sorry."[30] Erika

Figure 5: Students enrolled in Studio Art 16 and Film and Media Studies 47 perform Alison Knowles, Wounded Furniture *(1965), Hopkins Center plaza, Dartmouth College, May 6, 2011.*

continued that the collaborative approach of Fluxus teaches students in a highly competitive place like Dartmouth to stop thinking so much about "me first." Indeed, Sean said that he did not ultimately feel any ownership of the wounded furniture because it was not "his work." If destroying the *id* was part of Fluxus, both students got it, but only one saw that as the point. Professor Mack thought that the students were experiencing more profound emotions of violent rage and guilty remorse, but said that the students would never admit to these feelings. Despite promising to carry the relic into the gallery the next morning, only three students showed up to put it in place, where it remained for the duration of the show (Figure 6). The complicated responses to *Wounded Furniture*, at once emotional and dismissive, indicate that students felt stuck between the communal, performative, and absurd aspects of Fluxus.

Figure 6: Relic from the performance of Wounded Furniture *and the student-made film of the performance on public view in the exhibition* Fluxus and the Essential Questions of Life, *Hood Museum of Art, Dartmouth College.*

Professor Mack concluded that removing classroom rules – entering Fluxus's magic circle once again – made the experience open to everyone involved and "pulled the rug out" from under students' ideas of what their professor expects of them. "You're not just throwing something at them, but rather discovering something together. Teaching with Fluxus takes

away the student/teacher/art viewer/artist distinctions. This had the effect of democratizing the classroom." [31] Students also had to learn to trust their instincts, think fast, and accept the notion of chance as part of the art experience. Mack said, "Fluxus is a tool for the spectator to become the artist or for the participation in general to become the work of art. For students, that is mind-blowing. That's why it is so important to do this at an undergraduate level." [32]

Conclusion

The fact that the collaborative, performative, and open-ended nature of Fluxus was destabilizing to most, and enlightening to some, students at Dartmouth offers some proof that the artists' fifty-year old intentions are still potent and that Fluxus is "working." When experimented with as part of a course curriculum whose rules students thought they had mastered, Fluxus subverted their ideas of what art is in an art history or studio art class, what performance is in a theater class, and where they fit into all of it.

The testimony given by these students and faculty members gets at the subtle, yet tangible outcomes of engagements with Fluxus. Given the opportunity, they promptly complicated the museum's (and the college's) fundamental practice of teaching and learning. Students smashed furniture, chopped cucumbers, and crowded their peers into a bathroom for course credit. Faculty members loosened up their expectations of success in the classroom. Coffey wrote, "I still stick to a conventional syllabus... but I feel like if they go directions I

didn't intend, the course is still working... rather than feeling like I failed somehow to communicate specific outcomes." [33] When the Hood Museum of Art stepped back out of the magic circle within which it had taken the risk of inviting student work into its galleries, it carried with it something new about the possibilities for encouraging student engagement. Student work again went on display in the museum's galleries in Fall 2011, this time finding a place even within the more conventional exhibition *Native American Art at Dartmouth: Highlights from the Hood Museum of Art.*

Learning with Fluxus was difficult and revelatory at times for faculty and students. Coffey wrote, "Watching the students grapple with the metaphysical questions the Fluxus material posed helped me to better appreciate how student growth happens, not only intellectually, but also emotionally and psychologically." [34] Given Jan van der Marck's high hopes for a Fluxus collection at Dartmouth and Baas's inquisitive take on it, is it too much to ask that students leave an exhibition (and an undergraduate education) with not only answers but one overarching question: did they learn better how to be themselves?

NOTES

1 Mary Coffey, gallery talk at the Hood Museum of Art, "Flux Dartmouth: Adventures in (Muse)ology," May 17, 2011.

2 Coffey partnered with choreographer and writer David Gordon and playwright and actor Ain Gordon through the Center for Creative Research in the creation of this class.

3 Email from Lindsay Borrows to Mary Coffey, June 23, 2008.

4 Coffey gallery talk, May 17, 2011.

5 Janet Marstine, "What a Mess! Claiming a Space for Undergraduate Student Experimentation in the University Museum," *Museum Management and Curatorship*, 2007, Vol. 22, No. 3, p. 304.

6 Mary Coffey, gallery talk, May 17, 2011.

7 Letter from Jan van der Marck to Jean Brown, August 31, 1978. Hood Museum of Art archive.

8 *Dartmouth Alumni Magazine*, "The Stuff of Art," October 1992, p. 31. The exhibition ran from November 1978 to January 1979.

9 *Dartmouth Alumni Magazine*, p. 26.

10 *Acquisitions 1974–1978* (Hanover, N.H.: Trustees of Dartmouth College, 1979), 28.

11 Memo from Jan van der Marck to Members of the Steering Committee for the George Maciunas Memorial Collection, March 5, 1979. Hood Museum of Art archives.

12 Jacquelynn Baas, preliminary exhibition proposal for *Fluxus and the Essential Questions of Life*, February 28, 2007.

13 On view at the Hood Museum of Art, April 16–August 7, 2011; Grey Art Gallery, New York University, September 9–December 3, 2011; and the University of Michigan Museum of Art, February 25–May 20, 2012.

14 *Fluxus and the Essential Questions of Life*, p. 9.

15 See, for example, *Hood Museum of Art, Annual Report 2005–6*, or other annual

reports through 2009 online at www.hoodmuseum.dartmouth.edu.
See also Janet Martine's article cited in this chapter, and her discussion of the
Hood's student-curated gallery, *A Space for Dialogue*.

16 Marstine, p. 305.

17 Mary Flanagan, *Critical Play: Radical Game Design*, Cambridge, Mass.: MIT Press,
2009, p. 7.

18 Coffey gallery talk, May 17, 2011.

19 Flanagan, p. 175.

20 To view the video of the performance see:
http://www.youtube.com/watch?v=z9g1-Uj4SQo.

21 Talene Monahon, interview by author, October 28, 2011.

22 Email from Peter Hackett to the author, October 24, 2011.

23 Emma Fidel, interview by author, October 27, 2011

24 Sydney Ayres, "Knowles Serves Appetizers and a Salad in Novak," *The Dartmouth*,
July 22, 2011.

25 Coffey, gallery talk, May 17, 2011.

26 Email from Stina Köhnke to the author, October 20, 2011.

27 Interview with Rebecca by author, October 25, 2011.

28 Ibid.

29 Sean Hammett, interview by author, November 15, 2011.

30 Erika, interview by author, November 19, 2011.

31 Jodie Mack, interview by author, November 15, 2011.

32 Ibid.

33 Email from Mary Coffey to the author, November 20, 2011.

34 Ibid.

The Curatorial Classroom: Creating Opportunities for Engaged Learning

JESSICA HUNTER-LARSEN
Colorado College

Museum curators and college professors face a similar mandate: both are challenged to create opportunities for learners – whether casual or conscripted – to have meaningful engagements with ideas. Embedded in environments richly populated with authoritative experts and novice learners alike, academic museums are, at least theoretically, ideally positioned to function as sites for the collaborative development of active learning strategies (Figure 1).

Despite a shared ideology, the practicalities of exhibition development and classroom instruction frequently present barriers to collaboration. Potential partners wrestle with thorny philosophical and procedural questions: Where does curatorial authority reside when museum personnel, faculty, and students all have a stake in authorship? Can pedagogically-based museum exhibitions serve the institution's broader constituency? How do the partners reconcile divergent timelines? And, perhaps most importantly: How can we create repeatable, yet meaningful, models of engagement between students and exhibitions that are not solely content-dependent?

Unlike many academic museums or exhibition spaces that originated from mandates to preserve and interpret specific collections or to serve a broad community audience, a teaching mission has been central to the Interdisciplinary Experimental Arts program (IDEA) at Colorado College from its inception. Hosting a variety of public exhibitions, performances, lectures, and events, IDEA functions as both a non-traditional locus of education for students and as a nexus for presenting

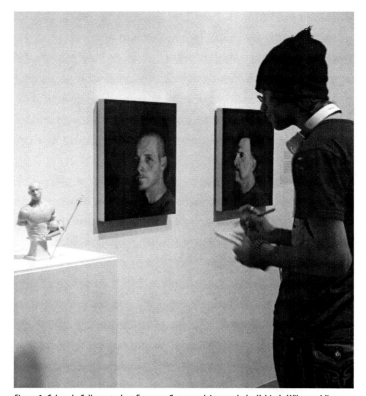

Figure 1: Colorado College student Emerson Gates studying works by Kehinde Wiley and Jimmy Baker featured in Strange Beauty: Baroque Sensibilities in Contemporary Art. *Artwork images courtesy of the artists and Roberts & Tilton Gallery, Los Angeles, and The Art Affair, Denver, CO. Photo: Scott Bauer Photography.*

the college's intellectual and cultural resources to the regional community.

The program evolved from the Cornerstone Arts Initiative, an annual week-long event, begun in the 1990s, that integrated the performing and visual arts into the Social Sciences, the Natural Sciences, and the Humanities. With the addition of

an academic curator in 2006 and a dedicated exhibition venue in 2008, the college has expanded the initiative's mission to support intellectual and artistic exploration through arts-based learning opportunities. Colorado College's IDEA program operates on the premise that, in a media-saturated world, fostering the ability to analyze, interpret, and understand visual culture is a crucial component of a liberal arts education; the program's academic curator therefore works collaboratively with faculty across disciplines to integrate the arts into a broad range of academic experiences at the college. The ideological alignment between the production of exhibitions and the development of innovative pedagogy at the college has created an environment particularly conducive to exploring opportunities for active engagement between the teaching and presenting functions of the academic gallery.

While Colorado College's unusual teaching schedule creates additional challenges to the development of academically-based exhibitions, the Block Plan also affords opportunities for collaborators to think creatively and expansively about the ways pedagogically resonant exhibitions are developed and presented to the public. On Colorado College's Block Plan, professors teach, and students take, one course at a time; students complete the equivalent of a semester of coursework within the three-and-a-half weeks that comprise a Block. An advantage to the system is that students work swiftly and intensively on projects, often becoming both intellectually engaged and emotionally invested in their given topics.

The short duration of the courses does, however, require a

re-envisioning of collaborative processes because the locus of curatorial authority must quickly shift between the academic curator, the professors, and students as the exhibition develops. While Colorado College's projects are developed and implemented under the constraints of the Block Plan, the issues of time management, curatorial authority, and public presentation remain broadly applicable to other academic institutions. The compression of time that characterizes Colorado College's academically-based projects can be seen as a further testing ground to explore more expansive models for effective collaborative efforts.

The following analysis examines two recent projects at Colorado College: *Strange Beauty: Baroque Sensibilities in Contemporary Art* (2011) and *Nigar Nazar: Freedom and Authority in Pakistan and the Middle East* (2009). Selected from the many collaborative exhibitions at Colorado College in the past five years, these two highly effective projects offer concrete models for creating engaged learning opportunities by positioning exhibitions as natural extensions of the classroom. Developed by the college's academic curator, Jessica Hunter-Larsen, and two faculty members in History and Art History, the projects invited students to become active participants in the co-creation of public exhibitions. While distinct in their specific strategies and pedagogical goals, both projects featured course assignments that required the students to reframe their academic investigations within exhibition contexts. As scholars and researchers, the students honed their critical thinking processes and writing skills; by developing the

exhibitions' interpretive materials, they demonstrated mastery of course materials and the ability to communicate key ideas to the general public. Through the integration of assignments into exhibition research and design, the projects created "curatorial classrooms" in which the processes of exhibition development provided additional avenues for students to interpret materials, akin to writing papers or giving an oral presentation. The exhibitions that resulted from these collaborations consequently functioned both as the products of sustained intellectual inquiry and as methods for realizing deeper and more nuanced understandings of subject materials.

Strange Beauty: Baroque Sensibilities in Contemporary Art
Project design: Engaging students in the art history course The Age of the Baroque: Art and Empire of the 17th century, the exhibition *Strange Beauty* examined how elements of 17th century aesthetics and culture are reinterpreted and expressed in the 21st century. As contributors to the exhibition, students conducted historical research on specific aspects of 17th century art and were then asked to reframe that knowledge through a comparative analysis of works in an exhibition of contemporary art. A year prior to the course, Hunter-Larsen and course professor Rebecca Tucker laid the groundwork for the students' research by developing an exhibition checklist that reflected issues or artistic practices common to both eras. Featuring established contemporary artists Ken Aptekar, Jimmy Baker, Renee Cox, Tsehai Johnson, Liza Lou, Andres Serrano, Cindy Sherman, Kehinde Wiley, and Sherrie Wolf,

the exhibition addressed issues central to the understanding of the 17th century Baroque. Areas of focus included: the relationship between art, politics, and power; self-fashioning through representation and display; and the function of spectacle. As specific contemporary pieces were secured for the exhibition, Tucker and Hunter-Larsen identified Baroque corollaries. For them, the process of identifying the specific comparisons reinforced the primary themes of the course and strengthened the conceptual framework of the exhibition; these comparisons later provided the foundation for the students' creation of interpretative exhibition text that explored the parallels between 17th and 21st century art.

The first two weeks of the academic course focused on the historical Baroque. Students studied the broader social, political, and philosophical issues of the era and wrote research papers examining specific aspects of 17th century art; these essays were reproduced in a limited-run exhibition catalog. While immersed in the historical Baroque, students also developed basic museum literacy skills by reading and discussing essays on museum philosophy and visiting and analyzing a variety of local exhibitions. They met regularly with Hunter-Larsen to discuss the contemporary artists in the exhibition and to begin to frame how, through its design and interpretation, the exhibition could define and elucidate the parallels between the 17th century and the 21st century for a novice audience. In the last third of the course, students composed extended object labels for the exhibition. By comparing each contemporary piece to a Baroque artwork,

the labels analyzed how the contemporary artists engaged ideas and strategies common in the Baroque era. Based on their broad knowledge of the historical Baroque and their specific investigations of works within the exhibition, the students then collaborated with Tucker and Hunter-Larsen to develop the exhibition's introductory text. Finally, the students presented their research at a public reception for the exhibition's opening. In the context of an ongoing series hosted by the Interdisciplinary Arts Program called *IDEA Cabaret*, the students were assigned to develop an interactive, informative live public program that effectively distilled and communicated the exhibition's themes (Figure 2).

Learning objectives and outcomes: The *Strange Beauty* project presented a unique opportunity for students in The Age of the Baroque not only to study 17th century art but to develop, test, and refine their own first-hand interpretations of works of art, drawing conclusions about the artworks' broader aesthetic and cultural significances. Beginning as novices, students first developed expertise over the course material, a process that culminated in the completion of traditional research papers. Through the subsequent comparisons between contemporary and historical artists, students then questioned their knowledge of the 17th century material by re-examining that information within the context of an exhibition of contemporary art. The results of those analyses were further distilled and communicated to a public audience through interpretive text and live programming. The process of acquiring knowledge in an academic setting and reframing

that knowledge for an exhibition context demanded that the students move repeatedly between states of ambiguity and mastery; at each juncture, the students were challenged to develop more nuanced understandings of the concepts.

Creating the interpretive elements for the exhibition further demanded that students reflect on their own learning processes. To write informative – but not exhaustive – exhibition texts, the students had to re-position themselves deliberately as novice learners to identify and explain ideas, terms, or facts that might be unfamiliar to the exhibition's diverse audience. The development of the public educational program at the exhibition's opening *IDEA Cabaret* event provided additional opportunities for the students to retrace and replicate their own learning processes. For example, to frame their subsequent discussions of specific artists within the exhibition, the students first screened two short documentaries for the audience. A brief discussion of Caravaggio's rejection of artistic conventions and insistence on naturalism to challenge social norms and religious decorum was immediately followed by an interview with contemporary artist Kehinde Wiley, whose monumental and explicitly aristocratic portraits of African-American men challenge pervasive cultural stereotypes. The development of the introductory material resulted from the students' conscious examination of their own initial preconceptions of the historical Baroque and its relevance to contemporary art. The choice of the video format and the specific comparison between artists represented an attempt to replicate for a general

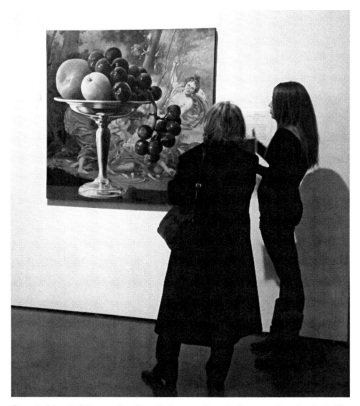

Figure 2: Colorado College student Alison Speissegger discussing her research on Sherrie Wolf's painting Time Conquered by Youth and Beauty at the Strange Beauty IDEA Cabaret program. Image courtesy of the artist and Laura Russo Gallery, Portland, OR. Photo: Scott Bauer Photography.

audience what the students identified as "breakthrough" moments in their own learning processes. Coming at the conclusion of the academic course and after the completion of the exhibition text, the *IDEA Cabaret* provided further evidence that the students had indeed achieved a higher level

of learning. Not only had they understood The Age of the Baroque's core concepts and gained familiarity with the work of selected contemporary artists, but they also understood, and were able to articulate and replicate, the trajectory of their own learning processes.

Core elements of project success: Several key elements contributed to the project's success. At the outset, it was important that Hunter-Larsen and Tucker established a clear curatorial vision and organizational structure for the project while allowing flexibility for students to conduct and present original research. The students did not choose objects for the exhibition, nor were they given free rein to choose the comparisons between 17th and 21st century artworks. However, the structure of their assignments stimulated their investigations of the meanings of the works and inspired them to draw original conclusions about the broader social and aesthetic implications of the comparisons between specific 17th and 21st century objects. This balance between predetermined structure and intellectual exploration ensured that the project resulted in a professional, yet lively, public exhibition.

Another factor in the project's success was the inclusion of the museum studies component, as the extended investigation primed students to consider the implications of arts-based learning within a public setting as they were engaged in the process of developing interpretive elements. The collaborative nature of working on the exhibition further demanded that the students negotiate between different philosophical or

aesthetic viewpoints to arrive at a shared vision. For example, while initially undertaken as individual assignments, the labels that compared 17th and 21st century artists ultimately had to present a unified and cohesive explanation of the exhibition's thesis to a diverse public audience. To ensure the texts were not repetitive, while remaining stylistically unified and comprehensive, the students presented their labels in a workshop format, reading them aloud, critiquing them, and suggesting revisions. Despite the very compressed timeline for their creation, these short texts went through three revisions prior to the exhibition's opening.

Finally, the exhibition's public presentation in the college's IDEA Space gallery invested the exhibition-related assignments with a sense of urgency and importance. Much was at stake for the students, and they rose to the challenge. Academically, the students were evaluated both on their understanding of the course material and on their ability to reframe and distill that information within the informal learning environment of the gallery exhibition. As they realized their work was part of an active scholarly and public discourse about art and art's broader social meanings, students became increasingly emotionally invested in their research and the development of the exhibition as a whole. By immersing students in an authentic, high-stakes learning experience, *Strange Beauty* ultimately resulted in creative, popular, and critically acclaimed exhibition that inspired participating students to understand the intrinsic value of the arts in the production of knowledge.

Future directions: The crux of the students' involvement in the development of the *Strange Beauty* exhibition – the comparisons between historical and contemporary art – addressed one of the core challenges to the development of collaborative exhibitions at Colorado College: how to develop exhibitions that support teaching within content areas but are not solely dependent on the presence of specific objects. Like many small institutions, the college does not host a permanent collection, nor does the institution have the financial means and physical infrastructure to borrow representative works from the full canon of art history for temporary exhibitions. United by a desire to collaborate, but unable to host a full exhibition of 17th century works, Tucker and Hunter-Larsen had to develop an alternative methodology to uncover and elucidate concepts central to the understanding of Baroque art using available resources. The process of inviting students to conduct in-depth research on the historical Baroque and then further developing that knowledge within the context of a contemporary art exhibition presented an effective solution. With relatively few adjustments to the existing curriculum for The Age of the Baroque, Tucker was able to explore thoroughly the course's salient art historical issues while the students' research added historical gravitas to a public exhibition of contemporary art.

While this particular exhibition project was a one-off event, the model remains applicable within other collaborative contexts: the professor and academic curator identified aesthetic, social, and philosophical issues central to the time

period or culture of a regularly-taught course and developed a fully-realized exhibition that provided opportunities for students to further their understanding of those issues through historical or cross-cultural comparisons.

Nigar Nazar: Freedom and Authority in Pakistan and the Middle East

Project design: While the *Strange Beauty* exhibition comprised a significant portion of the students' coursework in The Age of the Baroque – and therefore required a deep engagement between the professor, the students, and the academic curator – the *Freedom and Authority* project presents a model for interaction based on a single course assignment. In the eighteen days of the course, only four involved direct class time on the exhibition. The project involved students enrolled in a history/cultural studies course entitled Freedom and Authority: Men, Women, and Children in the Middle East, taught by professor Jane Murphy. The course examines conflicts of individual freedom and institutional authority in ethics, politics, science, and religion as manifested within the lives of citizens living in Middle Eastern societies. Rather than participate in the co-development of an exhibition, students in Freedom and Authority were invited to contribute to an existing exhibition, which was re-installed to reflect the expansion of the curatorial thesis (Figure 3).

The project began with an exhibition of cartoons by Nigar Nazar, Pakistan's first published female cartoonist and a visiting Fulbright scholar to Colorado College in the fall of

Figure 3: Cartoon by Nigar Nazar. Image courtesy of the artist.

2009. Several months in advance of the exhibition, professor Jane Murphy and academic curator Jessica Hunter-Larsen chose works for the exhibition from digital images sent by the artist. Selections for the exhibition focused on the central themes of the Freedom and Authority course with specific emphasis on the intersections between citizens' private and political lives and the shifting roles of women in the Middle East. The high-resolution digital images were then printed, mounted, and installed in an exhibition held at the Colorado Springs Fine Arts Center, a separate institution located adjacent to Colorado College. Upon her arrival at Colorado College, Ms. Nazar toured the exhibition with students and gave a public talk at

the Fine Arts Center, establishing a baseline understanding of the initial exhibition and the exhibition's goals for both the campus and the broader community.

For their assignment, students in Freedom and Authority were invited to select Western cartoons that focused on expressions of power in public and domestic life. They wrote wall text labels that compared the Western and Pakistani cartoons, identifying common themes and areas of cultural disconnect. In preparation for the assignment, students met with Hunter-Larsen to tour a museum exhibition and discuss how exhibitions can communicate complex ideas through the selection, presentation, and placement of objects and ideas. Once the students had chosen their comparison images and completed the explanatory text, they worked with Hunter-Larsen to re-design the exhibition to include their work. By adding curated images and written analyses, the exhibition purview broadened to include issues of global cultural identity; the new iteration of the exhibition then reopened to the public with a gallery talk featuring the artist Nigar Nazar and the Freedom and Authority students.

Learning objectives and outcomes: Using the familiar medium of cartoons, the project presented Freedom and Authority students with a concrete way to engage their burgeoning academic knowledge of Middle Eastern cultures and conduct sophisticated comparative cultural studies. Working with the familiar medium of the cartoon seemed to dispel the anxiety of non-arts students that they might be expected to engage in formal aesthetic analyses of the works. By responding to

broader cross-cultural issues as expressed within a popular form of visual culture, the students achieved a greater understanding of social nuances. Creating interpretive labels demanded that the students further reflect on the means by which they understood the subtle social norms communicated through the cartoons, and thus the assignment became a particularly effective means to teach non-arts students to read and dissect elements of visual culture.

In a broader pedagogical sense, the assignment served to build students' expository writing skills. The project's curatorial process required that students identify cartoons with particular relationships to each other and, through the creation of interpretive text, explain and develop those relationships for a novice audience. The process mirrors the construction of a good expository essay where the author orchestrates a "conversation" between various sources to lead readers to a fuller understanding of a particular issue. Through the process of selecting, interpreting, and presenting their comparisons, students came to understand that, while any given cartoon in the exhibition could have multiple interpretations or tell many stories, the assignment required the students first to locate, and then elucidate, a specific story to be told. The project thus allowed students to negotiate between the elements of creativity and factual authority that form a compelling intellectual argument. Not coincidentally, the assignment also replicated the core conceptual framework of the course: the tension between freedom and authority.

Core elements of project success: Comprising a small portion

of an academic course and executed in a short period of time, the success of the *Freedom and Authority* project relied upon the existence of a structured framework, created by Murphy and Hunter-Larsen, within which the students could conduct their investigations. Students acted as creative responders to a pre-existing exhibition, a condition that allowed them the autonomy to explore their topics while remaining secure in the knowledge that the success of the exhibition as a public enterprise did not rest solely on their contributions.

That the exhibition was held in an off-campus venue and widely publicized in the region did, however, significantly heighten the stakes for students. Rather than turning in an essay for the solitary evaluation of their professor, the students were aware that their work comprised a significant element of a public, and very popular, exhibition. As with the *Strange Beauty* exhibition project, the public presentation of the project demanded that the students reflect upon their own processes of understanding the material – a necessary step in the construction of clear interpretive text that facilitated visitors' learning processes. An ongoing engagement with the artist Nigar Nazar also introduced a personal dynamic to the project; students first experienced and analyzed her cartoons without knowing the artist, then, after working with Ms. Nazar in a classroom setting, became ambassadors for her work to a broad public audience. Finally, the universality of the medium of cartoons and the flexibility of the method of presenting and quickly re-presenting them ensured that the project could be developed and executed within a short period of time.

Future directions: Based on the public and academic success of the project, Murphy and Hunter-Larsen collaborated on a further iteration of this project in the fall of 2011. Similarly situated within the context of the course Freedom and Authority in Everyday Life: Men Women and Children in the Middle East, the project began with an exhibition of cartoons from the Middle East in one of the college's public galleries. Curated by Murphy and Hunter-Larsen, the exhibition *Humor in a Global Context* presented cartoons from multiple artists in the Middle East. The format of the project remained the same: the students were assigned to select comparative cartoons and write interpretive labels, and the exhibition was redesigned to reflect an expanded thesis. Both pedagogically and publicly, the second *Freedom and Authority* project was quite successful. Through the curatorial and interpretive processes, students again achieved – and publicly demonstrated – a fluid understanding of the issues presented in the course. The appeal of the cartoons, and the inclusive and transparent nature of the exhibition's evolving structure, drew audiences from the campus and broader community.

While a yearly public exhibition of Middle Eastern cartoons may not best serve a broad audience, with modifications to artists and specific subjects addressed, the project can be repeated at regular intervals to support the Freedom and Authority course while providing a dynamic cross-cultural experience for public audiences. Modifying the project to include other forms of popular culture, such as an exhibition comparing banned books from the Middle East and the

United States, would further expand the range of exhibition possibilities while retaining the structure of the assignment within the academic course.

Conclusion

In both the *Strange Beauty* and the *Freedom and Authority* collaborations, the professors felt that active involvement with exhibitions significantly strengthened the students' understanding of the material. By engaging in the curatorial processes and their public presentations, the students in both classes not only achieved a greater understanding of their academic materials, they were also able to understand and explain how they knew what they knew, thus demonstrating ascending levels of mastery.

Through the exhibitions' public presentations, a broader audience was invited to participate in the curatorial classroom as well. In both instances, introductory exhibition material explained and credited the students' involvement in the development and interpretation of the exhibitions. Making the process explicit invited viewers to consider the medium of the exhibition as a fluid mode of understanding rather than a distinct and fixed product of a singular curatorial vision. By focusing on exhibition development as an evolving and transparent intellectual process, both projects offer models for collaboration that mediate between the museum's mandate to offer variety to a broad audience, and the professors' need to develop effective and repeatable pedagogical elements within their regular courses. By developing these collaborative

models, Colorado College created a new paradigm for considering the museum as a central player in fulfilling the college's mission to provide opportunities for active learning to academic and public constituencies alike.

EXHIBITIONS AND EDUCATION

Faculty and Student Curators: An Exhibit Template for Course Integration

JOY BECKMAN
Wright Museum of Art, Beloit College

Curating an exhibition as part of a class can be an exciting opportunity for faculty who want to deviate from the standard routine of papers and exams as modes of learning. Yet, at the same time, faculty may be hesitant to take this opportunity because of their justified concern that the medium of learning becomes the sole object of learning. In other words, the project of curating an exhibition overwhelms the course. For example, a seminar on Asian religions – with an exhibit as a final project – becomes enmeshed in the logistical problems of exhibit design. As director of a small college art museum, whose mission is centered on undergraduate teaching, I was interested in encouraging faculty to curate exhibitions with their students. I set out to develop a template for a syllabus that could minimize these logistical concerns. The goal was to create a template that could be appropriated by any faculty member and incorporated into a class with only modest modification to the course syllabus. This would allow the faculty to use exhibit development as a means to explore their own subject with their students. This template is not meant to teach exhibition design – the ultimate goal is to facilitate student learning using museum objects.

The syllabus template divides the exhibition development process into a series of short assignments that are spread over a semester. The model that follows was designed with a fifteen-week semester in mind. The template requires four to six class periods, and consists of three paper assignments (one individual paper and two group papers). Through these papers and assignments, students study individual art works

or artifacts and then relate them to the larger topics addressed by the course.[1]

Syllabus template

Prior to the semester: Before the semester, the faculty member works with the museum staff to select a group of works of art from the museum's collection that are related to the topic of the course. A course on American Realism in Literature might consist of a series of complementary prints from the Ashcan school; while a class on Buddhism might consist of a group of religious icons. The number of objects selected, typically ranging from ten to fifteen works, is tailored to the number of students in the class, with an ideal class size being seven to twelve students. The works are drawn primarily from the permanent collection, but on occasion when art works are not available for a particular subject, inexpensive reprints may be purchased for the show. Faculty and students generally accept reprints, especially when the nature of the course is directed primarily to the subject matter presented in the works of art, and the course is not exploring the topic of authenticity or a particular art process. Faculty are also asked to choose a title for the show before the semester begins.

Second week of the semester: At some point in the second or third week of the semester, a member of the museum staff gives the class a guided tour of the gallery space where the exhibit will be mounted. Before the gallery tour students are introduced to the basics of exhibit design through assigned readings. A good example of a basic introduction is *Designing*

Exhibits in David Dean's *Museum Exhibition Theory and Practice.*[2] Students are provided with a diagram of the gallery space that gives the gallery dimensions and other pertinent details such as outlets. Following the gallery tour, students are taken to the print study room, where all the objects that have been pre-selected for the show are laid out. They are given a brief introduction to the objects and to museum archives, where they might find information about the objects. This introduction is led by the faculty and museum staff. The faculty can use this as an opportunity to discuss how these objects fit within the theme of the class, while museum staff can talk about the curatorial and conservation concerns that impact what objects are chosen. Students are asked to choose one or two of the works to study and write a five-page paper on their chosen object(s). Students are given four weeks to complete their object studies.

Weeks three through six: Museum staff make the works of art accessible to students as they research their objects.

Week six: Students hand in their object papers for review.

Week seven: By week seven, students are well into the course and are ready to think about the major points or sub-themes that they want to focus on for the exhibition. Depending on the number of students in the class, and the size of the gallery, students are divided into three or four sub-themes groups. Faculty may identify sub-themes based on various topics covered in the course or allow students to choose the sub-themes based on the student's own interests. Once students are assigned to a subgroup, the students are asked to share their

object study papers with members of the group. Each group reads through the different object studies and discuss among themselves how the objects can be brought together under the sub-theme. Through group discussion, each sub-theme group develops a short paper (two or three pages) describing or delineating the sub-theme.

Week eight: By week eight of the semester, students are ready to start designing the exhibition. Class redivides into new groups to create a plan for organizing the exhibition. Members from each sub-theme group are divided up into different design teams, so that each design team contains members from each sub-theme groups.

The reorganization of groups is *essential* to create a balanced exhibition and a coherent narrative. If sub-theme groups and design teams are made up of the same students, each design team will tend to highlight its own sub-theme, instead of trying to design a coherent exhibition. Therefore, *the reorganization of the groups is essential*.

Each design team is charged with developing an exhibition design that includes all the sub-themes. Drawing on the sub-theme papers and list of objects, each team creates gallery drawings that identify where the objects are to be placed and the general flow of the exhibit. These designs are then presented to the entire class. Through discussion, the class as a whole selects one of the designs or modifies and combines different proposals to create a design that is agreed on by the entire class. A good discussion is generally facilitated by having the class present the different proposals in the gallery space.

Museum staff may wish to join this discussion to address some of the curatorial concerns that need to be considered, such as conservation and visitor safety. Alternatively, museum staff may wish to hold a separate meeting with the students to talk about the various factors that go into to exhibition design.

Students are asked to do a few basic readings on exhibit design and object labeling. Texts that have been used effectively include *Storyline and Text Development*, from David Dean's *Museum Exhibition Theory and Practice*, and excerpts from Beverley Serrell's *Exhibit Labels: An Interpretive Approach*.[3]

Assignment: The students are asked to reduce their five-page object studies to a single page of approximately 500 words. As part of this editorial process, students are asked to consider how their work or works of art help narrate the sub-theme and how the pieces fit into the exhibition as a whole. Compelling the students to take their longer papers and edit them down to gallery label length gives them an opportunity to reflect on their work in the context of the larger project. This editorial process also helps ensure that even though an exhibit label may only be a couple hundred words, a substantial amount of research has gone into the project.

Week nine: Students continue to refine their individual object papers and work in groups to edit the sub-theme papers. Each student is also asked to write a two-page main wall text explaining the exhibit. They are then asked to share their main wall text with the class. The faculty may choose one of the main texts or he/she may have the class collectively write a main text panel after reading the individual text panels. At this point, the

each group should edit their sub-theme paper down to a label of approximately 500 words.

Week ten: By week ten, the art works are ready to be moved into the gallery. Museum staff may choose to move the art works themselves, or have students from the class help move the art works. Students identify any necessary pedestals and vitrines for their exhibition, and assist in moving them into the gallery. Art is arranged on the floor on blue board or other archival material in an approximate arrangement as decided upon by the class. Another option, which works really well when museum staff would prefer that students not handle the art, is to mock up the layout in the gallery using butcher block paper. Paper is cut to the exact dimensions of each work of art and then printed images of the artwork are attached to the paper, which is then hung on the wall using painter's tape. Using paper mock-ups allows students to make final adjustments to the arrangement of the artwork, prior to the installation of the actual works of art. Museum staff may join the class to offer final critique and advice.

In addition to arranging the art works, it is also helpful to have the students review their narrative one last time, this time in the gallery. A printout of the main theme and each of the object labels and sub-themes are tacked to the wall in the desired arrangement. Students are asked to read through the narrative they have constructed, looking to see if there are redundancies or gaps in the narrative that they have created. Placing these final drafts of wall texts in the gallery prior to preparing the texts for mounting allows students to

spatially experience the arrangement that they have created and make all necessary final edits to their text before they are dry mounted.

The texts should all be prepared for final proof. At this point the faculty may choose to do the final editing before sending the entire wall texts and labels to the museum staff for mounting. The museum staff takes responsibility for mounting the texts on card stock and installing the art works in the gallery.

Student work load for the exhibit consists of:
- One five-page object study paper, which is edited down to around 500 words.
- Group sub-theme paper of two or three pages, which is edited down to around 500 words.
- One main text panel of two pages, which is edited down to around 500 words.
- Group project of exhibit design.

Museum staff work load for each course is as follows:
- Work with faculty to select the works to be included in the show.
- Provide a tour of the gallery space and a lecture on curatorial concerns that impact what objects are exhibited.
- Provide students with access to the works as they research their objects.
- Matte and frame works for the show, and create any

necessary mounts.

- Help students identify pedestals and vitrines needed.
- Participate in exhibition design reviews.
- Mount labeling and wall text.
- Coordinate final gallery layout and installation, providing critique when necessary.
- Install the show.

Faculty class time: total of four to six class periods

- One class to view the gallery and objects.
- One class for students to present their object studies.
- One class for students to present their exhibit designs and agree upon a final design.
- One class to arrange the gallery and read through the narrative they have created.
- Potentially two additional class periods, where the students meet with the museum staff.

NOTES

1 It should be acknowledged that this template was designed for a campus art

museum, whose primary mission is to support undergraduate education.

As each museum is unique, faculty are strongly encouraged to involve

the museum staff from the beginning in the planning of such a course.

2 David Dean, *Museum Exhibition Theory and Practice* (New York: Routledge, 1996),

32-51.

3 Dean, *Museum Exhibition Theory and Practice*, 103-131, and Beverley Serrell, *Exhibit*

Labels: An Interpretive Approach (AltaMira Press, 1996).

Bibliography

Dean, David. *Museum Exhibition Theory and Practice*. New York: Routledge, 1996.

Ferguson, Bruce and Reesa Greenberg. *Thinking about exhibitions*. New York: Routledge, 1996.

Lord, Barry and Gail Dexter Lord (eds). *The Manual of Museum Exhibitions*. AltaMira Press, 2001.

Putnam, James. *Art and Artifact : The Museum as Medium*. New York: Thames & Hudson, 2001.

Serrell, Beverley. *Exhibit Labels: An Interpretive Approach*. AltaMira Press, 1996.

CONTROVERSIAL PROJECTS

University College London

Managing a Controversy: Art, Politics and Hitler's Early Years in Vienna

DEBORAH ROTHSCHILD
Williams College Museum of Art

In 2001 the Austrian Cultural Center and the Clark Art Institute initiated the Vienna Project – a summer program involving eleven cultural institutions in Berkshire County, Massachusetts. The Williams College Museum of Art (WCMA) was among those asked to participate. Its contribution, an exhibition that examined Hitler's early years in Vienna, was the Vienna Project's most risky and potentially inflammatory component. However, through proper management and advance planning the exhibition became a blockbuster, garnering national and international press and bringing record-breaking numbers of visitors into the museum. This essay will examine the controversial aspects of the show and how the museum developed a successful plan for anticipating and preempting negative reactions.

Exhibition overview

The organizers of the Vienna Project had suggested WCMA mount a modest exhibition of Vienna Secessionist posters, but that did not seem like a challenging enough subject for a college campus. I was given responsibility for our Vienna exhibition, and so, in the course of seeking a topic that I found more engaging I was led, through a conversation with a Viennese-born friend and colleague, to Brigitte Hamann's highly acclaimed book, *Hitler's Vienna: A Dictator's Apprenticeship*.[1]

The book engrossed me immediately, and as I read, I noticed the illustrations were few and of poor quality even though art, architecture, and theater were a major part of

Hamann's story. Adolf Hitler was a frustrated architect and set designer, who was a practicing artist until his thirtieth year. Thus, there was plenty of material to make this an appropriate investigation for an art museum. For example, how many people know the work of Hitler's favorite artists: Eduard von Grützner, the kitschy painter of tipsy monks, or Rudolf van Alt, the more accomplished watercolorist who painted scenes of Vienna for Emperor Franz Josef? Who today is aware of Alfred Roller, the progressive scenic designer for the Vienna Opera, whom Hitler idolized and who influenced the staging thirty years later of Third Reich spectacles? The grand buildings of the Ringstrasse and archival film footage of the elaborate historicizing pageants which Hitler witnessed under Emperor Franz Josef made clear how closely he followed these models for the building projects and parades of the Nazi era.

Further, Hamann elucidated the repercussions for Hitler of the social and political situation in Vienna during the time he lived in there, and I could envision ways to bring those aspects into an exhibition as well. The roiling underbelly of the glittering Austro-Hungarian Empire was the young Hitler's milieu. Living in poverty and filled with resentment, he was the perfect target for the anti-Semitic oratory of Vienna's charismatic mayor, Karl Lueger, as well as for the torrent of xenophobic pamphlets, postcards, and newspapers that inundated the city. Many years later both provided blueprints for anti-Jewish hate-mongering and propaganda.

My rational for wanting to organize such an exhibition was that the Williams College Museum of Art is not only an

art museum – it is also an academic institution whose primary mission is to compliment, extend, and fulfill the curriculum of Williams College. We often originate exhibitions based on scholarship that contribute to scholarship across disciplines. Although most for-profit museums would not be able to investigate a controversial subject like Hitler as an artist and the forces that shaped him, that is not the case for a college museum dedicated to fostering scholarly investigation and open debate. Hamann's book presented new information based on thorough research, which only needed a visual component to bring it to life. It seemed like a perfect fit for an academic museum.

WCMA's director, Linda Shearer, was cautiously receptive and together we discussed the exhibition proposal with the college's dean of the faculty, Thomas Kohut. The stars were in alignment because the dean's area of concentration was German history of the first half of the twentieth century. He knew of Brigitte Hamann's book and was interested in the topic. Most importantly, he saw the value of the exhibition to the campus community: the project fitted not only the mission of the museum but also that of Williams College. Thus, to our great delight, he responded favorably and agreed to fund the show up to $100,000 from his discretionary account. If we had not had this support we could never have pulled off a show with over 200 loans, most from overseas.

Exhibition issues

The exhibition dealt with a number of controversial issues. First, anything that potentially humanizes Hitler, the

Figure 1: Georg Ritter von Schönerer, In the 20th Century! *Detail from the Ideal state of the future showing* Juden Galgen *or Jew Gallows. From the:* Politische Bilderbogen, *1894. Printed broadside/pamphlet.*

embodiment of evil in our time, is liable to arouse anger and opposition. It is understandable that many people cannot bear to think about Hitler as anything other than a monster.

In line with this, the light we cast on the primacy of art and theater in Hitler's life was cause for complaint. People tend to believe that those who love art and music are also possessed of decent character. How could the quintessential hate figure of the twentieth century – a madman capable of unspeakable horrors – also be a devotee of art? But the fact remains that from early adolescence Hitler had a deep and abiding response

Figure 2: Executions: hanging of Jewish men. Photograph c.1945.

to architecture, theater, and music. It was in large part his capacity to experience feelings of wonder and pleasure before such works that enabled Hitler to understand and use the power of aesthetics. On his own he studied architecture, stagecraft, and oratory and knew how to tap into the powerful emotions these forms elicit in order to – as he wrote – "bypass reason and manipulate sentiment."[2]

In the exhibition, we showed how as Führer he translated dramatic theatrical effects learned from Imperial state pageants, and especially from the numerous operas he attended, into spectacles of the Third Reich. In particular the Vienna Court Opera productions, as interpreted by the scenic designer Alfred Roller, were his classroom for absorbing the tools of stagecraft, décor, and lighting.

After failing to be admitted into the Academy of Fine Arts,

Hitler spent much of his time studying the architecture of Vienna, and planning imaginary projects such as rebuilding the city of Linz. His boyhood friend, August Kubizek, wrote: "What the fifteen year old planned, the fifty year old carried out, often as for instance in the case of the new bridge over the Danube, as faithfully as though only a few weeks, instead of decades, lay between planning and execution." [3]

A third controversial feature of the exhibition was a section comparing anti-Semitica from around 1900 to that of the Nazi era. Some of the images were highly disturbing (and painfully prophetic) such as Georg Ritter von Schönerer's broadsheet from 1894 advocating murder to achieve a Jew-free state, which we showed alongside Nazi photographs from the 1930s of just such state-sponsored racial killing (Figure 1). I thought it was important to show there were precedents and sources for Hitler's hatred of non-Aryans as well as the notion of a "final solution." [4] Anti-Semitic writings, postcards and cartoons were everywhere in multi-ethnic Vienna during Hitler's time there (as they were throughout Europe). The negative stereotypes Hitler encountered in Vienna in the years around 1910 were recycled almost verbatim during the Third Reich. We showed about fifteen such comparisons. Visitors were shocked not only by the virulence of anti-Semitic cartoons and children's books that were part of the Third Reich's propaganda machine, but by seeing that the same malevolent racist tropes were common at the turn of the century. A key difference was that the murder of innocents was not state policy in Vienna.

A fourth controversial feature was the inclusion of two

Figure 3: Adolf Hitler, Mountain Chapel. *1910, watercolor on paper.*

watercolors painted by Hitler (Figure 3). Some on the museum's staff and others in the college thought hanging his paintings on our walls would be seen as validating his status as an artist. The college administration was supportive of the exhibition but was absolutely against including actual watercolors by Hitler. Beside the reason stated above, there was fear that neo-Nazi groups would swarm to the museum as to a shrine or that anti- Nazi groups would picket and protest. Thus, the administration requested that we use facsimiles. In the end, we prevailed and displayed the original watercolors without major incident. Although some individual skinheads attended and some left Holocaust-denying pamphlets in our brochures, no groups disrupted the exhibition.[5]

Probably one reason there were no such disturbances was because the two watercolors we showed are so slight and

insignificant. They are amateurish and innocuous in subject, style, and scale – measuring about four by seven inches. Secondly, the label made clear that one of the watercolors was commissioned by a Jewish man – a lawyer named Joseph Feingold. Mr. Feingold saw Hitler's postcard drawings in the frame shop of his friend Samuel Morgenstern and ordered several scenes of his hometown. Morgenstern helped Hitler, who was then living in the Meidling men's homeless shelter, by displaying the watercolors, finding clients, and advancing him money. Through this arrangement Hitler was able to recover from abject poverty. He moved into a municipal men's hostel in 1910, where he lived until he left for Munich to avoid the draft in May of 1913.

The picture that emerged of Hitler during these years was of a conflicted young man filled with juvenile fantasies and delusions. His idolatry of Richard Wagner (1813–1883) led him to adopt the master's belief system, including his anti-Semitism, the cult of Nordic pure blood, pan-Germanism, and especially the idea of an artist/prince arisen from the people who redeems his country. Yet, at the same time, Hitler was an admirer of the adventure writer and pacifist Karl May.[6] Hitler's personal experience led to friendships and associations with a surprising number of Jewish people. As Dr. Eduard Bloch, his mother's physician noted, during these years "Hitler had not yet begun to hate the Jews." [7]

In the exhibition we included reminiscences of people who knew Hitler at this time and we were lucky enough find and borrow the memoir of Reinhold Hanisch, a handyman who

occupied the cot next to Hitler at Meidling. He described not only Hitler's friendly relations with Jews but also Hitler the nascent tyrant whose political rants made him a figure of fun to the other inmates.

The public relations strategy
Once the exhibition proposal was approved by the college administration, I met with the director of the Clark Art Institute and impresario of the Vienna Project, Michael Conforti, and told him of the idea for an exhibition on the formative influence of Vienna upon the young Hitler. Naturally, he was at first taken aback. After all, the county-wide project was intended as a celebration of Vienna as a tourist destination – a show about Hitler was not what he had in mind. But to Mr. Conforti's credit and open-mindedness, he did not try to deter WCMA from mounting this controversial exhibition. Instead he offered to extend the services of Resnikow Schroeder Associates, a high-end New York public relations firm with whom the Clark was already working, to help WCMA prepare for any controversy our contribution to the Vienna Project might generate. Thus, in November 2001 we had a four-hour meeting with David Resnikow where he and his staff set out the pitfalls that lay ahead, for which we needed to plan, and tutored us in the way to present an exhibition with as much sensitivity as possible.

With Resnikow's help we created a preemptive approach that had five elements. First, we generated awareness of the show several months in advance. So in the spring of 2002, from

March through May, I spoke with Rabbis and met with diversity coalitions, interfaith councils, local leaders, faculty from Williams and neighboring colleges, and various community groups. I presented slide lectures to Jewish congregations, to assisted living homes, to continuing education groups, Hadassah, the Chamber of Commerce and to visitor and tourist associations. I spoke to educators from throughout the county including college professors at Williams College, the Massachusetts College of Liberal Arts, and Berkshire Community College as well as local high school teachers. I also went before the Viennese Cultural Center in New York City and explained the show.

In all these gatherings I stressed that the exhibition did not in any way glorify Hitler but rather looked at the influences that formed his ideology including his pan-Germanism and his belief in the myth of Aryan pure blood. These ideas initially were transmitted to Hitler through his profound response to the music and philosophy of Richard Wagner, and were buttressed by books and pamphlets written by a lunatic fringe of racial theorists (such as Guido von List, Georg Ritter von Schönerer, and Lanz von Liebenfels) that the young Hitler encountered in Vienna. In the wildly popular anti-Semitic mayor of Vienna, Karl Lueger, Hitler found an exemplar of a savvy and charismatic political leader who could rouse masses of people through stirring oratory.

In addition I stressed how Hitler's understanding of the power of aesthetics played a tremendous role in his rise to power. As chief designer, producer, director, and leading actor

in Third Reich productions Hitler created a quasi-art form where dramatic lighting and overblown scale combined with the thrilling rush of music, stylish yet fear-inducing uniforms and banners topped by his carefully choreographed speeches worked crowds into a frenzy.

Finally, I outlined Hitler's years in Vienna from his initial struggle to become an artist beginning at age 16, until his departure for Munich at 23. All of this helped to inform people who might be anxious about the theme and content of the exhibition.

Second, we formed a planning committee of seventeen people composed of faculty, students, and members of the community who could speak about the exhibition to their various constituencies. In these advance meetings I answered people's questions and addressed their concerns, thereby short-circuiting negative reactions. People felt informed and in the loop and therefore did not react poorly when word of the show began to circulate.

Next, at Resnicow's suggestion we enlisted third-party spokespeople. The eminent historian and Princeton professor, Carl Schorske, and the author who inspired the exhibition, Brigitte Hamann both endorsed the show to the press and participated in our programming. Dr. Schorske spoke to a group of alumni in New York and Ms. Hamann delivered a public lecture at Williams.

Our preemptive work also focused within the museum. Mr. Resnicow cautioned that anyone on our staff could be a representative to the press and therefore all staff needed to be

aware and informed, so we prepared a question and answer sheet for everyone on staff. He told us that the Jewish Museum had encountered a problem with their *Mirroring Evil* exhibition the year before, in part because an employee spoke to the reviewer from *The New York Times* without being knowledgeable about the show. Thus, even casual conversation was addressed, since a staff member saying they didn't understand or support the exhibition could be very damaging.

Finally, in all our literature we were careful to put the exhibition in the context of our museum as part of an educational institution that fosters research, debate, and discussion. The press release read: "As an academic museum dedicated to the scholarly investigation and interpretation of important issues in relation to visual culture, WCMA is ideally suited to present the subject of Hitler's years in Vienna."

The reception to the exhibition

There was a press conference at the Austrian Cultural Forum in New York City in May – two months before our show opened – and the museum's director, Linda Shearer, wrote to the invited journalists, "This is a large and difficult subject to tackle and one that is quite distinct from the other Vienna project plans... We are concerned that it not be taken out of context and misrepresented before it opens on July 13th." She ended her letter by offering to answer any questions.

Several days before our show opened, while we were still installing, WCMA was included (along with Mass MoCA which was presenting a show of contemporary Viennese artists) in a

press junket organized and financed by the Clark Art Institute. We served lunch to a bus load of journalists and then gave them a tour. This gave us invaluable media exposure that our museum, being far from any metropolitan center, would not have had otherwise.

The exhibition *Prelude to a Nightmare: Art, Politics and Hitler's Early Years in Vienna, 1906-1913* opened in July 2002 with over 230 objects, three videos and included two watercolors by Hitler.

One of the first reviews that appeared was not favorable and I was devastated. Written by Lee Rosenbaum for the *Wall Street Journal* and titled *The Adolf Hitler You Never Knew*, it described the show as "insidious," because it "defines fascism as a kind of art movement." Of course, many writers and filmmakers had investigated the central role of the arts for Hitler and the aesthetic impulses at work in the Third Reich, including Peter Adam in *Art of the Third Reich*, Jonathan Petropoulos in *Art as Politics in the Third Reich*, Peter Cohen's film, *Architecture of Doom*, and most recently, Frederic Spotts in *Hitler and the Power of Aesthetics*. Puzzling to me was that Rosenbaum had ignored the social and political material in the exhibition and the descriptions from primary documents of the young Hitler's interest in politics and race. Several historians wrote letters to the editor of *The Wall Street Journal* in our defense, including Frederic Spotts and our highly-respected spokesperson Professor Carl Schorske, but the *Journal* did not print them.[8]

In any case, after that, nearly every other review was favorable. Peter Schjeldahl wrote a long piece in *The New*

Yorker and dubbed the show "a trenchant scholarly exhibition with well written wall texts and judiciously selected art works and artifacts." Holland Cotter in *The New York Times* called it "fascinating and well worth the effort." And Timothy Cahill in *The Albany Times Union* wrote, "the exhibition is an act of total intellectual courage."

In response to the positive press, Rosenbaum wrote a second article in *The Wall Street Journal* denouncing her fellow journalists who had praised the exhibition. It was titled *Critics Uncritically Buy Addled View of Adolf the Artist*. Here she chastised reviewers for buying into the premise of the show.

In the meantime, crowds descended upon the museum in unprecedented numbers. People lined up early in the morning for the ten o'clock opening. We often had more visitors in one day than we had in an entire year. Viewer response was overwhelmingly positive. The comment books record scores of notes requesting that the show travel, or writing how important and moving it was for them. I did receive a handful of hate mail, but most came from people who had not seen the show.

Not only did the Williams College Museum of Art's contribution to the Vienna Project fail to generate negative publicity and public response, it proved to be an unexpected success. The exhibition generated more visitors and press than had any previous show.

After the project ended Charles Bonenti, the art critic for *The Berkshire Eagle* wrote: "Of all the Vienna Project exhibitions around the county this summer, the one that got the most

press outside the Berkshires was not Klimt at the Clark or new art at Mass MoCA, but the Hitler-inspired show at the Williams College Museum of Art. It was written up in *The New Yorker*, *Newsweek*, *The Wall Street Journal*, *The New York Times*, and by the *Associated Press*. Not bad for a small college art museum." [9]

In addition to a spot on *CNN* and reviews in the publications named above by Bonenti we were covered by local television and radio stations across the country from San Diego to Dallas to Miami. *National Public Radio* did a feature and the exhibition was reviewed by over eighty newspapers and magazines nationally and internationally, including *Die Welt*, *Die Zeit*, *The Jerusalem Post*, the *Toronto Star*, and the *Irish Times*.

Conclusions

In the end there are a few reasons this exhibition, organized by a small rural college museum, received national and international attention. The main reason of course was the subject matter – the phenomenon of Adolf Hitler continues to horrify and fascinate more than 65 years after his death. As a scan of recently published books indicates, inquiry into Hitler's personality and the Third Reich's twelve-year reign of terror has not abated with the passage of time.

It has been my experience that well-attended shows result from having a buzz through word-of-mouth and/or press coverage. We were fortunate to have both. Because we had met with so many groups, the exhibition had recognition value when it began to appear in the press. People tend to note and respond to things that are already familiar.

In large part we owed the success of the show to having access to the resources of the Clark Art Institute. Not only for the advance press it was able to garner, but also for the advice of a seasoned PR firm that enabled us avoid pitfalls. We learned from Resnikow and Schroeder the way to be on the right side of a controversy is to prepare. Anticipation of potential problems for the most part allows one to avoid them.

We conveyed from the start our understanding that anything having to do with Hitler that can potentially humanize him is highly offensive to many people. But, as Joseph Brodsky said, "the most riveting thing about Evil, is that it is wholly human." [10] My hope was to communicate a more complicated and nuanced understanding of who Hitler was and the time and place that shaped him. I felt – and I still feel – the curator's job is to present a shaded picture since that is closer to the truth.

NOTES

1 I am grateful to Eva Grudin for suggesting I read Brigitte Hamann, *Hitler's Vienna: A Dictator's Apprenticeship* (translated from the German by Thomas Thornton (New York: Oxford University Press, 1999)).

2 Adolf Hitler, *Mein Kampf* (translated from the German by Ralph Manheim (Boston: Houghton Mifflin Company, 1943), p. 107 and pp. 650-651. Also relevant is Hitler's statement: "A mass rally is designed to switch off the thinking process, only then will the people be ready to accept the magical simplifications before which all resistance crumbles." Adolf Hitler, quoted in Joachim Fest's documentary film, *Hitler: a Career*, 1984.

3 August Kubizek, *The Young Hitler I Knew*, (translated from the German by E. V. Anderson (Westport, CT: Greenwood Press Publishers, 1954)).

4 Even before he arrived in Vienna, Hitler was aware of the founder of German ultra-nationalism, the politician Georg Ritter von Schönerer, from whom he appropriated the "Heil" greeting, the title of Führer, and the positions of exterminating Jews and forbidding racial mixing. Regular visits to Parliament were another source of future doctrine. There Hitler heard the pan-German deputy Karl Iro put forward measures against non-German ethnic groups: "Each Gypsy should be marked in a manner that will make it possible to recognize him at any time. For example, a number could be tattooed on his right forearm." At this same session Iro called for the internment of these "undesirables" in concentration camps. [June, 1908 session of Parliament. Hamann, p. 219.] In addition to von Schönerer's broadsides, Hitler encountered the notion of murdering "racially inferior" people in the writings of Lanz von Liebenfels: "Bad race is the reason insane asylums and looneybins are overcrowded. If the federal government pursued a racial economy and gently annihilated those families with hereditary impairments, it would be possible to save a considerable part of the nine million kronen

per annum!" Ostara, December, 1908.

5 The museum took extra security precautions, hiring additional guards and

working with campus security. The details of the security plan are beyond

the scope of the chapter.

6 Hitler borrowed a pair of shoes from a fellow hostelier to attend the lecture

by Karl May entitled, "Upward to the Realm of Noble Man" which

advocated universal tolerance for all races and ethnicities delivered

March 22, 1912 at the Academic Society for Literature and Music in Vienna.

May wrote: "Physique, color of skin, etc., do not matter at all and don't in

the least affect a human being's worth or lack of worth." From boyhood,

Hitler enthusiastically read May's novels of the old West. As Führer, in 1943

Hitler printed 300,000 copies of May's Winnetou, the Red Gentleman

about the adventures of a fictional chief of the Apaches for the soldiers

in the field. Hamann, p. 380 – 382.

7 Eduard Bloch, "My Patient Hitler," Colliers, March 15, 1941.

8 Frederic Spotts letter read in part: "Lee Rosenbaum's snide commentary

about Prelude to a Nightmare betrays a comprehensive ignorance of

Hitler and the Third Reich. At a minimum had she looked at Peter Adam's

Art of the Third Reich, Jonathan Petropoulos's Art as Politics in the Third Reich

or seen the film Architecture of Doom, she would realize that she, not the

curator of the exhibition, is out of her depth on this subject by failing

to understand the central importance of the arts to Hitler and the

aesthetic impulses at work in the Third Reich." Letter dated July 31, 2002.

9 Charles Bonenti, "Last Call for Hitler", The Berkshire Eagle, October 16, 2002.

10 Joseph Brodsky, Baccalaureate Address, Williams College, Williamstown,

Massachusetts, 1984

Effective Collaborations: The Case of the Dominated and Demeaned Exhibition

ALICE ISABELLA SULLIVAN,
WENDY SEPPONEN & JENNY KREIGER
University of Michigan

Dominated and Demeaned: Representations of the Other was a small temporary exhibition organized at the Kelsey Museum of Archaeology at the University of Michigan (21 October 2011 – 29 January 2012). The installation focused on racist household objects produced in the first half of the twentieth century for White America known as "Black Collectibles." [1] These included small, handheld objects such as salt and pepper shakers, a letter opener, and a fishing lure, all of which feature exaggerated, degrading caricatures of African Americans (Figure 1).

In contrast to the antiquities displayed in the Kelsey galleries, these objects were brightly colored and highly glazed, which made them visually magnetic, even startling in purely aesthetic terms. In the exhibition, these Black Collectibles were placed in dialogue with visual representations of the enemy Other from the imperial era of New Kingdom Egypt, which were represented by photographic images of famous artifacts from the Tomb of Tutankhamun. The ancient-modern juxtaposition highlighted the remarkable extent to which many visual tropes of Otherness deployed in the Black Collectibles had their roots in formulae that appeared in ancient Egypt specifically to represent ethnically stereotyped domination over traditional enemies.

This juxtaposition also highlighted the shared concept in the ancient and modern phenomena of saturating a social environment with imagery purveying these tropes of Otherness specifically for objects to be held, touched, grasped, and used in various ways that emphasized modes of physical power relations. These visual tropes of Otherness and their

Figure 1: Display case with Black Collectibles.

physical presentations on objects meant to be handled took on a new and elaborately expanded life in the household items from Jim Crow America, however. The juxtaposition of the Black Collectibles with the ancient material made manifest the extent to which the American phenomenon took ancient tropes into a unique and historically contingent zone of relentless racially-based suppression far removed from the ideological basis of the ancient model. One such shift was clear in the virulent sexually allusive and demeaning content presented by the Jim Crow objects – a phenomenon that was not part of the ancient Egyptian message, which eschewed motifs of male emasculation and representations of female Others altogether.

While thus being revealing in many ways about the ancient Egyptian experience, *Dominated and Demeaned* called into question for some the appropriateness of introducing modern American material and political issues into the galleries of a

museum dedicated to Old World archaeology. The ancient comparative material could only appear in the form of large color photos on wall panels because the museum's collections do not include good exemplars. This, combined with the extraordinary visual magnetism of the modern artifacts in all their vivid materiality of physical presence, emphasized the modern content and, in the minds of some, tipped the balance. Additionally, the exhibition asked visitors to confront issues of racism and the complicity of visual and material culture production in forging and perpetuating racist stereotyping and racist behavior.

Political content of this sort had not previously been in the tradition of the museum. However, the Kelsey Museum's academic mission made possible the display of the Black Collectibles and public engagement with the exhibition's themes. Indeed, what was most remarkable about *Dominated and Demeaned* was that it was the result of a creative and effective learning collaboration involving Professor Margaret Cool Root (Professor of Classical and Near Eastern Art and Archeology, and curator at the Kelsey Museum of Archeology), 80 undergraduate students from her history of art course Art and Empire in Antiquity (Fall 2011), along with the three Graduate Student Instructors (GSIs – the authors of the present chapter), museum docents and professional staff, as well as Professor Kenneth W. Goings.

The unique opportunities and challenges that *Dominated and Demeaned* provided make it an exceptional case study not only for exhibiting controversial materials in an academic

museum setting, but also (and especially) for collaborating among students, faculty, and museum staff. The flexibility and strategic thinking necessary for this project created a precedent for future collaborative learning experiences on sensitive topics in campus museums at the University of Michigan. In exploring the genesis and reception of this special exhibition project, we will consider the actual interactions between teachers, students, and university and museum staff, the praise and criticisms from the exhibition's many and varied audiences, and the opportunities afforded by the particular setting. This chapter aims to reveal the value of this exhibition for the university community, the public at large, and future collaborative museum projects (even of a controversial nature) intended for academic settings.

From its early stages *Dominated and Demeaned* was closely tied to the history of art course, Art and Empire in Antiquity. The course was an active and integral factor in the planning, development, and execution of the exhibition, and in turn the exhibition accounted for student participation with the complicated and problematic social histories involved in the Black Collectibles. This tightly intertwined relationship between curriculum and museum led to several collaborative opportunities between students, teachers, and university and museum staff.

The exhibition formed a critical portion of the course's sustained mission to encourage student engagement with visual strategies used in imperial subjugation along ethnic, racial, and gender lines. The course was structured carefully

around the Race and Ethnicity (R&E) requirement for undergraduates in the College of Literature, Science, and the Arts (LSA) at the University of Michigan. Courses such as Art and Empire in Antiquity that are designed to satisfy this requirement must prove a commitment to serious and sustained discussions of: "a. the meaning of race, ethnicity, and racism; b. racial and ethnic intolerance and resulting inequality as it occurs in the United States or elsewhere; c. comparisons of discrimination based on race, ethnicity, religion, social class, or gender." [2] Art and Empire in Antiquity thus presented case studies from modern-day America – in conversation with the art of ancient cultures of Egypt, the Near East, Greece, and Rome. Class lectures given by Professor Root delved deep into visual materials that featured images of imperial power, propaganda, and racial and gender stereotyping. Discussion sections led by the GSIs provided students with the opportunity to talk through, analyze, and contextualize the difficult themes and power struggles articulated in the visual material of the course. Through close involvement with teaching staff and adherence to LSA's R&E initiative, the students of Art and Empire in Antiquity explored parallel imperial strategies between historically remote and historically recent visual cultures. *Dominated and Demeaned* became the most immediate, tactile, and experiential example of the course's cross-cultural and cross-temporal studies.

In addition to the 80 undergraduate students enrolled in Art and Empire in Antiquity, ten motivated and committed Kelsey Museum docents also attended the twice-weekly

lectures. The docents participated actively in the course and also served as an ideal focus group for the planning of the exhibition. During the planning of *Dominated and Demeaned*, the docents participated in a workshop with Professor Root, in which they handled the loan objects from Professor Goings' collection and discussed the main issues of the exhibition. They provided an invaluable perspective on the challenges of displaying these sensitive objects for the Kelsey's audiences, with which they are intimately familiar.

In order to come to terms with the visual tropes of Otherness found in New Kingdom Egypt and Jim Crow America, the participants in Professor Root's course experienced the tactile values of the Black Collectibles first-hand before developing their written work on the material, in which they critically assessed how representations of Otherness have operated culturally and historically. The students (in groups of eight to fifteen) handled the Black Collectibles during discussion sessions led by the GSIs and supervised by Kelsey Museum curatorial staff. The handling sessions played a critical part in allowing the students to engage with the tactile value of the Black Collectibles, so much so that Professor Goings encouraged such an experience as part of the loan. In preparation for the handling sessions, lectures addressed the ancient Egyptian historical and visual material, and the students read selections from Goings' book, *Mammy and Uncle Mose: Black Collectibles and American Stereotyping*. During the sessions, the GSIs encouraged the students to pay close attention to the objects' physical, tactile, and material

qualities, as well as to discuss the experience of handling objects with such problematic histories.

The close looking and handling, as well as the discussion of these objects, gave students a unique opportunity to reflect on racial issues in the classroom. The benefits were manifold. To begin with, the experience placed students in the curatorial role, empowering them to look closely for information beyond the immediately apparent. The students became aware that artifacts can carry hidden signs of their manufacture and use that raise fresh issues for contemplation about their social entanglements. They noted, for example, the *Made in Japan* imprints that appeared on the base or back of certain objects, which an ordinary gallery display would conceal. They also took note of signs of wear and areas in which paint had been worn off from repeated handling, thus making the imaginative reconstruction of the objects' everyday use all the more immediate. The close looking and touching also made many of the students painfully aware of the normalized functions that the Black Collectibles performed in the homes of some white Americans in the early- to mid-twentieth century. The handling sessions also affected how the students understood photographic reproductions of the three-dimensional artifacts. Prior to the handling, the students had only seen the Black Collectibles as images in Goings' book, or projected onto a screen during lectures. The sessions encouraged students to draw distinctions between "reading" objects in photographic reproductions, and seeing and handling the objects themselves. The students also gained a sense of the

objects' small scale. The artifacts are easily manipulated and students considered how such diminutive images of African Americans would have reinforced the virulently bigoted attitudes that bred their production and use. The handling sessions cast the students in the role of the performers of these physically subjugating acts, and the students ably and sensitively discussed the troubling implications. For example, they processed the grabbing, turning over, and shaking of a saltshaker in the form of an exaggerated and stereotyped caricature of an African American man. In these handling sessions, the relationships and the divergences between America's immediate past and a millennia-old culture came strikingly alive for the students. Later, they elaborated on their classroom discussions in a written assignment about the specific ways in which formal strategies can articulate imperial and racial power dynamics.

The assignment asked the students to write a two hundred and fifty word wall text that created dialogue between the Black Collectibles and ancient Egyptian artifacts around shared and divergent themes, functions, and formal treatments of Otherness. These short essays were the products of close collaborations between the course, students, and objects. These became a jumping-off point for curatorial decisions regarding the interpretive information that would appear with the exhibition. Logistical constraints, however, prevented the curators from including all of the students' texts in full, though there was still a desire to represent the students' ideas and voices in the exhibition. The museum's editor (Peg Lourie)

Figure 2: Wall with word cloud and surrounding display panels.

synthesized their individual essays into one large document, from which she created a word cloud for enlarged display on the gallery wall. She used an internet program to generate a mass of individual words and phrases that reflected their popularity in the students' writings. The more frequently the students used a word, the larger it appeared in the word cloud (Figure 2). The word cloud panel effectively pulled the students into the physical space of the exhibition and testified to the close collaborations between students, faculty, and curatorial staff.

The students from Art and Empire in Antiquity found the experience of the objects' tactile values – before developing their written work on the material – dynamic, useful, and thought-provoking. The handling session, one student commented, "was especially influential in the way I thought about the *Dominated and Demeaned* exhibition. Holding the Black Collectibles and seeing them as functional objects that existed in people's homes made their meaning and importance resonate with me more than just looking at the images did." Another student, reflecting on the handling session, wrote:

"There is something more dynamic about the learning experience when you can interact with the works [as] opposed to just seeing them in photos on a screen. Being able to touch and interact with the objects allowed me to visualize what it would have been like to use them in everyday life." For most students who have never before worked so closely with art objects or artifacts, the experience of actually examining the Black Collectibles first-hand provided an opportunity unlike any other. Perhaps it is no surprise that one student described this encounter with authentic objects as "one of the most uniquely wonderful experiences I have had at this university."

The physical setting of *Dominated and Demeaned* – not just in an academic museum, but in the particular context of the Kelsey Museum – created a unique context for collaboration. Academic museums (ideally) exist in environments conditioned for learning; college and university campuses abound with intellectual inquiry and dialogue. With sixteen on-campus or affiliated museums and galleries, not counting displays in lobbies, libraries, and other campus spaces, the university gives students ample opportunity to study, work, and engage with challenging issues in museum settings. In an academic environment, where people may expect to encounter things and ideas outside their typical experiences, one hopes that a display of culturally sensitive material will be met with thoughtful contemplation of its meanings – that the viewer will look to *learn*. At the same time, a campus museum may receive off-campus visitors who require additional mediation, so that they can approach the display with its educational goals in

mind. An academic museum should ask for substantial mental effort from its visitors, but it should also prepare visitors for thoughtful engagement with the material presented.

The Jim Crow Museum of Racist Memorabilia, on the campus of Ferris State University in Big Rapids, Michigan, sets a powerful example of how objects like those in *Dominated and Demeaned* can be displayed and interpreted. Before renovations (ending in early 2012), the Jim Crow Museum kept its collection in a single closed room. Visitors entered only by appointment and escorted by guides.[3] Even in an academic setting, this museum provided intensive mediation to ensure that the installation clearly communicated its educational objectives, and that visitors could engage in dialogue about the objects under controlled circumstances.

The Kelsey Museum of Archaeology offers an unusual combination of opportunities and challenges for the collaborative study and display of Black Collectibles. With recently reinstalled permanent exhibitions of ancient Mesopotamian, Egyptian, Etruscan, Greek, and Roman artifacts, this mostly traditional archaeology museum has been experimenting with non-traditional content and means of display (contemporary art inspired by ancient cultures, iPads as in-gallery interpretive tools).[4] Faculty in History of Art, Near Eastern Studies, Classical Studies, Classical Archaeology, and other departments use the museum as a teaching space. Undergraduate and graduate students are invited to view and study objects on display and in storage. The museum also welcomes thousands of primary and secondary school students

every year, as well as home-schoolers, families, and adults. A thriving docent program meets visitors' interpretive needs, and frequent facilities rentals bring various segments of the community into the museum for special events. Any display in this context must take into account the audience's diversity and the museum's educational objectives.

The space available in the Kelsey Museum for *Dominated and Demeaned* shaped the exhibition from its very beginnings. The temporary gallery on the museum's second floor was already reserved for another installation, but the museum was willing to offer a "swing space" by the rear entrance of the first floor galleries. Measuring 10.8 x 14.8 feet, this recess gives access to a public elevator at its north end and a service space behind double doors on the west wall, while the south end of the space is open to the gallery. Because of its transitional nature, the space suited a shift in narrative from the nearby presentation of ancient objects in large vitrines to a comparative discussion of ancient and modern materials. Conveniently for the GSIs, the swing space is located in the part of the galleries closest to the museum classroom where all discussion sections for Art and Empire in Antiquity were held, so they were able to bring the students over to consider the space first-hand as plans for the installation proceeded.

After accounting for compliance with the Americans with Disabilities Act given the constraints of the space, the exhibition preparator (Scott Meier) designed two display cases and a small table. The larger of the two cases and the table fit along the east wall, to the left of a person leaving the elevator,

Figure 3: Entrance to exhibition from elevator.

and the smaller case stood directly opposite and facing the elevator, at the transition between the swing space and the main passage of the gallery (Figure 3). Addressing the need to prepare the viewer for the change in topic, the preparator created a freestanding, spotlit panel to carry text advising the visitor of the sensitive nature and the objectives of the display. This panel stood immediately on the gallery side of the small case, so that visitors entering from the gallery would see it before approaching the displays.[5] Two long interpretive wall panels inside the space offered deeper discussions of the objects and information about the association of the exhibition with the Art and Empire in Antiquity course, as well as images of the ancient Egyptian comparative material. In the limited space on the west wall, three short panels presented contextual information: one explained the origins of the name *Jim Crow*, one quoted the writings of W.E.B. Du Bois and

Ralph Ellison on African-American marginalization, and one displayed the word cloud. The small table held a clear plastic box for comments, slips of paper, and pencils, and a sign above encouraged visitors to leave feedback about the installation. The special properties of this usually empty space provided a unique opportunity for collaborative learning and for an exhibition outside the Kelsey's traditional purview.

Once *Dominated and Demeaned* opened to the public, the feedback received through the comment box reflected the diverse audiences and opportunities afforded by this exhibition, its theme, and in particular the academic setting in which it all unfolded. The students who worked on the exhibition thought the result was "terrific" and "wonderful." Other comments revealed that the majority of the visitors found the exhibition informative, thought-provoking, and overall very interesting. One visitor, for instance, wrote: "I'm so glad the Kelsey Museum made this Jim Crow exhibit. I find it very powerful…" Another referred to the exhibition as "eye-opening" in the dialogue it set up between the modern material and the ancient. Other visitors, however, had stronger reactions. On the issues addressed by the exhibition, a visitor wrote: "Shocking… to think that such disregard for another ethnicity was common place. Very interesting." And yet others had more visceral reactions, finding the objects on display and the issues of racial cruelty at stake "repugnant and sad" as well as "powerful."

A number of visitors even commented on the nature of the exhibition and its ties to the museum setting. Some noted the

scope, approach, and organization of the exhibition, as well as the manner in which the objects were displayed. "This is an incredible place," one visitor stated, "with a huge amount of info to be shared. Please continue doing just what you are here, it's great…" Another visitor wrote: "You have done a great job tackling this material that is far too close to home for comfort! I would love to see more Ancient artifacts alongside, but I am grateful for the writings and pieces you curated!" Others, however, thought the exhibition was too small and wanted to see it expanded so that the parallels between the Jim Crow objects and the ancient material could be drawn out more explicitly. Some also wanted to see this installation placed in a more prominent location in the galleries. And yet others recognized and commented on the nature of the Kelsey Museum as the ideal setting for *Dominated and Demeaned*. Signing her comment "White, Enlightened Woman," one visitor wrote: "Thanks for displaying these taboo objects. In this museum context, they can be safely viewed as objects of the past without being provocative. I am sorry that these were used in fun, since there is nothing funny about them."

Although for the most part the many and varied audiences of *Dominated and Demeaned* celebrated and praised the exhibition, one visitor in particular found it inappropriate for this particular museum setting and strongly criticized it. The comment reads as follows: "This exhibit is downright dumb. These objects do not belong in the Kelsey. Go take your liberal, post-modern ideas somewhere else and stop polluting the Kelsey Museum." This reaction reveals that this

exhibition indeed called into question the appropriateness of introducing modern American material and political issues into the galleries of a museum of Old World archaeology. And yet that the Kelsey is a museum of Old World archaeology and an academic museum is precisely what made this exhibition possible.

Supported by the academic museum setting, the collaboration between students, faculty, and staff was instrumental to the success of *Dominated and Demeaned.* Flexible and creative thinking fostered this collaboration; the participants made room for the exhibition's success. The museum improvised gallery space for the exhibition, and the director agreed to extend the run of the exhibition through Martin Luther King, Jr. Day, opening it on a traditionally closed Monday (with attendant costs in guard salaries) so that the Kelsey Museum could for the first time partake in campus-wide conversations on contemporary racial issues. The collaborative dimension of this project brought people together across disciplines and departments initially for an unusual classroom experience that developed into a dialogue with the larger community through the exhibition of the materials. The outpouring of students' enthusiasm for the project, contributions from faculty, museum, and university staff, and public feedback attest to the effectiveness of this collaborative effort.

NOTES

1 We would like to thank Professor Margaret Root for her invaluable suggestions
 and guidance through the course, exhibition, and writing of this article.
 These objects come from the personal collection of Professor Kenneth W. Goings,
 professor of African American and African Studies at Ohio State University,
 and were discussed in his book *Mammy and Uncle Mose: Black Collectibles
 and American Stereotyping* (Bloomington and Indianapolis: Indiana
 University Press, 1994), figures. 40, 41, 43, 49, 51; plates 16, 26, 27, 28.
 From this point forward in the essay, we refer to the "Black Collectibles" as
 Black Collectibles.

2 For more on the Race and Ethnicity requirement, see the College of Literature,
 Science and the Arts website at:
 http://www.lsa.umich.edu/umich/v/index.jsp?vgnextoid=de5ed377a3ce9110Vgn
 VCM1000005001010aRCRD&vgnextchannel=ff35901e14ccd210VgnVCM100000
 a3b1d38dRCRD&vgnextfmt=default Accessed March 11, 2012.

3 Plans for renovation include expanded facilities and open hours, so that
 members of the public may visit without appointments
 (http://www.ferris.edu/jimcrow/fundraise.htm).

4 The collections in the Kelsey were reinstalled in their current arrangements in
 2009.

5 We owe special thanks to Ray Silverman and Brad Taylor from the Museum
 Studies Programs for their advice on this panel. The text of the panel read as
 follows: "How do images mold our thoughts? How do images attached to
 material objects within our personal spaces work on our imaginations? How
 does the saturation of a social environment with imagery depicting a category
 of humanity as a dominated, controlled, demeaned Other affect our
 perceptions? History of Art 286, Art and Empire in Antiquity, asks that
 students compare ancient uses of visual representation to perpetuate

stereotypes of Otherness with related phenomena closer to their own life experiences. In that spirit, we have assembled a set of images illustrating ancient Egyptian tropes of the enemy Other that were deployed in New Kingdom Egypt. We have placed these images in dialogue with a display of household artifacts marketed to White America in the early to mid-20th century. These hateful objects insistently legitimized demeaning characterizations of African-Americans. They are disturbing; and they are part of our collective recent past.

"This project is possible only through the extraordinary generosity of Professor Kenneth W. Goings of Ohio State University, a distinguished scholar of African-American history. The artifacts you see on display behind the wall were lent to the Kelsey Museum by Professor Goings from his personal collection so that students in HA 286 could physically handle them in small discussion sections, grappling with the tactile and functional force of the objects as well as with the visual messages they convey. All the objects are discussed in Professor Goings' 1994 book, *Mammy and Uncle Mose: Black Collectibles and American Stereotyping*.

"We gratefully acknowledge financial and material support for this installation from the Kelsey Museum of Archaeology, the Department of the History of Art, and the College of Literature, Science, & the Arts. We also thank colleagues in the Department of Afroamerican and African Studies and the Museum Studies Program for meaningful consultations."

Whose Body Now?
The Many Lives of a
University Medical Collection

LEONIE HANNAN

University College London

In 2011 University College London (UCL) unveiled *The Body in Pieces*,[1] an exhibition which begins a long journey towards public reclamation and re-examination of the human body as museum object, educational tool, and medical artefact. This chapter explores the collection's future within the context of its past lives and discusses the many roles it can play in challenging new audiences, questioning the controversial, and promoting cross-disciplinary research and teaching at a university.

UCL's museum collections include zoological specimens, Ancient Egyptian artefacts, prehistoric archaeological finds, and etchings by Old Masters. The collections today reflect the scholarly projects of nineteenth- and twentieth-century luminaries, such as Robert Grant (1793-1874)[2] and Flinders Petrie (1853-1942),[3] who were embarked on the project of collecting and systematising the world's knowledge. However, whilst these men collected animals, paintings and artefacts, others harvested from the human body itself to improve their libraries of medical specimens. The bodily remnant of one lost life, encased in fluid and glass, became the didactic tool which would help save the next. But unlike the other artefacts, which are displayed to the general public, collections of human tissue sit behind closed doors, reserved for the specialist eye.

Like other academic collections, UCL's museums have forged a role for themselves in the twenty-first century: one which attends to their original mission of progressing academic knowledge, but which also engages audiences outside of the Academy.[4] Originally established explicitly as

teaching collections, some university museum collections
fell into disuse during the later twentieth century as their
collections began to be perceived as outmoded, and the
pressures of teaching schedules precluded the "luxury" of a
museum visit. However, this picture is changing, and rapidly.

This chapter focuses on UCL's use of its pathology
collections as a whole but treats *The Body in Pieces* exhibition
in 2011 as a symbolic event in the history of these long-hidden
artefacts. The exhibition concentrated on one section of the
collection, originally from the Great Ormond Street Children's
Hospital, which contains specimens derived from young
patients in the nineteenth and twentieth centuries. Perhaps
as a result of the challenging content of childhood pathology,
the Great Ormond Street collection had previously been
locked away in a cupboard for nearly twenty years, unused by
researchers or students, before the exhibition placed some of
its artefacts on public display for the first time. The exhibition
therefore represented a watershed and a critical first step
towards engaging a wider public in this collection's history,
whilst also highlighting its potential to audiences closer to
home.

The human body as museum object

Medical collections containing pathological and anatomical
specimens represent a particularly difficult arena in terms of
museum ethics. By keeping or displaying human remains,
museums have traditionally overlooked the culturally
sensitive question of the corpse as a commodity.[5] Across

the globe there are, of course, many and varied traditions relating to the disposal of human remains after death. These traditions naturally hold great weight within societies and are considered especially important for the closest family members of the recently deceased. For example, historically, Western Christian societies have emphasised the importance of a "decent burial" soon after death: mass unmarked graves were reserved for paupers and the public display of human remains resonant of criminality and its punishment.[6] As Ruth Richardson has amply shown, nineteenth-century medics' demands for cadavers for dissection placed a disproportionate burden on the bodies of the destitute. Richardson's exploration of her subject reveals that in nineteenth-century Britain, the fate of dissection was greatly feared by those whose remains were most at risk of foregoing the burial plot for the surgeon's table.[7] However, the twentieth century heralded another dominant narrative in Western understandings of the body. A secular and biomedical model prevailed, which was capable of conceptualising the dead body as a scientific specimen and research tool – furthering collective knowledge about disease in order to engineer its eradication.[8] But despite a greater acceptance of the imperatives of scientific research, the twentieth century also developed a culture of informed consent. So, whilst it is possible that fewer individuals feel unadulterated fear and disgust at the prospect of a cadaver being dissected in the course of medical training, many more expect that they themselves should be the arbiter of the fate of their own body. As an extension to this, and in the case

of a sudden demise, it is commonly considered the role of the next-of-kin to decide on the manner in which a person's physical remains should ultimately be disposed. The fact that most collections of pathological specimens were taken from patients from the eighteenth to the twentieth century, with no permission acquired from either the patient or their family, has been considered in retrospect a matter of severe ethical transgression. It is in this context that surviving pathology collections of the twenty-first century must assert their value both within their own institutions and also to the wider community.

The pathology collections

UCL's collections of pathological specimens have come to include those of the Middlesex Hospital, the Hospital for Women in Soho Square, the Royal Free Hospital, and Great Ormond Street's Hospital for Sick Children. They trace the histories of great medical institutions and their practitioners and some parts of the collections are still used in the training of medical students today. The specimens are either stored or displayed in spaces within the university and its associated hospital site, London's Royal Free Hospital, and there is no space accessible by the general public in which they can be viewed. However, at the Royal Free, the museum space displays some 550 specimens, available to view by the staff and students of UCL. In some cases legislation dictates this fate but in others it is the perception of the specimens as objects of purely medical interest, shocking to the untrained eye, or

illustrative of unsavoury histories before personal consent became a prerequisite for scientific investigation.[9]

For collections of human tissue in the UK, the Human Tissue Act of 2004 proved a pivotal piece of legislation. Coming into effect in 2006, it regulated the removal, storage and use of human tissue. For museums, the most important part of the Act was its stipulation that a licence was now required to display human bodies or human tissue in public. However, the Act only included in its licensing regime material that was taken from people who were either still alive or had been dead for less than 100 years. But the Act did give some museums in England:

> discretionary power to move human remains out of their collections, if the remains are reasonably believed to be those of a person who died less than one thousand years before the date that the relevant provision of the Act comes into force.[10]

It was suggested that this provision would allow museums to return human remains to, for example, aboriginal groups.[11] But in the early 2000s it was not clear how many specimens of human remains were lodged in UK museum collections and as totals began to be produced, it became clear that the scale of the problem was considerable.[12] Moreover, as the debate developed, it was revealed that museums treated different types of human remains very differently and that high profile calls for repatriation of some human remains over others could lead to a disjointed approach to this category of collection. As

Ratan Vaswani put it in 2001: "The important questions we need to consider are those of consistency. By what standards do we judge it 'acceptable' to exhibit Egyptian mummies but decide to withdraw Maori heads from display?"[13]

Vaswani called for an inclusive discussion of these issues leading to the design of clear principles. No doubt museum professionals have developed a more considered approach to the human remains in their collections over the intervening decade, but it is still the Human Tissue Act that has had the most defining effect on the ways in which universities and museums use and display their human remains.

The Human Tissue Act was introduced in answer to calls for a reassessment of the ethical framework for the use of human tissue in research and museum environments. In 2003, D.G. Jones, R. Gear and K.A. Galvin voiced the common concern that despite use of human tissue being "integral to medical research and teaching for many years", "the removal of tissues and organs from dead bodies has traditionally occurred, however, in an ethical vacuum." [14] Interestingly, much of the literature exploring the subject of human tissue collections focused on the difficult legal and ethical arena of the body as property.[15] Prominent scandals, such as the Alder Hay Children's Hospital – where hospital staff retained organs from hundreds of children who died at the hospital between 1988 and 1996 without permission from their next-of-kin – created an imperative for improved regulation.[16] Gradually, a more informed discourse on the use of human remains has emerged in UK academic institutions, one that attempts to

balance the needs of contemporary research with an awareness of the plural perspectives on human remains that exist across different cultures. As Mark O'Neill has suggested: "the ideal outcome would be some sort of reconciliation of the European scientific world-view, which places research at the pinnacle of human insight, with other peoples who value other forms of knowledge." [17]

Another trend which affected the status of pathology collections was the general decline, over the latter part of the twentieth century, in their use for medical training. At UCL, medical students' encounters with the specimens as part of their studies became very limited, reduced to brief sessions taken during the annual Pathology Week or through their contact with the few consultants who still felt the collections to be a worthwhile educational resource. The museum space at the Royal Free Hospital, whilst spacious compared to some of the university's public museums, was under-used and had an old-fashioned air. With a lack of the facilities teaching staff had come to rely upon, such as a projector and interactive whiteboard, the space was not used to anything like its capacity. When asked, medical students participating in a session in the museum during Pathology Week had largely never entered the museum before, despite taking many of their classes at the Royal Free Hospital site. During the 2000s, therefore, the collections had essentially become peripheral to the teaching of the medical curriculum. As Antony Hudek, a Mellon Postdoctoral Research Fellow working on the collection, highlighted: "the medical museum has ceased to function as a

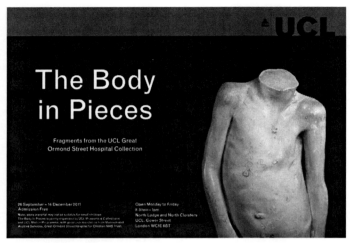

Figure 1: Exhibition flyer.

vibrant space of exploration and education, it is now a relic in fact. It contains relics that are particularly provocative since they can no longer be shown." [18]

However, despite this history of declining use, it was felt strongly amongst UCL's Museums & Collections staff that the pathology specimens represented a unique resource for teaching and research and that work needed to be done to advocate for its renewal in the context of both the university and the wider community.

In the process of planning for the collection's future, there were several factors in its favour. Firstly, it had been diligently cared for by the conservator, Paul Bates. He not only made sure that the specimens were in good condition, but had also created high-quality digital photographs and supporting text files for all the specimens in the main collection. It was also

Bates who had salvaged the Great Ormond Street collection when it was moved into long-term storage in a basement of the children's hospital. Moreover, within the Medical School, there were several motivated practitioners who wanted to see the collection embedded in the teaching and learning of medicine at UCL. Aside from the collection's traditional audience of medics, academics from other disciplinary backgrounds, such as art history and medical history, had become interested in what this collection had to offer.[19] However, the real breakthrough for the collection's future came when space was identified in a location on the central London campus of UCL, for a display and teaching area for the pathology specimens. With the collection's use within the university looking more optimistic, attention could be turned to the engagement of wider audiences in the discussion (Figure 1).

The exhibition: hopes and fears

When head of collections management, Jayne Dunn, and research fellow, Antony Hudek, initially proposed the idea of an exhibition based on the Great Ormond Street collection, it was not met with universal enthusiasm. Perhaps the anticipation of a negative public reaction to specimens taken from children's bodies led to a cautious attitude amongst some staff. However, careful advocacy for the importance of allowing the public to engage with collections of this kind won the argument and the exhibition was given the go-ahead for a period of 20 days to be displayed in two sites: the prominent North Lodge which faces onto the main road

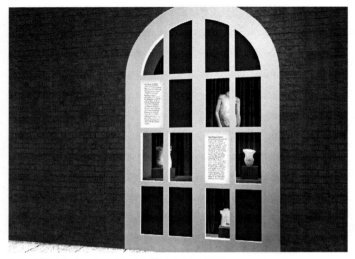

Figure 2: Visualisation of one side of the North Lodge exhibition space.

at the gates of UCL and the Cloisters, a busy thoroughfare for staff and students but less often frequented by passers-by (Figure 2).

The title of the exhibition referenced the book *The Body in Pieces: The Fragment as a Metaphor of Modernity* written in 2001 by feminist historian Linda Nochlin. This starting point represented the exhibition's intention to broaden engagement with medical objects and encourage interest from the arts, humanities and social sciences. The object selection was made from the vast 2,800 wet and dry specimens, the earliest dating from 1860; around 80 Plaster of Paris models of child pathology; and a series of original reports containing a precise record of the clinical and pathological findings. The plaster models were particularly intriguing because they had been

made by the craftsman Luigi Broquotti (c.1818–88) in his shop
in Leather Lane, London during the 1870s on a commission
from Dr Charles West (1816-98), a founder of the Great
Ormond Street Hospital.[20] The medium for the models was
unusual, as most anatomical modelling had traditionally been
undertaken in wax or *papier mâché*. Moreover, the techniques
used to create these pieces had, in their own lifetime, been
overtaken by photography as a dominant mode of medical
documentation (Figure 3). However, Hudek was keen to draw
out the relationship between these artefacts and the work
of artists such as Louise Bourgeois and Marc Quinn, who
have explored the physical and emotional impact of works
in plaster. The models depicted variously children's torsos,
limbs, hands and feet exhibiting a range of disorders but most
common were manifestations of diseases such as tuberculosis
or rickets, which were prevalent in late nineteenth-century
London. At one remove from the specimens themselves, the
plaster casts offered a reflection of the unfortunate patients
of the nineteenth-century hospital. In the exhibition design,
these objects took centre stage in the North Lodge, positioned
against a black background and lit under white light. Hudek
and Dunn were keen to present the plaster casts as objects
of beauty and were interested in them as representations of
disease that were not wholly visceral (Figure 4). When the
exhibition opened in the depths of a London winter, the
models were often to be viewed after sunset. In this lighting,
their small sculptural forms appeared stark and beautiful.

In undertaking this exhibition, Dunn and Hudek and the

Figure 3: Plaster of Paris model of a child's foot exhibiting disorder.

department more generally, had to consider the potential for a negative response to the human remains, however sensitively they were displayed. Whilst the ghostly forms at the North Lodge merely mirrored the diseased specimens in the collection, the cases in the Cloisters exhibited actual examples of human tissue alongside documentary evidence from the children's hospital and other artefacts, such as a surgical boot.[21] The choice of human tissue specimens was relatively conservative, including the rickety tibia of Harry Lymer, who died aged 11 years in 1881, and an example of gallstones. Staff experience informed this choice and the selection incorporated an understanding that viewers of human tissue tend to be both less concerned by bone than soft tissue specimens and to find certain internal organs less shocking or provocative than others. All specimens on show dated from the 1800s as, with no public licence, more modern material would have been prohibited. As a first step in engaging wider audiences with the pathology collections at UCL, a cautious approach was considered appropriate – to test the water with a view to pursuing future projects of this kind.

The exhibition was accompanied by research and publicity generated by Antony Hudek, which dwelt on both the history of the collection and its care, but also the social context of the nineteenth-century hospital and its young patients. Hudek's intervention on the collection and its display has also enriched the range of responses to artefacts that have traditionally been viewed as simply medical, he commented:

This is a second lease of life... we are interested in re-looking at these objects, deemed scientific, that have now attained the level of archival object with little remaining relationship to actual practice. Artistically they feel very peculiar, something quite disturbing that requires definition and yet resists it at the same time.[22]

An interesting outcome of Hudek's work with the collection was the discovery that the specimens held at UCL had the potential to be cross-referenced with other sections of the wider Great Ormond Street archive, including documentary medical evidence and glass-plate photographic negatives of patients and their pathology. This knowledge has led to discussions between UCL and other institutions holding Great Ormond Street material about the possibility of digitising and re-connecting this unique and historically rich collection. Although the exhibition unfortunately failed to gain funding for a planned seminar series, the transition for the collection from cupboard to cabinet was a great leap.

Looking at the experiences of displaying human tissue at the Manchester Museum in 2008-09, a cautious strategy seemed sound. Manchester's exhibition of the *Lindow Man* had courted substantial controversy and attracted complaints from the viewing public concerning the character and content of the display. In the spirit of openness and public debate, Manchester had opted for an approach that represented many different views of human remains and their meanings. Alongside academic interpretations of the body and its Late

Iron Age or Early Roman period context, were contributions from a member of the local community and a Pagan. The museum had also encouraged visitors to comment on the exhibition, adding to the "polyvocal" range of the exhibit. In its decision not to present one interpretation or narrative as dominant and in asking the viewer to make up their own mind about the exhibit, Manchester Museum achieved its goal of stimulating public debate but encountered some extremely hostile responses. Bryan Sitch commented on the museum's experimental exhibition: "university museums have an important role to play in presenting novel and potentially controversial work that would be difficult for a different venue such as a local authority museum." [23] It is this sense of the differentiated role of the university museum that informed *The Body in Pieces* exhibition and will hopefully guide future public-facing ventures based around the pathology collections. As this initial exhibition did not attract hostile reactions from the visiting public, it has opened the door to a purposeful debate about the collection's place within UCL in the twenty-first century. More than that, it has shown the potential for the development of a public-facing pathology collection which can engage audiences in a dialogue about human tissue and its uses. The positive experience of *The Body in Pieces* has also highlighted the great opportunities for integrating teaching and learning outcomes into any future exhibition and thereby capitalising on the established use of museum objects in teaching at UCL.

Object-based learning at UCL: the bigger picture

Over the last five years, UCL's Museums & Collections have refined their argument in favour of using object-based learning to enhance teaching and learning in a higher education context. This has had positive results for the profile of the university's museums. Object-based learning is a method of teaching that uses objects (often museum specimens or artefacts) to facilitate learning. The method encourages both the development of subject-specific knowledge and also a range of key skills and it works for students across a wide range of disciplines. Although, traditionally, pedagogies that encouraged active and student-centred learning, were more firmly established in schools and public museum settings, it has become clear that teaching practices in universities also need to adopt principles of educational best practice that are supported by recent research.[24] Moreover, with an ever-increasing emphasis on the student experience in higher education, providing high quality and effective teaching and learning has become a critical factor for success in terms of student recruitment.

On account of the hands-on, active nature of object-based learning, it connects closely with pedagogies on active, experiential and problem-based learning. As such, it has been seen to help students acquire "troublesome knowledge" and negotiate "threshold concepts" pertinent to their development as scholars.[25] So, as the pathology collections represent an important part of the wider collections at UCL, they are being incorporated within this broader drive to increase the

use of objects in teaching and to encourage positive learning experiences for UCL students.[26]

In 2011, a new role in the Museums & Collections department was created specifically to generate opportunities for object-based learning in undergraduate and postgraduate courses. The interaction with objects could come in several forms, including the use of collections in classroom-based sessions, object-led practicals in a museum setting, or the use of images of objects in e-learning resources. This work builds upon a wide range of existing teaching that the museum curators have developed in concert with academic departments. Initially, the focus of this teaching was in departments, such as archaeology and earth sciences, with a tradition of using objects in learning. However, increasingly more diverse curriculum links to the collections are being created and there is now engagement with object-based learning from a great range of disciplines, including the arts, humanities, social sciences, and sciences. This process of proliferating the use of the collections in teaching takes time and effort, but is achievable, especially if museum staff attend to the logistical and time constraints that have typically deterred lecturers from using the museums as a resource.[27] Alongside the class sessions and practicals, the department gained funding to develop object-based digital learning resources in 2011 and those resources will be ready for embedding in undergraduate courses in the 2012-13 academic session.

So, whilst staff and student engagement with the pathology collection as a whole has traditionally focused on medical

teaching and taken place in the Medical School, the use of the collections is increasingly being viewed within the context of developing object-based learning across disciplines at UCL. The limited engagement that most medical students currently have with the collections – such as the annual Pathology Week, which was mentioned above, is beginning to seem too limited and out-of-step with the more innovative object-based learning activities taking place elsewhere in the university. Moreover, in recent years a broader variety of students have shown interest in the pathology specimens, including students and researchers of the history of art. In 2010, an AHRC funded research network The Culture of Preservation: the afterlife of specimens since the eighteenth century, was established, which started to generate interest in human tissue specimens amongst postgraduate arts students. Over the past two years there has also been some innovative new use of a range of the collections, including the pathology specimens, by lecturers in Science & Technology Studies, teaching the history and philosophy of science. Although not a large subject at UCL, the History of Medicine is also providing opportunities to introduce staff and students to the pathology collections. So, the future uses of the pathology collections look to be potentially wide-ranging and initiatives such as *The Body in Pieces* has helped to improve the collection's profile within the university. With a new display space planned for the pathology collection and the integration of dedicated teaching rooms, it seems that medical students will be just one cohort of students who can benefit more fully from the learning opportunities

these specimens provide. Overall, UCL is beginning to see new pedagogical relationships with collections being formed across a range of academic departments. Despite its difficult past and legally prescribed present, the pathology collection is no exception to this trend, and – in many ways – offers some of the most interesting prospects for academic and non-academic learning and debate.

The use of medical collections for discussing "difficult histories"

The Body in Pieces exhibition was not directly linked to a particular course or courses of study at UCL. However, an opportunity arose to use the exhibit to discuss the ethical issues surrounding the storage, display and use of human tissue with a visiting group of postgraduate students from another institution: Royal Holloway, University of London. The students were studying for a Masters degree in Public History and their lecturer wished them to concentrate on medical collections as a case study. Their visit was timely.

The session started with an introduction to the key issues for discussion: What are pathology specimen collections for? Why were they collected? What future do they have? The students were warned that they would be shown specimens of human tissue that were not on open display to the public and were usually reserved for use by medical students. This scenario posed its own questions about access. The students were also asked to engage with the legal and ethical dimensions of the topic by looking at the stipulations of the Human Tissue Act and exploring precepts such as informed consent in relation

to medical and scientific research. These issues were related to other areas which their course had covered, such as the collection of oral history testimony, where the use of recorded interviews with living subjects might subsequently be re-used or made public. In general, the session was successful in its aim of generating discussion around ethics, human tissue and the role of universities and university collections. However, the session had been added to the teaching schedule at a fairly late juncture and could, therefore, have been better integrated into the broader course structure.

Through exploring widely the ethical, legal and practical dilemmas concerning the collection's use and accessibility, the session did reveal the potential engagement of this kind can have for students of history, public history, museum studies and the history and philosophy of science. As the session was broad in its coverage of issues, it suggested that the careful redevelopment of particular themes would work well in other teaching contexts. Having trialed this session successfully, it is clear that any future exhibition of the pathology collections at UCL would need to forge firmer links with the teaching programme, building on existing work with the museum collections as a whole.

The future uses of pathological specimens in universities
In conclusion, a word needs to be said about the practical interaction between collections such as this and their current parent organisation, the university, in relation to their previous institutional and departmental affiliations. Whilst

many of the museum objects at UCL are enjoying a renaissance in their use by students and staff, the historical peculiarities of collections can sometimes interfere with their accessibility for teaching, learning and research. Many university collections have been acquired or amassed in quite specific departmental situations and can, therefore, prove difficult to integrate into over-arching principles of collections management. To a large extent, these difficulties have been surmounted at UCL and there is now one department with jurisdiction over the university's collections as a whole. However, despite this sole management, there is an enduring inheritance from the objects' previous custodians in terms of views on who the collections are for and how they should be used. This is no doubt a common difficulty for universities across the world. *The Body in Pieces* sought to break down some of those barriers to cross-disciplinary work with the medical collections.

The pathology collection's history – rescued from a hospital basement, lovingly conserved, but placed in long-term storage – imbues its current status within the university. But the broader mission of Museums & Collections to make use of its unique artefacts in teaching and learning is providing momentum for change. So, the future looks bright. The collection's long-term development will inevitably rest on its ability to attract funding and, therefore, it is the active engagement with teaching, learning and research described here that will be critical to its regeneration.

This case study has sought to demonstrate that a thoughtful approach to providing wider access to pathological

and medical collections can generate new opportunities for curators, teaching staff and students. It is the firm intention that future activities based around the pathology collections should promote new teaching relationships with, and audiences for, these complex objects. Like many pathology collections, UCL's specimens represent a unique resource for research and learning because no collection of this kind could ever be collected again. Moreover, we are increasingly seeing the broader potential of the specimens to evoke important themes within a range of disciplines from art history to forensic science.

The display of the Great Ormond Street artefacts was fortunate enough to coincide with institutional plans to move the location of the pathology collections to a new suite of teaching rooms on the central campus. This decision also synchronised with the Medical School's plans to re-design its curriculum and place a much greater emphasis on the use of pathology specimens in teaching from 2012 onwards. To these larger developments, *The Body in Pieces* contributed a creative approach and a determination to engage audiences outside of the Academy. These are all milestone events in the collection's recent history, but there is still much work to be done.

NOTES

1 See http://blogs.ucl.ac.uk/events/2011/10/24/the-body-in-pieces/

2 Robert Edmond Grant was an important early nineteenth-century
 comparative anatomist and in 1827 until the end of his life he was Professor
 of Zoology at the new London University, see the Oxford Dictionary of
 National Biography online: http://www.oxforddnb.com.

3 Sir William Matthew Flinders Petrie, an Egyptologist, was known for promoting
 a systematic approach to the practice of archaeology and amassed a collection
 of artefacts from a range of excavation sites, including Tanis, Abydos and Amarna.

4 S. MacDonald, "University Museums and Community," *University Museums and
 Collections Journal* 2 (2009): 5-6.

5 M.M. Ames, *Cannibal Tours and Glass Boxes: the anthropology of museums*
 (Vancouver: UBC Press, 1992) and A.W. Bates, "Dr Kahn's Museum:
 obscene anatomy in Victorian London," *Journal of the Royal Society of Medicine*
 99 (2006): 618-24.

6 S.C. Lawrence, "Beyond the Grave – The Use and Meaning of Human Body Parts:
 a historical introduction," in *Stored Tissue Samples: ethical, legal, and public
 policy implications*, ed. R.F. Weir (Iowa City: University of Iowa Press, 1998), 111-142.

7 R. Richardson, *Death, Dissection and the Destitute* (London: Routledge &
 Kegan Paul, 1987); this research focuses on the impact of the 1832 Anatomy Act,
 which made it possible for the corpses of those who died in the workhouse to be
 used for medical dissection, a fate that had previously been reserved for executed
 criminals.

8 S. Lawrence, "Medical Education," in *Companion Encyclopaedia of the History
 of Medicine*, 2 vols., eds. W.F. Bynum and R. Porter (London: Routledge, 1993),
 2: 1151-1179.

9 S.C. Lawrence, "Beyond the Grave – The Use and Meaning of Human Body Parts:
 a historical introduction," in *Stored Tissue Samples: ethical, legal, and public*

policy implications, ed. R.F. Weir (Iowa City: University of Iowa Press, 1998), 111-142.

10 Department of Health, *The Human Tissue Act 2004: new legislation on human organs and tissue* (London: DoH, 2004), http://www.dh.gov.uk/prod_consum_dh/groups/ dh_digitalassets/@dh/@en/documents/digitalasset/dh_4103686.pdf.

11 For more on the repatriation of human tissue see: K.S. Fine-Dare, *Grave Injustice: the American Indian Repatriation Movement and NAGPRA* (Lincoln, Nebraska: University of Nebraska Press, 2002); Department of the Prime Minister and Cabinet (Office of the Arts), *Australian Government Policy on Indigenous Repatriation* (August, 2011), http://www.arts.gov.au/sites/default/files/ indigenous/repatriation/repatriation-policy.pdf; and M. Pickering, "'Dance through the minefield': the development of practical ethics for repatriation," in *The Routledge Companion to Museum Ethics*, ed. J. Marstine (Abingdon: Routledge, 2011), 256-274.

12 For example, in 2001 The Natural History Museum had 19,000 examples (from whole skeletons to individual bones) and The Museum of London's collection contained 18,000 human remains, see T. Butler, "Body of Evidence," *Museums Journal* 101(8) (2001): 24-27.

13 R. Vaswani, "Remains of the Day on the Ethics of Displaying Human Body Parts," *Museums Journal* 101:2 (2001): 35.

14 D.G. Jones, R. Gear and K.A. Galvin, "Stored Human Tissue: an ethical perspective on the fate of anonymous, archival material," *Journal of Medical Ethics* 29 (2003): 243.

15 See, for example, L.B. Andrews, "My Body, My Property," *The Hastings Center Report 16* (1986): 28-38; R.S. Magnusson, "The Recognition of Proprietary Rights in Human Tissue in Common Law Jurisdictions," *Melbourne University Law Review* 18 (1992): 612-16.

16 House of Commons, *The Royal Liverpool Children's Inquiry: summary and recommendations* (London, 2001), http://www.rlcinquiry.org.uk/download/sum.pdf.

17 Mark O'Neill speaking as Head of Museums and Galleries at Glasgow City Council, as quoted in Butler, "Body," 27.

18 *Body in Pieces: saving medical collections (UCL)*, YouTube: http://www.youtube.com/watch?v=GAXcoGe1R_0 .

19 See, for example, the AHRC-funded 'The Culture of Preservation' research network at http://www.ucl.ac.uk/art-history/events/culture_of_preservation.

20 For a biography of Charles West, see the ODNB online: http://www.oxforddnb.com.

21 The surgical boot was designed by eminent paediatric surgeon, Denis Browne (1892-1967).

22 David Shanks, 24 October 2011, comment on The Body in Pieces "UCL Events", http://blogs.ucl.ac.uk/events/2011/10/24/the-body-in-pieces/.

23 B. Sitch, "Courting Controversy: the Lindow Man exhibition at the Manchester Museum," *University Museums and Collections Journal* 2 (2009): 53.

24 See, for example, S.G. Paris, Perspectives on Object-Centered Learning in *Museums* (Mahwah NJ: Lawrence Erlbaum Associates, 2002); H.J. Chatterjee, "Staying Essential: articulating the value of object based learning," *University Museums and Collections Journal* 1 (2008): 1-6, http://edoc.hu-berlin.de/umacj/1 /chatterjee-helen-1/PDF/chatterjee.pdf

25 J.H.F. Meyer and R. Land, "Threshold concepts and troublesome knowledge (2): epistemological considerations and a conceptual framework for teaching and learning," *Higher Education* 49:3 (2005): 373–388.

26 R. Duhs, "Learning from University Museums and Collections in Higher Education: University College London (UCL)," *University Museums and Collections Journal* 3 (2010): 183-186, http://edoc.hu-berlin.de/umacj/2010/ duhs-183/PDF/duhs.pdf

27 J. Cain, "Practical Concerns when Implementing Object-Based Teaching in higher Education," *University Museums and Collections Journal* 3 (2010): 197-201, http://edoc.hu-berlin.de/umacj/2010/cain-197/PDF/cain.pdf

INTERDISCIPLINARY COLLABORATIONS

Yale Peabody Museum of Natural History

Beyond Collections:
Big Issues and University Museums

JANE PICKERING
Yale Peabody Museum of Natural History

"Can you believe this?" the man mutters to the people nearest him, then calls across the room, "Honey! Look at this!" To himself he says, "I'm drinking too much soda."

You don't often hear this type of comment in the galleries of a natural history museum. Yet it, and similar ones, can be heard every day in *Big Food: Health Culture and the Evolution of Eating* at the Yale Peabody Museum of Natural History. The visitor had been staring at rows of spoons, each of which showed how much sugar is found in various beverages, from juice boxes to cans of ice tea and bottles of soda (Figure 1). The amount – up to 24 spoonfuls in a single container – can be staggering to those who've never considered it. And it is just one facet of the complex forces that have led to excess weight and obesity surpassing undernourishment as the world's leading food and nutrition problem. The World Health Organization reports that obesity has reached epidemic proportions, with more than one billion overweight adults among the world's population and the numbers growing at an alarming rate.

Big Food: Health, Culture and the Evolution of Eating, the latest temporary exhibit at the Yale Peabody Museum of Natural History, was developed to engage people in an important discourse around food, community and health. It was the first time the museum had focused on an issue as the main theme for an exhibit, rather than content directly related to an area of our collections. While there are many excellent exhibits at children's and other museums on obesity, they frequently concentrate solely on personal behaviors and children's health.[2]

Figure 1: Display showing a selection of common sugar-sweetened beverages with the amount of sugar in each contained displayed next to them.

As a university museum, our mission and resources enabled us to take a more wide-ranging approach, to produce an exhibit that looked at the complex biological, social, cultural, and societal forces behind the obesity epidemic.

Big issues and the mission of university museums

Today most museums see themselves as being in "the service of society and its development," as defined by the International Council of Museums in 2006. Over the last few decades there has been a transformation as museums seek to be relevant and benefit society in ways beyond traditional collecting, preserving and educating activities.[2] Some people disagree with this change, because they view it as a threat to museums' scholarship, or because they feel museums are not effective in this arena. However, museums have been a vehicle for social

c1

EXHIBITIONS AND EDUCATION

change since their beginning in Classical Antiquity when they were seen as places to experience the power to change, facilitate social interaction, and address universal human concerns.[3] In a 2008 survey, a majority of Americans (59%) had attended an informal science institution in the previous year.[4] Given this, and that most Americans spend only 5% of their lives in the classroom,[5] museums have an important role, and some might say a moral responsibility, to foster people's understanding of important issues. While there are countless newspaper articles, documentaries, health campaigns, and other resources that address the obesity epidemic, the characteristics of an informal learning environment provide an important complement these other media.[6] For example, they offer multisensory educational opportunities and encourage families and other groups to learn together. As Lois Silverman states in her book on museums and social work, given all the serious social challenges of the 21st century "the social work of museums no longer seems optional, or a clever way to keep collections-oriented institutions relevant, but an essential responsibility to humankind."[7]

University museums vary from small departmental museums to being the major cultural institutions in their region, with corresponding differences in mission and resources. But there are commonalities. First, university museums are part of the academy. They must support the research and educational mission of their parent institution by remaining relevant and engaged in the university's scholarly and teaching activities. They must promote research, develop

teaching partnerships with faculty, and engage students. In addition, almost all university museums are institutions that promote public engagement with the university, providing a place for dialog between the campus and its surrounding communities. As such they are often the front door of their parent, and have a mission to serve a broader public and to interpret research going on at the university. Perhaps more than any other type of museum, they must struggle with how to navigate the competing needs and expectations of their many audiences.[8] For example, the Peabody is part of the landscape of New Haven. Every taxi driver knows where it is and every local school student has visited. Its reputation as a "dinosaur museum" draws an audience typical of many natural history museums: families and school groups. It is also an active research center with more than 25 faculty curators producing hundreds of peer-reviewed publications each year, as well as serving significant numbers of Yale students through classes and research projects. This dual mission – service to the university and to the broader community – has significant impact on programming. An interactive exhibit on Earth's biodiversity designed for family learning may not suit a professor who is using the exhibition regularly in classes. For these reasons university museums need to be creative, strategic, and in some cases highly targeted in their programs. As Juliette Bianco from the Hood Museum of Art at Dartmouth noted, in regard to the institution's recent strategic planning, "It is not middle ground we [seek] but an alternate model, one that [is] reflective and responsive to the complexities of a

museum on a university campus." [9]

University museums pioneered object-based learning from their earliest days. While the use of collections waned in some areas (notably the life sciences) during the early- and mid-20th century, recent years have seen a renaissance in their use as faculty have realized they can significantly enrich a student's learning experience.[10]

There is no doubt that providing such learning opportunities is a fundamental role of university museums. However, such museums also have much to offer in the realm of programming about big issues that affect society and are able to engage in the type of "social work" advocated by Silverman. There are two particular aspects of being part of the academy that position university museums to make unique contributions. First, significant social issues like the obesity epidemic have causes and solutions that are equally complex and multi-faceted. Universities have faculty and other scholars who undertake research on different aspects of these topics, increasingly as part of teams or institutes that bring together scholars in an interdisciplinary effort to understand and mitigate these challenges. Second, they may have more academic freedom than their stand-alone counterparts to explore these issues in depth, including the surrounding controversies.

Natural history museums have long been places that tackle the issues surrounding education about evolution through natural selection; when the current Peabody Museum building opened in 1925– about the same time as the famous Scopes Trial

was taking place in Tennessee – the exhibits were explicitly laid out to provide "visual proof" of evolution.[11] More recently, museums around the world have been doing significant work on the issue of climate change, both in their research and their public activities.[12]

Museums are powerful places to promote health messages and can impact people's attitudes, values and behavior. For example, the Arizona State Museum[13] collaborated with the Tohono O'idham Community Action organization on type 2 diabetes prevention for local Native American communities. They used a children's book, *Through the Eyes of the Eagle: Illustrating Healthy Living*, as inspiration for an exhibition of the same name, about the diet through time of the Sonoran Desert people. The exhibition highlighted the devastating health impacts of the loss of traditional food systems as well as current efforts to increase wellness and cultural vitality within the Native community. An accompanying digital comic book and smartphone app explored the choices teenagers might make to affect their health and happiness. Museums can also raise public awareness of the social dimensions of key health issues and can contribute to increased awareness of stigma and representation.[14] This is an important topic in relation to obesity as, despite decades of research showing how difficult it is to lose weight and keep it off, our society tends to blame overweight individuals for their condition, and overweight and obese people often experience negative stereotypes, bullying, prejudice and discrimination. While research on the impact of informal learning is still relatively rare, the work that has

been done has shown to be particularly effective at changing people's affect towards topics.[15]

A big issue at the Peabody

New Haven, Connecticut, host city for the Peabody Museum, is a diverse urban community of 124,000 people. The median household income is $36,095 (compared to $63,104 in Connecticut as a whole) and 20.2% of families live below the federally defined poverty level. About one quarter of the population identify themselves as Hispanic or Latino, another quarter are non-Hispanic White and 36% Black/African American. There is a large immigrant population including an estimated 5,000 illegal immigrants. *Engaging Our Communities*, an audience research project undertaken by the Peabody, used questionnaires and focus groups with museum visitors and non-museumgoers from the city to explore the relationship between the museum and the city.[16] One of the research objectives was an investigation of New Haven community residents' ideal museum experiences. Participants felt the museum's content did not connect with the community and that the dinosaurs and other animals (that were perceived as the main displays) did not connect with them personally. Participants also felt that the museum needed to provide more interactive exhibits to engage families, as one woman put it:

> *A lot of parents they work... they have... two jobs to take care [of] their kids. You don't have that extra time to go to a museum... I remember doing a lot of sacrificing just so [my*

daughter] would be well rounded. But I had to know that she was going to enjoy the place I was taking her and she'd get a lot out of it. I had to know in advance that it was worth our time.

We knew we needed to make an active effort to increase the interactivity of our exhibits, develop a variety of associated programming, and answer the question: Why is it important to me?

Enter faculty member Jeannette Ickovics, from Yale's School of Public Health. Professor Ickovics came to the Peabody because, as Director of the Yale Community Alliance for Research and Engagement (CARE) she works extensively in the New Haven community. She collaborates closely with another department at Yale, the Rudd Center for Food Policy and Obesity, which is a research and public policy organization with the goal of improving the world's diet and preventing obesity, and reducing weight stigma. Ickovics' health assessment programs found that more than one-third of adults and one-half of 5th and 6th grade children in New Haven were overweight or obese. Much of the city is classified as a food desert, i.e. a place where at least 20% of people live at or below the poverty line and without a supermarket within a one-mile radius. She knew first-hand that the obesity epidemic was a serious local issue. There are several city-wide efforts to address the challenge. For example, the New Haven school system has recently made significant changes in its school lunch program to be more healthy (and sustainable) by using

Figure 2: The exhibit's food corridor, illustrating the food consumption of the average American in one year. The data comes from the US Census Bureau.

locally-grown fruit and vegetables. Ickovics thought that an exhibit at the Peabody could make a significant and unique contribution to this community crisis, as well as providing an in-depth analysis of the global issue using the resources of the university. She had noticed that the museum had recently produced two exhibits on infectious disease[17], and felt that, as the city's major science museum that served a family audience, we should explore the topic of chronic disease and how it is driving health in the 21st century.

The Big Food experience

Big Food is a 2,250 square foot exhibition and was developed as a partnership between the museum, CARE, and the Rudd Center. We had additional curatorial support from the Yale Department of Anthropology. The show begins with a

striking visual – the amount of food that the average American consumes in a year (Figure 2).[18]

Using a combination of models and actual products (where our pest management policies allowed!) we fabricated an eight-foot high "corridor of food" that forms the entrance to the exhibit. This is followed by exhibit stations setting out the basics of food, nutrition, and the physiology behind hunger and appetite. Practical advice on what to look out for in nutrition labels goes along with a fun game, Smash Your Food,[19] that demonstrates in real time (complete with sound) what happens when you squish a doughnut or hamburger, and how much oil, salt and sugar it contains. As part of our planning discussions, especially those about how the project fitted with our mission, we had decided we wanted to work with an anthropologist on the effects of our evolutionary history. The next section investigates this impact, noting that for about 98% of human history people were hunter-gatherers. Objects from modern hunter-gatherers, the Ache people in Paraguay, are juxtaposed with archaeological spear points, arrowheads and other food-related objects.

The exhibit continues by exploring the larger social issues that underpin the obesity epidemic. For example, industrialization during the last 200 years has removed agriculture and food production from its central role in our society. Machines and non-renewable resources like fossil fuels have replaced manual labor; for most people employment requires little physical activity. Urbanization has led to changes in our built and social environments that have substantial

Figure 3: A teen bedroom showing how many different ways companies market food to children.

consequences for food, obesity and health. Rates of obesity are far higher among city-dwellers, particularly in developing countries, as people shift from producing their own food to purchasing processed foods, and opportunities for exercise are far fewer. Food is now transported across the globe and the social and economic changes that underpin the obesity epidemic in the United States and Western Europe are now driving a similar epidemic in developing countries. Finally, the enormous highly-mechanized agribusinesses have had significant impacts on the environment and greatly reduced the price of food, while government policy has impacted the price and availability of different types of food.

The next section looks at food marketing, particularly marketing targeted at children. This is a major part of the Rudd Center's research effort. A teen bedroom (Figure 3) provides a setting for showing how marketing is found on all screens – the computer, TV, and mobile devices – as well as in

Figure 4: An exhibit showing the effects of obesity on several different body organs.

many forms (adverts, "advergames," product placement etc.). Evidence links obesity to sugary drink consumption more than any other single food category. One of the most powerful exhibits proved to be the case of beverages with the teaspoons of sugar behind them as described earlier. We also included a section on how our ideas of a "normal" portion have changed over the last few decades. An analysis of a popular American cookbook, *The Joy of Cooking*, showed that a recipe for Chili con Carne in the 1936 edition had 243 calories per recommended portion size, but in the 2006 edition it had 611 calories!

Finally, we look at the health consequences of obesity, and how behavior, genetics and the environment all play a role in an individual's weight. The goal was to highlight the importance of personal responsibility, but not by shaming people. We discussed how evidence for a genetic basis for obesity comes from family studies and gene-wide association

studies, and how our environment – at home, work, school and neighborhood – needs to make the healthy choice the easy choice. An interactive computer game, Strike a Balance, enables visitors to try to balance food consumption with exercise and activity. A stationary bicycle hooked up to a light tube showed how many calories are burned as you cycle. Examples of healthy and diseased organs from Yale's Medical School graphically illustrate the changes wrought by obesity in organs such as the liver, kidney and heart (Figure 4). We also discuss the social acceptability of weight bias, which leads to all types of negative consequences for overweight and obese individuals.

One concern the exhibit team had throughout the process was that visitors should leave with a positive message. So the last part of the exhibition was designed to challenge visitors to reflect on their own role in personal and community health and the sustainability of our food system. Suggestions included small changes that individuals and families can take to improve their health, as well as community action such as improving school meals and supporting locally-grown healthy foods. The final exhibit asks visitors to make a pledge (through voting) for a specific action that they will take for themselves, families and communities. This has now been expanded to an online poll on the museum's and CARE's Facebook pages (Figure 5). We also paid attention to making the exhibit interesting and fun, providing different types of learning opportunities, since a museum is a free-choice learning environment.

In addition to the exhibit itself, the topic inspired a wide

Figure 5: Visitors can go to the museum's or CARE's Facebook pages to vote on actions they intend to take.

variety of programming. The opening weekend was a family event with activities hosted by a variety of food-related community groups, exercise classes, food tastings with a local city market, and puppet shows. A documentary series included a showing of *Cafeteria Man* (a film about improving school meals in Baltimore) followed by a discussion with the Executive Director of Food Services for New Haven Public Schools. A lecture series developed by the Rudd Center included topics such as *The Sugar Pandemic: Policy vs. Politics* and *Falling in Love with Food: Connection and Disconnection in Food Advertising*. On a lighter note there are regular chef/author events and a showing of *Ratatouille*.

In the summer there will be a city-wide marketing campaign (leaflets, bus wraps etc.) to promote drinking water as a healthy alternative to soda. The logo for the campaign

was developed alongside the *Big Food* graphic design, and is featured in the exhibit. Conversely the *Big Food* logo is part of the water campaign, encouraging people to learn more at the museum. This fall there will be a food summit, at which invited speakers will discuss corporate food ethics as part of a regular conference series at the School of Public Health. There will also be a cultural festival focused on food and diet of indigenous South American cultures, including the Ache.

One of the most interesting projects was a collaboration between CARE, The Color of Words (a local non-profit), and the museum. The Color of Words works with high school youth to produce short films on issues of relevance to New Haven. The students' spring project was to produce shorts inspired by *Big Food* which will then be shown at a film festival in the museum. It is worth noting, however, that even with all these programs, and the variety of expertise we used, we still did not cover as many areas as we might. For example, we would have liked to do more on how notions of beauty have impacted people's weight across cultures, perhaps through its representation in the fine and decorative arts.

As of writing we are still at the beginning of assessing the impact of *Big Food*. It was clear in the flurry of publicity when we opened the exhibit that journalists were using it as an opportunity to write about the wider issues of obesity, as well as other community activities in the area. Indeed, when the controversy about a new exhibit at Walt Disney World hit the headlines[20] a local journalist wrote an opinion piece specifically comparing her experience in our exhibit to the approach

taken by Disney's exhibit, *Health Habits*. On the opening day, a brief survey indicated that the food corridor, sugar-sweetened beverage display and the body organs were the most memorable for visitors. They also felt that the nutritional display and, again, the sugar-sweetened beverage display had provided them with the most surprising information that they would apply in their everyday lives.

Anecdotal observation by staff has showed extensive engagement with the exhibit, as indicated at the beginning of the chapter. Visitors have engaged in active discussion with each other as well as spending significant time in the show. During the summer we will undertake some tracking studies, as well as more formal interviews as part of a summative evaluation effort. An immediate impact for the museum itself has been deepening relationships with community organizations, as well as the development of new ones. Local organizations are using the museum to hold their own meetings and public events specifically to allow their constituents to see the exhibit. And, of course, we have collaborated with new funders who may go on to support the museum for other projects in the future.

Engaging with big issues

Our experiences developing the *Big Food* project have shown that even a traditional object-based museum can successfully address issue-based exhibits. We learned that we can take steps outside our comfort zone. The Peabody is a traditional university museum with nearly 13 million specimens in its

collections representing the immense biological and cultural diversity of our planet. *Big Food* is next to the museum's world-renowned dinosaur hall, downstairs from its spectacular dioramas, and across the lobby from the anthropology galleries. It followed an exhibit on bloodsucking insects and will be succeeded by an exhibit on the influence of ancient Egyptian culture through history. Our temporary exhibit program is usually driven by the desire to display and interpret our collections and associated research, or to host traveling exhibits that will be of interest to our audiences.

Making the decision to commit to developing an in-house exhibition about an issue (the obesity epidemic) generated a lot of discussion. The answers to questions we pose for exhibit projects, (Does it further our mission? Is this topic a good fit for the Peabody? Does it serve our audiences?) needed careful consideration. Answering these questions caused us to think through different parts of our mission, which includes interpreting Yale research (an important part of the exhibit) but also focuses on our collections (potentially less applicable). What quickly became clear was the immediate and significant level of staff engagement in the project, not only among the exhibit team but also in other museum departments. People feel strongly about weight issues and the politics and other forces behind the obesity epidemic. Staff and curators whom we feared would think it an inappropriate topic for the Peabody (particularly as the number of museum objects in the show would be relatively small) were very supportive. They thought it was an important topic for the community, and therefore

for the museum. At meetings, staff also shared personal stories about their own (or a loved one's) experience with weight issues. We found that we needed to allow time for these discussions, which were very helpful in thinking through how visitors would respond to the exhibit.

This level of engagement was mirrored by the exhibition's sponsors. Finding financial support for the exhibit proved easier than expected. Obesity is an issue that is in the news every day and is a major concern for many businesses and foundations. We found funders were very interested in supporting this project. It is often said that, with the right project, fundraising is straightforward and we certainly found it was the case with an exhibit that was so closely aligned with demonstrated community need.

We also discovered that preparing exhibits on big issues requires understanding and knowledge from many different disciplines. For example, we were going to include a regular and bariatric wheelchair (or movie seats) in our exhibit to show how they have changed over time. However, one of our collaborators pointed out that could just as easily engender disgust that patients have got bigger (thereby contributing to the weight stigma issues we are trying to address) rather than showing the results of the obesity epidemic. This is where a university museum is ideally suited to undertake such projects. What better place to find expertise in a variety of disciplines than in a university? For *Big Food* we had a small curatorial team, but eventually involved anthropologists, evolutionary biologists, economists, environmentalists,

historians, nutritionists, physiologists, psychologists, and public health professionals from across the campus.

Working with multi-disciplinary teams, particularly individuals who have not curated exhibitions before, is a learning process on both sides. Often there are misunderstandings about the amount of work it takes to curate an exhibition, and the length of time it takes to design and fabricate exhibit elements. There is the challenge of developing interpretation for a variety of audiences who are in an informal learning environment, as compared to writing an academic paper or even giving a public talk. A museum audience is not captive and the museum environment provides opportunities that go far beyond text and photographs on a wall. What we did find, however, is that exhibit curators who do not work in museums do not accept that things can't be done! They had many creative ideas that provided museum staff with major implementation challenges, but which in the end sparked several excellent exhibits, for example how to show the amount of sugar in a soda bottle. While the inclusion (often late in the day) of additional voices in the process did mean reworking some exhibit sections, in retrospect we found they were far better for it and it is possible to change things closer to the end than we might normally think.

The role of academic museums, with their full range of academic expertise and the intent to explore issues seriously and in-depth, was amply demonstrated by the contrasting experience of Walt Disney Corporation two weeks after we opened *Big Food*.[21] As our exhibit made clear, the issues

surrounding obesity are not trivial. There are many complex forces at play – it's not just about everyone needing to eat their vegetables and do more exercise. However, a new exhibit at Walt Disney World's Epcot Center in Florida, *Health Habits*, despite millions of dollars of investment, did not present this reality. *Health Habits* was an exhibit focused on obesity, specifically childhood obesity, and invited visitors to take part in a series of interactive experiences in the company of role models Will Power and Callie Stenics. The villains were characters such as Lead Bottom (who doesn't exercise) and Snacker (who eats junk food). The goal was to encourage kids to develop good health habits, but the exhibit was roundly criticized for reinforcing stereotypes about overweight and obese children and adults, and using shaming and stigmatizing techniques that have been repeatedly shown to be ineffective in encouraging healthy choices. *Health Habits* had a soft opening on February 3 2012, just before *Big Food* opened, and was closed less than four weeks later. It is, of course, commendable that Disney decided to address the topic in a venue that serves millions of families a year, but by not taking the time and care to research the underlying issues, their exhibit would likely have negative consequences rather than the positive outcomes they intended. Presumably they had not consulted with a wide range of experts or practitioners in the area, thereby producing an exhibit that was ill-informed and misjudged.

Another strength of an academic environment is that we are freer to explore difficult issues in our programming. Indeed, it can be argued that that very freedom makes it a moral

imperative for university museums to take these risks. For example, we decided at the beginning of exhibit development that we wanted to use real products rather than generic or fake food that is commonly used in museums. We believed that using the actual product that is on the supermarket shelves would be far more powerful than an imitation and this was borne out by visitor observation. So we included Coke™ and Pepsi™ bottles rather than ones with the labels soaked off and replaced with the word Cola. We displayed the Strawberry Pop-Tarts™ that have an extensive nutrition label because of all the additives. We discussed specific marketing strategies of fast food restaurants like McDonalds™. And we had the scholarly research to support every statement. This is not always possible at other venues or museums, which may fear alienating potential donors, or worry about legal implications.

A final thought
Big Food was innovative in its scope and depth: addressing historical context, biology, behavior, and broad social and cultural imbalances that drive the epidemic, and may provide insight into solutions. As the great museum thinker Stephen Weil constantly reminded us, museums need to matter to their communities. They need to make full use of their potential as "places that have the potency to change what people may know or think or feel, to affect what attitudes they may adopt or display, to influence what values they form." [22] University museums can undertake programs that address 21st century challenges with a different toolkit than that available to

many other museums, in an environment that enables more risk-taking and experimentation. Our programs benefit from the intensive involvement of active researchers in many disciplines and they take place in an environment that promotes interdisciplinarity, and fosters academic freedom. *Big Food* is just one example of how academic museums can make a difference in people's lives, even if it's a simple thing like drinking less soda.

NOTES

1 For example, see the initiative Good to Grow! from the Association of Children's Museums, www.goodtogrow.org

2 Silverman, I.H. 2010. *The Social Work of Museums*, Routledge.

3 Simpson, T.K. 2000. The Museum as Grove of the Muses. *Journal of Museum Education.*

4 National Science Board. 2010. *Science & Engineering Indicators*. National Science Foundation, Washington DC.

5 Falk, J.H. & Dierking, L.D. 2010. The 95 Percent Solution. *American Scientist.*

6 Ibid.

7 Silverman 2010 p. 139.

8 Pickering, J. 2009. Ivory Tower or Welcoming Neighbor: Engaging Our Communities. *University Museums and Collections Journal.*

9 Bianco, J. 2009. A purpose-driven university museum. *University Museums and Collections Journal.*

10 Chatterjee, H.J. 2010. Object-based learning in higher education: The Pedagogical power of museums. *University Museums and Collections Journal.*

11 Pickering, J., Fawcett, L., & Munstermann, L. in press An Alternative Approach: Teaching Evolution in a Natural History Museum through the Topic of Vector-Borne Disease. *Evolution, Education & Outreach.*

12 Cameron, F. 2011. Climate change as a complex phenomenon and the problem of cultural governance. *Museums and Society* 9 (2): 84 – 89.

13 The Arizona State Museum is an anthropology museum that is part of the University of Arizona.

14 Silverman 2010 p. 13 and132.

15 National Research Council. 2009. *Learning Science in Informal Environments.* National Academies Press, Washington DC.

16 Yale Peabody Museum. 2005. *Engaging Our Communities.* Yale Peabody Museum.

17 Solving the Puzzle: Lyme Disease, West Nile Virus and You and

Invasion of the Bloodsuckers: Bedbugs and Beyond

– see http://peabody.yale.edu/exhibits/online-exhibits

18 The data came from the U.S. Census Bureau (http://www.census.gov/

compendia/statab/cats/health_nutrition/food_consumption_and_nutrition.html)

and is based on food sales.

19 Smash Your Food is part of an online experience produced by Octave Media,

called FoodnMe.

20 See description later in the chapter about the critical reception of *Health*

Habits. The story was extensively covered by national and international media,

for example see *Time Magazine* at http://newsfeed.time.com/2012/03/02/disney-

closes-anti-obesity-exhibit-amid-critical-backlash/

21 Ibid.

22 Weil, S. 2002. *Making Museums Matter*. Smithsonian Institution Press,

Washington DC.

References

Bianco, J. 2009. A purpose-driven university museum. *University Museums and Collections Journal* 2/2009: 61 – 64.

Cameron, F. 2011. Climate change as a complex phenomenon and the problem of cultural governance. *Museums and Society* 9 (2): 84 – 89.

Chatterjee, H.J. 2010. Object-based learning in higher education: The Pedagogical power of museums. *University Museums and Collections Journal* 3/2010: 179-181.

Falk, J.H. & Dierking, L.D. 2010. The 95 Percent Solution. *American Scientist* 98 (6): 486 – 93.

National Research Council. 2009. *Learning Science in Informal Environments.* National Academies Press, Washington DC. 336pp.

National Science Board. 2010. *Science & Engineering Indicators.* National Science Foundation, Washington DC.

Pickering, J. 2009. Ivory Tower or Welcoming Neighbor: Engaging Our Communities. *University Museums and Collections Journal* 2/2009: 15 – 21.

Pickering, J., Fawcett, L., & Munstermann, L. in press An Alternative Approach: Teaching Evolution in a Natural History Museum through the Topic of Vector-Borne Disease. *Evolution, Education & Outreach.* V. 5 (1).

Silverman, L.H. 2010. *The Social Work of Museums.* Routledge, London. 192 pp.

Simpson, T.K. 2000. The Museum as Grove of the Muses. *Journal of Museum Education* 25 (1-2): 28 – 31.

Weil, S. 2002. *Making Museums Matter.* Smithsonian Institution Press, Washington DC. 273pp.

Yale Peabody Museum. 2005. *Engaging Our Communities*. Yale Peabody Museum. 30pp. Accessed 3/26/12 at: http://peabody.yale.edu/sites/default/files/documents/about-us/ypmEOCproject.pdf

Acknowledgments

The author would like to thank the everyone who worked on the development of the Big Food exhibition, particularly the curatorial team: Jeannette Ickovics (Lead Curator), Richard Bribiescas, Jacqueline Bruleigh, Megan Orciari, and Marlene Schwartz. She would also like to thank the exhibition's presenting sponsor, Anthem Blue Cross Blue Shield Foundation.

Cultivating a Curatorial Culture Through the College Library

LAUREL BRADLEY, MARGARET
PEZALLA-GRANLUND, AISLING QUIGLEY
& HEATHER TOMPKINS
Carleton College

On a typical spring day in 2012, visitors to Carleton College's Gould Library encounter multiple exhibitions installed throughout the spacious first floor. These include a visual exploration of gender roles in Nigerian masquerade told through photographs, video stills, and videotaped interviews; a student art project comprised of photographs from Vietnam mounted on large wooden panels; and an exhibition of books about mythical creatures drawn from the library's collections. Many libraries host art exhibitions and book displays from their collections; some libraries have curators or library professionals charged with organizing exhibitions. At Carleton the library exhibition program is central to developing a collective "curatorial culture" across campus, extending from classrooms and departmental display cases to the library and teaching museum.

The Gould Library art and exhibitions program materializes a desire to make art and design a part of students' everyday lives, and contributes to the library's being a social and cultural space, not just a repository for books. This vision, nurtured by Sam Demas, library director from 1998 to 2011, came to life with the addition of a curator of library art and exhibitions to the staff, and programmatic funding. The first library curator partnered with Laurel Bradley, Director of the Carleton College Art Gallery (now the Perlman Teaching Museum), to author a Memorandum of Understanding (2002). The memorandum stated that the library exhibition program and the art gallery would "collaborate on the display of artworks and exhibitions in the library, to achieve the optimum audiences and teaching

opportunities for both departments and for the college as a whole." This formal document, amplified by nearly ten years of productive collaboration, laid the groundwork for broadening participation in exhibitions across campus, and embodies the dream of ambitious collaborations between library and museum. The goal of adding exhibitions to the faculty toolkit, and encouraging object-based assignments and research projects, is also supported by a college-wide initiative called Visualizing the Liberal Arts, supported by a grant funded by the Andrew W. Mellon Foundation.

Since the fall of 2006, a team of library staff – including a curator, special collections librarian, reference and instruction librarians, and a research associate – have developed a variety of curatorial and display strategies; timelines, procedures, and assignment guidelines; and partnership models that have made curricular exhibitions an attractive option for faculty. In contrast to the long planning curve behind museum projects, library exhibitions are scheduled at relatively short notice. Instead of privileging original artifacts and objects, these presentations may include a variety of materials, including reproductions. Curatorial responsibility rests with non-professionals, that is, students and faculty members; the professional curator and librarians play instructional and support roles. Curricular exhibitions vary widely in form, formality, and duration. Some blossom as term-long exhibitions accompanied by public talks, an opening reception, and an online exhibit; interpretive materials and display strategies approach the formality of museum

standards. Others, such as a table display of books initiated by a student organization, are organized on a short timeline, remain on view for a few weeks, and employ more provisional display strategies and minimal interpretive labels.

Common Criminals or Portraits of Dissent? Mug Shots from the Montgomery Bus Boycott 1955-56, mounted in fall 2006, was the first significant experiment in curricular curating. The exhibition, featuring photographs of protesters arrested in February 1956 as part of the year-long bus boycott, grew out of a seminar on civil rights led by history professor Harry Williams. While well-known figures were among those arrested, class participants, working closely with librarian Heather Tompkins, focused on the lesser-known protesters. Inspired and energized by research, Williams and his students proposed an exhibition, featuring prints of photographs discovered on the Alabama State Archives website, to the library curator. Over the spring and summer, the curator and librarian worked with the professor and students as a curatorial team, through the various stages of exhibition planning and implementation. They developed an umbrella concept and honed the central themes; selected the photographs; wrote and edited exhibit texts; organized printing and display. The exhibition opened to enthusiastic responses; what might have been a largely hidden, classroom exchange between a few students and a professor, gained a broad audience in the lobby of the highly trafficked Gould Library. The curatorial team was proud to share original research, disciplined through exhibition protocols, with friends and other members of the college community.

Three case studies, drawn from a roster of over fifteen curricular exhibitions organized in the Gould Library since 2006, enrich the larger conversation about the role of exhibitions and museums in the academy. The following will demonstrate how Gould Library exhibitions originate; planning and implementation processes; pedagogical outcomes; and the relationships between curatorial team members comprised, variously, of faculty, curators, librarians, students and others. These case studies will demonstrate variations on a successful system aimed to integrate exhibitions more broadly into teaching and learning and link the library and museum through shared methodologies. The examples will launch further reflections on how Carleton's experiments fit into larger trends reshaping academic libraries and museums, as both entities seek to more effectively serve users through teaching and innovation.

Case study 1: Student-initiated exhibition

In Spring 2010, four independent study students created an exhibit about the history of mapping Haiti. *"The fairest sight in all the world..." Five Centuries of Mapping Haiti* is an excellent example of how student-curated exhibitions offer rich opportunities to cultivate critical literacies in information, writing, and working with visual materials. This project also highlights various ways the curatorial process maps onto teaching research methods, and how exhibition assignments bring together staff, students and faculty as a curatorial team. Working closely with history professor Victoria Morse,

the students embarked on a shared independent study adventure exploring the history of cartography. Catastrophic earthquakes, rocking Haiti less than two months earlier, inspired a focus on this island nation. By using Haiti as a case study, students could address both broad issues related to cartography, and specific questions defined by place. In charge of their own research, these students explored the library collections to gather insights into the historical, economic, and political conditions impacting maps of Haiti over time.

Library staff, whose essential charge is student and faculty support, functioned as consultants to the student curatorial team. Early in the term, two librarians – in charge of Special Collections and Government Documents – provided instruction on finding, accessing, using, and thinking about maps and other collection materials. Students found facsimiles, atlases and books in both Special Collections and the general circulating collection. They discovered hidden maps by simply turning pages and opening folios, gaining access to incompletely catalogued materials invisible to the researcher relying only on existing bibliographic records. In addition to scanning the shelves and spending time with items recommended by their advisors, students also searched online map repositories, and used print bibliographies to locate travel narratives by early European visitors to Haiti and the Dominican Republic. Organizing an exhibition, the students learned, depended on the same research process as writing a traditional scholarly paper.

As research progressed, library exhibitions staff instructed

the student team on the curatorial process which begins with defining and articulating themes through objects, encompasses the rhetoric of museum labels, and ends with display methods. Primed by research and motivated by enthusiasm, students were poised to exercise curatorial choice. They were limited to two display cases, one flat and the other vertical, holding up to ten objects in total. The final exhibition, reflecting the multiple contexts under which maps are created and used, brought together sheet maps, books, and news content available on the web. Students divided materials into five roughly chronological categories: Haiti as the New World; Haiti in the European Colonial Imagination; How? or Who? but not Why?; Haiti as the Land of Adventure and Leisure; and Foreign Users and Maps of Port-au-Prince.

By incorporating questions and new insights into their presentation, students gave viewers a taste of an in-depth research project yielding open-ended results. Rather than distill what they learned into a single text, the curators presented a complex story through multiple objects supplemented by textual enhancements. Unifying the various artifacts and interpretative texts was the realization that maps often tell us more about outsiders' interests and experiences than revealing truths about the people and places being mapped. As one label remarked: Haiti functions as a geographical "container" into which observers pour content relevant to their own interests.

The exhibition demonstrated that maps, contrary to expectations that they convey an objective truth, embody the worldviews and specific needs of particular users. For example,

Haiti in the European Colonial Imagination

PLATE 53: OCCIDENTALIS AMERICAE PARTIS, 1594
Illustration by Theodore de Bry

Reproduced in:
Margaret Beck Pritchard and Henry G. Taliaferro
MAPPING COLONIAL AMERICA: DEGREES OF LATITUDE
Williamsburg: The Colonial Williamsburg Foundation, 2002, 67
Gould Library Special Collections

CARTE DE L'ISLE DE ST. DOMINGUE, 1801

Gilles Robert and Didier Robert de Vaugondy
ATLAS UNIVERSEL
Paris: n.d.
Gould Library Special Collections

In these maps, Haiti is dotted with European towns and criss-crossed by colonial jurisdictions. These images convey a sense of control and ownership over Haiti that was largely a product of the European colonial imagination. As the inscription on the *Atlas Universel* explains, "All the animals and plants brought there [to Haiti] from Europe have taken well and multiplied." For these cartographers — and the worldview that they were reproducing — Haiti was not its own entity capable of self-sufficiency, but a land to be filled by European colonial aspirations.

Figure 1: Label from "The fairest sight in all the world..." Five Centuries of Mapping Haiti.

when describing an 18th century map of Léogâne and Port-au-Prince by French cartographer Jacque Nicolas Bellin, students asserted that it was likely used by an ambitious merchant for whom "atlases such as this were on the cutting edge of geographical knowledge and would have provided him with a sense that the world was at his fingertips."

The fledgling exhibition organizers learned that choosing and discarding are two sides of the curatorial coin. Students interacted with a fascinating wealth of materials as they spread their research net wide. The ninth edition (1895) of *Encyclopedia Britannica*, called the Scholars Edition, seemed particularly promising in entries on the Caribbean, Haiti, and exploration. A political science major was excited by the United States Congressional Serial Set, accessible online.[1]

Full of 19th and 20th century maps, and diplomatic and consular correspondence, this virtually forgotten reference set contained exploratory reports about Haiti as a potential site for the resettlement of former slaves from Africa. These sources, while not physically presented in the exhibit, helped the students conceptually frame their objects, make decisions about what objects to include, and bolstered confidence in their story of mapping Haiti.

The student curators focused primarily on the intellectual work of research and writing. Library advisors worked closely with the students as they translated raw research into an exhibition. Once objects were selected, the librarians and library curator helped the students hone themes as they wrote exhibition labels (Figure 1). Providing editorial assistance, the library team guided student writing into section and individual object label formats defined by museum consultant Beverly Serrell in her book *Exhibit Labels: An Interpretive Approach*. At installation time, students were on-site to guide placement of objects, texts, and artifacts with the library installation team.

The exhibit opening, sweetened with cookies and lemonade, dovetailed with public conversations around a recent global tragedy, and built support for Haiti relief efforts. The exhibition opening was coordinated with a campus screening of a documentary on the political, social, and historical roots of international aid to Haiti. In their introduction to the documentary and the discussion that followed, students made a clear connection between popular U.S. conceptions of Haiti in 2010 and the 15th and 16th century

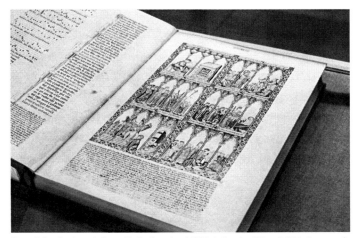

Figure 2: Las Cantigas de Santa Maria. *Completed 1280. Codice rico, El Escorial T. 1. Courtesy of Lawrence V. Mott, University of Minnesota.*

maps. The exhibition proved an effective format for presenting research, and helped build community around a set of student interests and goals.

Case study 2: one rare facsimile, two professors, an exhibition with flashcards

During spring term, 2011, the Gould Library presented *Cultures in Counterpoint: Music, Image, and Text in Medieval Iberia.* The project was initially built on a fragile foundation of pure enthusiasm fueled by the hefty magnificence of *Las Cantigas de Santa Maria* (1280), a large facsimile of 420 beautifully illustrated poems or songs (cantiga) composed at the Court of King Alfonso X' el Sabio in the thirteenth century (Figure 2). The pages of *Las Cantigas* are festooned with colorful, narrative images that bring to life a panoply of characters

playing musical instruments, witnessing miracles of the Virgin Mary, and engaging in quotidian activities. Indeed, the facsimile represented such a rich visual and historical resource that its acquisition drove the entire exhibition process. It promised students an intimate and tactile encounter with an illuminated manuscript in the Special Collections classroom, and provided rigorous research and writing opportunities. The final presentation of research in exhibition format added value to an object-based learning opportunity.

In February, the library curator, her associate, Aisling Quigley, and faculty co-curators met to define themes, align goals, plan syllabi, and talk through potential exhibition-related assignments. Even while the *Cantigas* facsimile awaited its journey from the Madrid offices of the Scriptorium press to the hospitable shelves of Carleton's Gould Library, the curatorial team began to organize an exhibition around it in connection with two spring term courses, The Creation of Classical Arabic Literature, and Crusade, Contact and Exchange in the Medieval Mediterranean. The first crucial task was identifying and articulating a theme that would encompass not only the *Cantigas*, but also additional materials. The following Big Idea[2] emerged through a series of email exchanges:

> *Medieval Iberia witnessed significant social, economic, and cultural exchange between the three predominant monotheistic religious traditions of the time: Christianity, Judaism, and Islam.*

Seeking to connect the Christian *Cantigas* with Special Collections facsimiles from other monotheistic religious traditions, faculty experts selected six additional volumes: the *al-Hariri*, a work of classical Arabic literature; the *al-Qali*, an early lexicographical work; the *Dala'il al-Khayrat*, a book of prayers; the *Sarajevo Haggadah*, which narrates the Passover ritual and also offers an illuminated codex of the Jewish Bible; *Die Pamplona Bibel*, a twelfth century Picture Bible; *In Apocalipsen*, Saint Beatus' commentary on the Bible; and the *Catalan Atlas*, providing fourteenth century contextual maps.

Yaron Klein, Victoria Morse, William North, and Stacy Beckwith, faculty specializing in either Middle Eastern languages or history, wrote the interpretive labels for the exhibition in advance of the term launch. Carleton's terms, only ten weeks long, can be an obstacle to sustained student research projects. In the case of this exhibition, the collaborators did an initial phase of curatorial and interpretive work prior to spring term, and then allowed students to re-animate or recreate exhibition didactics. This two-part interpretive process engaged the viewing public with fresh material throughout the term.

The arrival of a long-awaited *Cantigas* launched the exhibition team into action. The library curator and her associate installed the facsimiles, nestled in their unique cradles, in display cases but also designed tactile and accessible interpretive materials. Faculty-authored texts, published in inexpensive booklet form, functioned as illustrated catalogues available for taking. The booklets were visually connected to

the featured objects through a shared motif. An abstract rose appeared on the brochure's front cover, on signage floating above the exhibition objects, and on the accompanying computer display.

An interactive computer kiosk further facilitated access and created an alternative immersive experience to the books themselves. A member of the Presentation, Events, and Production Support (PEPS) staff converted this virtual flipbook, born as a modest PowerPoint, into a user-friendly slideshow. Visitors could click through several pages of the *Cantigas* and the *al-Hariri*, and listen to music from the Rose Ensemble, a musical group from St. Paul that specializes in early choral music, including Gregorian chants.

The first iteration of *Cultures in Counterpoint*, with brochures and the interactive computer kiosk, was transformed by student projects later in the term. Victoria Morse, teaching Crusade, Contact and Exchange, and Yaron Klein, The Creation of Classical Arabic Literature, each created a series of assignments leading up to the final research and label-writing project. Professor Morse, with several previous exhibitions under her belt, mentored Professor Klein. Klein's students focused on the *al-Hariri* while Morse's students researched the *Cantigas*. The librarian and curator offered valuable support; Heather Tompkins set up course pages that offered on-line advice and useful links to both classes. Margaret Pezalla-Granlund provided the label-writing template, specifying a clear rhetorical structure and limited to 75–100 words. Steps in realizing the assignment included choosing a page from the

Cantigas or the *al-Hariri*, completing a research worksheet, and writing an informal research paper and interpretive labels. In final class presentations, students explained their research process and how they condensed research into a succinct exhibition label.

The two greatest challenges to library staff supporting this project were providing safe access to the facsimiles, and designing an effective format for interpretive labels. The delicate and valuable nature of the objects required vigilant monitoring by the library curator and associate. Tomes were removed from public display and transferred to the Special Collections classroom where students were instructed on proper handling methods (Wash your hands first! No pens in the Special Collections classroom!). In addition to safeguarding the objects, library staff shared knowledge and talked with students about both images and texts.

Installing the interpretive labels proved a logistical challenge because of limited space in the exhibition cases. Instead of the conventional tombstone labels, the library exhibition staff ultimately produced loose double-sided cards contained in a holder outside the case for didactic information. One side of each card presented a color image, usually a zoomed-out picture of the selected page, with a general textual description (Figure 3a), while the other used close-ups highlighting specific elements of the illustration (Figure 3b). The exhibition staff used digital manipulation to combine student commentary on specific sections with enlarged details. This display method, combining reproductions with selected

Cantiga 44
from Cantigas de Santa Maria

This panel of the *Cantigas* displays the story of an Aragonese lord who loses his prized goshawk while hunting. After failing to reclaim itself, he presents the Virgin Mary with a beeswax figurine of the goshawk, and the bird miraculously returns to him.

Illustrations of falcons or falconers during this time period indicated nobility. Many contemporary authors classified different types of hunting birds by their noble quality. The goshawk's specific identity in the text accompanying these illustrations is particularly intriguing due to the classification of the goshawk as an "ignoble" bird by the contemporary author Juan Manuel (the nephew of Alphonso X).

Card prepared by George Guenthner '14 and Sharyl Rich '13

Figure 3a: Side 1 of student-interpreted labels for Cultures in Counterpoint. *This side provides a contextual image and descriptive text.*

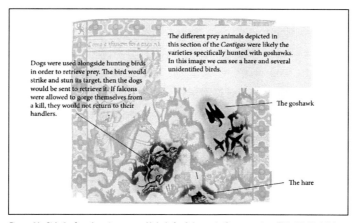

The different prey animals depicted in this section of the *Cantigas* were likely the varieties specifically hunted with goshawks. In this image we can see a hare and several unidentified birds.

Dogs were used alongside hunting birds in order to retrieve prey. The bird would strike and stun its target, then the dogs would be sent to retrieve it. If falcons were allowed to gorge themselves from a kill, they would not return to their handlers.

The goshawk

The hare

Figure 3b: Side 2 of student-interpreted labels for Cultures in Counterpoint. *This side highlights specific details of an image.*

page spreads offered under glass, expanded viewer access to complex, multilayered book objects. The cards, made from thick cardstock and meant for handling, not only delivered information, but also added a tactile and engaging dimension to the exhibition.

As a culmination of their term-long project, students from both classes joined to host a reception in the Gould Library. The interpretive "playing cards" became effective and amusing tools in a public scholarship game of show-and-tell with their peers. Recently, Professor Klein recycled the *Cultures and Counterpoint* exhibition assignment; although there was no exhibition this time around, he relied on his earlier curatorial experience to incorporate the research methods and Special Collections primary source materials in designing student learning tasks. The *Cultures in Counterpoint* exhibition provided an effective and public platform for student and faculty research. It also serves as a model for collaboration between faculty, librarians, exhibition experts, and additional support staff united around a single tangible outcome.

Case Study 3: a museum-ready exhibition – in the library
If the curatorial culture at Carleton has helped a variety of small, informal exhibitions flourish on campus, it has also supported more formal, but still collaborative exhibitions in the library. In the Spring of 2011, Gould Library presented *Métis/sage*, an exhibition generated and curated by French professor Stephanie Cox with the technical assistance of library exhibitions staff. The exhibition featured the work of

Canadian artist David Garneau, whose large-scale paintings on canvas feature images drawn from popular culture, spaghetti westerns, and the history and culture of the Métis, a Canadian aboriginal group. The title of the exhibition, *Métis/sage*, comes from the French word *métissage*, and suggests a wise (sage) coexistence of elements otherwise foreign to each other.

Unlike many library exhibitions, *Métis/sage* – Garneau's first solo show in the United States – would have been appropriate for a more formal museum setting. This was a classic loan show, complete with logistical challenges related to transporting borrowed works of art, and requiring an uncluttered gallery setting for optimum experience. Shipping arrangements proved complex for this artist based in Regina, Saskatchewan. Professor Cox navigated the intricacies of international shipping. She secured a carrier and customs broker, organized the complex import paperwork, and maintained pressure on the shipper when the crate took an unexpected detour to Ohio before arriving in Northfield. The exhibition consisted of eleven paintings; the largest measured eight by ten feet, nearly the height of the library's tallest wall. Functioning both as the lead curator and a lowly technician, Cox supervised the placement of the artworks – and lent a valuable extra hand when needed.

While many aspects of this exhibition would be typical of what one would find mounted in a museum "white cube" environment, others reflect the library's less formal, more didactic approach to exhibitions. *Métis/sage* was implemented in two phases, a sequence driven by the curricular goals of the

Figure 4: Installation photo of David Garne's paintings in Métis/sage: visually translating the Métis experience in Canada.

project. Library staff worked with Cox to plan Garneau's visit, design the assignment, and provide feedback on the students' label drafts by means of an online course-management tool. The initial installation (Figure 4) included only the most basic exhibition text: a statement by the artist and tombstone labels for the artworks. Midway through the term, these basic labels were replaced by French/English labels developed by students in Professor Cox's Transnational Writers in Quebec. In just three weeks, the students became experts on Garneau. Prepared by background reading on Métis culture, students took full advantage of the artist's campus visit. They attended a public talk and conducted interviews with Garneau. These steps produced well-informed texts formatted as new exhibition labels. Each student successfully illuminated, in less than 75 words and in two languages, how the artist combines

European and North American artistic traditions, comics, and traditional Métis beadwork to comment on the unique experience of his people.

The exhibition, by most measures, was a success: it looked great in the library, the artist's talk was well-attended, and the students took full advantage of the opportunity to work with a contemporary artist whose work embodied the primary issues of a course on Transnational Writers in Quebec. One could argue, though, that opportunities for student learning were overlooked. Mounting an exhibition of this scale and complexity challenged both the faculty member and the staff: How do we work with an artist from another country? Will the crate get through customs? Will it fit through the library doors? What is a square-head drill-bit? The curatorial team, comprised of the faculty member and library exhibition staff, met these challenges. Students were given responsibility for interpreting the exhibition objects, a limited task they performed admirably based on well-honed guidelines and the multi-staff support system. The Gould Library formula for curricular exhibitions, emphasizing research, writing, and interpretation, must leave out some of the behind-the-scenes processes which challenge, confound, and reward curators executing the full array of professional tasks.

Despite these constraints, students and faculty felt rewarded for their efforts. One student reflected on the linguistic challenge of translating his exhibit text from English to French, and expressed appreciation for the opportunity to "produce good and useful work for a real need." For Professor

Cox, the assignment gave students a "hands-on experience with the course cultural and artistic material." [3] While she often assigns short writing exercises with strict word limits, Cox noted that the peer-editing process and public nature of the final labels encouraged their best efforts. She also remarked on the more lively impact of student interpretive labels in contrast with the rhetorically silent tombstone labels.

Carleton's library has invited faculty and students to participate as partners in creating and presenting knowledge through exhibitions. With advance planning, narrowly defined goals, the use of time-tested writing templates, and designated staff eager to support the enterprise, curricular exhibitions now enrich the intellectual life of the campus. Many faculty members, eager to add a public dimension to assignments and to initiate students into the pleasures of primary research with cultural artifacts, are joining the curatorial ranks. The question remains, though, whether this model can prepare the ground and fuel productive collaborations in the more demanding environment of the campus museum.

Connecting faculty curators to the teaching museum
Can the Gould Library model of modestly scaled, short-term exhibitions produced in conjunction with specific courses translate into more ambitious projects, privileging unique artifacts displayed according to polished professional standards, in the teaching museum? Campus museums are sometimes defined as laboratories for learning, foregrounding ideas and the research process in displays and didactic

materials. And, indeed, in comparison with public museums, addressing broad and diverse audiences and needing large attendance numbers to justify their funding, college museums offer a safe space for more experimental, process-oriented exhibitions, for exploring obscure problems, and examining artifacts that are not necessarily beautiful or familiar. The Gould Library exhibitions, animated by scholarly research interests, and presenting dynamic combinations of rare and mundane objects and texts interpreted by experts and non-experts, demonstrate that scholarly conversations can take physical form. What would it take to orchestrate a library exhibition on a larger scale and in full accordance with museum conventions? Would the new venue change the nature of the collaboration? The roles played? What would be gained and what lost?

To answer these questions, it is useful to review the library formula, and compare staffing, roles, timelines, and objectives with the parallel universe of the museum.

The library exhibition program bolsters faculty members – in the role of lay curators – with a supportive team. The faculty member takes on key curatorial tasks: he/she leads the class in defining the problem, selects objects that materialize the themes and subthemes, and designs an interpretive framework. Library staff, including the curator and librarians, mentor faculty new to the process, and lend their experience and technical expertise to the project design. They are often full partners to faculty in designing student assignments and shaping outcomes and are adept at bringing in additional

resources such as audio-visual or technology specialists when needed. Technical production, in most cases, is left to library staff to perform outside the curricular arena. Because the library has multiple exhibition spaces, and follows a basic set of exhibition practices, projects can be realized within a short ten-week academic term. Learning goals for students are clearly focused, do not encompass the entire exhibition project, and represent only one of many course assignments. Primary outputs take the form of concise texts pitched at a non-specialist audience. Participants – both faculty and students – are uniformly enthusiastic about their exhibition experiences because of the hands-on nature of the process, and the public nature of the product.

The campus museum is, like the library, a site for object-based learning. Working with objects from the collection and on loan, the curator and collaborators –including students and faculty members – organize exhibitions of resonant objects in an uncluttered, subtly lit gallery. Each artifact embodies a series of choices and preliminary activities; the relationships between objects in space articulate broad concepts, as do discretely placed, carefully formatted, labels and signage. If library exhibitions are material versions of well-executed student research assignments, presented at an end-of-term class symposium for classmates and friends, the museum exhibition aspires to the status of a scholarly publication, summarizing significant research in a definitive format.

The campus museum, comprising a more formal, "authoritative" space than the library, organizes exhibitions

connecting disciplines across the liberal arts. Art works and artifacts, selected for their beauty, technical artistry, historical significance, formal power, and conceptual content, catalyze conversations around issues and ideas. The curator is the primary "author" of these visual/verbal offerings, drawing on her expert knowledge of art history, contemporary artists, and museum presentation strategies. To realize the vision of the new Perlman Teaching Museum, faculty and students must become partners in producing exhibitions and other museum programs, and gain access to the art storage inner sanctum in order to activate the collection as a teaching and learning resource.

Currently, the ability of the museum to collaborate dynamically with faculty curators and student co-curators is limited by the calendar, the faculty workload, and by the staffing levels and staff structure at the museum. Museum exhibitions typically take six months to three years to organize, a time span that stretches far beyond a single grading period, or term, at the college. As the curatorial culture at Carleton matures, and communication flourishes between staff at the new museum and the faculty, faculty may begin to design assignments that allow students to contribute to an exhibition slated for a future date. Already, it is common practice to invite faculty to use a museum exhibition through writing assignments soliciting interpretive responses from student spectators.

A full partnership between a professor and the museum curator requires a hefty time commitment by both parties.

Unlike the library, where the librarians and exhibition professionals play essentially supportive roles, the museum arena – with its elaborate loan protocols, security and conservation requirements, logistical considerations – requires a more equal partnership between faculty and museum team members. The meetings necessary to meld two disparate research processes, and to work through curatorial choices impacted by availability, lending protocols, and shipping costs, are time consuming and may strain a professorial schedule filled with classroom instruction, student contact hours, and administrative duties.

Staff support is central to the library exhibition program's success. Similarly, staff – of sufficient number, and organized to facilitate curricular engagement in addition to maintaining the usual roster of programmatic and collection care activities – are vital to up-scaling the dynamic curricular exhibition program to the museum. The Gould Library embraced innovation by hiring a designated exhibition specialist (curator), and by expanding the duties of reference and instruction librarians to include collaborative curatorial work. A well-functioning teaching museum – at Carleton or elsewhere – will deploy staff to support curricular and faculty-generated exhibitions as effectively as at the Gould library. The successful academic curator networks constantly with faculty to identify potential partners; like the library curator and librarians, the curator mentors faculty in exhibition practices, and deploys technical staff to give polished form to ideas embedded in well-chosen objects. The museum curator and

technical staff, working out of specialized support spaces, have the opportunity to initiate students into behind-the-scenes exhibition routines and practices.

As campus museums – both new and established – seek to connect or reconnect with the curriculum, the new job title of academic curator, or academic outreach coordinator, has emerged. At institutions from the Spencer Museum at the University of Kansas to the Frances Young Tang Teaching Museum and Art Gallery at Skidmore College, this staff member orchestrates the complex tasks and manages changing casts of characters to produce exhibitions enriched by faculty and student research and interpretation. As the authors of the 2007 Mellon Foundation College and University Art Museums report observe,[4] adding staff strategically can vastly enhance chances of successfully realizing the teaching museum vision. At Carleton, on a smaller scale and in a library setting, adding a library curator provided just the right energy and skills to make the program work.

Many campus museums do not have the option of adding staff, even as programmatic demands for more academic connections reshape their mission. Are there any solutions in the Gould Library model to the problem of recalibrating museum activities in order to free up time and resources for a more collaborative enterprise? The authors of this chapter can only offer a few speculative proposals, sometimes radical and possibly radically impractical notions, to stimulate creative minds in the profession:

· *Expand the Memorandum of Understanding between library*

and museum: Define both the library and the museum as college-wide resource centers and laboratories for learning. Encourage staff collaboration and information sharing beyond the obvious partnership between library and museum curators. Break down silos between library and museum so that expert teams can support exhibition projects at multiple venues on campus. Design access to the art collection in keeping with the library service ethos while maintaining high preservation standards (a goal virtually impossible to achieve without adding staff through hiring or cross-departmental borrowing).

- *Mess with the museum's white cube*: The uncluttered gallery spaces and high production values of the classic museum exhibition confer authority and promote a mood of objectivity and reflection. To return to the analogy between a museum exhibition and a scholarly article or book: in both cases, production values correlate with the intellectual gravity of the contents. Yet these standards are time consuming and labor intensive to achieve, and rely on expert technical staff for implementation. The museum white cube container both validates the exhibition as an authoritative experience, and intimidates amateur aspirants to museum practice.

- In order to open up the museum to faculty and

students, to foreground the learning process, and to abbreviate the exhibition timetable, *redefine at least one museum gallery as a "third space,"* where guest curators are free to mess with museological protocols, design strategies, and notions of authority.[5] Infuse the museum with the active energy of the classroom, or the campus library, by leaving traces of process visible.

· *Design an object-based learning structure,* with a sequence of activities and well-defined learning outcomes, to be integrated into the curriculum broadly. Map how library curatorial projects set the stage for museum exhibitions with curricular connections, and sell the resulting game plan to the administration by stressing institutional goals and pedagogical innovation.

· *Experiment.*

NOTES

1 United States. Congress. Congressional Serial Set, 1817-1980. Washington, GPO. Readex. *Archive of Americana. U.S. Congressional Serial Set, 1817-1980.*

2 Beverly Serrell, *Exhibit Labels: An Interpretive Approach* (Walnut Creek, CA: AltaMira Press, 1996) 2-8.

3 Email correspondence with the author, April 15, 2012.

4 Suzannah Fabing and Marion M. Goethals. "College and University Art Museum Program Summary Report", *The Andrew W. Mellon Foundation Museums and Conservation Program*. November 2007. http://mac.mellon.org/CUAM.

5 Janet Marstine, "What a Mess! Claiming a Space for Student Experimentation in the University Museum," *Museum Management and Curatorship* 22, no. 3 (2007) 304.

Bibliography

"Cultures in Counterpoint: Music, Image, and Text in Medieval Iberia," Viz, accessed February 2012, https:// apps.carleton.edu/campus/library/now/exhibits/ pastexhibits/2010_2011_2/rose_ensemble/?image_ id=735545.

Fabing, Suzannah and Marion M. Goethals. "College and University Art Museum Program Summary Report", *The Andrew W. Mellon Foundation Museums and Conservation Program.* November 2007. http://mac.mellon.org/CUAM.

Marstine, Janet. "What a Mess! Claiming a Space for Student Experimentation in the University Museum." *Museum Management and Curatorship* 22, no. 3 (2007) 303-15.

"Métis/sage: Visually Translating the Métis Experience in Canada," Gould Library, accessed February 2012, https://apps.carleton.edu/campus/library/now/exhibits/ pastexhibits/2010_2011_2/garneau/.

Serrell, Beverly. *Exhibit Labels: An Interpretive Approach.* Walnut Creek, CA: AltaMira Press, 1996.

United States. Congress. Congressional Serial Set, 1817-1980. Washington, GPO. Readex. *Archive of Americana. U.S. Congressional Serial Set, 1817-1980.*

"Visualizing the Liberal Arts Initiative at Carleton College," Carleton College, accessed March 2012, https://apps.carleton.edu/campus/viz/.

EXHIBITIONS AND EDUCATION

Pharmacy Students in the Art Museum: Lessons Learned from an Unlikely Collaboration

AMANDA MARTIN-HAMON
& BARBARA WOODS
University of Kansas

PAT VILLENEUVE
Florida State University

The Spencer Museum of Art at the University of Kansas developed an outreach program, University in the Art Museum (UAM), designed to foster curricular and research connections and collaborations between the museum and university faculty or academic units. The program uncovered an unlikely faculty collaborator within the School of Pharmacy. Initially, the reasons for collaboration were modest. The pharmacy curriculum was evolving with greater recognition of the value of culturally- and socially-sensitive patient-centered care. The pharmacy program intended to use health-related visual artwork to enhance the observation and communication skills of pharmacy students and deepen their appreciation of the historic role of healthcare in society. This was undertaken through the analysis and discussion of artworks. However, the collaboration, which has lasted for over a decade, resulted in unintended consequences. The collaborators discovered a synergy created by teaching through art. Both the museum and the academic unit generated a unique environment that resulted in significant learning as described in Fink's *Taxonomy*. In addition, the long relationship led to a deeper understanding about the value and potential of interdisciplinary collaborations. This chapter introduces a strategy for museum and academic unit collaboration that can be applied across disciplines, describes our practices and project, and cites educational theories that have informed this project.

An art museum is not the most likely place to find a group of pharmacy students gazing intently at a 17th century oil painting or conducting a visual analysis of a sculpture with

a museum curator. However, these students are participating in an elective course designed and developed through the collaboration of the School of Pharmacy and the Spencer Museum of Art Education Department at the University of Kansas. The collaboration, which started over a decade ago, began with modest educational goals for both areas, but resulted in deeper understanding and appreciation of the value of interdisciplinary teaching and collaboration.

Why art?

As part of the University of Kansas, the Spencer Museum of Art sees integration into the academic life of the university as mission essential.[1] As a resource and classroom for faculty, staff, and students, the museum strives to become deeply rooted in teaching, learning, and research. In addition to the usual galleries, the Spencer designed a Print Study Room and Teaching Gallery to support this academic mission.

Another outgrowth of this mission was the faculty workshop, University in the Art Museum (UAM), which was developed 20 years ago by Pat Villeneuve, former curator of education and Professor of Visual Art Education.[2] Across the years, UAM has introduced hundreds of faculty members to museum resources and strategies for interpreting art. The program provides the basic framework for incorporating the museum resources into curricula and research. Regularly scheduled UAM workshops give Spencer staff an opportunity to communicate their interest in collaborating with faculty and share examples of art that make content connections

to various disciplines. These interactions help dispel the misunderstanding that staff would be inconvenienced by faculty requests to use museum resources or collaborate. We credit this faculty workshop for our initial connection with pharmacy.

Why pharmacy?

Professional pharmacy degree programs are heavily science-based with few credit hours during the pre-pharmacy semesters available for students to enroll in humanities. In addition, many courses are delivered in a didactic format and focus on fact retention. The students learn the scientific method, become competent in laboratory science, and comfortable with the vocabulary of the pharmaceutical sciences. Arguably, students need to acquire and assimilate vast amounts of pharmacy-related scientific information in order to practice competently, but at the same time, pharmacy is a human-centered enterprise.

In the early 1990s, the American Association of Colleges of Pharmacy (AACP) through its Commission to Implement Change in Pharmaceutical Education challenged schools of pharmacy in the U.S. to enhance student competencies in a variety of facets. These included critical thinking, communication, professional ethics, and aesthetic sensitivity. AACP described aesthetic sensitivity as "enhanced aesthetic awareness of arts and human behavior for both personal enrichment and application in enhancing the profession."[3] This challenge articulated growing recognition within the

pharmacy profession that provision of high-quality pharmacy care is patient-centered. In addition, quality care means taking a holistic view of the patient, including psychosocial and cultural issues that affect the patient's disease, suffering, and treatment.

Over the past decade, additional voices joined the call to modify pharmacy student education. The national agency responsible for accreditation of professional pharmacy degree programs, the Accreditation Council for Pharmacy Education (ACPE), reviewed, revised and expanded curricular standards. Their motivation was to ensure that pharmacy students would be adequately prepared to provide patient-centered and population-based care following graduation and remain competent life-long learners. The ACPE Standards "focus on the development of students' professional knowledge, skills, attitudes, and values, as well as sound and reasoned judgment and the highest level of ethical behavior." [4] College and university pharmacy professional degree programs responded to these calls for change by making curricular revisions. The University of Kansas School of Pharmacy added a professional ethics course, reviewed and expanded active learning experiences, and eventually squeezed in a narrow opportunity for students to enroll in short pharmacy electives. [5] Overall, however, the professional curriculum remained heavily focused in the pharmaceutical and medical sciences. Time and the high cost of education constrain the opportunity of pharmacy students to enroll in humanities, social sciences, and art courses.

This professional dialogue for change, the challenge to meet pharmacy curricular standards, and the simultaneous UAM workshop conducted by the Spencer Museum of Art laid fertile ground for our long and successful collaboration.

Fink's Taxonomy of Significant Learning
The initial educational activity that resulted from our collaboration relied on published literature that described the value of including visual art and humanities studies in medical education[6,7,8,9,10,11,12,13,14] and the few published studies[15,16,17] supporting the inclusion of humanities in pharmacy education. The length of the educational activity grew with our experience, eventually culminating in a one credit-hour elective course offered in the pharmacy curriculum.

Although we did not rely on a formal framework for planning instructional activity, we will use the language and framework of Fink's *Taxonomy of Significant Learning*[18] to analyze and explain the lessons we learned from our collaboration and the resulting learning activity and course. Unlike other approaches, the types of learning described by L. Dee Fink are interactive with each other rather than hierarchical. Fink defined six general categories[19] of learning that, when present, interact to produce lasting change important to the learner's life – what he defined as significant learning.[20] Four of these categories are most relevant to our analysis. These categories are foundational knowledge, application, integration, and caring. Foundational knowledge is an in-depth understanding of concepts, ideas, and perspectives as a basis for further learning.[21] Application "or using foundational

knowledge includes developing particular skills, learning how to manage complex projects, and developing the ability to engage in various kinds of thinking." [22] Integration involves the ability of students to identify interactions and connections between different disciplines or bodies of knowledge. [23] Fink characterizes "caring as a change in feelings, interests, or values." [24] Drawing on Fink's categories, our analysis in the following sections follows the chronological order of our collaboration.

Early collaboration: lab exercise

The initial learning goals for developing an art-centered learning activity for pharmacy students were modest. We wanted to enlarge their university experience outside of the science building, sharpen their observation skills, and broaden their appreciation and perspective of healthcare, pharmacy, and art.

The early format of our activity was a three-hour lab exercise held at the museum. [25] The students received visual analysis training and then completed an analysis and reflection assignment on works of art in the museum. The visual analysis format provides a way to identify the visual, technical, and expressive properties of art, and discover and articulate how they operate within works of art, which forms the foundation of visual literacy. [26] Works of art were chosen to create opportunities for students to focus on the pervasiveness of health and healthcare in the human condition. The works of art focused on the need to see and think critically about the

whole person, not just the physical manifestation of disease or injury. Students were encouraged to express their ideas and interpretations about what they saw. In the post-assignment survey, one student wrote that "no one has asked my opinion before."

Getting the students to the museum was easy, but successfully developing the skills to communicate the relationship between art, science, and healthcare was difficult to accomplish in such a short period of time and with such a large number of students.[27] However, this early collaboration allowed us to see the potential and served as a good foundation on which to build. Student evaluations showed we were on the right track and provided guidance for future plans. Their responses supported the idea that the opportunity to learn in the art museum and engage in activities that approached learning in new ways was a valuable experience. For example, one student commented that:

> *The historical info on the works increased my attention span when looking at a given work. It's a pity we don't spend more time doing non-structured activities and assignments. One can definitely cram too many facts into one's head. Not being able to have a right or wrong answer is a nice change! Art is a good thing. (Spring 2000)*

Enhanced collaboration: elective course
From the early iteration grew the full-semester, one-credit-hour elective seminar[28] in the pharmacy curriculum. Pharmacy

and the Arts was conducted at both the Pharmacy School in the science building and the Spencer Museum of Art. The learning objectives were:

- Describe the confluence of science and visual art.
- Explain and demonstrate the process of visual analysis as a guide to viewing and gaining greater enjoyment from visual art.
- Explore the use of visual art to convey non-verbal feelings and attitudes towards health, disease, treatment, and care by patients and society.
- Examine the value visual images provide in learning and gaining understanding of disease and treatment.
- Investigate the role visual art has played and currently plays in the marketing of healthcare and pharmaceuticals.

Beginning readings and discussion

The facts-based learning environment of the pharmacy curriculum leaves little room for open-ended discussion and, thus, not much opportunity to learn the art of civil discourse. The first few classes, which focused on discussions about the readings, created a safe, intimate learning environment for students to get to know each other through the seminar format and become comfortable sharing ideas and asking questions. Students were encouraged to engage in critical discussion and inquiry, support their ideas, listen to the ideas of others, and be respectful of opposing perspectives. The variety of personalities and points of view informed by culture and life

experiences became apparent during these early class sessions. Observation of these differences would be unlikely in the context of the regular pharmacy curriculum. These activities support the significant learning domain of application, as described by Fink.[29]

Whereas the seminar discussion format set the stage for students to productively and respectfully share their ideas and appreciate the opinions of others, the content of the readings[30] was chosen to lay the groundwork for individual interest by beginning to create a bridge between art and science. Because interest is thought to result from an interaction between a person and a particular content,[31] we used the students' well-developed knowledge in pharmacy and healthcare as a scaffold or bridge to spark an interest in the museum and art. This would be defined as "caring" according to Fink, which means that "students have developed certain feelings associated with a particular subject or learning experiences that certain interests have emerged and that various values have become important to them." [32] "Caring" motivates students to "feel differently about something." [33]

Art museum visit

The next phase of the seminar was to visit the Spencer Museum of Art where students would begin to learn the foundational knowledge of art. Foundational knowledge as described by Fink is "...the basic understanding of particular data, concepts, relationships, and perspectives...." [34]

Figure 1: Jon O'Neal, United States, 1957; The Bonham Project Panel, *1993; gelatin silver print; Gift of the artist; 1993.0285.*

Men in briefs

A group of pharmacy students stand in front of the imposing neoclassical entrance of the Spencer Museum of Art staring

in disbelief at 17-feet high banners of men in nothing but their underwear. Conversation alludes to their confusion over why something that looks like a Calvin Klein underwear advertisement is hanging in front of an art museum. How could this be?

The group moves into the museum and heads for the exhibition XY.[35] Everyone gathers in front of a large black and white photograph depicting individual images of headless men placed in grid-like rows wearing nothing but their underwear.

Students discover that the banners were enlarged details of the photograph, *The Bonham Project Panel* by Jon O'Neal (Figure 1). The clinical, faceless, repetition of this image is no longer reminiscent of an underwear ad. Something else is going on here. An inquiry-based dialog begins to identify the visual language of the work in an attempt to decode its meaning. Intermixed in this process, students make observations rooted in their own expertise of pharmacy. Nothing seems terribly out of the ordinary regarding the appearance of these men, if you don't take into account the perplexing cropping of their heads and feet.

Finally, the museum educator reveals that this is a photograph taken of men who may be HIV positive, a disease that often lies hidden for many years, undetectable by observation through the naked eye. These men appear fine – possibly underwear model material. Yet, hidden within them may be a life threatening disease.

This revelation marks a shift in the conversation, a shift that opens the door to creative and critical conversation about

the issues and ideas represented by this photograph and the extraordinary way in which art communicates these complex issues. The environment of the museum also provides a shift from the laboratory atmosphere of the science building.

The arts, like the sciences and the humanities, communicate through a particular vocabulary and framework. The museum visit became the beginning point for learning art concepts and skills of observation. These lessons included implementing an objective strategy of visual analysis followed by discussion informed by arts-based inquiry.[36] This method of visual analysis integrated with the students' prior familiarity with the systematic nature of the scientific method. This strategy became the foundation for expanding their skills of observation and understanding of art that would lay the foundation for greater insight into their own field of study. It quite literally expanded their toolbox and modeled how this could enhance and broaden understanding of the healthcare field.

The aesthetics of Jon O'Neal's photograph *The Bonham Project Panel*[37] promoted smooth movement in the conversation between ideas related to healthcare and those related to art. The black-and-white photograph with repeated images of almost naked male bodies stiffly and frontally posed spoke the vocabulary of art, but was also clinical in appearance. Even without knowledge of the photograph's subject, the discussion encouraged integration of ideas and observations related to both healthcare and art.

However, the aesthetic might be better understood through knowledge of O'Neal's inspiration:

A physician and a photographer, KU graduate Jon O'Neal responded to the AIDS crisis with photographs of the areas of mens' bodies that are examined to detect AIDS. O'Neal began the Bonham Project in 1985, when he was a medical intern in San Antonio participating in the military's first rounds of systematic tests for the AIDS virus. The men O'Neal examined were HIV positive but bore no outward signs of the disease. His job was to look at their bodies for symptoms of AIDS. That bodies could be HIV positive and have no symptoms that showed up in visual and tactile examination fascinated O'Neal and led him to his project. To make these photographs, O'Neal set up a makeshift photography studio in a local disco, the Bonham Exchange, where he could photograph the bodies of the men he had examined and of other men who volunteered.[38]

Once the subject of the photograph was revealed, the space between art and healthcare continued to narrow. Students used the vocabulary of art and healthcare to explore, through this image, issues including the idea of faceless people filing through the healthcare system, loss of individualism in clinical contexts, and the complexity of disease and suffering. This conversation continued to lay the groundwork for students to comprehend the rich connections between art and healthcare, described as integration by Fink[39] and illuminate the value of learning through new methods.

The position the students shared as art novices also seemed to allow them more freedom to converse easily about both art and healthcare. In this context, they seemed more willing

Figures 2 and 3: The sculptures of Saints Cosmas and Damian, the patron saints of pharmacy, were a favorite stop during the museum tour. Ignaz Günther, Germany, 1725-1775; Saint Cosmas (on left), Saint Damian (on right), ca. 1750-1765; linden wood, polychrome, gilding; Museum purchase; 1950.0090, 1950.0091.

to participate and take risks like initiating conversation and asking and answering questions. The pressure to appear as an expert or to always be correct seemed lifted.

The lesson of art's many-layered meanings further supported an environment of discovery and discourse rather than a quest for the "right" answer. We noticed that students seemed at ease talking about difficult issues through this framework with art mediating the experience. Rather than interpreting comments as personally directed at each other, the artwork became a neutral sounding board. This unique

feature of art allowed students to explore the more subjective, messy parts of their discipline in a safe space, broadening their perspectives on medicine, healthcare, and the human condition.

Visual analysis assignment

The next few classes continued to introduce students to resources and provide them with an opportunity to begin to apply their new knowledge and strategies to discover the connections between art and healthcare through the museum. These activities supported significant learning, described as application by Fink.[40] This included a tour of the museum highlighting works that made connections to science, pharmacy, and healthcare.[41] It also included a presentation on how to locate resources in the KU libraries, specifically the Murphy Art and Architecture Library, and how to search the Spencer Museum of Art online collections database. Then students were asked to complete an assignment that required them to identify ten works of art on view in the Spencer Museum of Art, analyze them visually, and research the artist and time period of three. This assignment provided students with an opportunity to apply their new skills and knowledge. It also encouraged them to begin to identify works of art and topics in which they were particularly interested (Figures 2 and 3).

Capstone projects

We identified and defined four of the six types of learning experiences that Fink encouraged instructors to integrate

in their course design in order for the learner to achieve significant learning. Fink emphasized that optimally these learning experiences will use active learning methods and involve the learner in doing, observing, and making meaning through reflection.[42] He pointed out that a teaching strategy that uses several types of significant learning simultaneously (for example, foundational knowledge, application, integration, and caring) can create for the student what he calls "rich learning experiences." [43]

The final two assignments in the course illustrate how learning experiences that take advantage of several types of significant learning can lead to "rich learning experiences." The first of the two assignments was modeled after an interactive board in one of the galleries at the Spencer Museum of Art; we termed it the Conversation Board. We directed students to select four pieces of health-related art meaningful to them and not necessarily in the Spencer Museum of Art collection. They were required to then locate images of the artworks and write a brief narrative for each, including something they found particularly interesting. Then they displayed their prints and narratives on a large bulletin board in the hallway outside of the pharmacy department in the science building. Students and faculty were encouraged to vote for their favorite work of art or write comments on a large, blank paper adjacent to the board. The purpose was to allow students to showcase their new knowledge and skills, encourage them to build connections, and pursue their own interests. The student work reflected the ability to integrate and link ideas between art and

healthcare. For example, one student was surprised to notice that the images on the cover and spine of his pharmacotherapy textbook[44] was taken from an oil painting by Obi-Tabot Tabe, PharmD, a painter, graphic designer, scientific illustrator, and pharmacist. Other selected works of art included Eric Avery's *Use Your Head, Use a Condom*,[45] Damien Hirst's *Pharmacy*, and Jenny Schmid's *Anorexia Girl*.[46]

The conversation board generated lively discussion between the seminar students, their peers, and faculty. The works of art provided a vehicle that pushed discussion about issues in healthcare and art beyond conventional classroom conversation. A few students became quite passionate and outspoken about the artwork they selected and what the artwork communicated about pharmacy and healthcare.

The final project of the semester provided the students additional opportunity for significant learning. Drawing upon their knowledge of pharmacy and art, each student developed a short, oral presentation for the class. The assignment served several purposes. Students could select and learn about a topic of individual interest and relevance to them. For example, several students built on creative and artistic talents that they had relegated to the status of hobbies when they elected to pursue a course of study in pharmacy. The student time and effort required to develop coherent oral presentations also benefited their organizational and communication skills. In addition, class discussion following each presentation gave art and pharmacy faculty the opportunity to share feedback from each of their perspectives.

The quality and variety of presentations exceeded our expectations and evidenced that students had acquired deep understanding and appreciation of points of intersection and commonality between the disciplines of art and science. One student, for example, developed a presentation around the Liz Lerman Dance Exchange performance of *Ferocious Beauty: Genome*[47] held at the Lied Center of Kansas. The performance, which explored viewpoints in genetic research, resulted from a Creative Campus project led by the Lied Center of Kansas with the Spencer Museum of Art as a collaborator. The student combined her scientific knowledge of genetics and its relevancy to drug therapy with her enthusiasm and love for dance. She suggested new ways to perceive the human genome and her presentation stimulated a lively discussion about the ethics involved with the quest for eternal youth. Additional presentation topics included connections between creativity and mental illness, the use of video art and its value to medicine, and the use and value of exhibits of plastinated human bodies to art and science.

When we asked students what they liked best about the course on the post-seminar evaluation, they wrote:

- The projects because everyone did something completely different but still brought it back to art/ pharmacy/healthcare. And it was fun to research something I found interesting.
- I liked how we were free to pick our own projects and artwork to complete the assignments. It really helped me to learn because I wasn't getting a million things

thrown at me. I also like how Amanda lectures and how she attended our classes and showed interest!!

- The fact that it took me outside of the sciences (and into the area where most of us, I think, were not as comfortable as we probably should have been.)

Lessons learned and conclusions

It was our intention that the collaboration would enhance students' skills of observation and engender a life-long personal interest in art and museums. Learning through the art museum transformed our vision for this program. Art as metaphor or platform for expressing the human condition provided a bridge between the familiar physical expression of illness and the seemingly less tangible or visible psychosocial dimension of illness. With art as bridge, students explored and discussed difficult topics of illness and healthcare with unexpected ease and comfort. Art as catalyst for ideas and creativity inspired students to discover and explore the intersection between art and healthcare beyond literal representation (i.e. images of sick people).

The strategies used in the interdisciplinary seminar course culminated in a coherent and rich learning environment that included foundational knowledge, integration, and application that resulted in students and faculty gaining greater interest in and a deeper appreciation for (caring) the relationship of art and healthcare than they would likely have experienced in a didactic course.

This unique partnership initiated through the faculty

outreach workshop UAM underscored the potential and identified educational strategies for collaborative projects with the art museum across the disciplines.

NOTES

1 P Villeneuve, A Martin-Hamon, KE Mitchell. "University in the Art Museum: A Model for Museum," *Art Education* 59, no 1:13

2 Ibid., p. 13

3 American Association of Colleges of Pharmacy. Background Paper II. *Commission to Implement Changes in Pharmaceutical Education* (1991):1-23.

4 Accreditation Council for Pharmacy Education. *Accreditation Standards and Guidelines for the Professional Program in Pharmacy Leading to the Doctor of Pharmacy Degree.* Available at: https://www.acpe-accredit.org/standards/ default.asp. Accessed April 10, 2012.

5 All the elective courses were scheduled at 8 a.m.

6 "How to Look at a Mountain," *Artnews* no.3 (1993): 92-99.

7 AL Barry and P Villeneuve, "Veni, Vidi, Vici: Interdisciplinary Learning in the Art Museum," *Art Education* 51, no.1 (1998):16-24.

8 PA Scott, "The Relationship Between the Arts and Medicine," *Journal of Medical Ethics: Medical Humanities* 26 (2000):3-8.

9 S Naghshineh, JP Hafler, AR Miller, MA Blanco, SR Lipsitz, RP Dubroff, S Khoshbin, and JT Katz, "Formal Art Observation Training Improves Medical Students' Visual Diagnostic Skills," *Journal of General Internal Medicine* 23, no. 7 (2008):991-7.

10 JM Reilly, J Ring, and L Duke, "Visual Thinking Strategies: A New Role for Art in Medical Education," *Family Medicine* 37, no. 4 (2005):250-2.

11 VJ Grant, "Making Room for Medical Humanities," *Journal of Medical Ethics: Medical Humanities* 28 (2002):45-48.

12 LE Hicks and RJH King, "Confronting Environmental Collapse: Visual Culture, Art Education, and Environmental Responsibility," *Studies in Art Education* 48, no. 4 (Summer 2007):332-335.

13 PU Macneil, "The Arts and Medicine: A Challenging Relationship," *Medical Humanities* 37 (2011):85-90.

14 J Shapiro, L Rucker, and J. Beck, Training the Clinical Eye and Mind: Using the Arts to Develop Medical Students' Observational and Pattern Recognition Skills," *Medical Education* 40 (2006):263-268.

15 CR Phillips and RJ Morrow, AACP Annual Meeting Presentation Abstract, *American Journal of Pharmaceutical Education* 61 (1997):97S.

16 WA Ritschel, "Physicians and Pharmacists as Fine Artists," *Journal of the American Pharmaceutical Association*, 40, no. 5 (2000):683-697.

17 GW Bumgarner, AR Spies, S Asbill, and VT Prince, "Using the Humanities to Strengthen the Concept of Professionalism Among First-professional Year Pharmacy Students," *American Journal of Pharmaceutical Education* 72, no. 2 (2007):1-6.

18 LD Fink, *Creating Significant Learning Experiences* (San Francisco: Jossey-Bass, 2003): 27-59.

19 Fink's categories of significant learning include foundational knowledge, application, integration, human dimension, caring, and learning how to learn.

20 Ibid., p. 30

21 Ibid., p. 31 and 36

22 Ibid., p. 38

23 Ibid., p. 42

24 Ibid., p. 31

25 P Villeneuve, A Martin-Hamon, and KE Mitchell, "University in the Art Museum," *Art Education*, p. 12.

26 P Villeneuve, *Making Sense of Art* (Lawrence, KS: Spencer Museum of Art, 1992), 1-6.

27 The early iteration was a 3-hour lab activity within a required semester course. Approximately 100 students enrolled in the course.

28 The seminar elective course was called Pharmacy and the Arts and was offered through the Pharmacy Practice Department. Nine pharmacy students enrolled.

29 Fink, *Creating Significant Learning Experiences*, p. 31.

30 RL Solso, *The Psychology of Art and the Evolution of the Conscious Brain*, Cambridge, MA: MIT Press, 2003.

31 S Hidi and KA Renninger, "The Four-Phase Model of Interest Development," *Educational Psychologist* 4, no.2 (2006):112.

32 Fink, *Creating Significant Learning Experiences*, p. 49.

33 Ibid., p. 49.

34 Ibid., p. 31.

35 Link to the exhibition *XY*: http://www.spencerart.ku.edu/exhibitions/xy/ Accessed April 10, 2012.

36 GD Keller, M Erickson, and P Villeneuve, *Chicano Art for Our Millennium* (Tempe, AZ: Bilingual Press, 2004), pp. 155-191.

37 O'Neal's image *The Bonham Project*

38 "Bonham Project Panel Label Text," Spencer Museum of Art, http://collection.spencerart.ku.edu/eMuseumPlus?service=direct/1/ ResultDetailView/result.tab.link&sp=10&sp=Scollection&sp=SfieldValue&sp= 0&sp=0&sp=3&sp=SdetailView&sp=0&sp=Sdetail&sp=1&sp=F&sp= SdetailBlockKey&sp=2.

39 Fink, *Creating Significant Learning Experiences*, p. 31.

40 Ibid., p. 31.

41 List of artwork used in the seminar course, which can be located in the Spencer Museum of Art online database "Search the Collection" at spencerart.ku.edu:
Jenny Schmid, *Anorexia Girl*, 2005.0055 (Accessed from the Print Study Room)
Ignaz Günther, *Saint Cosmas*, 1950.0090
Ignaz Günther, *Saint Damian*, 1950.0091
Cenni Di Francesco, *Madonna and Child*, 1960.0046
Madonna and Child and Saint John, 1960.0050

Master of Frankfurt Workshop, *Descent from the Cross with Scenes from the Passion*, 1984.0196.a-e

Pierre Eugène Emile Hébert, *Et Toujours! Et Jamais!*, 1977.0066

Hollis Sigler, *Haunted by the Ghosts of Our Own Making*, 1996.0008

Robert Arneson, *Forge*, 1994.0037

Lesley Dill, *Thread Man*, 1995.0052

Irving Norman, *The Race*, 1996.0103

Xu Hongbo, *Clone 07-4*, 2008.0211

Renée Stout, *Sanctuary for the Deacon's Son*, 2001.0063

42 Fink, *Creating Significant Learning Experiences*, p. 104.

43 Fink, *Creating Significant Learning Experiences*, p. 111.

44 MA Chisholm-Burns, BG Wells, TL Schwinghammer, PM Malone, JM Kolesar, JC Rotschafer, and JT Dipiro, *Pharmacotherapy Principles & Practice* (New York: McGraw Hill, 2008).

45 Spencer Museum of Art website "Search the Collection" at spencerart.ku.edu

46 See note 44 above.

47 Dance Exchange, "Ferocious Beauty: Genome," http://danceexchange.org/projects/ferocious-beauty-genome/

References

Accreditation Council for Pharmacy Education. "Accreditation Standards and Guidelines." ACPE. January 23, 2011. https:// www.acpe-accredit.org/standards/default.asp (accessed April 9, 2012).

American Association of Colleges of Pharmacy. "Commission to Implement Changes in Pharmaceutical Education." Background Paper II, 1991, 1-23.

Barry, Arlene, and Pat Villeneuve. "Veni, Vidi, Vici: Interdisciplinary Learning in the Art Museum." *Art Education*, 1998: 16-24.

Bonham Project Panel Label Text. n.d. http://collection. spencerart.ku.edu/eMuseumPlus?service=direct/1/ ResultDetailView/result.tab.link&sp=10&sp=Scollection&s p=SfieldValue&sp=0&sp=0&sp=3&sp=SdetailView&sp=0&s p=Sdetail&sp=1&sp=F&sp=SdetailBlockKey&sp=2 (accessed April 10, 2012).

Bumgarner, GW, AR Spies, S Asbill, and VT Prince. "Using the Humanities to Strengthen the Concept of Professionalism Among First-professional Year Pharmacy Students." *American Journal of Pharmaceutical Education* 72, no. 2 (2007): 1-6.

Chishom-Burns, Marie A, et al. *Pharmacotherapy Principles & Practice*. McGraw-Hill , 2008.

Fink, L Dee. *Creating Significant Learning Experiences*. San Francisco: Jossey-Bass, 2003.

Grant, VJ. "Making Room for Medical Humanities." *Journal of Medical Ethics: Medical Humanities* 28 (2002): 45-48.

Hicks, Laurie E, and Roger JH King. "Confronting Environmental Collapse: Visual Culture, Art Education, and Environmental Responsibility." *Studies in Art Education* 48, no. 4 (Summer 2007): 332-335.

Hidi, Suzanne, and K Ann Renninger. "The Four-Phase Model of Interest Development." *Educational Psychologist* 41, no. 2 (2006): 111-127.

"How to Look at a Mountain." *Artnews*, no. 3 (1993): 92-99.

Keller, Gary D, Mary Erickson, and Pat Villeneuve. *Chicano Art for Our Millennium*. Tempe, AZ: Bilingual Press, 2004.

Macneil, Paul Ulhas. "The Arts and Medicine: A Challenging Relationship." *Medical Humanities* 37 (2011): 85-90.

Naghshineh, Sheila, et al. "Formal Art Observation Training Improves Medical Students' Visual Diagnostic Skills." *Journal of General Internal Medicine* 23, no. 7 (2008): 991-7.

Reilly, Jo Marie, Jeffrey Ring, and Linda Duke. "Visual Thinking Strategies: A New Role for Art in Medical Education." *Family Medicine* 37, no. 4 (2005): 250-2.

Ritschel, Wolfgang A. "Physicians and Pharmacists as Fine Artists." *Journal of the American Pharmaceutical Association* 40, no. 5 (September/October 2000): 683-697.

Scott, P Ann. "The Relationship Between the Arts and Medicine." *Journal of Medical Ethics: Medical Humanities* 26 (2000): 3-8.

Shapiro, Johanna, Lloyd Rucker, and Jill Beck. "Training the Clinical Eye and Mind: Using the Arts to Develop Medical Students' Observational and Pattern Recognition Skills." *Medical Education* 40 (2006): 263-268.

Solso, Robert L. *The Psychology of Art and the Evolution of the Conscious Brain*. Cambridge, Massachusetts: The MIT Press, 2003.

Villeneuve, Pat. *Making Sense of Art*. Lawrence, KS: Spencer Museum of Art, 1992.

Villeneuve, Pat, Amanda Martin-Hamon, and Kristina E Mitchell. "University in the Art Museum: A Model for Museum-Faculty Collaboration." *Art Education* 59, no. 1 (January 2006): 12-17.

Where Art and History Meet:
A Perspective and An Approach

RICK RICCIO & TERRY BARNHART
Eastern Illinois University

Art and history intersect on a broad plane of human experience. Although distinct branches of learning, the perspectives, approaches, and methodologies of art and history that define each discipline are accessible, permeable categories of aesthetic and historical analysis. Art museums sometimes take historical perspectives on their collections and history museums and historical societies occasionally take an aesthetic frame of reference in their interpretations of the artifacts and works of art found within their collections – either in whole or part. Portraits, paintings, and decorative arts are found in the collections of both art and history museums and there are instances when distinctions between art and artifact become blurred and problematic. And it is just there – where art and history meet – that opportunities exist for mutually beneficial collaboration between academic art museums and cultural history programs.[1]

Recognition of those distinct, yet compatible, frames of reference led to a series of fruitful discussions between the staff of the Tarble Arts Center (TAC) on the campus of Eastern Illinois University and the faculty of the Master of Arts in Historical Administration program (HA program) at Eastern that considered prospective projects from that interdisciplinary perspective. How might the teaching missions of the Tarble Arts Center and the Historical Administration program be enriched through collaborative ventures, yet still be true to who they are and to what they do as distinct academic units and departments? Cooperative partnerships of this nature at Eastern Illinois University receive further encouragement as part of the

campus-wide commitment to integrative learning – a holistic and interdisciplinary approach to curricular development that links the studies and experiences of students and faculty in ways that take them beyond the mastery of disciplinary content to tangible applications in the real world outside of academe.

Different missions, common purpose

The mission of the TAC is to engender an appreciation for and involvement in the visual arts. It serves as a major arts resource for the people of east-central Illinois and Eastern Illinois University through the presentation of temporary exhibitions and community-based educational and outreach activities. A division of the College of Arts & Humanities at Eastern Illinois University, the TAC has a mandate to collect, preserve, exhibit, and interpret the university's permanent collection of art, and to support the educational mission of the university.[2] That mission, though distinct, is highly compatible with that of the Master of Arts in Historical Administration Program. The HA program prepares students academically and technically for leadership roles in history museums, historical societies, and other cultural organizations that care for and interpret historic collections. The HA program, established by the History Department in 1975, is a traditional cultural history program with a strong applied component (applied or public history by another name.) The curriculum consists of courses in historical research and interpretation for public audiences, history museum exhibits, the care and management of historic collections, American material culture, historic architecture and historic preservation,

archival methods, and historical administration proper.

Philosophical and pedagogical discussions of mutual needs and opportunities between the faculty of the HA program and the staff of the TAC eventually bore fruit in the form of six student exhibits at the Tarble. The exhibitions drew upon the expertise of the Tarble staff, the faculty of the History Department, the creativity and hard work of the students, and recruited the cooperation and talents of colleagues across campus during specific phases of the research, planning, design, fabrication, and installation of the exhibit. Each year these essential components of the exhibit-development process are undertaken and completed by the students through their scheduled assignments within the two-semester history museums exhibits course. Student exhibits require a balanced perspective and presentation in order to be on mission for both partners. An exhibition that took a strictly historical approach to exhibit development would not fall within the scope and mission of the Tarble's public programming; one that took a strictly aesthetic frame of reference would not meet the curricular needs and mission of the HA program as an applied history program. There has been a blending of both perspectives and approaches – a coming together of disciplinary ideas, methods, and sensibilities in each of the six student exhibits at the Tarble.

A question of balance: theory and practice
Training graduate students to be stewards and interpreters of museum collections requires a curriculum that combines

theory and application in equal parts. Ensuring a proper balance between theory and practice raises important philosophical and practical questions about the goals, objectives, and desired outcomes of graduate programs in applied history that ultimately define them. Achieving a proper balance in integrating knowledge and skills in such curricula is a recurring issue and daunting challenge.[3] Faculty who teach in the Master of Arts in Historical Administration Program at Eastern Illinois University have identified essential goals, objectives, and outcomes that seek to strike a balance between theory and practice, and that combine the study of documentary and material evidence, preservation, and issues of accessibility with analysis and interpretation. Students demonstrate mastery of content knowledge in these subject areas through their understanding of material culture and archival collections, and their ability to apply historical methodologies and historiography in presenting that evidence to pubic audiences. They must be able to tell stories with objects and documents that convey multiple viewpoints or perspectives. Students must be literate in all aspects of museum and archival practice, including the social, philosophical, and historical underpinnings of the museum, archival, and historical agency professions. They must likewise be conversant in the legal and ethical considerations involved with collections. Students are trained to be leaders no matter what their titles or the positions they hold.

Partnerships on the model of the Tarble-HA collaborations enable each entity to mitigate limited resources – most notably

Figure 1: The Arts and Cultures of the Ancient Mound Builders *exhibit in the Tarble Arts Center's Brainard Gallery, 2006.*

the lack of collections in most history departments – and to reach beyond their own fields of expertise by drawing on the knowledge and expertise of practitioners. A further benefit of working with program partners is that it allows students to work as members of project teams, where they experience first-hand the collaborative, interdisciplinary, integrative, and largely anonymous nature of historical agency work. Projects are modeled on the project-team approach used by the staffs of history museums and historical societies to better prepare students for the exigencies of their six-month internships (the capstone experience of the program) and for full-time employment as emerging professionals. They have the opportunity to work alongside museum and archival professionals, and to lend a hand with inventorying, arranging, and cataloging of historic collections as well as with researching historic structures and landscapes. Students also develop interpretive strategies in those projects, which

Figure 2: An interactive map showing the origins of raw materials in The Arts and Cultures of the Ancient Mound Builders *exhibit at the Tarble Arts Center, 2006.*

require them to document, analyze, and interpret archival and material culture evidence and translate their findings into public programs.

The academic year

A cornerstone of the HA curriculum is a two-semester course on history museum exhibits that partners the students with an area museum to create an exhibition proposed by the host museum – the TAC in the case studies discussed here. The course strives for a good balance between theory and practice. During the fall semester, students study the role of exhibitions within the museum and how the medium has developed over time. They learn how to do front-end, formative, and summative exhibit evaluations, create design briefs, and

produce computer-aided design and graphics. The course follows the protocols and exhibit development processes used by museums in strict adherence to professional standards and best practices. The host museum signs off at each stage of the process. In the fall semester students conduct research, write and edit labels, and design the exhibition. During the spring semester they build and install the show and participate in the ancillary public opening and programs. The exhibits course further prepares students in the principles of visual literacy and the interpretive principles necessary for presenting objects and images to public audiences in both an effective and affective manner. The partnership between the TAC and the Master of Arts in Historical Administration program has furthered those aims and objectives in what has been an enriching and mutually beneficial manner.

From 2000 through 2012 the students in the History Museum Exhibits class have successfully produced six exhibitions for the TAC on campus. Both the class and the exhibit project take two semesters to complete. The course readings and discussions roughly follow the progress of exhibition development. Even the majority of class assignments relate to the exhibit and are mostly performed in groups. The project is treated like a formal client/contractor relationship. Although contracts are discussed in the Administration of Historical Organizations course, the students do not perform under an actual contract for the TAC exhibition but rather conduct all assignments and responsibilities as if a contractual arrangement with the TAC exists.

At the beginning of the semester the students apply for positions on a committee of their choice, although some students prefer the term *team* instead of *committee*. The five committee positions include: curator, registrar, educator, designer, and photographer/digital technician. The week before the fall semester starts, the graduate students participate in a practicum which includes meeting with the client, the TAC director, to discuss the exhibition theme, the historical and aesthetic approaches to be applied to the collection, and the general working relationship and operating procedures at the museum. A faculty curator is also assigned for each year's exhibit based on their expertise in the subject area. So far, they have come from either the Tarble or the History Department staff and faculty. Students refer to the staff/faculty curator with all content-related questions. Although applying an historical approach to an art collection is not a new concept, it often takes the students a few weeks to formulate this approach succinctly in a design brief. Getting everyone to agree to a Big Idea statement, take home messages, etc. takes time and several client/contractor meetings before a final draft can be approved. Just scanning some of the titles of those six exhibitions reveals some of the difficulties even a seasoned exhibit developer might have with coming up with an exhibit focus:

- *The Architecture of Eastern's Old Main: Aesthetics, Education and Politics;*
- *Propaganda, Patriotism, and Protest: Posters from the WWII and Vietnam War Eras;*
- *The Arts and Cultures of the Ancient Mound Builders;*

- *Tales Untold: The Stories of Folk Art;*
- *The View from Here to There: The Aesthetics of Travel in the Rural Midwest;*
- *Bridging the Past: Paul Sargent's Coles County.*

Creating an exhibit approach

In recent years the HA faculty has put together background materials and a bibliography of resources for the incoming class to review over the summer prior to the start of the fall semester. This has helped familiarize the students with the subject matter and given them an earlier start on the research process. Also, most applicants to the program come from a history undergraduate background. So, where there is a strong aesthetic component to the exhibition, the students are not expected to be the content experts. Instead, the TAC faculty curator provides the artistic content, and the HA students provide the historic content. The students are still responsible for applying the TAC faculty's aesthetic content into the display format, and germane to that is to quickly gain a familiarity with the subject matter. Of course, before the class can solve any of these problems, they have to come up with the questions that need to be addressed. These are formulated in one of the first products of the design stage, namely, the design brief or prospectus. Examining some aspects of these briefs reveals how the class both states the problems and arrives at solutions to those problems.

An important aspect of the design brief is the big idea. Although a simple statement that guides the intentions of the

exhibit team, it often takes several iterations before all parties can agree on its specific wording. The big idea for the *Tales Untold: The Stories of Folk Art* exhibit reads: "This exhibit will identify the functionality and artist motivation behind folk objects by examining the traditional use of folk artifacts as well as some aspects of consumerism found in these artifacts." Further refinement and simplification of this statement made its way into the first sentence of the exhibit's introduction label. "This exhibit explores the stories behind the folk art presented – the tales uncovered and understood by examining the background of and influences on the artists, and the forms and materials they used to make objects." Interviews during the front-end evaluation project also informed the design brief. "Preliminary surveys have indicated a severely skewed understanding of folk art by the general public… We plan on using the E-Gallery to explore the definition of folk art and introduce visitors to what folk art actually is… We will display the definition of folk art that we chose to use for our exhibit at the back of the gallery, which will allow visitors to think about and express their own ideas about folk art before they come to ours… We will define folk art for the audience as well as highlight its potential for interpretation in the Humanities." The definitions actually ended up in the front of the E-Gallery on the introduction panel, but the E-Gallery in its entirety became an exploration of the notion of folk art and served as an intellectual appetizer for the main course of a more traditional display of folk art in an adjacent gallery.

The following label for a horse bridle demonstrates how

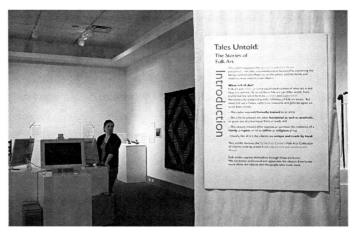

Figure 3: The introduction panel for the first of two galleries for the exhibit Tales Untold: The Stories of Folk Art, *Tarble Arts Center, 2007. This label poses the question, What is folk art? and provides generally accepted notions about folk art. In the gallery visitors are asked to decide if the examples represent works of folk art.*

the students presented one definition of folk art: *An Amish man named Amos Miller handmade this bridle. Although it is handmade, it is very similar to any number of mass-produced leather horse bridles. Is this folk art? Would a similar commercially produced example be folk art?*

Like this example, the answers were sometimes inconclusive with reasoning falling on both sides of the folk art definition. This reinforces the concept that museums do not have the last word on a subject, and that there is more than one point of view.

The student textbooks, *Labels: An Interpretive Approach*[4] and *Planning for People in Museum Exhibitions*,[5] both stress the importance of letting the visitor know the point of view

of the exhibit developers. This is especially true for an art museum where the visitors do not necessarily expect to find an historical approach to an art collection. The point of view could be subtly gleaned in earlier exhibitions through credit panel statements like: *Exhibition produced by the graduate students in the Historical Administration Program in collaboration with the Tarble Arts Center.*

The point of view has been more prominently displayed in the most recent exhibition, *Bridging the Past: Paul Sargent's Coles County.* The introductory label to the exhibit not only states who the exhibit developers are but also the rationale behind their exhibit approach. This resulted from the original purpose stated in the design brief: "It will provide historical content to an audience that is used to simply viewing artwork. People will leave the exhibit with a new outlook into the role of an art exhibit... Also, you can draw an art audience to a history exhibit and draw a history audience to an art exhibit by combining the two."

The class of 2006 met a similar challenge with an archaeological theme in *The Art and Cultures of the Ancient Mound Builders* exhibit: "The exhibit will highlight the aesthetic value of the objects as well as their cultural importance. The historical background about the artifacts and cultures we include will be presented without undermining the artistic value of them... The visitor will understand the complexity of these cultures and their beliefs shown through their artifacts, as well as gain a greater appreciation for the artistic qualities of them."

Figure 4: Introductory vignette for the exhibit, Bridging the Past: Paul Sargent's Coles County. *The Historical Administration students provided an historical context to the scenes that Paul Sargent painted in Coles County, Illinois.*

Community outreach

The Tarble Arts Center's founding purpose is "to take the arts to the people." That mission is the foundation of every student-produced exhibit. Reaching out to the greater community consequently plays a major role in HA/TAC collaboration. That community includes the town of Charleston within which the campus is located, Coles County, and the broader region of east-central Illinois. Of course, the HA class also employs strategies to reach out to the academic community – the students, staff, and alumni of Eastern Illinois University. For every exhibit the HA program develops with the TAC, the education committee (team) works with the TAC education coordinator and area school districts to create lesson plans and educational programs that satisfy the state curricular requirements. Adding an historical focus to works of art

broadens the possibilities for satisfying those requirements.

Besides developing learning strategies for school groups, on two separate occasions the HA class has produced a traveling component of the exhibit that has gone to libraries in surrounding towns. No original artwork traveled with the exhibit, but in one instance photographs of the artwork were included. For *The Art and Cultures of the Ancient Mound Builders* exhibit, the Tarble purchased reproductions of Mississippian artifacts, and the students produced a video about the cosmology of the Mississippian people. Both the reproductions and the video traveled with the exhibit.

For the exhibit *Bridging the Past: Paul Sargent's Coles County*, the students employed another strategy to attract both college students and community members who never, or infrequently, visit the TAC. They created a geocaching component. Paul Sargent (1880-1946) was a regionally famous landscape painter. His home in Coles County, Illinois, served as his muse for his most well known landscapes. The students chose five locations depicted in Sargent's paintings to use as geocache sites. An image of his painting was a clue for the geocachers to find the exact location where Sargent painted the scene. Two of the paintings are on EIUs campus. We do not have statistical data, but it is believed that several of the geocachers that logged their discovery of the caches, had never been to the TAC, and it is hoped that their interest in geocaching led them to see the Sargent exhibit at the museum. At the very least the geocachers learned something about a local artist's paintings and the locations he frequented.

Another indirect community outreach success came about during the student's research for the *Tales Untold: The Stories of Folk Art* exhibit. In the Exhibit Benefits section of the design brief, the class stated that: "It will utilize the Tarble Art Museum's pre-existing collection of folk art, allowing the organization to become more familiar with its present holdings through in-depth analysis." Much of the folk art in the TAC collection had very little provenance beyond the artist name and residence. So, the student's research attempted to add to that database. Even if the artist had died, students contacted surviving family members who remained in the area. This resulted in not only a wealth of information about some of the pieces in the collection and the artist's lives, but it also formed or renewed relationships with the families and the museum, many of whom attended the exhibit opening.

Interdisciplinary collaboration

Besides the collaboration between the history department and the art museum, the beautiful thing about producing exhibits at a university is the other collaborations that are made possible. Even if the HA faculty does not have expertise in a specific area, the chances are someone else on campus does, and is usually willing to lend a hand. Even though the students fabricate the exhibit each year, the history department lacks a workspace for it. The TAC has a small work area, but it is used mainly for matting and framing. Since 2006 the Art Department has allowed the HA Program to use the tools and equipment in their sculpture

studio. Before that time all fabrication and installation was conducted in a one-week period. It necessitated detailed planning and design, but also demanded long work days and high tensions. With its industrial grade woodworking tools, walk-in spray booth, welding equipment, and ground level loading dock, the students get hands-on fabrication experience in a state-of-the-art facility. Beyond the ability to fabricate components like platform, pedestals, vignettes and the like, the workspace allows the program to concentrate more on the artifact mount making process. The students gain useful skills with appropriate materials like poplar, Plexiglas, brass, and Ethafoam. They not only attain a level of confidence with these materials, but also realize when a particular situation is beyond their skill level and how to deal with it. Novel situations arise with each exhibition. For the *Paul Sargent* exhibit, several paintings were borrowed from private collectors, two of which were unframed. As a favor to the lender, and as a good fabrication lesson, the student made frames in the style that mimicked the frames that Sargent made for his own paintings.

Another campus department that we collaborate with on a regular basis is the Center for Academic Technology Support (CATS). The *Bridging the Past: Paul Sargent's Coles County* exhibit also provides a good example of this collaboration. The historic component of this exhibit explored the landscapes of Sargent's time with those same landscapes today. This resulted in a wealth of documentation, much of which, though interesting, would not fit in the limited gallery space. Both the client (TAC) and the contractor (HA) agreed that a handheld mobile device

could be a complementary component to the exhibit. The plan was almost scrapped when the foundation we approached for purchase of the mobile devices turned down our proposal. It revived, however, when news came from EIU's Gregg Technology Center, which lends out multimedia equipment for student use. They were getting ready to purchase new iPod Touch devices, and an arrangement was worked out whereby the museum could have their old ones. The technology coordinator at CATS created the platform for the media to be put on the iPod Touch devices. The students provided the content, and CATS made it accessible on the web, so visitors with their own smart phones could use it.

The paintings were arranged on the touch devices in the order they should be viewed in the gallery, but they could also be selected at random. Each painting included both an historic and contemporary photo of the painting location, text, and a brief audio message. The artist's niece provided many of the photos for both the exhibit and the mobile tour and was interviewed about her recollections of her uncle. Some of that interview went into the audio segments. The students not only realized the potential of an exhibit where art and history meet, but they saw exhibit benefits reaching beyond the life of their own project. Their design brief stated: "This will benefit the HA program because we are using electronic content for the first time, i.e. audio tours and geocaching. It will lay the foundation for future classes to utilize these elements in their exhibits. The electronic content will also benefit the TAC because the devices will stay with the institution for years to come."

Conclusion

The HA program also partners with other area museums, so we do not produce an exhibit at the TAC every year. But we are starting to plan exhibits several years in advance and are designing research projects with the current class in anticipation for those future exhibitions. We are currently developing our first exhibit at EIU's Booth Library with *Building Memories: Creating a Campus Community*. We plan to incorporate the use of social media in an effort to engage college students in active ways to create their own campus community.

To coincide with the sesquicentennial of the Civil War, the TAC and HA program have begun planning for an exhibition on Civil War Art for 2013. Since art and history meet on many levels for such an exhibition, one of our first goals is to find the direction and focus of that intersection. As a first step in the planning process a current student is researching museums in Illinois that have Civil War art collections. The interdisciplinary-collaborative model works well for academic museums and for other departments and units on campus that embrace the benefits that such cooperative ventures provide for students and faculty alike. New collaborations form with every new exhibit project. The mandates of both the Tarble Arts Center and the Historical Administration program, though distinctly different, have both common purpose and opportunities for collaboration.

NOTES

1 See, for example, Cassandra Lee Tellier, "What You See and What You Get: Frame of Reference in Museum Exhibits," *Curator* 29 (September 1986), 221-226 and "The Significance of the History Museum as a Resource for Art Appreciation," Ph. D dissertation, The Ohio State University, 1984.

2 Tarble Art Center, Eastern Illinois University, Charleston, Illinois http://www.eiu.edu/tarble/about.php

3 The question of balance in the design of public history curricula is discussed in Constance B. Shultz, "An Academic Balancing Act: Public History Education Today," *The Public Historian* 21 (Summer 1999), 143-154 and Terry A. Barnhart, "Serving Many Masters: A Perspective on Integrating Knowledge and Skills in Applied History," *The Public Historian* 21 (Summer 1999), 155-165.

4 Beverly Serrell, *Exhibit Labels: An Interpretive Approach* (Walnut Creek: AltaMira Press, 1996).

5 Kathleen McLean, *Planning for People in Museum Exhibitions* (Washington, DC: Association of Science-Technology Centers, 1993).

EXPERIENTIAL LEARNING

Fitzwilliam Museum, Cambridge

A Mutually Beneficial Exchange: The University of Melbourne's Cultural Collections Projects Program

HELEN ARNOLDI
University of Melbourne

I felt we had done something useful for the collection as well as ourselves. – Student exit review comment.[1]

Cultural collections occupy an interesting place within a university environment. Many objects in these collections were originally acquired as teaching aides and with the passing of time have become rare and historically valuable items. Once utilitarian objects such as an anatomical plaster model or an old microscope used to study geology specimens are being reclassified as museum artefacts. These items still have tremendous teaching value, though not necessarily in the way originally intended. While the change in status of these objects brings some challenges to the fore, they may equally be seen as presenting opportunities. The University of Melbourne's Cultural Collections Projects Program (CCPP) is unique in the Australian context in the way that it links students from across the university to its museums and collections. Through the Program students are provided with professional development opportunities which cultivate their vocational skills and enhance their learning experience. The Program was established to act as a facilitator between the museums, their collections and the students. This ongoing engagement through the Program has enabled both students and collections to experience a mutually beneficial exchange.

The 30 cultural collections managed by the University of Melbourne generally mirror the disciplines that have been taught at the university during its 160 year history. As such, these extensive collections which include art, botanical,

historical, scientific, literary, medical and archival, are well placed to engage with students from a wide range of backgrounds and study areas. Since 2004, the university's organizational goals have reflected the realization that these collections contribute to what makes the student experience at Melbourne unique. Consequently, there has been a focus on the university's role as a facilitator in using the collections as an ideal way to encourage life-long learning experiences. This is illustrated in the university's current Cultural Policy where:

> As a custodian and manager of cultural resources, the university is committed to the propositions that its cultural inventory should be documented and preserved, accessible to students and the general community, illuminated by research and teaching, and engaged with the community as widely as possible... As a place of education, the university wishes to engender among its staff and students a sense of our cultural heritage, values and ideals, and an understanding of what the university has to offer among those who will deliver it to the community.[2]

When the CCPP was established in early 2004, it was seen as a way of enabling student access to the collections and supporting these objectives. Through the creation of carefully conceived collection management projects, students have the opportunity to work closely with a particular cultural collection and develop vocational skills that enhance their employability. These project placements also give participants an insight into

the history of the university and an appreciation of areas that may exist outside their area of study. So for example, a Bachelor of Music student can become involved in a preventative conservation project with rare musical manuscripts in the Louise Hanson-Dyer Music Library's collection. Or similarly, a history student can commence a research project on papier-mâché anatomical models in the Harry Brookes Allen Museum of Anatomy and Pathology. Through these project placements the students are also exposed to the management, conservation and access issues that relate to the collection. Consequently, not only are the students broadening and enriching their world view, but they are also contributing to the management of these collections. The student support makes possible the extension of existing collection management projects. In turn, this support improves access to the collections, and contributes to the university's wider organizational goals of their cultural holdings becoming more available to the university community and beyond.

At the start of each year as part of the Program, a list of projects is developed between the projects coordinator and the collection managers. These projects, which engage with the majority of the collections on campus, may include cataloguing, preventative conservation, research, exhibition and interpretation and significance assessment. Each project is carefully devised to ensure that it offers a high calibre learning experience for the student (with clearly defined outcomes) and also has a real benefit to the collection. Once the project details are defined, a position guide is created for the role and

Figure 1: Sample position guide.

the project is added to the projects list which appears on the Cultural Collections' website (Figure 1). Students can then apply to work on a particular project, and are placed after a comprehensive selection process which includes written application and interview and takes into account their personal motivations and skills set. After an induction and

personally tailored training session to suit the role, the student commences work on the project for a fixed period of time, usually a semester. They then work closely with the collection manager and other professional staff on the designated task. A recent preventative conservation project at the University of Melbourne Archives enabled an art history student to work on a collection of trade union and women's liberation banners. After training in object handling, the student then recorded any information associated with these vulnerable large scale banners on the collection catalogue. They then photographed and labelled the banners for easy identification and rolled and rehoused them to meet conservation storage standards. The project appealed to this art history student as she was keen to gain some practical experience in textile conservation to see if this was an area that she might like to pursue with further study. The project provided the student with the unique opportunity to access the collection and to see firsthand some of the issues involved in textile conservation. Through the student's application of these collection management procedures, the banner collection also benefitted with its longevity increased and access improved.

The project was professionally managed and ensured that my development needs were being met as well as the university's objectives for the project…

The benefit of having the project placements centrally administered by the Cultural Collections Projects Program

coordinator is that the project work is always designed with the student learning experience at the fore. The coordinator balances the learning imperatives and motivational drives of the students with the needs of the collections acting as an independent voice to ensure that the placement offers the student a rich learning experience while addressing the collection's priorities.[3] Understandably, when a collection manager thinks about possible student projects, they often do so from the collection's perspective. For example, if there is a focus on the cataloguing of collection materials for increased public access, then this will likely be the collection manager's starting point for thinking about potential student projects.

A recent project at the university's Medical History Museum offers a good example of this. The museum had as a priority to catalogue a backlog of recent acquisitions to ensure they were available on-line to researchers. This was an ideal starting point for a student project. The program coordinator worked with the collection manager to identify a manageable sub-collection within the acquisitions that would give the student exposure to a broad range of object types to catalogue. The art curatorship student matched to the project was keen to complement the theoretical based skills being taught in the classroom with the more practical skills of cataloguing. After training in the cataloguing process by the collection manager, the student then applied these newly developed skills to these objects in a real museum setting. By the end of the semester-long placement the objects were available online through the museum's electronic catalogue and the student had broadened

their vocational skills and advanced their future employability in the sector.

At the commencement of my internship I hoped to familiarise myself with the EMu database as I knew it to be industry standard software. Learning how to use EMu gave me practical skills and I am sure it increased my employability in this industry.

It is worth noting that students come from diverse backgrounds, and each student will have different motivations for wanting to undertake a project. The university's Cultural Collections Program aims to cater to this diversity by designing projects that have broad appeal and that are drawn from across the university's collections. Interestingly, the same project can be attractive to individual students for quite different reasons. A cataloguing project with an art collection may appeal to an art history student because it provides the opportunity to work closely with a genre of particular interest to them; an art curatorship student because they will learn the collection management practice involved in cataloguing artefacts; and a conservation student because it provides an opportunity to complement their practical skills with broader collection management practices. It is not always feasible for one project to have broad appeal, but it may be possible to develop several related projects which feed off one another. An example of this wide-ranging appeal can be seen in a recent research project and a preventative conservation project with the collections at

the University of Melbourne Herbarium. The research project related to a nineteenth century collection of mosses that was donated to the university in 1948. Little was known about the provenance of the collection and its donor and further information was sought in order to more fully appreciate it within the context of the university.

An additional separate, but related, exercise was a preventive conservation project that involved the re-housing of the moss specimens to meet conservation standards and the recording of all catalogue information as part of the process. The conservation project, as well as contributing to the longevity of the collection, also directly supported the research project. The ideal student match for each of these projects could come from a variety of backgrounds, depending on the interests of the individual. Not surprisingly the research project attracted a Masters in Public History student who was eager to investigate the history of the moss collection, while the re-housing project attracted an art history student keen to explore the area of conservation as a potential post graduate qualification. Both of these students proved to be a natural fit to their respective projects: the history student had the unique opportunity to hone emerging research skills on a project that would have real value to the collection (the eventual historical thread was traced back to Denmark, and contact stimulated with the donor's descendents resulted in a renewed and ongoing relationship with the collection). Similarly, for the student working on the conservation project, the chance to work with these delicate specimens and learn skills that gave

her an insider's view of conservation practices proved to be invaluable. Both students, having had no previous knowledge of botany prior to commencing work on their projects, by the conclusion of their placements had a new appreciation for the discipline. If a student with a botanical background had been placed on one of these projects doubtless they would have gained a different personal experience. Likewise, a visual arts student may have drawn inspiration from the beauty and intricacies of the moss specimens and used them as a catalyst for expression in their art.

> *[The collection manager] also encouraged my interest in prints and made effort to suggest projects that aligned with skills and knowledge I hoped to develop... [it] gave me additional confidence to realize that I was applying my studies in the real world.*

The museums and cultural collections on a university campus represent a myriad of opportunities for students from across all disciplines. The key is to have a program in place that facilitates the collections to be used in a way that student learning objectives are met and the collections themselves benefit from the exchange. Any projects with the collections should be beneficial to the students through the gaining of vocational skills, exposure to different collection management principles and practices, nurturing of future professional networks, self-improvement or even something as simple as satisfying an interest. Likewise this interaction must have

positive outcomes for the collections, whereby through student involvement collection management programs can be supported and extended. At the University of Melbourne through the student placements, the interpretative potential of the collections has greatly increased with lesser known collection areas researched and exhibitions developed that may otherwise not have been possible. Specialized significance assessments have been completed on historical agricultural and farming collections by museums studies students and gamelan collections by ethnomusicology students. These finished assessments have proved to be useful management tools for collection managers aiding in grant applications and the prioritizing of future conservation programs.

A fascinating and worthwhile experience that I highly recommend to other curatorship students in order to broaden and develop their skill set...

Another ongoing benefit to the university seen through this engagement with the museums and cultural collections is the way that the students act as excellent ambassadors for the collections in the university community and beyond. Students are typically enthused about their collection work and are keen to share their experiences with families and friends. It is very common for them to discuss these placements with their peers and hence generate more interest in the collections and future project placements. The enduring benefits of this positive word of mouth for a collection should not be underestimated and in

many cases are immeasurable. Positive associations between the students and the collections may also bring lifelong loyalty and a sense of connection to these places, valuable indeed as these students continue on their professional paths and perhaps one day become a benefactor to the university. This can be seen in the various alumni and friends groups that the university supports, where many graduates maintain an ongoing interest and personal investment in the places that they had a connection with during their formative years.

One final area worth noting is the unexpected benefit to the collection managers through working closely with the students on these projects. Many managers report feeling invigorated and revitalized by the enthusiasm and freshness that students bring to their project placements. At the conclusion of a student placement with the university's Special Collections the librarian overseeing the project commented:

[It was] valuable to revisit my own cataloguing practices (after time and experience entrench known practices and short-cuts). The need to explain theory and method from first principles was also useful. The input from a person 'fresh' to the task offered the opportunity to re-assess and also incorporate helpful new perspective which arose in the collaborative training/working situation.

In addition, for the collection managers who often do not work directly in teaching programs, the cultural collections projects provide them with the opportunity to be more engaged with

the student body and academic programs. It can reinvigorate their connection to the campus and reaffirm the reason that the collection exists in the first place.

The University of Melbourne's Cultural Collections Projects Program, through the construction of well thought-out projects, supports and enhances the organizational objectives of the university and the museums and collections on campus. At Melbourne over the past eight years nearly 200 students and volunteers have worked on over 100 different projects across the 30 campus collections. Through these placements the students have gained invaluable collection management experiences that have assisted their future employability and enriched their learning experience while the collections have continued to be actively used as part of the educative process. Thus the collections have maintained their relevance to the university community and become more accessible, energetically interpreted and used as sources of inspiration and investigation for this and future generations of students.

NOTES

1 Throughout this chapter I have interwoven quotations from students and
collection managers taken from exit review forms between 2010-2011.
These forms were completed by students and managers working with the
University of Melbourne's cultural collections at the conclusion of the
placements. Exit reviews are an excellent source of enlightening comments
about how participants feel about their time spent working with a
particular collection.

2 *Cultural Policy Statement*, The University of Melbourne, 2010 p. 5

3 This is particularly topical in the Australian educational sector where
recent industrial relations laws have focused attention on student work
placements and industry internships where it is perceived there is potential
for employers in the business community to exploit students as 'free labour'.
One needs to be mindful that these volunteer student placements do not
occupy roles and project work that should be paid positions. By having a program
coordinator overseeing the development of the student projects this is less likely
to happen as they will make sure that these projects meet the educational
needs of the student while not infringing on paid positions. Other factors that can
help ensure that student project work remains in compliance with industrial
relations laws and is ethically sound are having these projects completed within
predetermined time frames as well as having clearly defined position guides
which outline where these projects fit. These areas engage with much broader
and complex issues around volunteering that while needing to be considered
fall beyond the scope of this chapter's focus.

Bibliography

University of Melbourne, *Cultural Policy Statement*. University of Melbourne, 2010

University Museums Inspiring the Teachers of Tomorrow

PHILIP STEPHENSON
University of Cambridge

The Museums and Collections of the University of Cambridge offer staff, students, and the local, national and international community a unique opportunity to explore materials from the dawn of geological time through to the present day within the space of a square mile. The diversity of the living, once-living and non-living world alongside evidence of the breadth of human ingenuity, creativity and spirituality – all are represented within the collections thereby evoking a powerful sense of awe and wonder.

The principal institutions are:

- The Botanic Garden and the University Herbarium.
- The Fitzwilliam Museum (fine art and cultural artefacts).
- Kettles Yard.
- The Museum of Archaeology and Anthropology.
- The Museum of Classical Archaeology.
- The Polar Museum.
- The Sedgwick Museum of Earth Sciences.
- The University Museum of Zoology.
- The Whipple Museum of the History of Science.

Each museum and collection has specific links with particular academic departments and faculties and as such, they are principally centres for teaching and research within those subject areas. Certainly, this was the *modus operandi* for much of the development of the museums over the past 300 years. However, in modern times the university has striven to allow access for all and today, the audience is as diverse as the

collections themselves.

In her role as Vice-Chancellor, Professor Alison Richard, wrote in the introduction to *Places of Wonder: The Museums and Collections of the University of Cambridge*:

> The museums and collections of Cambridge have inspired some of the greatest minds in history. As places of wonder, discovery and contemplation they challenge our understanding of the past and present and are a living embodiment of the rigours of research and study. They offer stimulus and solace, education and recreation to scholars, schoolchildren and visitors from Cambridge and across the globe.[1]

In this simple appraisal of the museums and how they almost define the purpose of the university, the central place of education is made explicit.

Education in the museums

With regard to formal education within the museums, there is the fundamental role of supporting the teaching and research of their respective departments. Museum staff with a specific subject specialism work alongside their departmental teaching colleagues to ensure that fulfilment of this central function is maximised. However, for the purposes of this chapter, the focus will be on the museum educators who work with children of school age.

The ability of the university museums to inspire and enthuse young people through engagement with highly

diverse, world-class collections and exhibitions within one overarching institution is a unique situation. As a consequence, there is great benefit in working with schools and the wider community so that in addition to providing a rich environment conducive to learning it also engenders a positive public perception of the university. Age is no barrier to what can be achieved by university museums working with young learners. Highly successful programmes are offered in the museums to pupils aged three years and above, while the diversity of the collections ensures that genuinely cross-curricular approaches can be applied thereby making learning more meaningful than otherwise might be the case.[2]

Depending on the size of the museum and the potential to support both formal and informal learning of school age children, an educator or team of educators is employed to develop, deliver and administer education programmes. The size of the Fitzwilliam Museum and the breadth of objects allow it to operate as a hub around which the other museums can carry out their educative function. Increasingly, this leadership role ensures coherence between the various education programmes offered by the museums and a sharing of good practice and expertise.

The Fitzwilliam Museum has a long-standing and innovative education provision that is nationally recognised. In 2006, the then head of education was awarded an OBE for services to education and the museum service. More recently, innovative work by the museum education team was highlighted in the UK Department for Culture, Media and

Figure 1: A museum educator at the Fitzwilliam Museum models teaching approaches to a group of early years and primary trainee teachers using a Brueghel masterpiece as the starting point. Photo: Keith Heppell, Cambridge.

Sport policy paper *A Place for Culture: Towards a local culture offer for all children and young people.*[3] In the same year, it was the first museum in the East of England to receive the Learning Outside the Classroom Quality Badge. (Figure 1)

There have been comparable developments in the quality and diversity of education in the other institutions. At Kettles Yard an ambitious building project is underway that will enhance the already dynamic provision for both formal and informal learning. While the particular constitution of their roles echoes the differences between the departmental museums, dedicated museum educators at the Polar Museum, the Sedgwick Museum, the Museum of Zoology, the Museum of Archaeology and Anthropology, the Botanic Gardens and the Museum of Classical Archaeology constantly explore and

develop the learning potential of their respective collections. The only museum not to have dedicated education support, the Whipple Museum, is still able to make a significant contribution to learning in the university museums. A recent substantial funding award from Arts Council England has a strong emphasis on increasing engagement with children and young people, and it is anticipated that the specialist education provision will in future be provided for the Whipple.

In the last four years, the Fitzwilliam alone has worked directly with 83,000 school pupils and over 2,000 teachers providing gallery and studio-based sessions led by museum staff and tailored to individual schools' needs. A similar number of pupils come in teacher-led groups using the museum's online resources. Equally, schools show comparable enthusiasm for the other collections and increasingly co-ordinate visits to two of the museums following linked themes. The development of these cross-over programmes is indicative of the collaborative spirit that exists between educators in their respective museums.

As the rest of this chapter will explore, formal education programmes are informed by close links with the Faculty of Education and other leading academics and practitioners so they can best respond to developments in curriculum content, teaching approaches and theoretical perspectives on learning. By the same token, the work undertaken with school age children increasingly makes an impact on teacher training and research in the faculty.

Museum education and initial teacher training

The work of the educators in the departmental museums is set in the broader context of the university's mission for the museums as expressed in the University of Cambridge Museums Policy Statement. Three key paragraphs stand out:

- The university museums are a valuable research and educational resource locally, nationally and internationally. They also provide an unrivalled opportunity to present the university's work to a wider audience.

- The university recognises that the collections of its museums represents major components of national and international heritage. It acknowledges the duty to make these collections available as widely as possible without compromising the museums' function in university teaching and research.

- Subject to the limitation noted in the previous paragraph, the university will: use its best endeavours to maximise public access to the collections; support national and international organisations working to develop museum interests; within the existing framework and in collaboration with other bodies, make particular efforts to contribute to museum facilities in the City of Cambridge as a resource for life-long learning and cultural recreation in the region.[4]

In responding to these strategic policy statements, the museums' community recognised that one way these

aspirations would be likely to come to fruition was through successful engagement with local schools working in a national context. Association with the university Faculty of Education and in particular, the Initial Teacher Training (ITT) programmes, would prove an ideal conduit through which to channel this ambition.

What began in the 1990s as an emergent relationship started to grow apace. When once the only input might have been a lecture presented by the sole university museum educator to the trainee teachers within the faculty, by the new millennium, trainee teachers were engaging with the museums at a range of levels of intensity including mentored placements supported by a team of educators.

Synchronous with these developments within the museum education departments were shifts in the national context regarding the value of learning outside the classroom. Since the implementation of the UK Primary (ages 3-11) Schools National Strategy[5] significant funding was directed towards the museums and gallery sector. This was typified by UK Museum, Libraries and Archives Council (MLA) initiatives with which many of the University of Cambridge departmental museums already had some involvement.[6-8]

More recently, the UK Training and Development Agency (TDA) increased the funding for schools and university departments of education to support implementation of the Manifesto for Outdoor Education[9] and the associated Teaching Outside the Classroom programme.[10] Again, educators within the University of Cambridge museum community had

significant involvement.[11]

In response, the ITT community was making progress of its own. For some years, a limited number of teacher training providers had been successfully running elements of their teacher education programmes in these "alternative settings".[12] However, with the implementation of the revised UK Standards for the Award of Qualified Teacher Status (QTS) in 2007 which clearly state that trainee teachers should "... identify opportunities for learners to learn in out-of-school contexts",[13] there has been an expansion in the number of institutions engaging with providers of learning in settings other than schools.

For both the tutors in the faculty and the museum educators in the departments, this mutually beneficial relationship offers much. For ITT, the work with the departmental museums adds a new and relevant dimension to which partnership schools and trainees alike attach much value.[14] For the museums, it provides a vehicle for educator professional development as well as access to a large number of beginning teachers and, more pertinently, the schools they train in and where they take up employment.

The benefits for ITT from engagement with the university museums

What is it about working with the university museums that appeals to tutors in the Faculty of Education? In answer to this, it first must be argued why it is of benefit for ITT to engage with the museum and gallery sector per se. Essentially, trainees

need to be aware of the three critical factors that contribute to the power of learning in museums:

- The centrality of the objects themselves.
- How the ethos and shape of the institution provides intellectual and physical access to the objects.
- How the affordance offered by museum educators maximises the learning potential of the collection.

The trainees should also see how these three strands can be assimilated into their own practice. This means planning lessons where using objects is a default position. Shaping the classroom so the learning environment meets the physical and intellectual needs of the class and, incorporating the open-ended and dialogic teaching methods typical of museum educators into their armoury of teaching strategies.

Working with objects

At the heart of all museums and galleries are the objects. They are the *raison d'être* for a museum or gallery's existence. The potency of engagement with the real thing over facsimiles or virtual representations is widely accepted within the museum community. However, for the trainee, it is important that this recognition of the centrality of objects is shared and made explicit. They need to know that objects or things in the context of a museum or gallery constitute what might be termed material culture.[15] It is important they understand that while at one level, an ammonite is simply a fossil, in the context of the Sedgwick Museum, it takes on a higher

significance. It becomes a springboard into big ideas that have powerful cultural roots such as discussions surrounding the nature and philosophy of science. The interpretation of objects takes place in a socio-cultural context in much the same way as other facets of learning with which the trainee may already be familiar.

It is interesting to consider children's intuitive understanding of the potency and attraction of engaging with real objects. In school-based work on the Second World War with pupils aged between 10 and 11 years, the medals, photographs, letters and flying log-book of an RAF officer were brought into the classroom. When asked: "Did you like having the real things such as the medals brought in?", one child answered:

> Yes, I did enjoy it because having it in front of your eyes really makes the lesson come to life. The medal given by the King has to be the best because I mean... It was in the King's hands and now I've touched it.

Another wrote:

> Yes, because when I held the war-time artefacts it made me feel like I was in the war.

The recognition of the power of the real is a central point emphasised by museum educators when mentoring trainees in their institutions. This explicit celebration of the importance

of engagement with objects as a means to facilitate higher-order learning has real benefits in terms of trainee professional development.[16] Evidence from post-course evaluation shows that trainees who have had engagement with the museums are far more likely to bring objects of their own into the classroom and more likely to avail themselves of the artefact loan boxes that many museums now offer to schools.

The institution's ethos and environment

As academic teaching institutions, the Cambridge museums share a particular ethos. This has an impact on such things as how the collections are organised, displayed and labelled. At first sight, this might be seen as a potential barrier to young people in terms of accessibility. There are no buttons to press, few child-centred IT applications and a strictly hands-off policy. It is true that in one or two of the museums, small handling areas are set aside and the Botanic Gardens can have a park-like feel, but essentially the university museums are glass-case collections. However, young people respond surprisingly positively when they visit – both informally with families and on organised school outings. In post-visit evaluation, children often cite the outwardly imposing demeanour of the museums as making them "seem important" or "special places". As they see it, this raises the status of their presence in the museum and as such contributes to their motivation and sense of self-concept.[17] It also contributes to the awe in which the learners hold the museum environment.

At a more philosophical level, when analysing the

rationale for the museums' educational ethos, the trainees are confronted with the dichotomy between intrinsic value and instrumental value.[18] Which of these best reflects the function and philosophy of the museum?

There is a sense that much formal education in the UK has become overbearingly instrumental in nature; learning to achieve specific goals, to prepare for the workplace or higher education. A culture of testing and associated league tables contributes to this and, some would argue, has sterilised the creativity and willingness to think independently on the part of some teachers. While there is no doubt there are comparable instrumental pressures on museums in terms of satisfying breadth of access and visitor number targets, there is a sense amongst the university museum community that what they offer should also have strong intrinsic value. By this they mean providing an environment that engenders a sense of awe and wonder, stimulates a love of learning, that strives to satisfy natural curiosity and immerses the individual in cultural and creative ideas simply for the sake of it.

This is another powerful reason for encouraging museum educators to work with trainees; helping them to see that when schools bring their children to "do the Tudors", the museum educators who will work with them have a far wider agenda than simply ticking curriculum coverage boxes. This means adopting approaches that include encouraging cultural engagement, feeling empathy, promoting independence and facilitating analytical thinking. While it is true these intellectual human qualities cannot be measured in

instrumental terms, they are essential to the development of the rounded person. Ultimately, this should be the overarching aim of education.

The role of the educator

The pedagogy adopted by museum educators to teaching and learning in their collections has particular attractions for the ITT provider. Much of a trainee's experience will be in conventional school settings. Bearing in mind the undoubted quality of the school partners working with the faculty, this exposes trainees to some excellent and innovative practice. However, there are inevitable constraints to how teachers can operate in this environment. The UK has a predetermined national curriculum supported by published strategies, the implementation of which is closely scrutinised by a national inspection service. Certain practices such as the sharing of predetermined learning-objectives become embedded as being the correct way of doing things. As a consequence, interactions in the classroom can become synthetic and where what might be described as "authentic dialogue" is marginalised.

Research has shown that dialogue in primary schools is often shaped by the ways in which teachers structure interactions with and between pupils.[19] In some instances teachers observed actually discourage contributions from pupils when their ideas move outside the tight confines of predetermined objectives. More often than not, in these situations, primary classroom talk is characterised by:

- teachers still doing most of the talking;

- the use of supposedly open questions that are really closed;
- problem-solving or possibility-thinking that degenerates into a game of spot the right answer;
- the quality of discussion being undermined by the teacher maintaining a kind of talk that is unique to the classroom;
- the paucity of authentic questions.

Conversely, other teachers were seen actively encouraging learners in participating in extended dialogue thereby enabling them to articulate, reflect upon and modify their own understanding. They did this by providing stimuli specifically designed to promote dialogue. Museum educators will immediately identify the objects that they teach from as fulfilling this role. In the field of mainstream education, this has come to be called "dialogic teaching".

In his book *Towards Dialogic Teaching*,[20] Robin Alexander identifies some key features of the dialogic learning environment. The first of these is that it is a collective process where learning tasks are addressed together. Second, the interactions are reciprocal in that children are encouraged to listen to each other, sharing and recognising alternatives. The dialogue should also be "supportive" so that alternative, unconventional answers are seen as vital in the process of moving towards common understandings. The cumulative effect of this is evident in the way that teachers and children build on shared ideas to develop coherent lines of thinking

Figure 2: Wordscapes – the language of painting. A museum educator at the Fitzwilliam Museum supports a group of trainee teachers in developing narrative from a painting through dialogic approaches. Photo: Keith Heppell, Cambridge.

and enquiry. In these situations, teachers plan and promote dialogic teaching with particular educational goals in mind. Again, museum educators will recognise many of these characteristics in their own teaching. (Figure 2)

Analysis of museum educators at work points to an underpinning desire to establish a genuine dialogue between the learners and the objects with which the educators are teaching.[21] In doing this, they are seeking to find out what the children's existing conceptual frameworks are and, through questioning and discussion, to build upon these, constructing an increasingly sophisticated understanding of the what objects have to tell us about themselves, about the world and about the human condition.

A vital element of the "dialogic classroom" is reflected

in the approach of many museum educators when they ask questions structured so as to provoke thoughtful answers. The answers to such questions tend to provoke further questions and are seen as the building blocks of dialogue rather than its terminal point.

The questions that museum educators use to promote dialogue and discussion are of what are generally considered the "higher-order" type. This means they tend towards questions that encourage analysis and synthesis of ideas; questions that prompt critical and evaluative responses.[22] The open-ended nature of the questioning approach is unconstrained by highly specific top-down or predetermined learning objectives, as is often the case in conventional classroom settings. As such, the learners engaging in this process often respond with greater individuality and creativity than they might otherwise do. Rather than trying to guess what's in the teacher's head (What does she want me to say? What's the right answer?), children in the hands of the skilled museum educator are actively encouraged to think beyond this. While the expression "thinking outside the box" has become something of an ubiquitous cliché, in this instance, it is a useful descriptor.

This approach has its roots in the theoretical framework that is broadly termed Social Constructivism.[23] Essentially, this is based on the understanding that learning is personal and that new knowledge and understanding is mediated by whatever pre-existing conceptual and procedural understanding is held by the learner. Crucially, the experiences and interventions that

facilitate this construction of new knowledge take place in a shared social context and not a vacuum.

The concept of the museum or gallery as having a "constructivist" ethos is not necessarily limited to formal education programmes. In his book *Learning in the Museum*,[24] George Hein suggests the notion of the "Constructivist Museum". Here it is proposed that in many institutions, the way objects are organised and displayed, the way affordances are introduced to support visitor engagement with the collection, even things as apparently mundane as the colour schemes chosen for the gallery walls contribute in creating this constructivist learning environment. This means promoting a dialogue between the objects and the observer that enables the construction of new understandings to emerge, built upon the visitors' pre-existing conceptual framework. This happens regardless of the depth or intensity of any prior knowledge or experience on the part of the visitor.

The characteristic pedagogy employed by museum educators reflects an often intuitive understanding of this theoretical perspective. It will involve the elicitation of existing ideas amongst the group of children and encourages acceptance of alternative viewpoints within the group. In doing this, the educator will also challenge the ideas and encourage learners to critically evaluate what's being said. They will offer interventions and activities to structure and inform children's observations and interactions with the objects so that the critical evaluation can be undertaken with increasing depth and sophistication. Teaching will often

conclude with a sharing of new knowledge and understanding and some self and peer appraisal on the part of the learners in the light of their experience.

When trainees witness this methodology, they are asked to consider how it differs from what they may have seen in the classroom. Crucially, they are also asked to reflect on whether the approaches modelled by the museum educators can be integrated into their day-to-day classroom practice.

For ITT to develop a new generation of teachers that fully embrace these wider ranging dialogic approaches rooted in constructivist thinking, it needs to expose the trainees to pedagogy that goes beyond what they might experience in the conventional classroom. Developing partnerships with museum education is an ideal way of facilitating this.

Ways of working together

Having proposed a clear rationale for establishing partnership between the Faculty of Education and the university museums, what structures have been developed to maximise the benefits that this confers on trainee teacher professional development?

The Early Years and Primary Postgraduate Certificate of Education (PGCE) course trains almost two hundred prospective teachers every year to work in schools with children aged between three and eleven years. Teaching in the faculty involves whole cohort block lectures each followed by a linked group seminar. This structure is used for the generic professional attributes elements of the course (the purpose of education including sociological, philosophical and psychological strands

alongside more practical aspects such as planning, assessment and behaviour management) and for the core subject areas.

This aspect of the course constitutes something in the region of 40% of the trainees' time. The rest of their training is school-based under the tutelage of teacher mentors. Tutors from the faculty make periodic school visits to support trainees and mentors, to moderate assessment procedures and to ensure consistency of quality across the partnership.

Engagement with the museums takes place during both phases of training. At various points of the faculty-based taught course, all trainees attend a whole cohort museum and gallery education day. While out in schools undertaking their professional placements (teaching practice) some trainees also have the opportunity to spend part of the school-based time embedded within the museum education department, working alongside the museum educators undertaking their day-to-day practice. In this situation, trainees will experience more than the specific age-range and demography of their school. They are likely to work with learners of all ages, abilities (intellectual and physical) and cultural backgrounds. Their school-based teacher mentors work closely with the museum educators to ensure there is coherence between the two training locations. The trainees also return to the museum later in the placement with their class and lead a teaching session in the gallery with children they obviously know well.

Whole cohort museum and gallery education days
Following a keynote lecture which emphasises the power of

working with objects and working outside the classroom, the trainees go out to selected museums on the campus where they are taught by the museum educators in their professional studies groups.

Every group experiences a teaching session in the Fitzwilliam Museum where the educators model pedagogical approaches working with paintings, antiquities and the armoury. Throughout, the focus is on the centrality of the object to the teaching and how group dialogue prompted by effective questioning enhances and enriches learning. Strategies to encourage close observation, identifying patterns, making inferences, developing narrative are all explored. In addition, the highly cross-curricular character of the teaching is emphasised so trainees can see how the museum experience does so much more than simply fulfil specific subject agendas. For example, when working with portraits, trainees will be aware that as well as the obvious historical links, they may well be thinking about the perception of self (PSHE) and our place in society (Citizenship). They may also be developing literacy and language skills and processes or considering the technological implications for the culture under scrutiny – a whole range of areas vital to the intellectual and social development of the child.

From here, the trainees are sent to one other museum, some groups going to the Polar Museum while others go to Kettles Yard House and Gallery. In these settings, the educators build on what has been modelled at the Fitzwilliam but with the additional focus on maximising the learning potential that

a very individual collection offers in terms of both the ethos of its foundation and, particularly, the emotional impact that such museums and galleries can deliver.

In addition to these experiences, all trainees have an input from the Sedgwick Museum educator. The extensive collection of loan boxes that support schools outreach work are brought into the faculty. Here the trainees can see how to transfer the pedagogy modelled in the other museums to their own classroom using materials borrowed from the university collections. The trainees also have a day at the University Botanic Garden, working with the education officer as an integral part of their science education course.

The success of these whole cohort days engaging in various ways with the university museums is evident from the consistently high-rating evaluation outcomes. As one trainee revealed when asked in what ways did the day as a whole add value to the course:

> There was enormous value in being taught by experts in museum/gallery education and to understand the centrality of objects in teaching. The inspiration from the Fitzwilliam tutor (educator) urged me to continue developing my teaching in a creative way.

This response is typical of the ways trainees describe their time with the museum educators. Another commented when asked his opinion regarding the relationship between the faculty and the university museums:

> *It (the day) added a very valuable practical experience to the course that complements the lectures and placements. The good relationship between the faculty and museums became clear insofar that sessions were highly tailored to our specific needs and gave very practical information and advice.*

Critical to the success of the days was close liaison between the faculty tutors and the museum educators. Meetings took place well in advance of the sessions to ensure that the various phases of the day complement and built upon one another while at the same time giving strong and consistent over-arching messages. Consideration of changes and development to what's offered in the light of previous evaluation also informed the content of these meetings. The other benefit is that the liaison provides the opportunity for faculty tutors to support museum educator professional development with updates on the latest professional and research based initiatives in the world of education.

The final criterion for success is ensuring the trainees have a clear understanding of the purpose of the visits, particularly considering how the experience affects their thinking about teaching and learning per se; in what ways does this make them a different sort of teacher?

The immediate success of the day is fine at one level, but are these initiatives likely to have a lasting impact on future practice? When asked about the sustainability of the input, this trainee's response typifies the general feeling amongst the cohort:

It has added a new dimension to considering how themes can be developed in the classroom and extended by a visit to view and (ideally) handle artefacts. On a personal level it has made me reconsider how I could use museums and their professional staff to enhance my teaching. Further, it has provided me with an additional resource that I had not previously considered, I will be liaising with the museum staff and education officers from local museums in my future career.

Embedded placements

The consistently high levels of participant satisfaction reflected in evaluations made it clear that the vast majority of trainees greatly value what they experience in the museums. With this in mind, a structure for offering selected trainees a more sustained experience embedded in one of the university museum education departments was developed between faculty tutors and the museum education team.

The structure of the embedded placement, based principally at the Fitzwilliam Museum, has developed since its inception in 2008. Trainee teachers apply for one of six places a year. Successful applicants are paired and undertake a two-week block as "embedded" members of the education team at various points during the academic year. This is an integral part of the school-based training and is assessed in the same way as any other aspect of their professional development.

During their time in the museum, trainees observe educators teaching groups of visiting pupils with the opportunity for immediate feedback following the observation.

Figure 3: A Dialogue with Monet. Two trainee teachers undertaking an embedded placement at the Fitzwilliam Museum consider the learning opportunities that Monet's Springtime *might offer their pupils. Photo: Keith Heppell, Cambridge.*

This exposes them to different teaching styles and a whole range of ages, abilities and ethnic backgrounds. It also allows the educator the opportunity to help the trainees analyse and interpret what they have witnessed. The diversity of the collection also means trainees see a wide range of subject areas addressed as well as the over-riding cross-curricular aspects of teaching in the museum.

As part of the placement, the trainees have a full-day working with colleagues in two other of the university museums, which gives them the chance to see how a common methodology is adapted to reflect the specific content of particular collections.

The whole experience is overseen by a co-ordinator based at the Fitzwilliam who prepares the placement timetable,

offers daily evaluative reviews that help to inform the trainees' learning journals and generally ensures that the objectives of the time in the museum come to fruition. (Figure 3)

The trainees' voices best attest to the value they attach to their university museum placements. Notice how the trainees link their experience working alongside the museum educators to the theoretical framework discussed earlier in the chapter and how they consider the implications for their own practice.

The trainees were asked to consider their responses in relation to the various categories of professional standards by which they are judged. When asked in what ways is the museum and gallery placement likely to impact on the development of your professional attributes (these include relationships with pupils and colleagues, communication and inclusive approaches) a typical answer was:

> Learners who came into the museum responded well to the Educators as 'experts', and the novelty and scale of the different surroundings seemed to stimulate engagement and positive behaviour. Educators pitch their discussions appropriately to the age of the learners, and the use of a dialogic approach involves and engages learners from the start.

Others commented that:

> Using artefacts is a very inclusive way of teaching – children are often starting with little prior knowledge, but are prepared to share that knowledge in a dialogic atmosphere.

Learning beyond the classroom is valuable in itself as a way of inspiring 'awe and wonder'. Using artefacts within the classroom will usually present something unknown and therefore interesting to the learners, as well as presenting a valuable real life link to the learning that is to be explored'.

A second aspect they were asked to think about was in terms of their professional knowledge and understanding (such as teaching and assessment strategies, curriculum knowledge and personalised learning). Invariably, trainee responses echo the sentiments expressed here:

The Educators are very knowledgeable about the artefacts with which they work and this is a valuable strength when teaching in a dialogic atmosphere. It means that they are able to respond to questions and opinions that may arise, and therefore move the learning forward. This is quite difficult for the class teacher, and requires thorough research of the artefact(s) before the using them. A teacher who visits a museum and does not wish to use an Educator needs to have a good knowledge of the artefacts and the environment in order to make the learning experience worthwhile.

The last thing trainees were asked to consider was, in many respects, the most critical one: In what ways has your time in the museum helped you develop and think beyond simply meeting the standards?

This is the most significant aspect for me. I have learnt how a stimulus (visual or other) can be used to promote and elicit thinking in young learners, and how the teacher can be free to follow a line of dialogue which is partially pre-planned, but which can lead to a fascinating discovery of knowledge and ideas in those learners. This means that learners are (partly) responsible for the direction of their learning, and are therefore very likely to discover something new for themselves

This self-directed aspect is differentiating (in terms of ability and experience) by its nature, and the dialogic approach leads to a community of enquiry where all learners can be inspired by the thoughts and ideas of colleagues and the Educator.

There is little doubt as to the worth of the embedded placements. School-based teacher mentors report significant changes in the way their trainees operate in the classroom not only in terms of professional competence but, more importantly, in terms of confidence to think beyond the basic expectations thereby bringing learning alive.

Conclusion

In this chapter, it is hoped that a convincing argument has been but forward in support of greater collaboration between academic museums and the university departments of education, particularly those responsible for teacher training. The mutual benefits are clear and, certainly in the context of the University of Cambridge, the contribution of the

departmental museums to inspiring the teachers of tomorrow has been invaluable. I will leave the last word to one of the many now qualified teachers who have passed through the university:

> *What have I learned from my time in the museum? I have learned that the power of real, tangible objects and artefacts as well as the value of relating learning to children's experience is of paramount importance... it has made me a different kind of teacher.*

NOTES

1 Cambridge University Development Office, *Places of Wonder: the Museums and Collections of the University of Cambridge*, (Cambridge: CUDO, 2011) 1.

2 Philip Stephenson, "Science in the Making: the use of museum based culturally defining artefacts as part of primary science teaching", *Journal of Museum Ethnography*, 10, (1998).

3 Department for Culture, Media and Sport, *A Place for Culture: Towards a local culture offer for all children and young people*, (London: DCMS, 2010).

4 Joint Museums Committee, *University of Cambridge Museums Policy Statement*, (Cambridge: JMC, 2006).

5 Department for Education and Skills, *Excellence and Enjoyment: a Strategy for Primary Schools*, (London: DfES, 2003).

6 Philip Stephenson, "Ancients Appliance of Science" in *Excellence & Enjoyment: Primary National Strategy Professional Development Training materials*, (London: HMSO, 2004).

7 Philip Stephenson and Frances Sword, "Ancients Appliance of Science", *Primary Science Review*, 83, (2004).

8 Philip Stephenson, Frances Sword and Paul Warwick, "Ancients Appliance of Science", *Journal of Education in Museums*, 26, (2005).

9 Department for Children, Schools and Families, *Manifesto for Outdoor Education*, (London: DCSF, 2006).

10 Creative Partnerships, *Teaching Outside the Classroom*, (2008), accessed March 21, 2009, from http://www.teachingoutsidetheclassroom.com.

11 Museums, Libraries & Archive Council, *Alternative Settings for Placements*, (2009), accessed March 27, 2012, from http://research.mla.gov.uk/case-studies/display-case-study.php?dm=nrm&q=1

12 Sally Kendal, Jenny Murfield, Justin Dillon and Anne Wilkin, *Education Outside the Classroom: Research to Identify What Training is Offered by Initial Teacher*

Training Institutions, RR802, (London: NFER, 2006).

13 Training & Development Agency, *Standards for the Award of Qualified Teacher Status*, (London: HMSO, 2007).

14 Faculty of Education, *Early Years and Primary Course PGCE Evaluation*, (Unpublished: Cambridge, 2010).

15 Susan Pearce, *Interpreting Objects and Collections*, (Leicester: Routledge, 1994).

16 Jonathan Barnes and Stephen Scoffham, *Teacher Education Outside the Classroom: Why ITT students' experience needs to be broadened and extended*, (2007) accessed April 2nd, 2012, from http://www.teachingoutsidethe classroom.com/downloads.

17 Carol Dweck, *Beyond Modularity*, (Cambridge, MA: MIT Press, 1996).

18 Andrew Coles, A. (2009) "Museum Learning: Not Instrumental Enough?" in *Learning to Live*, (London: Institute for Public Policy Research, 2009).

19 Robin Alexander, *Culture and Pedagogy: International Comparisons in Primary Education*, (Malden, MA: Blackwell Publishers, 2001).

20 Robin Alexander, *Towards Dialogic Teaching: rethinking classroom talk*, (York: Dialogos, 2004).

21 Rika Burnham and Elliott Kai-Kee, "Conversation, Discussion & Dialogue" in *Teaching in the Art Museum*, (Los Angeles: Getty Publications, 2011).

22 Benjamin Bloom et al., *Taxonomy of educational objectives: the classification of educational goals; Handbook I: Cognitive Domain*, (New York: Longmans, 1956).

23 Lev Vygotsky, *Mind in Society: The Development of Higher Psychological Processes*, (Cambridge, MA: Harvard University Press, 1978).

24 George Hein, *Learning in the Museum*, (Cambridge, MA, Routledge, 1998).

Connecting University Art Galleries, Art Education Certification Programs, and Local Teachers

STEPHANIE HARVEY DANKER
Sawhill Gallery
James Madison University

There is an interdependent relationship between museums, students and teachers.[1] University art galleries and art education certification programs are in a position to provide mutually beneficial educational opportunities which can also positively affect local teachers. David Ebitz wrote, "Museum educators working in art museums may have more in common with museum educators and professionals working in other types of museums than they do with school and university art educators."[2] He recognized a "benign neglect" of art museum education on the part of most art educators. Teachers can feel threatened or uncomfortable within the museum context and may become reliant on museum educators on how to use the space and what their students need.[3] It is important to acknowledge the work of one another, and realize how practice can be strengthened through collaborative efforts.

When educators gain experience using museum resources as part of their pre-service training, they are more likely to continue this practice when teaching.[4] Carole Henry encouraged building and maintaining a working relationship between the university art education program and the art museum, out of shared interests and concerns.[5] She suggested coming together to make connections and generate ideas about how a pre-service program and an art museum can work together to help students meet national standards. Learning about differences (and similarities) between teaching in formal and non-formal spaces through coursework may prevent assumptions being formed by formal and non-formal educators about roles and responsibilities of one another.[6]

Moreover, when pre-service teachers create gallery resources as part of coursework, the gallery, university and community benefit.

Collaborations between university art education programs and university art galleries may bring new understandings to both formal art educators and museum educators. Insights can be gained for conducting successful partnerships between the gallery and local teachers, through the assistance of art education students and faculty. Strategies and examples of collaborations that have been successfully implemented will be discussed in this chapter, including the Krannert Art Museum, Sawhill Gallery and the Ulrich Museum of Art.

Krannert Art Museum, on the campus of University of Illinois – Urbana Champaign (UIUC), features a unique Resource Center that services pre-service teachers as well as area teachers. The museum houses over 10,000 works and opened in 1961, with the Kinkead Pavilion expansion added in 1988.

Sawhill Gallery is located on the campus of James Madison University, Harrisonburg, VA (JMU), and is one of five galleries at the university. The gallery opened in the mid-1970s and has no permanent collection. Sawhill Gallery has sixteen student interns per semester who receive course credit for managing the gallery space, attending workshops and openings, assisting with installations and other tasks. The gallery has strong connections to the pre-service art education program. In all, the director is responsible for overseeing 66 student interns between Sawhill Gallery, artWorks and Lisanby Museum.

The Ulrich Museum of Art is a contemporary art museum

located on the campus of Wichita State University, Kansas (WSU). It has over 7,000 pieces in the permanent collection and opened in 1974. The museum also cares for the 76 works in the Martin H. Bush Outdoor Sculpture Collection, spread across campus. It has developed an innovative partnership with local teachers based on Art21 screenings and student art shows that will be shared.

Krannert Art Museum: Giertz Education Center

The Education Center at Krannert Art Museum and Kinkead Pavilion promotes a direct connection between the museum, university pre-service art education program and the community. It was developed in 1989 in reaction to the removal of arts classes from the area school systems. The solution for the Education Center to this dilemma was to provide teachers access to resources that would allow them to incorporate the arts into their classrooms.[7]

The focus of the Education Center's collection is unique in that it does not only focus on works in the museum's collection. The coordinator listens to the wants and needs of local teachers and the university community in determining items for the collection. Currently, over 5,000 resources are available for loan through the Center, which are used mainly by pre-service teachers and educators. Available resources include: poster prints (individual and sets), books, videos/DVDs, object replicas, magazine issues, and hands-on kits (touch kits). In 2011, patrons who used materials from the Center included:

- pre-service teachers, 37%;
- educators, 36%;
- libraries, 10%;
- university faculty, 6%;
- other, 11%.[8]

Patrons can borrow materials directly from the Center (Figure 1) or through the Illinois Heartland Library System (IHLS), which can be accessed throughout the state. Being a part of the IHLS makes it feasible for educators at a distance to request high-quality resources for teaching.

Connections with local teachers

The coordinator of the Education Center collaborates with the museum educator at the museum on school programming. The coordinator assists with scheduling and logistics related to school field trips and assists the museum educator with teacher workshops that take place at the museum. One teacher workshop is hosted at the museum each semester. She maintains the teacher e-news distribution lists and publishes teacher e-news issues when there is news to communicate. During the 2010-2011 school year, in an effort to reach more teachers in the area, the museum called school principals in the area to ask them to pass on the teacher e-news to their teachers. The coordinator of the Education Center thinks that by forwarding the museum's teacher e-news, principals have been able to reach more non-art teachers in the area.

Both the coordinator of the Education Center and the

Figure 1: A Giertz Education Center volunteer examines prints with a local teacher.

museum educator maintain active membership of the National Art Education Association (NAEA). The coordinator of the Education Center has presented at the NAEA national conference several times, including a joint presentation in 2007 with the assistant director of the UIUC Saturday Art School program, highlighting ways that the pre-service methods class and the Education Center work together. She has also presented at the Illinois Art Education Association (IAEA) conference, and serves as the museum liaison representative for the IAEA. This position is ideal for communications with teachers in the state about what the Education Center can offer teachers. For example, the Teacher e-news from the museum is distributed through IAEA publications. More importantly, this position allows the coordinator to assist all museums around the state

to increase their visibility with teachers. The coordinator has been able to open communication with museums around the state informing them what teachers desire from them.

Connections with the pre-service art education program

The Giertz Education Center provides resources for local teachers, but also has a strong connection to the art education program at the university. Benefits of the Education Center to pre-service teachers include: accessibility to teaching resources; art historical background information; embodiment of curricula; and lesson ideas through resources.[9]

As noted in the 2010-2011 annual report, the UIUC School of Art + Design Art Education faculty members continue to collaborate with the Education Center. The coordinator of the Education Center identified three aspects of collaboration. The Art Education Department paid for student staffing to keep the Education Center open on Saturdays. The Education Center's staff continued to laminate teaching aids for students with film purchased by the Art Education Department. The Education Center staff provided introductions to the Center, consulted on curriculum, and assisted with loans for students enrolled in Art Education courses.

Resources from the Education Center are promoted and use is required in many of the pre-service art education courses at UIUC. Pre-service students in the Saturday Art School course are required to use resources from the Center in their lessons. They are required to plan and implement a gallery experience for students from the community they teach (Figure 2). The

Figure 2: A pre-service teacher leads students in an activity at Krannert Art Museum during UIUC Saturday Art School.

pre-service students are responsible for preparing community students for what they will see, as well as for appropriate behavior within the museum, prior to taking them to visit. They are also responsible for leading an activity within the galleries, and connecting the museum visit to the theme being taught through art-making in the classroom space.

Another art education course that requires use of the Education Center is one that is specific for elementary education majors. These students are required to integrate museum resources into presentations for their peers. Since this is a required course for all elementary education majors, exposure for the non-art audience is broadened.

Pre-service students at the university learn about available museum resources for teaching and practice teaching in

gallery spaces as part of the art education certification program at UIUC. The coordinator of the Education Center recognized that there are teachers around the state accessing resources from the Center who first learned about what was available as students at UIUC. It was also mentioned that local cooperating teachers who have hosted UIUC student teachers have started using resources after exposure through their student teachers.

Another example of resources created through assigned coursework in art education is touch kits. These are tubs of materials intended to be useful in teaching thematic units or for learning centers in a classroom and most have a relationship to a particular culture and artistic process or technique. They are relevant for use by other pre-service students and teachers. The kits are geared for elementary level and include: a teacher's guide, objects such as tools and samples, posters, and resources such as books or multimedia. Though these have been created through art education coursework in the past and donated to the Education Center, touch kits are sometimes created by community volunteers and retired teachers in the area.

Connections with the university community
Outside of required pre-service art education courses, the museum educator offers a course called Museums in Action open to the university community. In the past, the course has been co-taught with an art education professor. The course was conceived as a collaboration between the art education department and the museum. Resources created as part

of coursework include podcasts and historical contextual research related to works in the permanent collection. In past years, students in this course have planned and implemented an evening full of activities at the museum for the college community, centered on a theme. This type of event gives students experience with organizing, promoting, implementing and evaluating a museum event for a particular audience.

Sawhill Gallery: lesson plans and education-focused internships
Sawhill Gallery is located on campus at JMU. The gallery features "changing exhibitions of international, national and regional significance. In addition to showing contemporary art, a hallmark of the gallery's mission is to demonstrate art's multicultural and interdisciplinary dynamic." [10] The gallery administration includes a director, assistant director (graduate student) and student interns who contribute to daily operations. As a faculty member in art education, my role with the gallery has been to create links between the pre-service art education program and the gallery. The ways in which this has been implemented will be discussed and include lesson plans for exhibiting artists, faculty lesson plans, and education-focused student internships.

Lesson plans for exhibiting artists
In the fall of 2011, as part of coursework for an advanced pre-service methods class, students worked in pairs to create lesson plans based on exhibiting artists' work in the gallery. Art Across

the Curriculum (AAC) serves as a capstone experience for art education students prior to student teaching. The course is designed to cover both art educational theory and generalized methods and techniques related to the concept of teaching the visual arts across the curriculum. On completion of this course, students conceptualize art as an interdisciplinary subject as well as demonstrate competence in designing and implementing interdisciplinary art lessons.

There were two shows in Sawhill Gallery during the fall 2011 semester which featured work by nationally and internationally acclaimed artists. Each show had three accompanying standards-based lesson plans created by the pre-service students. The lesson plans were based on themes in the work; one was created for each level: elementary, middle and high school. I met students in the gallery that were assigned to create their lesson based on the Victor Ekpuk exhibit. Students experienced the work together and heard contextual information about the artist from the gallery director. They worked with grade-appropriate art standards and connected state standards from two other subject areas to come up with a theme-based lesson, using images from the exhibit.

After the lesson plan teams had completed their lessons, they were posted on the Sawhill Gallery website. These students also had the opportunity to meet in person with the artist to discuss their ideas, when the artist was brought on campus for a brief residency and artist talk. Later, Victor Ekpuk shared his perspective about the experience:

From my perspective, I was very impressed by the different ways the students engaged with my work. I appreciated the idea of creating collaborative ideas by bringing other disciplines like music to interpret the lyrical lines in the drawings. This expands the scope of art appreciation beyond what the artist had intended. The willingness to engage a deeper understanding of the cultural background that informs my work was also very touching. This, in particular prepares students for the new age of multiculturalism. (Personal communication, April 2, 2012).

Organizing a meeting for pre-service students to share their work with the artist, inspired by the artist, has potential to reinforce relations between the artist, gallery and university.

The link to the lesson plans on the gallery website was then shared with teachers throughout Virginia by pre-service students in the group that presented at the Virginia Art Education Association (VAEA) 2011 fall conference. They were also promoted to student teachers in the art education program and their cooperating teachers in the community. One of the pre-service students, in a separate presentation, discussed her artist lesson plan with other art educators attending the VAEA conference.

Faculty lesson plans

In the spring 2012 semester, the AAC students worked in partner groups to focus a lesson plan on JMU School of Art, Design and Art History (SADAH) professors. The project

involved focus on selected SADAH faculty and their artwork as the foundation for interdisciplinary, thematic lesson plans. The JMU Art Education Center and Sawhill Gallery invited senior level faculty to be a part of the special curriculum project.

If invited faculty were interested in being a part of this project, two AAC students were assigned to focus on the artist and their work. Ideally, the two students assigned to the faculty member would have had a class with him or her. Students were instructed to schedule an appointment with their faculty member to conduct an interview about his/her artwork and art making processes. The content of the lessons aimed to represent the faculty member and his/her work through meaningful art learning activities for K-12 students.

The project as a whole was designed to show appreciation for SADAH faculty members and to build yet stronger ties between studio art and art education. It is the beginning of a larger project that the JMU Art Education Center and Sawhill Gallery hope to continue over time. The lessons developed in partnership between the art education students and studio faculty will demonstrate how art education and studio areas collaborate with one another to promote excellence in art teaching.

This project provides a way for the JMU Art Education Center to show appreciation for the guidance and training that the SADAH faculty members provide to students, while also showcasing art education student work. It also provides an avenue for Sawhill Gallery to show appreciation for the

contributions that SADAH faculty members have made (and continue to make) to exhibit their work in the gallery space. Together, the JMU Art Education Center and Sawhill Gallery intend to honor faculty by educating others about their work. These lesson plans will be published on the Sawhill Gallery website, available to local teachers and accessible by the greater public.

Education-focused student internships

Student interns at the gallery have the option to obtain art education credit if they focus part of their work on an independent educational project. These interns fulfill all requirements for the gallery internship and work with an art education faculty member (supervisor) to design an educational project. The supervisor documents implementation of the project and the intern writes a reflection paper that outlines the proposed activity: what happened and tips for other interns that might want to do similar types of projects. These reflection papers are kept in a binder in the gallery for interns to access and become part of the archive related to the exhibits.

The education-focused internships give university students interested in gallery work experience with creating interpretive material for a particular audience. Interestingly, an equal mix of art education students and students from other areas have registered for the education option, which gives student gallery interns not on the pre-service certification track an opportunity to experience planning and implementing a teaching experience with art. Education-focused student

interns research Abigail Housen and Philip Yenawine's Visual Thinking Strategies[11] and weave guiding questions of the theory into their activities with children to create learner-centered discussion (Figure 3).

In addition to working with children, student interns have focused on other audiences. One student interviewed the artist whose work was on exhibit and created Quick Response (QR) codes, which were then placed next to the labels to provide more information about particular works. Another documented the installation of a campus gallery exhibit, created a blog with images and text showing the process and shared it with the university community.

Ulrich Museum of Art: Art21 partnership with local schools

The Ulrich Museum of Art is a contemporary art museum located on the campus of WSU. It provides an excellent example of an outreach effort in the community with local schools through its Art21 initiatives. Many university museums and schools hosted the sixth season of Art21 screenings (Season 6).[12] However, the Ulrich Museum was the only one to promote their partnership with local schools, inviting the public to attend screenings at the schools as co-sponsored events, with the final screening hosted at the museum. The school sites included a reception an hour before the film screening to view new student art inspired by their favorite Art21 theme or artist, self-curated specifically for the event.

In August 2011, the museum educator invited art teacher representatives from three local high schools to the museum

Figure 3: An education project with children at Sawhill Gallery, James Madison University.

for discussion about her idea to have each of the schools host a preview screening of the sixth season of Art21, taking place in April 2012. The museum educator wanted to attract a fresh, new audience for the Season 6 programming. The museum has held screenings for each of the Art21 seasons and has hosted many Art21-affiliated artists through their Buzz-worthy Art Talk series. Since 2008, the featured Art21 artists have included: Mel Chin, Mark Dion, Trenton Doyle Hancock, Alfredo Jaar, and Kerry James Marshall.[13] Also included in the museum's permanent collection are artworks by Art21 artists: Mark Bradford, Trenton Doyle Hancock, Hubbard/Birchler, Kerry James Marshall, Ursula von Rydingsvard, and Kara Walker.

Along with the individual preview screenings, each participating high school was invited to host an art exhibit on the same date as the screening (four consecutive Tuesdays in April). The exhibitions consisted of new student work inspired

by the student artists' favorite theme or artist from Art21. At one of the schools, the Ulrich Museum sponsored Art21 artist Trenton Doyle Hancock to speak as a further connection to the series of events. (He also spoke on campus at WSU.) As a way to build community, the schools were invited to attend each other's art shows and preview all screenings. The museum provided bus transportation for students from participating schools to attend the Trenton Doyle Hancock artist talk at the high school hosting the event. The WSU community was invited to attend as well and some of the art professors offered extra credit to their students for attending, since it was technically an Ulrich Museum sponsored event in the community. Community events are open to the public and were advertised in the Ulrich Museum newsletters, on their website, and through public marketing described below.

The museum educator proposed a standardized approach to the preview parties and exhibits at the individual schools. However, the involved teachers seemed most excited about having the flexibility to decide how they wanted to approach the events at their respective schools. They decided that each exhibition would consist of 30-40 works of student art, that this number should be consistent at all schools, and discussed how to include as many students as possible. For example, one teacher mentioned that graphic design students would create promotional posters and labels for the work while others would assist in roles such as hospitality.

In an effort to continue the conversations between the teachers and the museum during the planning process,

the museum educator suggested that the art teacher representatives come to the museum for meetings on a monthly basis. One of the teachers questioned the need to meet so often and proposed keeping in touch by email, which seemed to appeal to everyone. The museum educator thought that not meeting as often would take some pressure off of everyone, but in November 2011 was not sure how frequently the involved teachers had been in touch with one another. She planned a meeting with the participants at the museum in December 2011 to catch up on everyone's progress and to share some good news about the project.

The Wichita State University Foundation, in conjunction with the Ulrich Museum, received a $20,200 grant to support the Art21 community project from Kansas Health Foundation. The organization demonstrates to the city that health is defined beyond physical health, and through the grant committed "to help nurture a long-term interest in the arts among high school students living in Sedgwick County through museum visits and connections with artists." [14] The grant funded expenses related to Trenton Doyle Hancock's visit, an intern to assist the museum educator with logistics, marketing through the local PBS television station, the NPR radio station, and the printing and mailing of postcards and fliers. The museum printed postcards for the schools to send out to their communities, demonstrating the partnership between the museum and the local schools. There was an honorarium for a videographer to document the program (a student at WSU), as well as one for the three community artists asked to judge the student

exhibits. For each school, a Best of Show was awarded, and the student winner received a $75 gift certificate to a local art supply store. Two honorable mention certificates were also awarded. At the final preview party, held at the museum, an award was presented for the best school exhibition; the award was a $250 pizza party for that school's art department.

In addition to the $20,200 grant, the museum applied (along with the local PBS television station, KPTS) for an Art21 mini-grant related to this program. They received the grant, which covered some marketing costs for promoting the Art21 events held at the high schools and the museum. The WSU student commissioned to create a video visited each of the participating schools multiple times, interviewing students and teachers, and documenting art-making and the process of the exhibits coming together. This short video was shown at the final preview in Season 6 series at the museum, since students, families and community members representative of all schools were in attendance. The museum educator hopes to share the documentary video with Art21, demonstrating the dynamic way in which the Ulrich Museum is collaborating with local schools using Art21 programming.

This project has enabled the museum educator to remain in communication with a group of local art teachers over the 2011-2012 school year. It has also allowed her to get into the local schools on a fairly regular basis for planning purposes. She has been able to interact with individual teachers in the art departments at all of these schools and has been able to see the different ways in which each of the art departments operate.

She has been able to interact with students at the schools. Her visibility has increased in the local schools; she knows more teachers and more teachers know her. This project required meetings at both institutions – the schools and the museum; an understanding of one another's settings may become more comfortable because of programs like this. Teachers may see how the local museum can be of service to them, while the museum educator can see how teachers can be of service to her programming goals.

In addition to feeling supported by the school administrators for the programming, the museum educator commented that the art curriculum specialist in the local school district was very excited about this collaboration. And high school students were excited about people from the community seeing their artwork.

The Art21 partnership between the Ulrich Museum of Art and local schools demonstrates how other university museums can become more involved with selected high schools while promoting contemporary art presented through themes. The content is provided by Art21, with an extensive archive of video, images and teaching resources available on their website. Teachers and university museums interested in such a partnership could begin by dialoguing about these resources and how they might be used in the classroom and museum spaces.

There are ways this type of partnership could enlist further collaboration with a pre-service art education certification program. Art21 could be discussed in a secondary methods

course. Pre-service students could use or adapt available teaching resources or create their own to implement with local high school students. They could learn much from gaining experience helping in local high school art departments hosting an Art21 screening, particularly if there was a partnership with the university museum in place. Pre-service students could glimpse the meaning making potential of teaching through contemporary art themes. They could aid in the planning process and details associated with organizing an exhibit and event for the community. They could see first-hand how collaborations within art departments and with a museum work.

Additionally, since the museum owns a number of artworks by Art21 artists, pre-service students might be able to create curricular resources for course credit based on these pieces. These student-made resources could become part of the museum's educational resources. Pre-service students and local teachers could request to view the actual artwork and learn about its acquisition from the curator or museum educator. They could discuss the work (or use the teaching resource they create) with classmates, students or other teachers in the museum space. These resources could be shared digitally with local teachers, distributed through the museum educator or through the local art curriculum specialist.

Conclusion
There is a need for the museum community to focus on teachers and how they learn.[15] For this to happen, practicing

museum educators need to better understand the teacher audience in their communities.[16] The programs highlighted provide examples of ways of connecting university art galleries with art education certification programs and local teachers. There is a need for pre-service teachers to gain exposure and training on how to effectively use the museum early in their career.[17] If teachers are initially trained in how to use museum resources and to recognize links between formal and non-formal learning, it may be less intimidating for teachers to think about accessing museum resources or teaching in museum spaces.

University art galleries and museums interested in building bridges with local teachers might start by forging closer connections with the art education pre-service program at their university. Professors of pre-service courses may consider integrating course assignments that engage students with art in the museum or invite museum staff into the classroom. Museum staff and professors of pre-service students ought to provide experiences for these art teachers in training to experiment, learn together and have teaching opportunities within the museum. These experiences can build confidence and comfort for pre-service teachers and may show museum staff and professors ways they can collaborate.

Themes and big ideas connect well with many disciplines, evidenced through art. Addressing art in the gallery or museum through themes can relate to teachers of subject areas besides art and assist with addressing standards. University gallery and museum staff should be encouraged to connect to various

disciplines' pre-service programs within the university.

Art21 resources provide a manageable entry point for discussing contemporary art through themes, relevant to current social issues. University galleries and museums might consider hosting screenings of new seasons of Art21 films and promoting the events to their surrounding communities. As demonstrated by the Ulrich Museum, these resources have great potential to bring together the university museum, local teachers, students and the community.

NOTES

1 Janette Griffin, "Students, Teachers, and Museums: Toward an Intertwined

 Learning Circle" In *In Principle, In Practice*, edited by John H. Falk, Lynn. D. Dierking,

 and Susan Foutz, 31-42. Lanham, MD: AltaMira Press, 2007.

2 David Ebitz, "Responding to Benign Neglect: Relations between Museum

 Education and Art Education." *Visual Arts Research* 34, no. 2 (2008): 2.

3 Kalin et al. "Provoking Points of Convergence: Museum and University

 Collaborating and Co-evolving." *International Journal of Art & Design Education* 26,

 no. 2 (2007): 199-205.

4 Kathleen Unrath and Mick Luehrman, "Bringing Children to Art – Bringing Art to

 Children." *Art Education* 62, no. 1 (2009): 41-47.

5 Carole Henry, "The Art Museum and the University in Preservice Education." *Art

 Education* 57, no. 1 (2004): 35-40.

6 Lynn U. Tran, "Teaching Science in Museums: The Pedagogy and Goals of Museum

 Educators." *Science Education* 91 (2006): 278-297.

7 Virginia Erickson, *Report of Activities of the Fred and Donna Giertz Education Center:

 Spring 2007*. Champaign, IL: Krannert Art Museum, 2007.

8 *The Fred and Donna Giertz Education Center Annual Summary of Services 2010-2011*.

 Champaign, IL: Krannert Art Museum, July 2011.

9 Christina Chin and Virginia Erickson, "Synergizing the Pre-service Teaching

 Experience with Museum Education Resources." Presentation at annual meeting

 for the National Art Education Association, New York, NY, March 14-18, 2007.

10 James Madison University, "Experience the Arts at JMU: Sawhill Gallery." Accessed

 March 25, 2012. http://www.jmu.edu/jmuarts/galleries/sawhill.shtml.

11 See Visual Thinking Strategies, "What is VTS." Accessed April 23, 2012.

 http://www.vtshome.org/what-is-vts.

12 Art21, "Find a Screening." Accessed April 9, 2012.

 http://www.art21.org/art21-access-12/find-a-screening.

13 See Ulrich Museum of Art at Wichita State University. "News and events:

 Recorded talks." Accessed April 3, 2012.

 http://webs.wichita.edu/?u=ulrichmuseum&p=/NewsandEvents/RecordedTalks.

14 Kansas Health Foundation, "Ulrich Museum Pilot Project for Art21: Film

 Screenings and Art Contests." Accessed April 3, 2012.

 http://www.kansashealth.org/grantmaking/grants/

 ulrich_museum_pilot_project_art_21_film_screenings_and_art_contest.

15 John H. Falk and Lynn D. Dierking, *Learning from Museums: Visitor Experiences

 and the Making of Meaning*. Lanham, MD: AltaMira Press, 2000; George E. Hein,

 Learning in the Museum. New York: Routledge, 1998.

16 Alan S. Marcus, "Rethinking Museums' Adult Education for K-12 Teachers." *Journal of

 Museum Education* 33, no. 1 (2008): 55-78.

17 Henry, ibid.

Bibliography

Art21. "Find a Screening." Accessed April 9, 2012. http://www.art21.org/art21-access-12/find-a-screening.

Chin, Christina, and Virginia Erickson. "Synergizing the Preservice Teaching Experience with Museum Education Resources." Presentation at annual meeting for the National Art Education Association, New York, NY, March 14-18, 2007.

Ebitz, David. "Responding to Benign Neglect: Relations between Museum Education and Art Education." *Visual Arts Research* 34, no. 2 (2008): 1-4.

Erickson, Virginia. *Report of Activities of the Fred and Donna Giertz Education Center: Spring 2007*. Champaign, IL: Krannert Art Museum, 2007.

Erickson, Virginia. *The Fred and Donna Giertz Education Center Annual Summary of Services 2010-2011*. Champaign, IL: Krannert Art Museum, July 2011.

Falk, John H., and Lynn D. Dierking. *Learning from Museums: Visitor Experiences and the Making of Meaning*. Lanham, MD: AltaMira Press, 2000.

Griffin, Janette. "Students, Teachers, and Museums: Toward an Intertwined Learning Circle" In *In Principle, In Practice*, edited by John H. Falk, Lynn. D. Dierking, and Susan Foutz, 31-42. Lanham, MD: AltaMira Press, 2007.

Hein, George E. *Learning in the Museum*. New York: Routledge, 1998.

Henry, Carole. "The Art Museum and the University in Preservice Education." *Art Education* 57, no. 1 (2004): 35-40.

James Madison University. "Experience the Arts at JMU: Sawhill Gallery." Accessed March 25, 2012. http://www.jmu. edu/jmuarts/galleries/sawhill.shtml.

Kalin, Nadine, Kit Grauer, Jill Baird, and Cheryl Meszaros. "Provoking Points of Convergence: Museum and University Collaborating and Co-evolving." *International Journal of Art & Design Education* 26, no. 2 (2007): 199-205.

Kansas Health Foundation. "Ulrich Museum Pilot Project for Art21: Film Screenings and Art Contests." Accessed April 3, 2012. http://www.kansashealth.org/grantmaking/grants/ ulrich_museum_pilot_project_art_21_film_screenings_ and_art_contest.

Marcus, Alan S. "Rethinking Museums' Adult Education for K-12 Teachers." *Journal of Museum Education* 33, no. 1 (2008): 55-78.

Tran, Lynn U. "Teaching Science in Museums: The Pedagogy and Goals of Museum Educators." *Science Education* 91 (2006): 278-297.

Ulrich Museum of Art at Wichita State University. "News and events: Recorded talks." Accessed April 3, 2012. http:// webs.wichita.edu/?u=ulrichmuseum&p=/NewsandEvents/ RecordedTalks.

Unrath, Kathleen, and Mick Luehrman. "Bringing Children to Art – Bringing Art to Children." *Art Education* 62, no. 1 (2009): 41-47.

Visual Thinking Strategies, "What is VTS." Accessed April 23, 2012. http://www.vtshome.org/what-is-vts.

Peer-to-Peer Tours

KATHY GAYE SHIROKI
Burchfield Penney Art Center
Buffalo State College

Envision college students touring an art museum with their peers. They casually gather around a work of art mingling with one another. It might not be evident at first glance who is guiding the group, but there is no denying the students' comfortable mannerisms, active engagement, and animated conversations. These students are participating in a peer-to-peer tour at the Burchfield Penney Art Center at Buffalo State College. College students have a variety of learning styles; peer-to-peer learning in higher education declares that, as members of the academic community, we are in this together. This chapter outlines the framework of peer-to-peer tours and its many benefits (Figure 1).

Why develop peer-to-peer tours?

Peer-to-peer tours grew out of the need to serve the college learning community. Once located in a classroom building, the Burchfield Penney Art Center achieved a higher profile in the fall of 2008 with a LEED silver certified building designed by architects Gwathmey Siegel and Associates. With larger exhibition spaces and a fresh new ambiance, the Burchfield Penney Art Center looked for innovative ways to connect the college with the new museum. The goal of Buffalo State College is to inspire a lifelong passion for learning and is dedicated to excellence in teaching, scholarship, and cultural enrichment. The museum's mission is to encourage learning and celebrate the richly creative and diverse community. Peer-to-peer tours developed as one way to achieve both goals.

Peer-to-peer tours began in the spring of 2009 when the

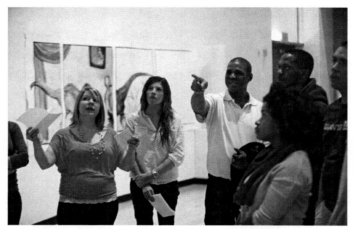

Figure 1: Student guides Kristen and Carly in conversation with Mechanical Engineering students on a peer-to-peer tour.

class location moved to the Burchfield Penney Art Center. While anyone can teach in the galleries, having access to the spaces without crossing campus is invaluable. The advantage of holding class in the museum is the accessibility of the artwork and exhibition spaces. The convenience and ease of access to the galleries is central to connecting the students with the museum. The move became the critical component for developing the peer-to-peer tours.

Faculty who register for peer-to-peer tours are looking for their students to explore the course content from another perspective. Students engaging students creates an environment where conversations on familiar topics take place in novel ways. Visiting students are asked to take a trusted leap to share openly with the leadership of their peer guides. Faculty and students experience the opportunity to use artwork as a

catalyst for engaged learning within the framework of this unique platform. The result is an in-depth connection to their course content.

What are peer-to-peer tours?

Graduate students enrolled in courses highlighting Museum Education studies at Buffalo State College study the artwork on exhibition, practice touring techniques, and take the time to understand the visiting class course curriculum. Visiting students experience a personalized tour conducted by peer guides who ask pertinent questions, listen actively to responses, and engage their audience in course integrated learning.

Working in pairs and small groups, student guides choose their own partners to develop their section of the tour. Relying on each other's skills and knowledge they appreciate their peer ideas and compromise when needed to compose the best approach for the peer tour. Developing content with a partner builds a trusting relationship that is evident when presenting. Students assist each other as needed and see this not as an interruption but a means by which to successfully deliver their information. As an example, Rebecca Truell is a graduate student guide. When her partner asked a specific question during one tour the group become quiet. Rebecca reflected, "All the side conversations stopped... I thought, Oh no! I casually jumped in and mentioned to the group that I had heard a lot of talk between them when I was walking around as they were looking. I just asked them to talk

Figure 2: Student guide Rebecca leading a peer-to-peer tour.

a little bit about what they were saying amongst themselves and what they think they were seeing. Then the comments started flowing." Peer-to-peer tours are a group effort; the collaboration enhances the tour experience due to diverse approaches to the artwork (Figure 2).

Student guides employ a variety of presentation styles in their approach to artwork. Groups have disco danced in installations, written poems on an adding machine tape that traveled throughout the gallery floor, and created character personas while examining artworks. Students have also looked at art while moving their bodies and have conducted soundscapes as they explored the galleries. Because the guides are encouraged to facilitate participatory activities within the museum, visiting students find themselves less intimidated and more willing to share their observations when looking at art in a new way. Sometimes silly, the activities break

down barriers and stereotypes that might limit the student's confidence in believing their view is suitable to share.

The guides decide as a class the overarching theme of the tour and how it will be presented. The interest of a visiting class in writing techniques was heightened by building a narrative throughout the tour. The students constructed a story which included setting, plot, and character development; this encouraged them to use all their senses throughout the galleries. Guides are expected to create interactive tours when the result builds content and is safe for the visitor and the artwork on exhibition. Faculty frequently comment on the refreshing approaches the students design to connect to their course curriculum: not just imagining flying a kite but taking the physical stance to feel the pull of the wind helped guide engineering students to examine how force can relate to the art. Many visiting students have commented that they feel relaxed with the informal approach to looking at artwork; it was easier for them to join the conversation and at times act rather unconventionally. When Tracy Giblin, a graduate student guide, decided she wanted the visiting students to experience the sounds created in the special project space, she began by moving her body to the music. Leading by example, she smiled, moved to the sounds and asked others to join her on the dance floor. As her peers trusted her guidance and relaxed their bodies she began to share information about the artist and how the sounds were created and orchestrated. As the sounds changed she quietly noted this to her group and watched the students shift their rhythm and movements.

Guides learn not to shy away from receiving a multitude of unexpected answers and learn how to solicit individual responses to facilitate a deeper engagement with the artwork and course subject. Having a conversation around an artwork is an authentic experience when delivered by a peer. The peer guides have a deep respect for the museum and the works of art. This is conveyed to the visiting class from the outset which sets the tone for a non-judgmental tour where divergent opinions are valued.

Bringing the campus to the museum

Peer-to-peer tours promote innovative learning in museums on college campuses. The tours foster relationships with faculty across disciplines which support the integration of the museum's resources into their teaching. A range of disciplines have participated in peer-to-peer tours including Art Education student teachers, Computer Applications, Elementary Reading and Writing, Emergent Literacy, Literature, Mechanical Engineering, Technology, and Social Studies. Upcoming tours include an intensive writing class in the Design department, a Social Justice course in Social Work, and a Service Learning class in the Sociology department. The tours help the museum attract new visitors from the campus community and model methods for the use of artwork in the classroom.

In the spring semester, an unlikely connection developed with mechanical engineering students. The graduate students assigned to this tour contacted the professor and subsequently

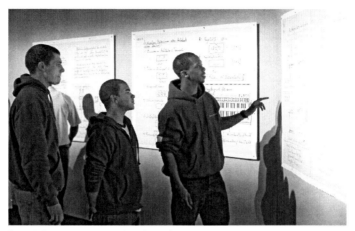

Figure 3: A peer-to-peer tour with mechanical engineering students.

searched for common ground between the art world and fluid mechanics. Students found connections in terms such as *static*, *focus*, *fluid*, as well as in the idea of how things *stand* (Figure 3).

Reflecting after the tour, mechanical engineering students were asked what connections were made between their class and the artwork. A sample of responses follows:

- [I saw] the way still images portray fluid motion.
- Center of gravity and Newton's 3rd Law – objects in motion.
- We were able to see some of the physical laws used in the classroom in action.
- I could see fluid flow in the artwork.
- The turbulent flow of sound in the charcoal artwork.
- I saw one piece that reminded me of a turbulent waterfall.
- All fluids were in static equilibrium.

- Not everything is always so cut and dry like the sciences.
- Saw artwork in a different perspective. There is more commonality between art and my major than I thought.
- We were able to see a visual representation of engineering concepts.

Visiting students and their professors contribute to the learning opportunity by completing a one page peer-to-peer evaluation. They are asked at the end of the tour to share a connection they made between their class and the artwork observed, something that was surprising or would be remembered, and any additional comments for their student guides. The evaluations are shared with the guides after the visiting class leaves for the evening. The immediate feedback is appreciated. The feedback allows the guides to reflect on how they communicated and what the visitor's perceptions were of their peer tour. The guide's conversation sparks debate at times and helps them see both sides of the experience. The guide's assignment is to write a reflection paper on their tour experience including the process; collaborating with their peers, what was learned, and what might they do differently. Both the evaluations and reflections are instrumental to the development of peer-to-peer tours.

Students who participate in peer-to-peer tours experience a connection with their discipline, become comfortable examining artwork, and have an affinity with the museum

wanting to come back on their own. Museum Studies student Confianza Joseph reports:

> In order to understand the group we were dealing with, we had to learn their lingo and understand their passion. Mechanical engineering is the mechanics of the operation of mechanical systems. It uses the laws of physics and applies to different systems to analyze performance...mechanical engineers look at energy – which can be motion, light, electricity, radiation or gravity – to create mechanical systems. Everything is related and one off molecule or particle can throw off a machine. The same can be said for art; if the composition is off, it can throw off the work. Newton's first law of motion relates to this. One student said that if a force changed the composition of the artwork, it would be like a family losing its balance...

In response to the aspiration for the college and museum to find additional common ground for learning, peer-to-peer tours were developed to heighten course content in new ways. Feedback from participating faculty has been overwhelmingly positive and encouraging. James Mayrose, Associate Professor of Technology commented:

> The fluids class I brought over a few semesters back initially wasn't happy with me that I was forcing them to go view art. Once they were there though and learned and experienced what your students put together for them, they really began

to appreciate the experience. When I met with them during the following class, they couldn't stop taking about what a great experience it was. They asked if I would do it in other courses so that is a big reason why I want to bring another class of students.

Faculty and students value the innovative introduction to the museum and the fresh point of view (Figure 4).

Benefits of peer-to-peer tours

Implementing peer learning generates student self-esteem. Guiding a group through a process of investigation and developing skills to succeed in connecting artwork with curriculum is a powerful tool. Graduate student tour guide, Nick Napierala, Art Education writes:

After my first tour, it was announced that there was going to be another peer-to-peer tour experience a completely different feeling came over me... instead of fear and apprehension I felt confident and excited to be able to experience this very beneficial process once again.

Peer-to-peer tours embrace the student voice within an art museum. The experience introduces students to opportunities to learn from their peers and cultivate critical dialogues beyond the classroom. Student guides report that they continue to use their tour experience outside of the museum. As Cassie Lipsitz from Art Education writes in her graduate student guide tour

Figure 4: Student guides Kristen and Carly in conversation with Mechanical Engineering students on a peer-to-peer tour.

reflection, "I still use the skills that I gained from the peer-to-peer experience in my high school classroom." Peer-to-peer tours connect course curriculum, class terminology, and course concepts while benefiting student learning across curricula.

Preparing for the tours

The galleries at the Burchfield Penney Art Center change frequently, which requires the tours to adapt to new exhibitions. Peer-to-peer tours are not scheduled to coincide with a particular exhibition; a professor's motivation to work on course content becomes the focus and tours can be scheduled throughout the academic year. They are developed from educational and artistic perspectives with course concepts connecting with curriculum. Developing a tour

becomes a coordinated effort of selection, editing, and flow. Many works can relate to a variety of topics while others connect distinctly with a particular idea. The group decides and balances what works best for their tour.

It is essential that the group works together designing their tour. Both course curriculum and the artwork selected need to flow throughout the tour with a variety of artworks and techniques that can be used and elaborated on.

After the first conversation we all had a week to mull over our topic and to solidify our concepts and ideas. The following week when our group met we were all there and went over our ideas, and which pieces of art we wanted to cover... it was time to take another look thorough the gallery with the entire group. – Graduate student guide tour reflection, Kari Achatz, Art Education.

"Nervous" is the first comment written in many of the student guide reflection papers:

I started the research. I found several sites that had basic information on mechanical engineering. I had to read these pages several times in order to understand one sentence. As time progressed, it started to click and more works of art started to come to mind. As I took notes, I wrote down possible artworks to be used; my partner had to agree with the connection that I made. If she did not, we would have discarded the idea and looked for a new one." – Graduate student guide tour

reflection, Confianza Joseph, Museum Studies.

"Looking back to my experience giving peer-to-peer tours, the most lasting impression was how much I learned. Preparing the information about the artist and the artwork and knowing that we would be presenting this information to our peers truly helped to internalize that knowledge. The ability to take knowledge in, plan how to explain it to others, and create interactive activities around the information is where the learning is solidified. This synthesis of the material took the learning to a higher level." - Graduate student guide tour reflection, Nick Napierala, Art Education.

What are the learning outcomes?
The student's ability to use artwork to communicate ideas was increased after leading their peers. Guides commented on how a range of ideas was discussed and how one insight could make a difference in understanding the work. Students observed how diverse subjects could be integrated into an art museum while still retaining the integrity of the artwork. When peers viewed a series of paintings depicting an urban landscape, the conversation began to unfold. Blocks of color revealed universal symbols for stores and restaurants. The discussion stimulated comments about how society craves a common visual language to feel safe. Before the group moved on, they again reflected on the artist color choice, the mood set in the painting. Another student reflected how beneficial school collaborations would be when "different disciplines

share a common theme."

The visiting students' concept of art evolved after participating in a peer tour. They gained insight into multiple methods of expressing, "seeing was not enough" and different approaches to viewing art were valid. One student in Elementary Education remarked, "I see a different world behind a work [of art]."

Art is a catalyst for engaging learning and guides demonstrated that seemingly unrelated artworks were connected through ideas. The use of questions encouraged the students to rethink preconceived notions and gain new perspectives. When students are actively involved "the deeper you can get the actual meaning," shared a visiting student in Art Education.

It is not surprising that the student guides feel a revitalization toward their teaching after giving a peer-to-peer tour. The guides feel ownership of their learning process and openness toward their peer's contributions. These qualities combined with their passion to teach art became a central core for learning in the museum.

Through the experience of leading a tour, student guides gained awareness of their classroom teaching. Students commented they were inspired to extend new lessons incorporating art into a general education classes and how a museum visit could transform into several units in their classrooms. They were surprised "how multiple lesson plans could be inspired from a single work of art." The peer-to-peer experience opened up a variety of methods to encourage

Figure 5: Art Education students participating in a peer-to-peer tour.

discussion and to respond to a work of art besides "it's cool" and "I like it."

Reflections from students studying elementary education and reading emphasized connecting course curriculum through artwork. They experienced linking literary elements combined with "making connections with their personal life and world around them." A student reflection highlighted: "when linking ideas in the classroom, museums can become the vehicle for connecting core concepts." (Figure 5)

Incorporating artwork with the English Language Arts curriculum was established using several models. Students experienced peers demonstrating activities to incorporate artwork that were not previously considered. Having an opportunity for students to learn from their peers was expressed consistently in evaluations. Many commented they "liked listening to all of the groups ideas. It really brought two

Figure 6: A visiting student adds to her character persona.

types of education together." The guides were praised for their creative approach to guiding a group and how valuable it was to gain new perspectives from their peers.

Guides designed tours to examine new perspectives for student teachers in Art Education. Influenced by the initial artwork viewed on the tour, students developed a persona contrived from the work. While in character the discussion was lively with the new persona being called upon throughout the tour to answer questions. Speaking from their characters voice enhanced the way artwork was selected and discussed. The character took on personal traits developing a history. "The character narrative made many of us more open to discussion," remarked a visiting student. "I really enjoyed the continuous thread created by our character's perspective." Looking at things that would not have normally been chosen was commonly heard. An Art Education student selected a bruise found on a women's face in a painting as her character.

Throughout the tour the bruise created a narrative that included a vantage point, a theme song and, a secret. At the end of the tour when asked if anything was missing from her story, a peer questioned the bruise persona asking if she was worried about her bruise disappearing? "No," she replied, "it will move on." When students were asked to dance to music it was out of their comfort zone but students felt more relaxed and uninhibited since it was their persona, a bride, a skeleton, a birthday cake moving to the sound. "I will remember my character Nora and how she interacted with art today." (Figure 6)

An unanticipated outcome was that I got to observe my students in an entirely different context. For example, in our last visit I was able to watch my undergraduate students interact and respond to the creative problems the graduate students' posed to them. I had the sincere pleasure of witnessing students' critical thinking processes, which were infused with wit, humor and intelligence. This experience provided me with significant new insights and assessment data regarding my students. – Kate Hartman, Associate Professor and Coordinator of Student Teaching, Art Education

To effect change in student learning, faculty and students need opportunities to view their cultural surroundings in new ways. Peer learning creates a supportive environment that results in the ability to challenge oneself and empower perspectives. Peer-to-peer tours are an inspiration to motivate the campus learning community.

COLLECTIONS STEWARDSHIP

Cravens Collection, University at Buffalo

Achieving Preservation and Access in an Academic Museum

SUZANNE DAVIS
Kelsey Museum of Archaeology
University of Michigan

The story behind the rich archaeological holdings of the University of Michigan's Kelsey Museum of Archaeology is one that many academic collections share. Whether they consist of archaeological artifacts, natural history specimens, or fine art, college and university museum collections exist for the same fundamental reason: they are teaching resources. The Kelsey Museum's collection was begun by Francis W. Kelsey, the museum's namesake, who was a professor of Latin language and literature at the University of Michigan in the late 19th and early 20th centuries. Kelsey was a teacher and scholar during a time when secondary and university level education was developing rapidly in the United States and educational philosophers like Vygotsky[1] and Dewey[2] were formulating new theories of teaching and learning. Kelsey was a passionate teacher and an innovative scholar who made significant contributions to instruction in Latin and classical archaeology. His ground-breaking Latin textbooks included, for the first time, contextual notes on the writings of authors like Caesar. These notes covered history, politics, geography, and archaeology, and provided a framework for understanding the texts.[3] Kelsey acquired archaeological artifacts for the same reason he included supplemental information in his textbooks: to enhance his students' understanding of the ancient classical world. Beginning in the 1920s, Kelsey secured funding to launch a series of archaeological excavations that he hoped would further scholars' knowledge of life in the ancient Mediterranean and Near East and, under international antiquities laws at the time, the University of Michigan

acquired a portion of the excavated material.[4] Today about 70% of the Kelsey Museum's collection comes from these early excavations, and the museum remains faithful to Francis Kelsey's vision of art and artifacts as resources for learning.

Academic museums like the Kelsey are undeniably sources of public enjoyment, and the Kelsey Museum plays an integral role in the cultural life of southeast Michigan. But the overarching pedagogical mission of academic museums means that they function quite differently from their non-academic counterparts. Whereas a non-academic museum may have a study collection, the university or college museum is the study collection, and museums on campuses typically provide a level of access that is unparalleled outside the academic environment. Academic museums provide important training for future scholars in the humanities and sciences and are sites for exploration and inspiration on college campuses, promoting cultural awareness in students from all disciplines. Students working with museum collections can experience a physical connection with other civilizations and cultures, conduct primary research, and learn first-hand about museum careers. Academic museums are able to offer the kind of constructive, individualized learning experiences thought to be most conducive to building knowledge.[5]

Object- and museum-based projects have a powerful ability to engage students with multiple intelligences, different learning styles, and diverse interests.[6] As the benefits of object-based learning become more apparent, colleges and universities are increasingly committed to making their

museum collections more accessible and more relevant to broader teaching and research goals.[7] At the same time, stewardship of collections is as vital for the academic museum as it is for any museum. As evidenced by their mission statements, many academic museums consider preservation to be of primary importance for their institutions.[8] Locking a valuable painting in a dark room with perfect, unchanging temperature and relative humidity improves the learning outcome of exactly no one, yet offering rare, fragile artwork or artifacts to college-age students for close examination can make even the most committed museum educators nervous. The question of how to balance these twin mandates – preservation and access – is a central one for the academic museum, and one that each institution answers differently.

At the Kelsey Museum, which is located on the central campus of the University of Michigan in Ann Arbor, the desire is always to provide more access while not sacrificing collections care. Preservation is vitally important for the Kelsey; many of the artifacts in the collection are from excavation contexts and are not only rare in terms of material and provenance, but are also closely tied to the ongoing research of scholars around the world. One of the best ways that the Kelsey Museum provides broad access while also ensuring preservation is perhaps obvious: exhibition. Exhibition of collections is an important activity in an academic museum and deserves brief consideration as a vehicle for preservation. The permanent exhibitions at the Kelsey were intentionally designed to support the teaching objectives of the museum's

faculty curators. For example, the gallery area devoted to the ancient Greek world showcases not only beautiful examples of painted vases, but also homely and even partial vessels which illustrate the materials, technology, and iconography of ancient Greek ceramics. While on view in the galleries, objects are available for teaching, but are housed securely in a climate-controlled environment and do not have to be handled.

As a complement to the permanent galleries, special exhibitions provide the opportunity to display light-sensitive artifacts. Works of art on paper, photographs, archival materials, textiles, some pigments, and organic objects like baskets are all light-sensitive, and short exhibitions which rotate frequently are a way to display more of these materials. Many museums do this with print galleries, but for some reason the option seems to be less obvious for other types of collections. The Kelsey Museum's three special exhibitions each year take advantage of the short duration to feature artifacts, like textiles and papyri, with light restrictions. Special exhibitions are often planned in tandem with teaching, so that the material on view dovetails with subject matter presented in a semester-long course. Sometimes, as will be discussed later, the special exhibition is the course, with students involved in the process of developing and implementing an exhibition from start to finish.

Exhibitions, whether permanent or changing, can be useful for teaching but, like many academic museums, the Kelsey prides itself on providing special opportunities for experiential learning. Over time the museum has increasingly

provided access in creative ways which minimize the potential for damage to artifacts. These avenues for engagement with the collections will be detailed below, from least to greatest physical access to museum objects. For each, I will examine the benefits for both access and preservation. Although the Kelsey Museum has an active program of community outreach and K-12 education, this chapter focuses primarily on learning at the undergraduate and graduate levels.

One of the most important ways the museum provides collections access to students and scholars is through an online database.[9] Many academic museums now offer this, but the Kelsey Museum's database is special. In addition to the information typically given for museum objects in most collections – description, material, time period, etc. – the Kelsey provides context. To give just a few examples, using the online database researchers can discover at what archaeological site an object was excavated, from what location on site, and during which field season. If the artifact was not excavated, acquisition information is given, as are references to publications in which the object appears. For textiles, weave structure and fiber content is accessible. For coins, descriptions of the obverse, reverse, mint, and authority are provided. For many artifacts, information from the typewritten index card filled out when the object was originally accessioned to the collection is available. Catalogs of the archival and fine art photographs housed in the museum are also provided, many with images. In short, this public, online version of the database makes available worldwide the

same data museum staff members are privileged to have to access to in-house.

While the Kelsey Museum is responsible for providing the content, the accessible version of the museum's database is the product of the University of Michigan's Digital Library Production Service (DLPS). Formed in 1996, DLPS is part of the University Library's Information Technology Division. Its mission is to digitize and host online collections, and to provide leadership in digital library development and best practices for online collections.[10] DLPS began to collaborate with the Kelsey Museum and other non-library collections around the year 2000. Using the Digital Library eXtension Service (DLXS), which was developed and built at the University of Michigan (UM), DLPS is able to host and serve databases from multiple UM collections. For academic museums considering digital collections initiatives, the comprehensive technical expertise to be found in college and university libraries is a resource that should not be overlooked. Libraries are on the leading edge not only for developing technology and best practices for access to digital collections, but also for the preservation of data.[11]

The Kelsey Museum's database, wonderful as it is, has plenty of room for improvement. Some of the terminology used can be confusing for non-archaeologists, and only about 10% of the 100,000+ records contain images. But even with the lack of object images for many records, the database has a substantive effect on both access and preservation. Students and scholars the world over have virtual access to the collection, which facilitates research at all levels. The most

significant benefit for preservation is that the database allows researchers to strategically plan their hands-on work with the collection. Undergraduate, graduate, and faculty scholars frequently undertake collections based research at the Kelsey, making individual appointments with the museum's registrars to view artifacts and archival materials like excavation ledgers and division photographs. The advance work done by visitors using the online database makes it possible for them to quickly locate items of interest without opening cabinet after cabinet, handling hundreds of objects, or sorting through large quantities of fragile documents. Collections managers and conservators can review requested material prior to access and identify and address any problems. The database also allows faculty to streamline teaching with collections. A class instructor can use it to identify and request materials for use in classes, but s/he can also go one step further; the database records can be exported into a format specific to the class and the files can be shared on CTools, the University of Michigan's web-based course and collaboration environment.[12]

Online databases like the Kelsey's have the ability to facilitate both virtual and physical access to collections, but securing the funding and technical support for digitization initiatives can be challenging. The Kelsey has had success with information technology grants available through the museum's home college within the University of Michigan. Specifically, the college of Literature, Science, and the Arts has a program which supports projects that seek to improve teaching and learning in the college through innovative use of information

technology.[13] Academic museums in the United States that wish to implement such projects can, in addition to internal funding, look to organizations like the National Endowment for the Humanities and the Institute of Museum and Library Services for support (IMLS).[14] IMLS has also sponsored a useful guideline for institutions wishing to digitize collections.[15] Collaboration with libraries, as previously noted, can assist with services, expertise, and infrastructure. Many colleges and universities also have schools of library or information science, and faculty and students in these programs can be a resource for academic museum collections as well.

Virtual collections access can be wonderful for facilitating the work of students and scholars with clearly defined goals, but for those who have a more general idea that they would like to see and use collections materials, a research database like the Kelsey's can be a daunting prospect. Enter the museum's class kits. The Kelsey Museum kit concept was developed by Dr. Lauren Talalay, curator of academic outreach for the Kelsey. In the late 1980s, under Dr. Talalay's direction, the museum began to pursue public outreach in a more serious and directed way. The kits were created as part of this program and consisted of thematic object assemblages that visitors could arrange to view as part of a docent-led tour. Different kits featured daily life artifacts from ancient Greece, Rome, and Egypt. One kit focused on objects from the museum's signature excavation, the Graeco-Roman town of Karanis in Egypt. The kits fulfilled two main goals. First, they were a way for visitors to see more of the collection. This was significant since the

museum's gallery space was then limited to three small rooms. Second, they offered a special experience that visitors could not have elsewhere – the opportunity to see objects up close and in person.[16]

Although Dr. Talalay originally intended the kits for the general public and K-12 school groups, they became popular as tools for undergraduate teaching. In the words of Francis Kelsey, they allowed students to reconstruct "the environment of life" in the ancient world.[17] Additional kits were developed for this purpose, kits of Latin inscriptions, Greek symposia objects, and ancient writing implements. The kits were low-tech – collections of objects stored in padded drawers in a cabinet in the museum's seminar room. The benefits for access are no doubt obvious. More objects were available for viewing, the kits allowed students to explore themes not highlighted in permanent exhibitions, and the method of presentation provided an opportunity for close examination. There were no barriers between the artifact and the student. The kits were popular, and classes came back year after year to study them. The kits were also enjoyable for museum staff; they were like mini exhibitions, fun to think about and put together, and docents had a sense of excitement in presenting them.

The kits did, however, present serious preservation challenges. Artifacts for use in the kits were chosen in tandem with the museum's conservator, and their selection was based on both educational impact and structural stability. Docents needed only to transfer the kit, which contained drawers, from a cabinet to a table, but objects moved within the

drawers and large groups of students crowding eagerly around caused anxiety for both docents and instructors. To address these issues, Geoffrey Brown, the Kelsey's conservator in the 1990s, designed a series of specialty Plexiglas mounts for the objects. The artifacts were affixed to the mounts, and docents held the mounts and slowly walked around the room to show the objects to students. This solved the problem of objects knocking against each other in the drawers and kept students from forming excited masses during the visit, but it required more object handling and accidental mechanical damage did occur. Another issue was that in order to be readily accessible, the kits were housed in the museum's seminar room, a room without humidity control in the alternately damp and bone-dry basement of the Kelsey's 1890s building. This caused problems for organic objects subject to dimensional changes with fluctuating humidity as well as for corroded archaeological metals. The museum's conservator regularly reviewed the condition of objects in the kits, and eventually the kits with more environmentally sensitive materials were returned to the climate-controlled storage area and brought out only when required. But this solution caused its own problems: the objects had to be carted up and down three floors of the museum every time they were requested for use.

The most recent incarnation of the kits is the best yet for preservation and has interesting benefits for access. It is a version of open storage and begins with a generous private donation to the museum by Edwin and Mary Meader in 2003. This donation funded a new, state-of-the-art, climate-

controlled building with 20,000 square feet of study, storage, and display space, and it exponentially increased the number of artifacts that could be displayed. As design and programming for the new building began, the Kelsey's conservators and curators were torn on the question of what should happen to the kits. With so much more gallery space, would the kits be necessary? Kit object assemblages, like the daily life artifacts from Karanis, could now occupy their own sections of the permanent galleries. And with a new, climate-controlled building, it seemed wrong to frequently bring artifacts into the museum's classroom or seminar room, which would remain in non-climate-controlled areas of the older building. Yet no one felt good about abandoning the kit concept. The kits were part of what made the museum special, and curators saw new possibilities. Latin inscriptions could be displayed in the new exhibition wing and no longer needed to be shown in a kit, but what about adding new kits? Ancient musical instruments, for example, or toys, or construction materials from ancient Rome. Perhaps the kits could be used to show multiples of the same artifact type, illustrating the ubiquity of some objects, like oil lamps, in the ancient world.

The best of both worlds seemed to be to somehow integrate the kits into the new building. In 2007, the museum applied for and received a National Endowment for the Humanities Conservation and Stabilization Grant. This grant funded, among other things, drawers beneath the exhibition case vitrines. These open storage, or study, drawers became the new home for the class kits. The drawers include an amazing

Figure 1: Angela Commito, a graduate student in the University of Michigan's Interdepartmental Program in Classical Art and Archaeology, works with Kelsey Museum Exhibition Coordinator Scott Meier on the layout for an open storage drawer.

range of materials from ancient sandals to funerary artifacts to archival documents, and new drawer installations continue to be sponsored by interested members of community. The objects are safely housed in climate-controlled space, securely fixed inside the drawers, and are protected from light.

As with the original kits, the drawers allow the presentation and study of themes not highlighted elsewhere in the permanent galleries, and they display many more objects than fit in the exhibition case vitrines. Also like the original kits, installation of the open storage drawers has been comparable to the development of mini-exhibitions, and the process has been an enjoyable one. Both undergraduate and graduate students have been involved in planning drawers and choosing objects for them. In doing so they have conducted research on

artifacts, considered issues of interpretation, and, in working with conservators, curators, registrars, and exhibition designers on these projects, they have learned about museum careers. This type of task-based learning, called workshop learning, is currently thought to be one of the best instruction practices possible.[18] It has been especially rewarding for students because of the real-life, tangible, final product. Unlike the original kits, the drawers are always available and can be viewed by any museum visitor, not only university classes or groups scheduling a docent-led tour. The open storage drawers also offer an experience that the original kits did not – a sense of personal discovery. Visitors are visibly delighted when they first open a drawer, and the drawers are at the perfect height for small children.

The open storage concept can be carried out in multiple ways. At the Kelsey it has closely followed and built upon an established model for presenting the collection in an enriching and educational way, the class kits. It has also been implemented in a way which encourages learning in undergraduate and graduate students. Housing objects in drawers in the permanent exhibition galleries fulfills important preservation goals as well, by providing protection from light, from handling, and from uncontrolled climate. Other academic museums may choose to implement open storage differently while still adding educational value. At the University of Michigan Museum of Art, located across the street from the Kelsey, a beautiful room of floor-to-ceiling glass cases displays a huge variety of objects with minimal labels

and no interpretation. A table with computer terminals located in the center of the room invites visitors to explore these collections on their own. This creates a sense of discovery in a different way from the Kelsey while encouraging and enabling free-choice learning. At the Johns Hopkins Archaeological Museum in Baltimore, Maryland, objects in open storage drawers are displayed exactly as they would appear in true storage, housed in archival storage materials and containers. For Johns Hopkins, the open storage drawers have dramatically increased access to the collection, made teaching with objects easier, and allow the display of fragile artifacts that would otherwise be stored out of sight. The method of display also provides a unique behind-the-scenes visual experience usually reserved for museum personnel and allows visitors a glimpse into the preservation and stewardship of archaeological collections.[19]

Open storage does, however, place a physical barrier between visitors and objects, and the dimensions of the drawers limit the sizes and numbers of objects which can be included. Furthermore, in the case of the Kelsey Museum, there are times when neither the exhibitions nor the study drawers fulfill teaching objectives. For this reason the museum offers customized object-based classes. In practice this process begins with object selection, which is carried out in one of two ways. The first and most frequent is by the museum's faculty curators, who have split appointments; they work both as Kelsey curators and as teaching faculty. These curators know the museum's collections well and can easily select artifacts

to fit class goals. But for faculty without a close association with the museum, object selection would be difficult were it not for the Kelsey's Curator of Academic Outreach. This position, currently held by Dr. Lauren Talalay, is key for the Kelsey, facilitating connections between the museum and faculty and students from a wide variety of departments across the University campus. Working with Dr. Talalay, professors can efficiently and effectively choose collections materials for use in their classes. Dr. Talalay maintains lists of artifacts previously used in classes, and this information is also tracked in the museum's collections database. For a new instructor teaching, for example, a class on funerary rituals in the ancient world, these lists are a simple way to review objects chosen by other faculty for similar courses.

Once object selections have been made, the artifacts are reviewed by the museum's conservators to make sure they are able to withstand both handling and the unpredictable temperature and relative humidity in the museum's older building, where the classroom is located. Before any object is used by a class, conservators create a condition record for it. This consists of both high quality photographs and a detailed written description. In case of damage or loss, this record provides valuable technical information that is typically not contained in other museum records for the object. Kelsey faculty curators are experienced in object handling, but for non-museum employees a collections manager or conservator will conduct a handling session for the instructor prior to the class session. On the day the class meets, a museum employee,

Figure 2: An undergraduate object-based class associated with the 2011 Kelsey Museum special exhibition, Dominated and Demeaned: Representations of the Other.

usually a collections manager, is present during the class to help facilitate and supervise work with the objects.

The benefits of these types of collections-focused classes are numerous and varied. They provide the opportunity for close, extended observation without visual barriers. Students are able to touch and manipulate objects, to feel their weight and appreciate characteristics like surface texture and wear which are often difficult to discern in display settings. In a few rare and special classes, students actually use objects for their original intended purpose, as in the case of ancient stamp and cylinder seals which students impress into soft, polymer-based "clay" to get a sense of how people signed documents in the ancient Near East. Museums in general are good sites for active, individualized learning, but the visceral experience of handling artifacts has the potential to create a sense of wonder

in students. These specialized classes also have the potential to engage students pursuing courses of study not traditionally associated with museums. For example, the Kelsey Museum has hosted classes from the nursing school (drugs and drinking in the ancient world) and from geological sciences (ancient construction materials).

Ensuring preservation for objects used in classes can be challenging, but the method described above does as much as possible to minimize risk. The detailed conservation records created prior to class use also provide an intellectual insurance policy of sorts. In the rare instance that an object is broken or damaged during use, conservators and curators can rely on the condition record when piecing the artifact back together and making decisions about visual and structural compensation of lost areas.

A variation of the objects-based class is the student-led special exhibition, which is perhaps the pinnacle of museum based workshop learning. At the Kelsey Museum, the framework for this is usually a practicum course taught by one of the museum's faculty curators and offered through a sister department, like History of Art or Near Eastern Studies. The curator guides the exhibition concept development and facilitates students' access to the collection and their collaboration with various museum departments. These courses are often taught over two terms, with the first term for developing the exhibition and the second for implementing and installing it. Various professionals at the museum, from the associate director to the administrative staff, participate as

desired to give students a complete education in how museums function and how exhibitions are produced. Students in these classes work with the collection in almost all the ways previously described, but in a focused, teamwork setting. They use the database to find and research objects for display. They create, evaluate, and study object assemblages. They closely examine artifacts in order to write label and didactic text. In the process, they work with each other, with professional curators, and with museum staff such as collections managers, conservators, educators, and exhibition designers. Frequently these classes involve both undergraduate and graduate students, creating valuable opportunities for teaching, learning, and mentoring at a peer level.

In terms of preservation and access, an exhibition developed by students differs significantly from a regular special exhibition in only one regard – staff time and involvement. Class-developed exhibitions involve broad and deep collections access for students and a major time commitment on the part of museum staff. At the Kelsey, this process runs most smoothly when the course goals and expectations are well defined, not only in terms of what is required from students, but also what commitments and contributions will be expected from museum staff. Although special exhibitions are usually scheduled several years in advance, the detailed planning of collection access and staff involvement for student exhibitions may not have taken place on the same timeline. Delineating these requirements and expectations at least one semester in advance of such a class is beneficial.

Of all the types of collections access described here, the requirements for student-led exhibitions are perhaps the most comprehensive. To plan exhibitions, students need access not only a broad range of artifacts, but also to the museum's archives and curatorial files. Photography must be carried out, and objects manipulated extensively by students for research, planning and design. However, such classes represent a unique opportunity for comprehensive education in the museum setting, and, at the Kelsey, most staff members strongly support this kind of learning. Students involved with exhibition projects perform intensive research on individual objects and deepen their engagement with an academic subject area while also learning about the practice of various museum careers. For some exhibitions, teams of students have participated in work in the conservation laboratory, the wood shop, the registry, and the education department as part of the exhibition experience. What better way to inform the next generation about collections care and preservation issues than involving them in the work first hand? In future, some of these students will be able to draw upon this experience as they pursue careers in museums or allied professions. For those who choose a different career path, the experience will inform their thoughts on museums' place in society as custodians of cultural heritage.

Independent student projects with collections materials represent the final type of access which will be discussed here. Individual students with defined research goals do not require the same breadth of access as a class-based project.

Often, however, their work with artifacts and archives is more intensive. At the Kelsey Museum, individual student research spans a wide spectrum, from graduate student publication projects to cross-disciplinary work by undergraduates. The Kelsey Museum headquarters the University of Michigan's Interdepartmental Program in Classical Art and Archaeology (IPCAA), a graduate program in the arts and material cultural of the ancient Mediterranean and Near East. Students in the program complete coursework and doctoral research in fields including art history, archaeology, and classical and Near Eastern studies. IPCAA students work with the museum's collection in a variety of ways. Many write essays on individual objects for publication in the joint bulletin of the Kelsey Museum and the University of Michigan Museum of Art. Others focus their doctoral research on subsets of the museum's collection. For example, graduate Karen Johnson's dissertation examined childhood in the ancient world, including the material culture of childhood as represented in artifacts from Karanis.[20] Andrew Wilburn, another IPCAA graduate, continues to investigate archaeological evidence for magic, again partly through artifacts from Karanis in the Kelsey Museum's collection.[21]

Graduate student involvement with the collection is a natural result of the IPCAA students' home in the museum and their mentoring by the museum's faculty curators. More interesting, and not quite as predictable, is the cross-disciplinary research conducted by undergraduate students. In 2002 Grant Martin, an undergraduate student in the

Figure 3: Undergraduate student Katherine Lazarus with her mold collection, in the James Mycology Laboratory at the University of Michigan.

School of Engineering, worked with the Department of Radiology to perform X-ray computed tomography on a child's mummy in the collection. He then used the CT scan to create a stereolithographic model of the child's skull.[22] In 2004, Geological Sciences student Jesse Ortega conducted scanning electron microscopy with energy dispersive spectroscopy to characterize minerals in stamp seals from

ancient Mesopotamia.[23] That same year, Classical Studies student Rob Stephan participated in the translation of sixteen papyri excavated in the 1920s from the house of Claudius Tiberianus at Karanis, and then organized an exhibition of papyri and artifacts from the Tiberianus house at the Kelsey Museum.[24] Currently Katherine Lazarus, a student in Ecology and Evolutionary Biology, is investigating biological stains and growths on ancient Egyptian limestone funerary stelae in the museum's collection (Figure 3).[25]

These students all worked (or are working, in the case of Ms. Lazarus) with faculty in their home departments as well as with curators and staff at the Kelsey Museum, and the level of collections access required for such projects is obviously quite high: the mummy had to go to the hospital, the stamp seals had to cross campus to the Electron Microbeam Analysis Laboratory, papyri had to be loaned from the Special Collections Library to the Kelsey and exhibited, and samples from the stelae were required for culturing and DNA analysis in the James Mycology Laboratory. The logistics involved in such endeavors are not inconsequential. Yet academic museums like the Kelsey are, at heart, laboratories for learning, and more often than not it is worthwhile to go the extra mile. It is tempting to characterize these examples of undergraduate research in terms of benefit to the students, but in fact the value for the museum may be greater. The CT scan of the mummy was fascinating, revealing, among other things, that the child was polydactyl. The scan and resulting resin model of the child's skull now form an important interpretive

component of the mummy's respectful display. Mr. Ortega's research was able to positively determine that several of the stamp seals were composed of minerals native to Iran, an important finding since the seals were collected by a scholar in the early twentieth century and do not have clear excavation provenance. Mr. Stephan's work resulted in a wonderful exhibition that illuminated the life of an individual family in ancient Egypt (the exhibition was both wonderful and popular, resulting in an interview on National Public Radio).[26] Ms. Lazarus' research promises to inform future conservation treatment and collections care for the stelae.

Students bring enthusiasm, fresh perspective, and technical expertise to researching museum collections, and benefit in turn from the opportunity to apply their knowledge and skills in a meaningful way. Projects like those described here can improve the understanding and interpretation of art and artifacts, and students' work can both highlight preservation concerns and inform conservation decision-making and collections care. Student proposals are not always as compelling as the examples above, but when they are, or when a vague interest can be matched with an appropriate project, the outcome can be highly positive for both the student and the museum.

In conclusion, I hope this chapter has demonstrated a few of the ways in which preservation and access can go hand-in-hand in the academic museum, without sacrificing one for the other. Campus museums like the Kelsey are uncommon in more than one way; they are neither traditional museums nor

traditional teaching units. But their uniqueness is a powerful, if sometimes challenging, gift. The academic museum can teach in ways a traditional department cannot, and it can leverage its collections for learning in ways beyond the capability of most traditional museums. For students, the opportunity to work with and learn from original artifacts and works of art is an exceptional, formative experience. Each academic museum has its own challenges for preservation and access and will answer them differently. The key components for success in this area are a clear definition of the museum's mission and a sustained commitment to best practices in education and collections care. Curators, educators, and conservators in academic museums are called upon to work creatively and collaboratively, together ensuring the safekeeping of our cultural heritage while also opening the doors to collections.

NOTES

1. Lev S. Vygotsky and Vassily Davidov. *Educational Psychology* (Boca Raton, FL: St. Lucie Press, 1997).

2. Douglas J. Simpson. *Teachers, leaders, and schools: essays by John Dewey* (Carbondale, IL: Southern Illinois University Press, 2010).

3. John G. Pedley. *The life and work of Francis Willey Kelsey: Archaeology, Antiquity, and the Arts* (Ann Arbor: University of Michigan Press, 2012), 28-31.

4. Lauren E. Talalay, and Susan E. Alcock. *In the Field: The Archaeological Expeditions of the Kelsey Museum* (Ann Arbor: Kelsey Museum of Archaeology, 2006), 9-10.

5. John H. Falk. "Museums as Institutions for Personal Learning," *Daedalus*, 128 (3) (1999): 259-275.

6. Michael J. Peterson and Mishael M. Hittie. *Inclusive Teaching: the journey towards effective schools for all learners* (Upper Saddle River, NJ: Pearson Education, 2010), 348-389.

7. This subject was the topic of 2011 University of Michigan Provost Seminar on Teaching. To read a brief account of the seminar, visit: http://ur.umich.edu/1112/Nov14_11/2866-provosts-seminar-engages. See also a recent *New York Times* article on this subject: Keith Schneider, "Art Museums Giving It the Old College Try," *New York Times*, March 15, 2012.

8. The mission statements of many academic museums are publicly available on their websites. To see two examples, the mission of the Harvard Art Museums can be found here, http://www.harvardartmuseums.org/about/mission.dot, and the Kelsey Museum's mission can be found here, http://www.lsa.umich.edu/kelsey/collections/collectionspolicies.

9. The Kelsey Museum's online artifact database can be searched or browsed at this address, http://quod.lib.umich.edu/k/kelsey?g=um-ic;page=index

10. The history and mission of DLPS, along with more information about this unit

within the University of Michigan's Library, can be found here:

http://www.lib.umich.edu/digital-library-production-service-dlps/

dlps-history-and-mission

11. For information in this paragraph, I am grateful for personal conversations

with John Weise, Manager, and Roger Espinosa, App Programmer and

Analyst, both of the Digital Library Production Service (DLPS) at the University

of Michigan. The following link contains more information about DLPS,

http://www.lib.umich.edu/digital-library-production-service-dlps, and examples

of projects using the Digital Library eXtension Service software can be found here,

http://www.dlxs.org/about/samples.html.

12. For information in this paragraph and portions of the next, I owe thanks to

Sebastian Encina, Collections Manager at the Kelsey Museum.

13. Examples of instructional technology grants offered through the college of

LSA, including the NINI grant which is referenced in this sentence, can be seen here

http://sitemaker.umich.edu/itc/home.

14. For the National Endowment of the Humanities (NEH), http://www.neh.gov/

whoweare/Divisions.html, look specifically at NEH grant programs suggested

by the Office of Digital Humanities and by the Division of Preservation and

Access. For the Institute of Museum and Library Services (IMLS), visit the site's

home page at http://www.imls.gov/ and browse available grants by type.

IMLS grant programs are undergoing restructuring at the time of this writing.

In the past, however, the National Leadership and Museums for America grant

programs both encompassed digital collections access projects.

15. A guide to building good digital collections (published by the National

Information Standards Organization) is available through the IMLS website as well

as here http://framework.niso.org/.

16. I am indebted to Lauren Talalay, Curator of Academic Outreach and the Associate

Director at the Kelsey Museum, for information in this paragraph and the next.

17. Sharon C. Herbert. "Introduction," in *Portals to Eternity: The Necropolis at Terenouthis in Lower Egypt*. Roger McCleary (Ann Arbor, MI: Kelsey Museum of Archaeology, 1987), v.

18. Peterson and Hittie, *Inclusive Teaching*, 392-393.

19. Sanchita Balachandran, email to the author, March 6, 2012.

20. Karen Johnson, *Materializing Childhood : An Historical Archaeology of Children in Roman Egypt* (PhD diss., University of Michigan, 2006).

21. Andrew Wilburn, *Materia Magica: The Archaeology of Magic in Roman Egypt, Cyprus, and Spain* (Ann Arbor: University of Michigan Press, forthcoming).

22. Grant Martin, "Undergraduate Engineering Student Now Analyzing Results of Mummy CT Scan," *Kelsey Museum Newsletter* (Spring 2002).

23. Margaret Cool Root, "Jane Ford Adams's "Buttons" from Ancient Iran: Exhibition Diaries," *Kelsey Museum Newsletter* (Fall 2004).

24. Rob Stephan. "Undergraduate Rob Stephan Digs Up a Story," *Kelsey Museum Newsletter* (Fall 2004).

25. Katherine Lazarus's work has not yet been featured in any Kelsey Museum publication. She is working with Dr. Timothy James in Ecology and Evolutionary Biology, and with Dr. Terry Wilfong and Caroline Roberts at the Kelsey Museum.

26. Steve Inskeep's interview with Rob Stephan can be heard here, http://www.npr.org/templates/story/story.php?storyId=1677960.

Bibliography

Cool Root, Margaret. "Jane Ford Adams's "Buttons" from Ancient Iran: Exhibition Diaries." *Kelsey Museum Newsletter* (Fall 2004).

Falk, John H. "Museums as Institutions for Personal Learning," *Daedalus*, 128 (3) (1999): 259-275.

Herbert, Sharon C. "Introduction." In *Portals to Eternity: The Necropolis at Terenouthis in Lower Egypt*, Roger McCleary, v. Ann Arbor, MI: Kelsey Museum of Archaeology, 1987.

Johnson, Karen. *Materializing Childhood: An Historical Archaeology of Children in Roman Egypt*. PhD diss., University of Michigan, 2006.

Martin, Grant. "Undergraduate Engineering Student Now Analyzing Results of Mummy CT Scan." *Kelsey Museum Newsletter* (Spring 2002).

Pedley, John G. *The life and work of Francis Willey Kelsey: Archaeology, Antiquity, and the Arts*. Ann Arbor: University of Michigan Press, 2012.

Peterson, J. Michael, and Mishael Marie Hittie. *Inclusive Teaching: The Journey Towards Effective School for All Learners*. 2nd ed. Upper Saddle River, NJ: Pearson, 2010.

Simpson, Douglas J. *Teachers, leaders, and schools: essays by John Dewey*. Carbondale, IL: Southern Illinois University Press, 2010.

Stephan, Rob. "Undergraduate Rob Stephan Digs Up a Story." *Kelsey Museum Newsletter* (Fall 2004).

Talalay, Lauren E., and Susan E. Alcock. *In the Field: The Archaeological Expeditions of the Kelsey Museum*. Ann Arbor:

Kelsey Museum of Archaeology, 2006.

Vygotsky, Lev S. and Vassily Davidov. *Educational Psychology*. Boca Raton, FL: St. Lucie Press, 1997.

Wilburn, Andrew. *Materia Magica: The Archaeology of Magic in Roman Egypt, Cyprus, and Spain*. Ann Arbor: University of Michigan Press, forthcoming.

University Museums in the Digital Age: The Cravens World Open Storage Teaching Collection

PETER F BIEHL & LAURA HARRISON
University at Buffalo

Museums have undergone significant organizational changes in the past thirty years, in response to discontent with the elitist underpinnings of the traditional practices of collecting, exhibition and research.[1] Referred to broadly as the New Museology, this approach stresses that museums are not only repositories for collections or centers for specialist research, but transformative spaces of social action that play an active role in educating the public.[2] Museums today are more focused than ever before on their responsibility to local audiences, and many institutions strive to balance community outreach with broader campaigns aimed at reaching national and international audiences.[3] Museum professionals are encouraged to introduce pluralistic accounts into their exhibitions and to foster ongoing, exploratory dialogues about objects, in an effort to deconstruct the elite ontologies upon which traditional museum exhibits are built.[4]

Recent attempts to articulate the role of museums in knowledge production promote a shift in focus from identification and classification towards education.[5] Museums are devoting resources to producing fluid ontologies, flexible knowledge structures capable of adapting to changing interests.[6] Fluid ontologies incorporate diverse forms of expertise; multiple, competing, expert accounts; and alternative forms of documentation.[7] There is also a growing realization that museums can generate new forms of knowledge based on collaboration with various stakeholders.[8] They can become places of interaction between multiple publics and objects as well as contact zones that foster divergent and

incommensurable accounts of exhibitions,[9] which the voices of different communities articulate and collect.[10] The creation of fluid ontologies in museums is made possible through the use of digital technologies,[11] which are inclusive, adaptable and accessible in ways that many traditional museum exhibits are not. The introduction of digital technologies and virtual museums are critical steps in the development of new ways of thinking about museums, and structure visitor experiences on a personal, rather than a normative scale.

The diverse goals of the New Museology have led to a fundamental reorganization of museum practices in recent decades and require that we rethink the mission of the 21st century museum. This reassessment should be structured around the central question of whether the objectives of collection, documentation, and research that lie at the very core of traditional museum management are still valid, socially relevant, and ethically responsible for museums today. The case study of the Cravens Collection at the University at Buffalo demonstrates that, despite a recent downturn in collecting due to high profile scandals involving the acquisition and display of illicit antiquities, if museums adhere to new managerial and curatorial guidelines, they can continue to build their collections, reach out to new audiences, and focus on developing engaging, diverse, and cutting-edge exhibitions and educational programs.

The Cravens Collection

The Cravens Collection is an archaeological and ethnographic

collection of over 1,100 objects brought together by Annette Cravens, over the course of 65 years as a world traveler and avid collector of antiquities. The University at Buffalo acquired this private collection, which spans 6,000 years of human history and contains artifacts from every continent, in 2009. Faculty members from a range of departments were immediately drawn to the collection because of its unique pedagogical value, as a rich material record of world prehistory. They worked to transform the private collection into a robust educational tool, developing plans for a new exhibition space on campus, conducting research on the provenance and cultural significance of the objects, and constructing new educational modules framed around a core of hands-on work with artifacts in the collection. Much of this work is theoretically grounded in ideas from the New Museology. A central goal is to use the Cravens Collection as an educational instrument, in which the objects on display are appreciated not only for their intrinsic value and aesthetic beauty, but also as the nexus for collaborative encounters with various public audiences, as well as an educational resource for K-12 schools, and for university students pursuing degrees in arts management, anthropology, archaeology, classics, economics, education, history, law, psychology, and visual studies.

In order to fulfill the objective of transforming the Cravens Collection into a world-class museum display, the Cravens World permanent exhibition was constructed under the direction of Peter Biehl at the University at Buffalo. Inspired by Annette Cravens' global travels, Mehrdad Hadighi of the UB

Figure 1: The Cravens World exhibition. [Photo: Laura Harrison]

School of Architecture conceived of a truly innovative design: a transparent globe with tiered display boxes that appears to hang from the ceiling of the gallery, bathed in simulated natural-sunlight, and surrounded with floor-to-ceiling open storage cabinets around the perimeter (Figure 1). Artifacts in the globe are displayed in transparent acrylic boxes and seem to float in space. They are never seen alone, and are always viewed within the context of other, neighboring objects, facilitating a seamless transition from object to object without borders or bias.[12] Artifacts are visible from an infinite number of perspectives, since all display cases are completely clear and it is possible to walk inside the center of the globe and become surrounded by objects in all directions. The entire experience of viewing the Cravens World exhibit is infinitely variable, fluid and dynamic.

Artifacts were arranged in the globe display by guest curator Sarah Scott, according to six thematic categories: storage vessels; masking tradition; the human figure; ritual, status and prestige; and personal adornment (Figure 2). This design allows for multiple pathways towards knowledge rather than a singular dominant narrative.[13] Within each curated theme, adjacent objects "speak" to each other in an infinite number of aesthetic, functional and cultural ways that crosscut geographical and temporal boundaries. The Cravens World can be considered the physical actualization of a fluid ontology; each visitor has a unique experience by charting his or her own personal course through the exhibit. Each visitor makes unique connections between artifacts,

Figure 2: Floor Plan of Cravens World Exhibit showing the central globe display and open storage cabinets around the perimeter.

acquiring an individualized body of knowledge about objects in the collection and simultaneously gaining a personalized knowledge of the global human past.

The Cravens World exhibit uses fluid digital technologies to convey information, rather than using inflexible, static text labels and curatorial narratives for each object (Figure 3). This allows visitors to first experience the artifacts on a purely aesthetic level, before they dig deeper into the cultural significance of particular objects by interacting with a touchscreen monitor that offers information about the cultures, countries, people and artists who created each object.[14] There is no predetermined pathway or directional progression that visitors must follow, and the exhibit expresses no single dominant narrative.[15] Rather, the integration of digital technologies into the exhibit allows visitors to explore exactly what interests them, rather than being forced to adhere to a classificatory scheme or singular curatorial message. The integration of digital media emphasizes individuality, creativity, and alternative forms of knowledge production, opening up the

Figure 3: The interactive touch-screen monitor in the Cravens World Exhibit. [Photo: Laura Harrison]

possibility for visitors to construct personalized fluid ontologies. The objects not housed in the globe are kept in open storage cabinets and drawers, located around the perimeter of the gallery and arranged by geographical region, then categorized according to medium (Figure 4). Here they are accessible to individuals pursuing specific research questions and interested in experiencing the great diversity of objects in the collection. Upper cabinets are locked and contain objects awaiting further research by students and specialists. By housing the entire collection within a single combined exhibition/storage space, the Cravens World exhibit is both a rich and accessible resource for students, scholars, and the general public.

The Cravens Collection is an educational collection. Learning opportunities are limitless due to the extensive depth and breadth of artifacts from around the world, that span thousands of years. Educators from area K-12 schools

Figure 4: Open storage cabinets organize objects in the collection by geographical region and artifact medium. [Photo: Laura Harrison]

and institutions of higher education visit the Cravens World exhibit on a regular basis; to conduct scholarly research, learn about past people, cultures, and places, and study museum management and curatorship. Sarah Robert, of the UB Graduate School of Education, developed the K-12 field trip curricula for the Cravens Collection in order to meet New

York State learning goals for elementary, middle and high school social studies.[16] The field trips are designed to produce meaningful, hands-on, and collaborative learning experiences for students of all ages, offering an innovative way to introduce past and present material culture from around the globe into existing social studies curricula.

University museums and acquisitions

The recent acquisition of the Cravens Collection by the University at Buffalo is in contrast to a recent downturn in museum acquisitions, which has occurred in response to a series of high profile scandals revolving around the collection and display of illegally acquired and unprovenanced artifacts.[17] At the J. Paul Getty Museum, a multimillion-dollar spending spree in the 1970s and 1980s led by curator Marion True was aimed at building a world class-collection of Classical art. This culminated in the purchase of a towering 5th century B.C. statue of a female goddess, for $18 million.[18] When Italian courts found that the statue lacked provenance, True was accused of trafficking in illegal art, becoming the first American curator to face such an allegation.[19] True's indictment forced collectors and curators to acknowledge that provenance provided by dealers could not simply be accepted at face value.[20] After the Getty scandal, a number of similar cases were brought against leading institutions, including the Metropolitan Museum of Art, the Boston Museum of Fine Arts, the Cleveland Museum of Art and the Princeton University Art Museum, resulting in a wave of repatriation of high-profile looted objects, the

adoption of anti-collecting stances in many museums and institutions, and the closing of some museums altogether.[21]

The acquisition policy of most museums today stresses the importance of only accepting new artifacts into the collection if they are accompanied by a full, reliable provenance.[22] Many antiquities lack this documentation, and recent scandals involving the acquisition of suspicious artifacts have alerted museum professionals to the dangers of acquiring anything but the most securely documented antiquities.[23] Yet even if museums oppose the acquisition of unprovenanced artifacts, the market for these looted antiquities does not dry up. Looting and trade in illicit antiquities continues, and private collectors continue to seek out rare, ancient artifacts and pay top dollar for them.

Private collectors of antiquities are aware of something that museum professionals are quickly losing sight of: that the desire to collect objects we find meaningful, beautiful, and desirable is part of our shared human culture, and therefore that it is not likely to diminish at any point in the foreseeable future. Archaeologists know that humans have been collecting objects for hundreds of thousands of years. Collecting is documented in innumerable societies worldwide, and is considered to be a universal aspect of human culture.[24] Is it reasonable for museum professionals to take an explicit stance against collecting, when the act of collecting objects from the world around us lies at the very heart of human identity and culture today, as it has for thousands of years?

This chapter proposes that university museums are in a

unique position to continue collecting because they possess the academic infrastructure to fully research the provenance of acquired objects, can take steps to repatriate any looted artifacts that may turn up during the research process, and can transform their collections into innovative, interdisciplinary, hands-on teaching resources. In accepting the donation of private collections, it may become apparent that some objects lack a sound provenance. Rather than shield this information from the public, ignoring and avoiding the problem of looting, university museums can research and repatriate these objects within a framework of academic transparency. These collections can be used to teach students about the ethical responsibilities of museum professionals to repatriate stolen objects. Hence, the university museum can begin to combat the problem of looting in a tangible way, by taking steps to educate the next generation of museum professionals about their ethical responsibility to research and return illegally acquired objects.

Both academic museums and the public benefit from the acquisition of private collections, because it liberates the objects from the restricted zone of the collector's house to the public domain where it can be enjoyed by broad new audiences and fulfill a number of new functions. Consider the alternative: if an academic museum chose not to accept the donation of a private collection out of fear that part of it may lack provenance, then all the collection, including legally acquired artifacts, would remain shrouded from public view. Consequently, the collector may decide to sell off their

collection to an antiquities dealer, another private buyer, or leave it to children or relatives with little concern for the accessibility of the collection. The collection will disperse back on to the market, and little new information will ever be generated about its provenance or cultural significance. These objects will remain in the domain of wealthy elite collectors, and be wholly inaccessible to the general public.

The Cravens collection at the University at Buffalo was acquired according to principles of transparency and with the stated goal of researching all objects and acting appropriately in any cases where objects were found to have inadequate provenance. The Cravens World exhibition displays only those objects found to have adequate provenance according to the highest ethical standards of museum practice. In the upper cabinets of the open storage cabinets, objects awaiting further research are studied before they will be acquired by the Anderson Gallery. An undergraduate and graduate level course in Museum Management spends a semester each year researching and studying these questionable objects, finding out about their cultural origin and significance, as well as researching their provenance and applicable legal guidelines. In cases where objects are found to lack full provenance, actions are taken to repatriate these objects. The course ultimately offers students an opportunity to learn the basics of museum management through engaging in collections management, exhibition design, and curation, while also introducing them to pertinent legal concerns. By using the academic framework already in place at the university, the

Cravens Collection is well researched and accessible to both the scholarly community and general audiences. This represents a positive step away from the alternative of the collection being hidden away in the house of the donor visible to only a select group of individuals, or redisposed on the antiquities market. This model of university museum as research institution can be employed in a range of other museums.

New guidelines for university museums
The management strategy employed by the University at Buffalo with the Cravens Collection is applicable to a wide array of other museums and institutions. These strategies and policies for assessment, research, recording and preservation, repatriation, exhibition and education are summarized below in the hope that they may become useful benchmarks for other museums and institutions.

University museums are practical manifestations of the spirit of scientific inquiry and academic curiosity.[25] Starting in the spring 2011 semester, courses on Museum Management and Ethics, Law and Cultural Property began studying the collection. Students learn about identification, classification and preservation as well as about their own culturally-bound responses to artifacts. Similar courses will follow over the next three years. During these courses, students are producing 3D scans of the objects they study.

The fluidity of digital technologies makes them an ideal medium to introduce visitors to the relationships between museum objects as well as to the cultural questions regarding

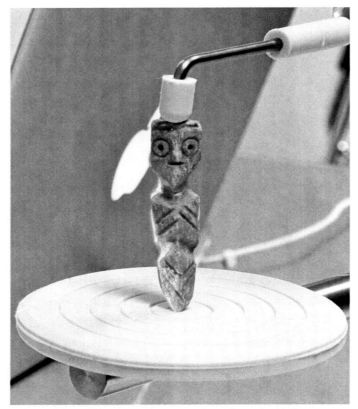

Figure 5: NextEngine 3D scanner documenting a Near Eastern figurine from the Cravens Collection. [Photo: Laura Harrison]

these technologies allows museums to connect with a new generation of potential visitors, and allows them to transform the experience of these visitors in innovative, cutting-edge ways. In addition to enhancing the visitor experience and broadening accessibility through the web, digital technologies can be used to record visual data about objects in the

collection. The Cravens Collection uses a NextEngine portable 3D scanner to create high-resolution scans of objects to be used for scientific research as well as in digital interfaces within exhibitions (Figure 5). These scans are used in exhibitions in the gallery and uploaded to the web. Digital technologies and the internet offer numerous ways for museums to reach remote visitors, address multiple communities, and offer a diverse and personalized museum experience.[26]

Following the opening of Cravens World in March 2010, class trips from Western New York schools began visiting as part of the collection's outreach program. The outreach program has developed a network of public school teachers who have participated in building the collection's education program in support of social studies curriculum. This existing network will prove to be an invaluable resource for focus groups and game testing as our project moves forward.

The university museum in the digital age

The guidelines outlined above demonstrate that the university museum can be an innovative educational instrument if new guidelines regarding assessment, research, recording, exhibition and education are adopted. The use of digital media is key for helping museums overcome singular expert accounts and reach multiple, diverse audiences. These digital technologies enhance the visitor experience on a personal level, by providing visitors with choice in pursuing individual interests, and encouraging collaborative encounters with the collection by fostering interactivity among visitors. By taking

steps to transform the museum experience into a more social activity, visiting a museum becomes a unique shared, cultural experience with educational value.

Numerous well-established museums are starting to experiment with the social web, the distributed, open-source, grassroots movement of internet users who are creating, modifying, and subverting online resources to an unprecedented degree.[27] When applied to the museum context, social computing technologies have the potential to address the shortfalls of the static curatorial narratives constructed around fixed object descriptions and classificatory and/or interpretive exhibitions. What is still unclear about their implementation in museums is whether these efforts reach a satisfactory balance between education and entertainment. We hypothesize that the extent to which current digital media is a positive contribution to the museum depends on the extent to which they foster active participation, interactivity, and engagement with the museum collection.

Our work with digital technologies in the Cravens Collection calls attention to the necessity for a critical analysis of how they contribute to visitor interaction and learning. We believe digital media provide a context for users to explore the power of appropriation and re-use of digital objects, but this must be extended to consider the ability to contextualize and engage with both the digital and real object. This goal is met in our project with an interactive touch-based website which blurs the line between the physical exhibition of a cultural object, and its virtual display. The website was built with

aesthetic appeal and accessibility in mind, designed to both entertain and inform viewers. It focuses on hyperlinking a single object with a location, video interview, photographed image, the donor's digitized travel diary and a blog that allows users to tag objects. This virtual component of the exhibit re-contextualizes objects, shifting them into a different ontological framework by introducing a multivocal approach to researching artifacts and cultural heritage that involves multiple narratives, conversations, and interpretations.

NOTES

1 Vergo, Peter. 1989. *The New Museology*. Ed. Peter Vergo. London: Reaktion Books.

2 Boast, Robin, and Peter F Biehl. Archaeological Knowledge Production and Dissemination in the Digital Age. In *Archaeology 2.0*, 119-155.

3 Weil, Stephen E. 2012. "American Museum From Being about Something to Being for Somebody : The Ongoing Transformation of the American Museum." *Museum* 128 (3): 229-258.

4 Gaither, Edmund Barry. 2004. "Hey! That's Mine!": Thoughts on Pluralism and American Museums. In *Reinventing the Museum: historical and contemporary perspectives on the paradigm shift*. Edited by Gail Anderson. AltaMira Press, 110-117.

5 Boast, Robin, and Peter F Biehl. Archaeological Knowledge Production and Dissemination in the Digital Age. In *Archaeology 2.0*, 119-155.

6 Srinivasan, Ramesh, and Jeffrey Huang. 2005. "Fluid ontologies for digital museums." *International Journal on Digital Libraries* 5 (3) (February 2): 193-204. doi:10.1007/s00799-004-0105-9. http://www.springerlink.com/index/10.1007/s00799-004-0105-9.

7 Srinivasan, Ramesh, and Jeffrey Huang. 2005. "Fluid ontologies for digital museums." International Journal on Digital Libraries 5 (3) (February 2): 193-204. http://www.springerlink.com/index/10.1007/s00799-004-0105-9.

8 Nicholas, George P., Welch, John R., Yellowhorn, Eldon C. 2008. Collaborative Encounters. In *Collaboration in Archaeological Practice: Engaging Descendant Communities*, ed. Chip Colwell-Chanthaphonh and T.J. Ferguson, 273-298. AltaMira Press.

9 Boast, Robin, and Peter F Biehl. Archaeological Knowledge Production and Dissemination in the Digital Age. In *Archaeology 2.0*, 119-155.

10 Peers, Laura, and Alison K. Brown. 2003. *Museums and source communities: a Routledge reader*. London: Routledge.

11 Schweibenz, Werner. 1998. "The 'Virtual Museum ' 1 : New Perspectives
 For Museums to Present Objects and Information Using the Internet as a
 Knowledge Base and Communication System." *Knowledge Management*
 (November): 185-199.

12 Biehl, Peter F., ed. 2010. *Cravens World: The Human Aesthetic*. New York. University at
 Buffalo Art Galleries.

13 Scott, Sarah. 2010. "Curatorial Essay"." In *Cravens World: The Human Aesthetic*.
 New York. Edited by Peter F. Biehl. University at Buffalo Art Galleries, 15-26.

14 Biehl, Peter F., ed. 2010. *Cravens World: The Human Aesthetic*. New York. University
 at Buffalo Art Galleries.

15 Hadighi, Mehrdad. 2010. *Cravens World: The Human Aesthetic*. New York.
 Edited by Peter F. Biehl. University at Buffalo Art Galleries, 35-37.

16 Robert, Sarah. 2010. "Cravin' the Cravens: The Outreach Program." In *Cravens World:
 The Human Aesthetic*. Edited by Peter F. Biehl. University at Buffalo Art
 Galleries, 39-44.

17 Gill, David, and Christopher Chippendale. 2007. "From Malibu to Rome:
 Further Reflections on Returning Antiquities," *International Journal of
 Cultural Property*. 14(2): 205-240.

18 Elisabetta Povoledo, Antiquities Trial Fixes on Collectors' Role, *New York Times*,
 June 9, 2007,

19 Frammolino, Ralph. 2011. "The Goddess Goes Home." Smithsonian.com.

20 Frammolino, Ralph. 2011. "The Goddess Goes Home." Smithsonian.com.

21 Gill, David W. J. 2010. "Looting Matters for Classical Antiquities: Contemporary
 Issues in Archaeological Ethics." *Present Pasts* 1 (January 8): 77-104.
 doi:10.5334/pp.14. http://presentpasts.info/index.php/pp/article/view/29.

22 Museums, American Association of. 2000. *Code of Ethics for Museums*. Ethics;
 International Council of Museums. 2006. "ICOM Code of Ethics."

23 Myren, Robin Short. 2010. Provenance Factors for Antiquities Acquisitions.

In *SCA Proceedings*, 24:1-13.

24 Elsner, John and Roger Cardinal. 1994. *The Cultures of Collecting*.
Reaktion Books Ltd, London.

25 Warhurst, Alan. 1992. "University Museums." In *Manual of Curatorship: A Guide
to Museum Practice*. 2nd edition. Edited by John M.A. Thompson.
Butterworth Heinemann Ltd, Oxford.

26 Galani, Areti and Matthew Chalmers. 2010. "Empowering the Remote Visitor."
In *Museums in a Digital Age*, edited by Ross Parry. Leicester Readers in
Museum Studies, Routledge, New York, 159-169.

27 O'Reilly, Tim 2005, *What is Web 2.0: Design patterns and business models for
the next generation of software*. Tim O'Reilly [blog], September 30.
http://www.oreillynet.com/pub/a/oreilly/ tim/news/2005/09/30/what-is-web-20.html
(accessed November 27, 2007).
O'Reilly, Tim 2006, *Web 2.0 compact definition: Trying again*. O' Reilly. Radar [blog],
December 10. http://radar.oreilly.com/ archives/2006/12/web 20 compact.html
(accessed November 27, 2007).

Acknowledgments

The Cravens Project has been made possible by the College of Arts and Sciences with generous support from Annette Cravens and Bruce McCombe, Dean, College of Arts and Sciences and UB Distinguished Professor. The Project Director, Peter Biehl, would also like to thank the Project Guest Curator: Sarah Scott, Wagner College, the Cravens World design team under the direction of Mehrdad Hadighi, Studio for Architecture, with Christopher Romano and Jose Chang, and the Cravens Project Faculty Committee: Stephen L. Dyson, Suzanne Gale, Deb McKinzie, R. Nils Olsen Sandra H. Olsen, the late Samuel M. Paley, Douglas Perelli, Sarah Robert, Robert Scalise, and Phillips Stevens, Jr., and the specialists. The Cravens World website and touchscreen was created on the occasion of the opening of Cravens World by Aleksander Ogadzhanov in his project in Peter Biehl's Anthropology Course Archaeology in the Digital Age. We would like to thank Kathryn Whalen, Department of Anthropology, for editing the video clips with the support of Michael Frisch, Department of American Studies and The Randforce Associates, LLC, Oral History and Multimedia Documentary. We would also like to thank the external specialists Susan Beningson and Gordon McEwan.

The Good, the Bad, and the Ugly: An Exercise in Curatorial Practice

LOUISE LINCOLN
DePaul Art Museum, Chicago

In the admittedly narrow world of museums, deaccessioning is understood as a natural corollary to acquisitions: a normal and necessary, if infrequent, part of building and shaping a collection. For those outside the museum world, however, the process is suspect (even the term itself seems confected and pretentious), in large measure because it tends to come to public notice only when something goes awry. And much has gone awry in recent years, particularly after 2008, when American institutions feeling pressure in the wake of economic downturn saw deaccessioning as a potential source of revenue. A steady stream of examples hit the headlines, each raising a different troubling issue and almost without exception treated critically in the media. Among the most discussed examples, the National Academy put two important nineteenth-century paintings on the market; Brandeis University attempted to shutter its Rose Museum of Art and sell its collection; the University of Iowa encountered legislative pressure to sell a Jackson Pollock mural to pay for flood damage; and Fisk University petitioned to sell half ownership of its Stieglitz collection material to the Crystal Bridges Museum.[1]

In short, it was hardly an ideal time to undertake a deaccession project, even for a small university museum, but at the DePaul Art Museum we were confronted with insufficient storage, an imminent move to a new building, and a standing collection of decidedly mixed quality. De-accessioning was a virtual necessity, and because the practice intersects so many important yet elusive issues, among them donor relations and institutional history, in addition to "quality" and "taste,"

we chose as a teaching museum to reject the usual strategy of discretion (so often read as furtiveness) and instead to make our actions straightforward, visible, and accountable – in fact, to develop what was and may still be the first and only exhibition on the process. We took inspiration from the example of the Indianapolis Museum of Art, which has managed the process with admirable transparency, publishing every deaccessioned object and its method of disposal on their website.[2] The resulting mass of unarguably minor objects makes a compelling case for the practice.

For DePaul, the process would not only free space on our storage racks, but would also help transform the nature, quality, and appropriateness of the collection, reshaping it into a broad but focused teaching resource for a large (24,000 students) urban university, ambitious and wide-ranging in its disciplinary offerings and through a presidential initiative newly attentive to the arts. Like many colleges and universities DePaul acquired an art collection without a conscious plan, as bequests and other gifts accumulated to a point of critical mass. The bulk of the collection, formed in the 1970s, came through a project of the Women's Board, a now-defunct "auxiliary" of the kind many American institutions built in the past, largely populated by alumnae and wives of members of the (all male) boards of trustees. The DePaul's Women's Board directed their energy towards amenities for students, and among other programs hoped to surround them with original works of art. Members solicited their friends for donations that could then be placed in public spaces of university buildings,

especially dormitories.[3] This source – well-to-do Chicago Catholic families – and the benevolent but unstructured intended use (student comfort and enjoyment) meant that the several hundred works donated were overwhelmingly decorative, domestic in scale and intent, and conservative in taste. Indeed, one may imagine that many of the works had passed out of fashion and the opportunity for donation allowed them to be replaced in their former homes by more adventurous selections. The quality of the works ranged widely, as did their potential use for teaching purposes.

Our first survey for deaccession candidates was not difficult: we focused on paintings and identified several categories of unsuitable works: reproductions, tourist-quality streetscapes (mostly of Paris), mass-produced landscapes, and works in poor condition, generating a list of about one hundred items. Following a fairly standard deaccession policy modeled on the templates from the American Association of Museum Directors and other sources, we reviewed records, initiated a search for donors or their heirs, and consulted with the university's Offices of General Counsel and Advancement. Having determined that none of the donors of works was an active contributor, Advancement manifested surprisingly little interest in the project. In retrospect, this reflects in part the museum's position as a small unit in a very big institution, as well as the several dormant decades in which art was not actively solicited; it is probably also related to a larger shift in the university's character and identity: radical changes in scale, academic ambition, and recruiting practices over the past

several decades mean that the donor base is entirely different: less localized or (literally) parochial, more geographically widespread, more diverse.

This lack of friction in the university political arena certainly made it easier to contemplate deaccessioning as a public process: not just a website, but even as the subject of an exhibition. When we looked for other examples it quickly became apparent that as an exhibition topic deaccessioning was largely unexplored. We chose thirty works from the deaccession list, candidates for a variety of reasons: everything from a faded New York Graphic Society poster reproduction of a Cézanne painting (and originally catalogued as a "painting" in the museum's records) to an over-scaled image of the Morton Salt girl, probably a student work.

The conceptual framework for the show was initially built on recruiting three faculty members: an anthropologist, a contemporary art historian, and a philosopher specializing in aesthetics. We expected to elicit critical reactions to pieces and build the exhibition in part on differences in their disciplinary approaches to the works. Probably the proposed structure was too neat for such an unruly topic: their responses were in fact too similar (their common first response to the works was laughter) and they readily poached each others' territory. The anthropologist critiqued the "atypical" placement of the horizon line on a German landscape, while the art historian talked about gender roles in American suburbs of the 1950s in relation to a paint-by-numbers fishing scene. When pressed, they all speculated about artistic influences and focused

on details of perceived incompetence in composition or technique; all invoked the term *kitsch*. But in the end their comments were descriptive ("awful"), not analytic, and revealed little about disciplinary perspectives.

In the meantime, the obligatory object research opened a string of understudied topics, some potentially interesting enough to threaten to hijack the deaccession project. Three works, all anodyne landscapes, exemplified the role of department stores in marketing works of art;[4] one artist specialized in paintings used for greeting cards, another in jigsaw puzzle images. In most art museums, works of this type seldom cross the threshold, yet as their donor history suggests they are a significant and formative part of many peoples' aesthetic experience, and to dismiss them out of hand is to ignore the nature of that experience and appeal. On the wall in a museum setting, they begged serious consideration of issues of quality and taste even as they were manifestly out-of-place, and we debated a focus on the distinction between "good" and "bad" and how those relate to issues of currency in the art market, place, and social class, for example. In the end we retained our focus on the deaccession process, while nodding in text labels to other issues.

Our initial goal of explaining deaccessioning and providing convincing examples in defense of the practice was potentially in tension with acknowledging the generosity of past donors. Furthermore, setting the tone and attitude of the show posed a quandary: it was tempting to adopt the stance of our faculty consultants – to emphasize poor

quality, in some cases remarkable artistic incompetence, so that the deaccessioning process would not be questioned; but with or without donors present, we did not want to be unappreciative of their generosity, not only because it seems ungracious, but also in practical terms because such an approach might understandably cause present-day potential donors to think twice. Again the strategy we deployed was to be straightforward about the nature of the Women's Board project, to express gratitude, and make a distinction between decorative works and those suitable for teaching.

We hoped also that describing the decorative domestic setting that was the intended use for most of the objects further protected them; we rendered this explicit in a wall text entitled *Context is everything*. To demonstrate, we surrounded two of the most striking examples with appropriate domestic settings: a modernist chair and lamp for a round resin abstraction, and an exoticized bar and stools (complete with leopard-patterned cushions) to set a sultry *décolleté* portrait of *La Trini* in proper context. In the didactic texts we attempted to walk a fine line of straight expository prose and slight tongue in cheek, knowing that without the latter it would be easy to sound humorless and over-intellectualizing. Thus we described *La Trini* as "a tame pleasure to male audiences and a nod to Goya's naked Maya and nineteenth-century European orientalist painting... that has not transcended its intended context of a bar or restaurant catering to men."

For better or worse we could not stay away from the cheeky title *The Good, the Bad, and the Ugly* – it seemed to encapsulate

the issue of quality while, in theory at least, allowing any individual work the possibility of being seen as good rather than bad or ugly. But thinking about both the difficulty in defining these terms (how to talk about a distinction between bad and ugly, for example) led us to the idea that ultimately was the hook, if not the interpretive strategy of the project: that visitors could assign the works in the exhibition to those categories and record their choices by sticking colored dots on the wall beside each painting: green for good, blue for bad, yellow for ugly.

We were not prepared for the response that followed: a small exhibition in a secondary gallery generated its own buzz: attendance was remarkably high, and many people cited word of mouth as the impetus for their visit. Anecdotally we heard about repeat visits to "vote" for favorites, and in fact there was apparently some confusion about the purpose of the

dots: although we said nothing about audience involvement in the selection for deaccessioning, and in fact the process was already complete, some visitors felt they were voting to save or condemn works. In one case this proved true: an art history faculty member asked to have the paint-by-numbers fishing scene retained so she could use it in teaching, and it remains in the collection.

Very quickly the works were surrounded by haloes of colored dots. Interestingly no strong consensus emerged about any particular piece – no painting was overwhelmingly thought to be "good," for example. The Cézanne poster may have had the strongest disparity (72 good, 70 bad, 134 ugly); the paint-by-numbers image (84 good, 113 bad, 94 ugly), like many others, registered a surprisingly high "good" score. But given the nature of the exhibition it is of course impossible to rule out ironic votes. [5]

A number of classes made museum visits, principally from

the departments of art history and art, media and design. One instructor commented on how the interactive aspect altered the space itself, normally a site of "restraint, quiet, and elitism." Another observed that by its transparency it undercut "the back-room decisions about collecting that nearly all museums engage in," thereby making an artistic canon seem more a product of consensus and less capricious. A faculty member who teaches museum studies brought her class to the exhibition and has continued to use it as an example when discussing the concept of deaccessioning; the nuts and bolts process; collections development and developing a strategic collections policy; the movement toward transparency in museum management; and the broader topic of evolution and change in museums.[6]

We were sufficiently surprised by the response to what was at heart a didactic show, albeit with unusual objects, that

when we had the opportunity we asked visitors to describe their response. Some, like our faculty consultants, were caught up in issues of quality. Wondering whether any of the aesthetic or emotional appeal the works carried for previous generations might still exert some appeal, I made it a habit to ask if visitors could imagine having similar works in their homes. The answer was always negative, but some invoked the taste of their grandmothers. Some visitors liked the behind-the-scenes glimpse at museum practice, particularly those who were aware of other examples. Again anecdotally, part of the appeal was a device that encouraged visitors to form judgment, even if in arbitrary categories. Another part seemed to be the physical act of sticking the dot to the wall – both the gesture and the evident participation in a collective process of judgment.

Perhaps because of the elusive "quality" of works chosen, deaccessioning itself became a non-issue. We assumed that the practice would remain at the heart of the project, and that laying the process out in full would prove interesting to visitors. Instead it seemed that the collective social activity of voting, something we initially conceived of as a minor twist, helped to overcome passive reception of the exhibition and engaged visitors in a participatory curatorial exercise. In retrospect, it seems regrettable that the categories were not more sophisticated, but it may in fact have been the off-handed quality of the terms and the exercise that generated the response.

NOTES

1 The preponderance of academic museums is not accidental: trustees of a
 university in financial difficulties are far more likely to be tempted by selling
 off works of art to alleviate cash flow, while museum trustees have a better
 understanding of permanent collection as core to the institutional mission.
 For a summary of shifting public attitudes on deaccessioning see Robin Pogrebin,
 "The Permanent Collection May Not Be So Permanent," *New York Times*, January 26,
 2011.

2 http://www.imamuseum.org/art/collections/deaccession

3 Marian B. McClory, "A History of the DePaul University Women's Board," manuscript,
 DePaul University Archives.

4 In one instance we found that the artist had lived out the Depression in
 western New York as one of a group of landscape artists who drove to the
 city weekly to deliver their output to department store buyers. This
 biographical narrative of the supply side of the market suggests that the
 artists had direct information about buyers' preferences and interests, and
 consequently an ability to tailor their production accordingly.

5 Counting dots was a tedious process and we were not able to tally responses to
 all the works.

6 Cheryl Bachand, personal communication, April 22, 2012.

About the Editors

Stefanie S. Jandl is an independent museum professional with expertise on strengthening the teaching role of academic museums within their campus communities. She has over twenty years of museum experience that includes exhibition planning and academic outreach. Stefanie was the Andrew W. Mellon Associate Curator for Academic Programs at the Williams College Museum of Art (WCMA) in Williamstown, Massachusetts. At WCMA she helped build and strengthen the museum's Mellon Foundation-funded academic outreach program to make the WCMA collections, exhibitions, and programs a vital interdisciplinary academic resource for Williams College faculty and students. Stefanie has organized numerous collections-based and loan exhibitions including the *Labeltalk* exhibition series; she has also written for *Gastronomica* and published on Man Ray. With Mark Gold she co-authored "The Practical and Legal Implications of Efforts to Keep Deaccessioned Objects in the Public Domain" in *Museums and the Disposals Debate*, published by MuseumsEtc. (Peter Davies, Ed.). She has a BA in Political Science from the University of Southern California and an MA in the History of Art from Williams College.

Mark Gold is a partner in the law firm of Parese, Sabin, Smith & Gold, LLP, in Williamstown, Massachusetts. His practice includes business and corporate law, venture capital and traditional financing, and nonprofit and museum law. Mark has done considerable research on deaccessioning and the use of the proceeds of deaccessioning. He is the author

of several articles on the subject, including "Death by Ethics" in the November/December 2005 issue of *Museum News* and "Nothing Ethical About It" in the September/October 2009 issue of *Museum*, and co-authored the chapter entitled, "The Practical and Legal Implications of Efforts to Keep Deaccessioned Objects in the Public Domain" in *Museums and the Disposals Debate* (Peter Davies, Ed.) He has participated in panels on deaccessioning, governance, and other legal issues related to museums at meetings of the American Association of Museums and regional museum associations in the United States. He holds a BA in International Studies and Economics from The American University, a master's degree in Museum Studies from Harvard University and a law degree from Georgetown University. He is a member of the Board of Directors of the New England Museum Association.

EXHIBITIONS AND EDUCATION

About the Contributors

Carolyn Allmendinger, director of academic programs at the Ackland Art Museum, manages academic initiatives and programs for university, K-12, and community audiences. She has been at UNC-Chapel Hill for 23 years as a graduate student (PhD art history, 1999), museum professional, and adjunct assistant professor of art history. During twelve years at the Ackland, she has increased the number of students and faculty members who use the museum from 4,000 to 10,000 a year through discussion-based class tours, collaborative exhibitions, and object-based research projects that serve two dozen different academic departments and professional schools. Prior to her work at the Ackland, Carolyn taught art history courses at institutions including UNC-Chapel Hill, Duke University, and Durham Technical and Community College.

Ellen M. Alvord is the Andrew W. Mellon coordinator of academic affairs at the Mount Holyoke College Art Museum. She has worked at a number of other institutions including the Yale University Art Gallery, the Smith College Museum of Art, the Guggenheim Hermitage Museum, and the Las Vegas Art Museum. Ellen has a Master's degree in Museum Education from The College of William and Mary, and has worked in the field for fifteen years. In her current position, she collaborates with faculty from a wide range of academic departments to develop engaging, cross-disciplinary experiences with original works of art. She oversees around 165 class visits representing over 24 different disciplines each year. She also organizes

interdisciplinary faculty seminars related to object-based learning.

Helen Arnoldi has been the cultural collections projects coordinator at the University of Melbourne since 2005. Through the position she manages student and volunteer placements on collection management projects with the university's 30 cultural collections. For the past 14 years Helen has worked extensively in collection management, including positions with print collections, art collections and house museums. She has postgraduate qualifications in art curatorship and a Masters in Museum Studies from Monash University, Australia. Through the Universitas 21 network, Helen has recently been involved in the development of an international student projects exchange. The Museums and Collections Award was developed with a colleague at the University of Birmingham and offers award recipients the unique opportunity to take part in a month-long exchange working closely with the host university's museums and collections. Helen's latest publication *Managing volunteers in museums and cultural collections: ten things you should know* (University of Melbourne, 2010) explores issues to consider if you want to effectively involve volunteers with your collections.

Terry A. Barnhart is professor of history at Eastern Illinois University and a faculty member within the MA in Historical Administration Program. He was formerly an associate curator

and a director of special projects with the Education Division of the Ohio Historical Society at Columbus and an adjunct faculty member at Otterbein College in Westerville, Ohio. The American Association for State and Local History, the American Association of Museums, and the National Council on Public History are among the professional organizations he calls home. His teaching fields are 19th century U.S. social and cultural history, historical research methods, historical interpretation for public audiences, archival methods, and public history writ large. He holds a PhD in history, an MA in history, and a BS in education from Miami University in Oxford, Ohio.

Dan Bartlett is curator of exhibits and education and instructor of museum studies at Logan Museum of Anthropology, Beloit College. He holds a BFA from the University of Wisconsin-Superior and an MA in public history and museum studies from the University of Wisconsin-Milwaukee. At the Logan Museum of Anthropology, Dan is responsible for developing new exhibits and educational programming. He mentors students and teaches courses on exhibit design and development, and museum education in Beloit College's museum studies program. Particular interests include using objects in formal and informal learning environments and how people learn from museum exhibits. Before coming to Beloit College, Dan was the curator of exhibits at Midway Village Museum in Rockford, Illinois. His work at Midway Village has been recognized by the Illinois Association of Museums (IAM)

and the American Association for State and Local History (AASLH).

Joy Elizabeth Beckman is Director of the Wright Museum of Art at Beloit College, where she is also Assistant Professor of Art History. She received her MA in Art History from National Taiwan University and her PhD from the University of Chicago. Her research focuses on art and ritual practice in Bronze Age China.

Juliette Bianco is assistant director at the Hood Museum of Art, Dartmouth College. She holds a BA from Dartmouth College and an MA in Art History from the University of Chicago. Juliette has coordinated more than 20 exhibitions and has been most recently co-curator and co-editor of the exhibition and publication *Nature Transformed: Edward Burtynsky's Vermont Quarries Photographs in Context*. Juliette's work has focused on college and university museums as centres of innovative teaching and as places to explore creative curatorial practice, diverse partnerships, and modelling the benefits of strategic planning and evaluation.

Peter Biehl is Chair of the Department of Anthropology and Director of the Institute for European and Mediterranean Archaeology at the State University of New York at Buffalo. His interests include Neolithic and Copper Age Europe and the Near East, archaeological method and theory, cognitive archaeology and the social meaning of visual imagery and

representation, the archaeology of cult and religion, museums and archaeological collections, and heritage and multimedia in archaeology. He has published extensively in the fields of cultural heritage and archaeology.

Laurel Bradley is director and curator of the Perlman Teaching Museum at Carleton College in Minnesota. Since 1996, she has advocated for connecting museum programs to the curriculum, through collaboration, pedagogical experiments, and design realized in the new Perlman Teaching Museum (opened fall 2012). Former chair of the Minnesota Association of Museums Steering Committee, Laurel regularly writes, lectures and consults on visual literacy, campus museum issues, and Victorian art. She spent eight years teaching at the School of the Art Institute of Chicago in the Department of Art History, Theory and Criticism, and was the founding director of Gallery 400 at the University of Illinois, Chicago. Her PhD is from New York University's Institute of Fine Arts.

Stephanie Harvey Danker is a doctoral candidate in art education through University of Illinois – Urbana Champaign (UIUC). Her dissertation research is concerned with strengthening relationships between museum educators and local teachers. She taught art in Fairfax County Public Schools (VA) for six years. She has taught art education courses at Wichita State University (WSU), UIUC, and James Madison University (JMU). In addition to teaching, she has served as an education consultant for the Ulrich Museum of Art (on WSU's

campus) and currently consults for Sawhill Gallery (on JMU's campus).

Suzanne Davis has headed the conservation department at the University of Michigan's Kelsey Museum of Archaeology since 2001. She oversees conservation and preservation for the Museum, serves as affiliated faculty for the University of Michigan's Museum Studies Program, and directs field conservation for Kelsey Museum archaeological excavations in Egypt and Israel. She is a professional associate member of the American Institute for Conservation and received graduate degrees in art history and conservation from the Conservation Center of the Institute of Fine Arts, New York University. Her primary research interests are the conservation of archaeological materials and the history and practice of archaeological field conservation.

Laura Evans is an assistant professor of art history and art education in the College of Visual Arts and Design at the University of North Texas. She is the director of the University's Museum Education Certificate, a unique program that allows students to focus solely on the educative aspects of art museums. Laura received her PhD at The Ohio State University. Her dissertation research centered on the educational impact of a socially important exhibition while it toured to university art museums. Previous to her PhD, she was an academic fellow at the National Gallery of Art in the Department of Education and earned her Master's in Museum Studies at the University of Toronto.

Ruth Fletcher was appointed student engagement officer at The Hunterian, University of Glasgow in 2011. She has varied experience as a professional trainer and educator spanning public and private sector organizations, primary and higher education and cultural heritage. A Business Studies graduate (Manchester Metropolitan University) and a member of the Chartered Institute of Personnel and Development with a Diploma in Training Management, Ruth is also a qualified Primary Teacher with five years of teaching experience. As a Training and Development Consultant at the Victoria and Albert Museum, Ruth was responsible for the re-development and coordination of the museum's Assistant Curator Development Programme, and the organization of a Museums Administrators Conference.

Linda Friedlaender has been the curator of education at the Yale Center for British Art for the past fifteen years. Before that, she held similar positions at the Wadsworth Atheneum Museum of Art, Hartford, and the Mount Holyoke College Art Museum, South Hadley, MA, where she is a member of the Museum Advisory Board. She has taught at all levels of education. Linda co-produced a program on enhancing observational skills to improve clinical diagnostic skills for Yale Medical Schools, now in its fourteenth year. She also has an appointment as instructor in the Dermatology Department. Enhancing observational skills is also used with the Yale School of Nursing and the Yale Physician Associate Program. Both programs have been published in leading medical and

nursing journals. She and her colleagues are working with the Department of Psychology and the Child Study Center to develop rubrics to measure learning outcomes in the museum setting and their viability to be transferred to the classroom. She has been the recipient of numerous grants and most recently The Wilbur Cross Award and Arts Council Award of Greater New Haven. She has collaborated on two children's books that are used throughout New Haven schools as preparation for a museum visit.

David Gaimster has been director of The Hunterian, the University of Glasgow museum and gallery service, since September 2010. He was formerly general secretary and chief executive, Society of Antiquaries of London (2004-2010); senior policy advisor for cultural property, Department for Culture, Media & Sport (DCMS), London (2002-04); and assistant keeper in the Department for Medieval & Later Antiquities, British Museum, London (1986-2001). David has published extensively on late medieval to early modern European archaeology and material culture and also on international cultural property policy issues. He has organized several major international exhibitions that have also toured overseas, including *Pottery in the Making* (Museum of Mankind, London,) and *Making History: Antiquaries in Britain 1707-2007* (Royal Academy, London). While at DCMS David led the teams managing UK acceptance of the 1970 UNESCO *Convention on the Means of Prohibiting and Preventing the Illicit Import, Export and Transfer of Ownership of Cultural Property* and the passing of the *Dealing in Cultural Objects (Offences) Act 2003*.

Leonie Hannan is an historian who has incorporated the study of material culture, alongside more traditional textual sources, in her research on gender and intellectual life in the 17th and 18th centuries. She has a professional background in museums and heritage and has taught extensively in higher education. In her role at University College London, she has responsibility for generating new opportunities for object-based learning using museum collections across all the university's academic departments.

Laura Harrison is a PhD student in the Department of Anthropology at SUNY Buffalo. She is involved with museums through her work as the teaching assistant for the Cravens Collection at the Anderson Gallery, and formerly held positions at the Smithsonian and the New York State Museum. Her research focuses on innovative approaches to collection management, digital technologies in museums, and cultural heritage and law.

Jessica Hunter-Larsen was hired to create the InterDisciplinary Experimental Arts (IDEA) Program at Colorado College in June 2006 and is now its curator. She received a BA from Colorado College in 1990 and an MA from the University of Colorado in 1995. As IDEA Curator, Jessica works closely with faculty to integrate exhibitions and performances into classes. She also teaches Museum Studies at Colorado College and is the advisor for the Museum Studies Thematic Minor. She has curated many exhibitions and in 2011

received the Pikes Peak Arts Council's Award for Curatorial Excellence. She frequently lectures on contemporary art topics and has presented original research on university/museum collaborations at conferences of the Association of Academic Museums and Galleries (2011) and the American Association of Museums (2009). Jessica has received project grants from the National Endowment for the Arts, the Institute of Museum and Library Services, the Andy Warhol Fund for the Visual Arts, the Elizabeth Firestone Graham Foundation; the Gay & Lesbian Fund for Colorado; the Richard Floresheim Foundation, the E.L. Wiegand Foundation, and the Paul G. Allen Family Foundation.

Louise Lincoln is director of the DePaul Art Museum at DePaul University in Chicago. She was previously curator of Arts of Africa, Oceania, and the Americas at the Minneapolis Institute of Arts, and has published on a variety of topics, including Dine (Navajo) aesthetics, Melanesian colonial history, and museum practice.

Emily Kass has been the director of the Ackland Art Museum at The University of North Carolina at Chapel Hill since 2006. She has a wealth of experience in exhibition planning, collection management, education and public programming, community collaboration, and development. Emily began her career as director of education programs at the Walker Art Center and subsequently served as director at The University of New Mexico Art Museum, the Fort Wayne Museum of

Art, and the Tampa Museum of Art. She is a member of the Association of Art Museum Directors and has served on a number of national and regional boards and committees and as a peer reviewer for the American Association of Museums Accreditation and MAP programs.

Jenny R. Kreiger is a graduate student in the Interdepartmental Program in Classical Art and Archaeology at the University of Michigan. She is concurrently pursuing a Certificate in Museum Studies at the same institution. Her research interests include childhood in the ancient world, Roman funerary art and epigraphy, Christianity in late antiquity, and issues of audience and accessibility in museums.

Amanda Martin-Hamon is associate director of adult community engagement at the Spencer Museum of Art, University of Kansas. She also teaches art appreciation for Washburn University. Amanda has worked in academic museums for over thirteen years, including Mulvane Art Museum, Washburn University where she was the assistant director. She was named 2002 Kansas Outstanding Art Educator in the Division of Museum Education by the Kansas Art Education Association in 2002. Amanda has presented at numerous professional conferences and has published in the Journal of Museum Education and Art Education, the membership journal of the National Art Education Association.

Henry McGhie is head of collections and curator of zoology at The Manchester Museum, The University of Manchester. He has had a lifelong passion for natural history, especially birds, and formerly worked on field ecology projects related to bird conservation. He has published widely on bird ecology, historical ecology and museum-based approaches to natural history. Henry has worked at The Manchester Museum in a range of different roles since 2000 and now leads a team of curators and curatorial assistants who are responsible for the day-to-day management and development of the collection, developing exhibitions, supporting university teaching and research agendas and facilitating access to collections and collections-related knowledge. He is involved in developing closer links between the university and the museum; he teaches on undergraduate courses in Animal Evolution and the Geography of Life, supervised final year BSc projects and currently supervises a PhD student whose project involves the museum collection. He is currently writing a book about the museum's main bird collector, Henry Dresser (1838-1915). He is also a participant in the project *Animals as Symbols and as Signs*, funded by the Norwegian Research Council. Henry was the lead curator of the museum's year-long Darwin programme, *The Evolutionist: a Darwin extravaganza* in 2009, *Living Worlds* in 2011 and *Alan Turing and Life's Enigma* in 2012.

Liliana Milkova assumed the position of curator of academic programs at the Allen Memorial Art Museum (AMAM), Oberlin College and Conservatory after a postdoctoral tenure

in the Department of Photographs at the National Gallery of Art in Washington, D.C. As liaison between the AMAM and the Oberlin faculty, she expanded significantly the museum's outreach across the curriculum and developed new pedagogic strategies for teaching with art in non-art disciplines. Liliana spearheaded and authored the publication of the first academic museum brochure, which analyzes the application of art as a cross-disciplinary teaching tool at Oberlin College. At AMAM, she has co-curated two exhibitions, *A Museum for Oberlin*, which chronicles the history and development of the museum's extensive, encyclopedic holdings, and *Italy on Paper*. She has also curated exhibitions and published essays on Soviet political propaganda and contemporary art from Eastern Europe, and contributed to catalogs published by the National Gallery of Art, Washington, D.C. and the Morgan Museum & Library, New York. Her scholarly expertise is in modern and contemporary art. She has taught at the University of Pennsylvania and Oberlin College and holds a PhD from the University of Pennsylvania and an A.B. *magna cum laude* from Brown University.

Jane Pickering is the deputy director of the Yale Peabody Museum of Natural History and has over 20 years' experience in university science museums. She spent eight years at the Oxford University Museum of Natural History as Assistant Curator for Zoology, when she obtained a Masters Degree in Museum Studies. After a year as Senior Curator of the Museums of the Royal College of Surgeons of London, she moved to the U.S. to be director of the MIT Museum in Boston.

At MIT she oversaw an extensive museum-wide reorganization to support a new mission focused on the relationship between the wider community and the university. In 2002 she joined the Yale Peabody Museum where she supervises all aspects of public programs and serves as deputy director. During her career Jane has focused on the unique opportunities available to university museums for public engagement, through her work on multiple exhibition projects and the development of initiatives in informal science education.

Richard V. Riccio, a professional exhibit designer, is the instructor of record for the exhibit courses in the Historical Administration Program at Eastern Illinois University. He received an MA in Museum Studies with a concentration in anthropology from the University of Arizona. Prior to coming to Charleston, Richard served as the exhibit designer at the Peabody Museum of Archaeology and Ethnology and taught within the museum studies certificate program at Harvard University. He is the principal of Riccio Exhibit Services and serves on the board of the Illinois Association of Museums.

Deborah Rothschild is senior curator emerita of modern and contemporary art at the Williams College Museum of Art. In her 26 years at the Museum she oversaw more than 50 exhibitions, organizing shows of work by James Turrell, David Hammons, Adrian Piper and other living artists as well as numerous historical exhibitions. She received an award for best historical show from the New England Section of the

International Association of Art Critics (AICA) for *Prelude to a Nightmare: Art, Politics and Hitler's Early Years in Vienna 1906—1913* (2002). Deborah was also honored with two first place national AICA awards for *Tony Oursler: Introjection* (2000) and for *Making It New: the Art and Style of Sara and Gerald Murphy* (2007). She is the author of *Picasso's 'Parade': from Street to Stage* and is currently working on an exhibition of work by Laylah Ali.

Deborah Schultz is assistant professor of art history at Richmond American International University in London and Senior Lecturer at Regent's College, London. She worked for a number of years as a research fellow on the Arnold Daghani Collection in the Department of History at the University of Sussex where her activities included teaching on and researching the collection of drawings, paintings, writings and documentation on the artist. Her primary areas of study focus on word-image relations, artists' books, photography, and memory in 20th century and contemporary art, with an interest in historiography and pedagogical projects. She is the author of "Crossing Borders: Migration, Memory and the Artist's Book", in *Moving Subjects, Moving Objects: Migrant Art, Artefacts and Emotional Agency*, Maruška Svašek (ed.) (Oxford, 2012), co-author with Edward Timms of *Pictorial Narrative in the Nazi Period: Felix Nussbaum, Charlotte Salomon and Arnold Daghani* (Oxford, 2009) and co-editor with Edward Timms of *Arnold Daghani's Memories of Mikhailowka: The Illustrated Diary of a Slave Labour Camp Survivor* (London, 2009). She is

a regular contributor to *Art Monthly* and other contemporary art journals.

Wendy Sepponen is a PhD student in the University of Michigan's History of Art Department. Before arriving in Ann Arbor, she received her MA, also in Art History, from the University of Toronto. While her research focuses on 16th century Italian sculpture, she worked as Graduate Curatorial Assistant at the Bata Shoe Museum (Toronto, ON) on an exhibition that explored the emergence of elevated footwear in Renaissance and Baroque Europe.

Kathy Gaye Shiroki is the curator of museum learning and community engagement at the Burchfield Penney Art Center, coordinator of the Czurles-Nelson Gallery, and a lecturer at Buffalo State College. She earned her MFA from the University of California, San Diego and her BFA from Temple University, Tyler School of Art. Kathy has been developing museum educational programming for over twenty years including the design of interactive spaces at the Albright-Knox Art Gallery. Her recent work has focused on how to have a conversation with a work of art and integrate the discussion into course curriculum.

Philip Stephenson is a senior lecturer in the University of Cambridge Faculty of Education. Following a career as a teacher and head-teacher in UK primary and middle schools he has spent the past 15 years working in the university. In his role as a teacher and trainee teacher educator, he has had the

opportunity to extend the links that already existed between the university departmental museums and mainstream education. The outcomes of this work have been the establishment of a range of structures whereby trainee teachers and higher degree education students have the opportunity to undertake mentored placements in the museums, developing both their pedagogical armory and an understanding of the theoretical frameworks in which these strategies are embedded. He has a particular interest in how well the dialogic approaches adopted by many museum educators translate into teachers' day-to-day classroom practice. The work with the university museums has also provided a template for engagement with museums and galleries beyond the campus community including several of the major national collections.

John Stomberg has nearly two decades of experience in the teaching museum field, having held curatorial and leadership positions at the Boston University Art Galleries and the Williams College Museum of Art before being appointed Florence Finch Abbott director of the Mount Holyoke College Art Museum and lecturer in art in 2011. He teaches courses in the History of Photography, Modern and Contemporary Art, and American Art. His publications include monographic studies of photographers Margaret Bourke-White, Jules Aarons, Verner Reed, and Ulrich Mack; painters John Walker and Jon Imber; and thematic studies such as *Looking East: Brice Marden, Michael Mazur, Pat Steir*. His curatorial work has included installations by Zhan Wang and Fiona Tan; one

person exhibitions for Liu Zheng, Edward Steichen, Hendrik Werkman and Dorothea Tanning; and group shows *Beyond the Familiar: Photography* and the *Construction of Community* and *Photography at the Frontier of Physics and Art*. In 2007 John was co-curator and contributing author for *Beautiful Suffering: Photography and the Traffic in Pain*. He earned both his MA and PhD in Art History from Boston University and a BA in Art History from Georgetown University. His current areas of research focus on artistic collaboration and the role that teaching museums can have in fostering innovation and leadership through the study of art.

Alice Isabella Sullivan is a PhD student in the History of Art Department at the University of Michigan and also works as a curatorial research assistant at the University of Michigan Museum of Art (UMMA). Her research focuses on the artistic production of East-Central Europe in the early modern period. She received an MA in Art History with a focus on Romanesque sculpture from the Williams College Graduate Program in the History of Art. While in Williamstown, she also worked as a curatorial assistant and a registrar intern at the Sterling and Francine Clark Art Institute (Williamstown, MA).

Pat Villeneuve is professor and director of arts administration in the Department of Art Education, Florida State University. She also directs certificate programs in art museum education, art and community practice, and museum studies for the department. Pat has published, presented, and consulted

extensively in art education and art museum education. She is a past editor of *Art Education*, the membership journal of the National Art Education Association, and was named the National Art Museum Educator in 2009. Formerly the curator of education at the Spencer Museum of Art, she developed and directed University in the Art Museum, a program to encourage faculty across disciplines to integrate museum objects in their teaching. Pat is currently developing a model for visitor-centered exhibitions, presented in a chapter she co-authored in *Museums at Play*.

Steven S. Volk is professor of history and director of the Center for Teaching Innovation and Excellence (CTIE) at Oberlin College (Oberlin, Ohio). His areas of specialty include Latin American history and museum studies. He has published on Chilean history, U.S.–Latin American relations, and Mexico (including Frida Kahlo, and the popular culture of femicide in Ciudad Juárez), as well as on higher education pedagogy. He was named 2011 U.S. Baccalaureate College Professor of the Year by the Carnegie Foundation for the Advancement of Teaching and the Center for the Advancement and Support of Education (CASE). Steven has received two National Endowment for the Humanities (NEH) grants and in 2001 he was recognized by the Chilean government for helping to restore democracy in that country. He co-curated an exhibit at the Allen Memorial Art Museum on prints of the Mexican Revolution, and helped develop the *Crossing the Streets* pedagogical model which has been showcased at various national conferences. He holds

a B.A. from Brandeis University, and an MA and PhD from Columbia University. Besides Oberlin College, he has taught at New York University, Yale University, and the New School for Social Research. He is currently working on a book-length project on how the Chilean coup of 1973 is remembered in the United States.

Barbara Woods is clinical assistant professor and director of postgraduate education in the School of Pharmacy, University of Kansas. She has received numerous teaching awards and was named Kansas Pharmacist of the Year in 2000. Barbara has extensive experience in developing and presenting continuing education programs in disease and drug management topics for pharmacists.

Index

EXHIBITIONS AND EDUCATION

Also from MuseumsEtc

Academic Museums:
Beyond Exhibitions and Education

Editors: Stefanie S Jandl and Mark S Gold

ISBN: 978-1-907697-55-5 [paperback]
ISBN: 978-1-907697-56-2 [hardback]

Order online from www.museumsetc.com

This is the second of two companion volumes which aim to aggregate in one convenient place good current thinking on the opportunities and issues unique to academic museums. The result is a collection of best practices, innovations, and sound approaches that offer guidance and inspiration for the entire community, large and small, well-endowed and modestly-resourced alike. This book is - above all - a practical resource.

While the first volume addresses key issues related to exhibitions and education, this second volume addresses most everything else, including the strategic issues of mission, relationship to the parent organization, phases of birth and growth of academic museums, new technologies, and the collection as an "asset" of the parent organization.

"A vital resource for anyone working in or concerned about Academic museums. It will become the standard text for generations to come." *James Cuno, President & CEO, The J. Paul Getty Trust.*

Museums at Play:
Games, Interaction and Learning

Editor: Katy Beale

ISBN: 978-1-907697-13-5 [paperback]
ISBN: 978-1-907697-14-2 [hardback]

Order online from www.museumsetc.com

Museums are using games in many ways – for interpretation, education, marketing, outreach and events. *Museums at Play* showcases tried and tested examples from the sector and seeks to inspire further informed use of games. It also draws on relevant experience from other sectors, and on the experience of game designers and theorists. It looks at learnings from other disciplines and explores the possibilities of interaction using gaming within museums.

Some 50 contributors include specialists from world-class institutions including: British Museum, Carnegie Museum of Natural History, Children's Discovery Museum of San Jose, Conner Prairie Interactive History Park, Museum of London, New Art Gallery Walsall, Science Museum, SciTech, Smithsonian Institution, Tate, Walker Art Center and specialists from Belgium, Canada, Denmark, Germany, Greece, Iceland, Italy, Mexico, New Zealand, Norway, Portugal, Spain, Turkey, UK and USA.

MuseumsEtc Books

Alive To Change: Successful Museum Retailing
Contemporary Collecting: Theory and Practice
Conversations with Visitors: Social Media and Museums
Creating Bonds: Successful Museum Marketing
Creativity and Technology: Social Media, Mobiles and Museums
Inspiring Action: Museums and Social Change
Interpretive Master Planning: Philosophy, Theory and Practice
Interpretive Master Planning: Strategies for the New Millennium
Interpretive Planning Handbook
Museum Retailing: A Handbook of Strategies for Success
Museums and the Disposals Debate
Museums At Play: Games, Interaction and Learning
Narratives of Community: Museums and Ethnicity
Naturalistic Photography
New Thinking: Rules for the (R)evolution of Museums
Photography and the Artist's Book
Restaurants, Catering and Facility Rentals: Maximizing Earned Income
Rethinking Learning: Museums and Young People
Science Exhibitions: Communication and Evaluation
Science Exhibitions: Curation and Design
Social Design in Museums: The Psychology of Visitor Studies (2 volumes)
Sustainable Museums: Strategies for the 21st Century
The New Museum Community: Audiences, Challenges, Benefits
The Power of the Object: Museums and World War II
Twitter for Museums: Strategies and Tactics for Success
Wonderful Things: Learning with Museum Objects

MuseumsEtc Videos
Cocktails and Culture: Cultivating Generation Next
Museums | Inclusion | Engagement
Planning and Designing for Children and Families
Real-World Twitter in Action

Order online at: www.museumsetc.com

Colophon

MuseumsEtc Ltd
Hudson House
8 Albany Street
Edinburgh EH1 3QB
United Kingdom

675 Massachusetts Avenue
Suite 11
Cambridge
MA 02139
USA

www.museumsetc.com

ISBN: 978-1-907697-53-1
This edition first published 2012
Edition © 2012 MuseumsEtc Ltd
Texts © the authors

The paper used in printing this book comes from responsibly managed forests and meets the requirements of the Forest Stewardship Council™ (FSC®) and the Sustainable Forestry Initiative® (SFI®). It is is acid free and lignin free and meets all ANSI standards for archival quality paper.

Typeset in Underware Dolly 10/16 and Adobe Myriad Pro 9/14

A CIP catalogue record for this book is available from the British Library.

Lightning Source UK Ltd.
Milton Keynes UK
UKOW040832061212

203241UK00002B/12/P